ROCK AND POPULAR MUSIC: POLITICS, POLICIES, INSTITUTIONS

Rock and Popular Music examines the relations between the policies and institutions which regulate contemporary popular musics and the political debates, contradictions and struggles in which those musics are involved. International in its scope and conception, this innovative collection brings together contributions from some of the most authoritative writers on rock and popular music in North America, Europe and Australia.

Ranging widely in both choice of topic and approach, the essays explore and develop three main areas of debate. First, comparative examinations of the role played by governments in either supporting or inhibiting the development of popular music industries reveal a significant diversity of relations between the state and the musical sphere. A second theme demonstrates the important role of broadcasting policies in organizing the 'audio-spaces' within which particular musical communities can be formed and seek expression, and finally the book reconsiders some of the classic political issues of rock and popular music theory and debate in the context of their specific policy and institutional settings.

Consisting entirely of new essays commissioned by the editors, *Rock and Popular Music* is a unique collection suggesting significant new directions for the study of contemporary popular musics.

CULTURE: POLICIES AND POLITICS

What are the relations between cultural policies and cultural politics? Too often, none at all. In the history of cultural studies so far, there has been no shortage of discussion of cultural politics. Only rarely, however, have such discussions taken account of the policy instruments through which cultural activities and institutions are funded and regulated in the mundane politics of bureaucratic and corporate life. *Culture: Policies and Politics* will address this imbalance. The books in this series will interrogate the role of culture in the organization of social relations of power, including those of class, nation, ethnicity and gender. They will also explore the ways in which political agendas in these areas are related to, and shaped by, policy processes and outcomes. In its commitment to the need for a fuller and clearer policy calculus in the cultural sphere, *Culture: Policies and Politics* will help to promote a significant transformation in the political ambit and orientation of cultural studies and related fields.

ROCK AND POPULAR MUSIC

Politics, Policies, Institutions

Edited by Tony Bennett, Simon Frith, Lawrence Grossberg, John Shepherd and Graeme Turner

London and New York

First published 1993
by Routledge
11 New Fetter Lane, London EC4P 4EE

Simultaneously published in the USA and Canada
by Routledge
29 West 35th Street, New York, NY 10001

Typeset in 10 on 12 point Times by Florencetype Ltd, Kewstoke, Avon
Printed in Great Britain by T J Press Ltd, Padstow, Cornwall

British Library Cataloguing in Publication Data
Rock and Popular Music:Politics, Policies, Institutions. — (Culture: Policies &
Politics Series)
I. Bennett, Tony II. Series
306.4

Library of Congress Cataloging in Publication Data
Rock and popular music : politics, policies, institutions / edited by Tony Bennett
. . . [et al.].
p. cm. — (Culture)
Includes bibliographical references and index.
1. Rock music — Political aspects. 2. Rock music — Social aspects. 3. Popular
music — Political aspects. 4. Popular music — Social aspects. 5. Music and
society. I. Bennett, Tony. II. Title: Politics, policies, institutions. III. Series:
Culture (London, England)
ML3534.R612 1993
306.4′84 — dc20 93–20233
 CIP

ISBN 0–415–06369–8 (pbk)
ISBN 0–415–06368–X (hbk)

CONTENTS

v

CONTENTS

CONTRIBUTORS

Mavis Bayton is Tutor in Sociology and Women's Studies at Ruskin College, Oxford. She is the author of 'How women become rock musicians', which appeared in Simon Frith and Andrew Goodwin (eds) *On Record: Rock, Pop and the Written Word* (1990) and of 'Out in the margins: feminism and the study of popular music', which appeared in *Women: A Cultural Review* 3(1), Spring 1992.

Tony Bennett is Professor of Cultural Studies at Griffith University where he has also served as Dean of the Faculty of Humanities and Founding Director of the Institute for Cultural Policy Studies. His books include *Formalism and Marxism* (1979), *Outside Literature* (1990) and (with Janet Woollacott) *Bond and Beyond: The Political Career of a Popular Hero* (1987).

Jody Berland teaches Cultural Studies in the Department of Humanities at Atkinson College, York University. She has written extensively on music, media, space and cultural theory and is currently co-editing a book entitled *Theory Rules*, on art and the institutionalization of theory.

Georgina Born is a cultural anthropologist and a musician, and lectures in the Department of Media and Communications at Goldsmith's College, University of London. She is currently editing a book called *Western Music and Its 'Others': Difference, Representation, and Appropriation in Music*.

Marcus Breen has been a music and film journalist for the past decade, writing for newspapers and magazines, including *The Hollywood Reporter* and *Music Business International*, as well as broadcasting on the Australian Broadcasting Corporation. He was educated at the University of Queensland and the Australian National University and is editor of the two-volume collection *Australian Popular Music in Perspective* (1987 and 1989). He is currently a postgraduate fellow and researcher at the Centre for International Research on Communication and Information

Technologies in Melbourne and is writing a doctoral thesis on the Australian music industry. He is on the board of the Victorian Rock Foundation.

Simon Frith is Professor of English at Strathclyde University, Glasgow and Co-Director of the John Logie Baird Centre. He is currently working on a book on the aesthetics of popular music.

Reebee Garofalo teaches at the University of Massachusetts at Boston and has written numerous articles on music and politics for academic and popular publications. He co-authored *Rock'n'Roll is Here to Pay: The History and Politics of the Music Industry* in 1977 and has recently edited a collection entitled *Rockin' the Boat: Mass Music and Mass Movements* (1992).

Line Grenier is Assistant Professor in the Département de Communication at the Université de Montréal. She has published articles in journals such as *Popular Music, New Formations, Communication* and *Ethnomusicology*, and has been a member of the executive committee of IASPM (International Association for the Study of Popular Music). Her current research focuses on the development of *chanson* as a social form of music and its role in the emergence of local music-related industries in French-speaking Quebec.

Lawrence Grossberg is a Professor of Speech Communication, Communications Research, and Criticism and Interpretive Theory at the University of Illinois, Urbana-Champaign. His most recent books include *We Gotta Get Out of This Place: Popular Conservatism and Postmodern Culture* and *Cultural Studies* (1992) (edited with Cary Nelson and Paula Treichler). He is the co-editor of the journal *Cultural Studies*.

Ross Harley is a video-artist, editor and pop culture commentator who works across a variety of media. He teaches art and film at the University of New South Wales, and is a former editor of *Art and Text*.

Steve Jones is Assistant Professor of Communication at the University of Tulsa. His most recent work is a book entitled *Rock Formation: Popular Music, Technology and Mass Communication* (1992). He has also published articles on virtual reality technology, the meaning of authenticity in popular music and popular culture, and popular music criticism.

Chris Lawe Davies teaches in the Journalism Department at the University of Queensland. His research and publication interests extend from popular culture and journalism practice through to questions dealing with cultural policy.

Krister Malm is the Director of the Music Museum in Stockholm. His background is in ethnomusicology.

Paul Rutten teaches at the Institute for Mass Communication at the Catholic University of Nijmegen in the Netherlands. His main research interests are popular music, the music industry, mass communication and culture. His most recent publications are a study on Dutch pop and rock music on the national and international market (together with Gerd Jan Oud, 1991) and his dissertation (1992), which is a study of the developments in chart music in the Netherlands in the period 1960–85.

John Shepherd is currently Director of the School for Studies in Art and Culture at Carleton University and has taught in the areas of sociology, cultural studies, the sociology and aesthetics of music, popular music history and the sociology of music education. He has also published widely in those areas including *Music as Social Text* (1991).

Will Straw is an Associate Professor within the Graduate Program in Communications at McGill University in Montreal. From 1984 to 1993, he taught in the Film Studies Program at Carleton University in Ottawa. He is an ex-chair of the Canadian branch of the Anternational Association for the Study of Popular Music, and currently editor of *RPM: The Review of Popular Music*. He has published articles on popular music in *Cultural Studies*, *Popular Music* and *The Canadian Universities Music Review*.

Graeme Turner teaches at the University of Queensland. He is the author of numerous books on the media, popular culture, and Australian cultural studies. His most recent publications are *British Cultural Studies: An Introduction* (1990) and (with Stuart Cunningham) *The Media in Australia* (1992). He is currently editing a collection of essays on Australian cultural studies.

Roger Wallis has spent a number of years working in broadcasting (both in Swedish radio and as news correspondent for the BBC in Sweden) and in the phonogram industry. Together with Krister Malm, he has spent much time studying the music industry in a number of small countries as part of the Music Industry in Small Countries Project (MISC). Their latest report was published as *Media Policy and Music Activity* in 1993.

Peter Wicke is Professor of the Theory and History of Popular Music and Director of the Centre for Popular Music Research at Humboldt University in Berlin. His books include *Rock Music: Culture, Aesthetics and Sociology* (1990). He is a member of the executive committee, and former General Secretary of, IASPM (International Association for the Study of Popular Music).

SERIES EDITORS' PREFACE

Culture is a political matter. So too, and inevitably, is its analysis. This is not simply because of the personal biases and investments which inescapably inform any particular individual's approach to a given topic. Rather, the issue is that of the political relation that is implied and produced by the manner in which intellectuals think of their work and the manner and circumstances in which they envisage it having practical effects. In the sphere of culture no less than any other, the ways in which intellectual work is conducted and circulated – that is, the contexts in which it is undertaken, the forms in which it is expressed, the constituencies to which it is addressed – have a crucial bearing on the ways in which such work might connect with and contribute to contemporary political issues and concerns.

In these respects, the *Culture: Policies and Politics* series is intended to help bring about a significant transformation in the political ambit and orientation of cultural studies. The direction of the change is indicated by the conjunction of the key terms 'policy' and 'politics'. Closely linked in many areas of social and political life and analysis, these terms have often been strangers in the discipline of cultural studies. If practitioners of cultural studies have talked about politics – as they have, for example, when discussing resistance and empowerment – they have rarely shown any interest in the policy instruments through which cultural activities and institutions are funded and regulated in the mundane politics of bureaucratic and corporate life.

There are a number of reasons for this striking silence. The most obvious is the political leaning that was given to cultural studies in the Anglophone world by its formative passage through the work of Raymond Williams and the New Left. In defining culture as a 'whole way of life' – and in promising to reclaim the cultural totality by restoring the popular and the political to the realm of the aesthetic – this tradition provided cultural studies with a prophetic and oppositional political voice which aspired to rise above the mundane calculations and procedures of the world of policy. In this way, through entertaining the possibility that it might bypass them, cultural

studies has failed to link its discussions of culture and politics to the instruments and ethos of policy. That is to say, it has lacked a policy calculus.

If it is to prove more than a passing intellectual fad and develop a capacity to make a sustained and long-term contribution to the governmental and industrial processes through which our cultural futures will most actively be shaped, cultural studies urgently needs to develop such a calculus. And this, in turn, can only be accomplished through more detailed and scrupulous attention to the various policy structures and processes – from government inquiries through the activities of the statutory bodies which regulate the legal environment of the cultural industries to specific industry practices and procedures – which influence the ways in which the relations between culture and politics are practically mediated.

It is work of this kind, therefore, that we shall publish in this series – work which, in recognizing the role which many forms of contemporary culture play in the relay of forms of power across relations of class, nation, race, ethnicity and gender, also takes account, both theoretically and practically, of the need to accord policy considerations their due in the formulation of political objectives and ways of pursuing them that are likely to be both practicable and effective. This is, to speak plainly, an advocacy for pragmatism which, given the more idealistic aspirations on which cultural studies has customarily been nurtured, will no doubt, in some quarters, be rejected as unprincipled by those who remain committed to the project of a wholly oppositional politics.

To view this as a cause for alarm, however, can now only count as backward-looking. Once we have ceased to think of cultural studies as the intellectual delegate of the subaltern fragments of human totality, then there is no reason to assume that it will speak with a single ethical or political voice. The private and civic environments in which cultural activities are funded and regulated are far too various – their ethical, legal, and economic orientations far too mundanely complex – to permit a single exemplary oppositional relation to them. It is the purpose of this series to trace some of the multifarious paths cut through the field of cultural activities by the instruments of policy – instruments that shape the often unpredictable, gritty and compromised ways in which such activities are pursued, thought about and argued over.

Tony Bennett
Jennifer Craik
Ian Hunter
Colin Mercer
Dugald Williamson

PREFACE

This book had its origins in a seminar organized by the Institute for Cultural Policy Studies in 1988. The purpose of the seminar, at which we had all planned to be present, was to see what light might be thrown on the terms in which the politics of rock and popular music were most characteristically posed and debated in Australia, Europe and North America by placing those debates in their relevant policy contexts. In the event, while we all collaborated in planning the seminar, only three of us were able to take part in it. However, it was clear to all of us, and especially when the proceedings of the seminar were published, that the occasion had proved productive.[1] This was especially true of the way in which the attention paid to the policy and institutional determinants of musical production and distribution allowed the differences between the cultural politics of music in different national contexts to be more clearly focused.

This book, therefore, grew out of the conviction that the issues that we had begun to discuss were ones worth exploring more fully and in greater detail. That said, we are conscious that the work collected and represented here is merely a beginning. This is, in part, to note the limited aims which, as editors, we set ourselves. The comparative geographical focus of the collection thus remains limited to Australia, Europe (with a bias toward Britain), Canada and the United States. We have been careful not to treat these as pre-given unities in ensuring that differences *within* national cultural formations (the position of Aboriginal music in Australia, and the delicacy of the question of 'the nation' when posed in relation to musical debates in Quebec) are attended to just as much as are the differences between them. As Georgie Born rightly points out in her *Afterword*, however, this exclusive concentration on advanced industrial societies means that many of the issues associated with the increasingly globalized patterns of musical production are not adequately dealt with – a limitation it is important the reader should note from the outset.

We have been equally selective with regard to those aspects of the relations between the institutional, policy and political vectors of rock and popular music that we have sought to have explored. In the main, the

attention of the contributors focuses on three aspects of these relations. In the first section, attention falls mainly on the role of governments – whether at the national, state or local levels – in establishing particular patterns of direct or indirect support for the production and distribution of music as well as providing the legal conditions necessary for the development of its industrial and commercial infrastructures. Then, in the second section of the collection, the emphasis shifts to national broadcasting policies and their implications for the different ways in which music is produced and distributed and made available to be participated in – both as producers and consumers – by different communities. Finally, the concluding section considers what have always been central points of focus in debates concerning the cultural politics of music – the relations between music, race and gender, for example – while also reconfiguring the terms of these debates in relating them to the kinds of institutional and policy considerations aired in the earlier sections. Obviously, there are omissions here too: for example, the technological and industrial conditions of music production, while by no means entirely neglected, are not points of primary focus.

These are limitations, however, which necessarily characterize any editorial project. If, therefore, we see this collection – and would like it to be seen – as merely a beginning, this reflects both our awareness of how little work has been done which deals adequately with the policy and institutional aspects of contemporary musical politics and our view that such work will prove increasingly important and necessary. In this sense, while we hope this collection will be found useful at the level of the information it provides and provocative in the range and verve of its arguments, it will have an added value for us if it serves to stimulate further work which can contribute to the debates it has sought to open up.

Tony Bennett
Simon Frith
Lawrence Grossberg
John Shepherd
Graeme Turner

NOTES

1 See Bennett, Tony (ed.) (1989) *Rock Music: Politics and Policy*, Brisbane: Institute for Cultural Policy Studies, Griffith University.

ACKNOWLEDGEMENTS

The editors would like to thank Bronwyn Hammond for her assistance throughout all stages of this project, but especially for her work in helping finalize the text for publication and preparing the index. Thanks, also, to Robyn Pratten and Olwen Schubert for ensuring an efficient flow of correspondence between us. And thanks, finally, to the staff of the Institute for Cultural Policy Studies – Sharon Clifford, Glenda Donovan and Bev Jeppeson – for providing organisational support.

INTRODUCTION

The history of popular music is littered with examples of opposition to and condemnation of new forms (new to the Anglo-American mainstream, that is) of Afro-American and Afro-American-influenced music and culture – from ragtime in the 1890s to rap in the 1990s. In every case the dynamics of this opposition and condemnation have been similar. The music is 'inferior' (if it can be graced with the term 'music' at all) and perceived as endangering preferred moral standards. These attitudes can take a long time to dissipate. Those wishing to institutionalize rock as a subject for serious study had only to look to the experiences of a previous generation of academics who had taken a music often vilified during the time of their youth (the 1920s, 1930s and 1940s), and begun the long process whereby jazz is now an almost respectable subject to study as a performer in music conservatories (see Leonard 1962).

It is likely that most readers coming to this volume will already have accepted that rock should be studied, thought about and discussed seriously as a cultural form of some considerable consequence. The history of its partial acceptance into the academic world and the fact that such acceptance is still remarkable to some might therefore seem not to be of concern. However, trajectories of study have histories and contexts in exactly the same way as the objects they study, and the study of rock is no exception. This volume resonates with such a history and with contexts which have changed markedly since this history's inception as a more or less continuous tradition in the late 1970s.

Debates which seemed *déjà vu* in the mid-1980s had been more real ten years earlier. Rock's early scholars were of necessity protagonists. The task was not only that of getting rock on the agenda but also, in the process, that of establishing rock as a form of music as worthy of study as any other. To those whose views derived from high-culture discourses rock, like many other forms of popular music, was inadmissible because of its obviously social character. Rock was of relevance to everyday life. Its embeddedness in social process was taken to compromise and distort the 'pure' tonal values evident in the music of the established canon, and to detract from

1

the autonomy of 'good' music – from the ability of such music to appeal to higher human sensibilities in a manner independent of the contradictions and paradoxes of everyday life.

The task for rock's early scholars – not always evident, but certainly implicit – was to make the social in music acceptable. Within the scholarly world, Adorno had already argued convincingly that all musics in modern industrial societies should be viewed as constituting a total field of cultural activity, a field of activity that could only be understood properly as a dimension of wider social processes. However, he used this argument to critique popular music – and a narrow segment of popular music at that – in terms not so dissimilar to those of traditional high-culture critics (for a detailed, perceptive and balanced assessment of Adorno's work in relation to the analysis of popular music, see Middleton 1990: 34–63).

What emerges from the work of Adorno – and from subsequent popular music discourses – is the continued effectiveness of high-culture discourses. If the social in music is to be acceptable, then paradoxically the criteria for such acceptability have been drawn very largely from these discourses. 'Good' popular music is authentic – not to people's socially decontextualized sensibilities, but to 'a person, an idea, a feeling, a shared experience, a *Zeitgeist*' (Frith 1987: 136). Bad music, continues Frith, 'is unauthentic – it expresses nothing'. In common with the critique made of popular music as a whole, 'bad' popular music is taken to be standardized, its creativity and distinctiveness quashed by the music industry. The final dismissal is that it is 'commercial'.

For many early writers on rock the effects of these discourses were difficult to avoid. It was not that they felt it necessary to subscribe to their evaluative criteria. Vulliamy, for example, had noted the similarity between high-culture discourses and what Frith subsequently referred to as the 'sociological common sense of rock criticism' (Frith 1987: 135) as early as 1977 (Vulliamy 1977: 191–2). Rather, there was a strong tendency to validate rock by virtue of its 'authentic reference' to communal values. As Frith explains, 'Different groups possess different sorts of cultural capital, share different cultural expectations and so make music differently – pop tastes are shown to correlate with class cultures and subcultures; musical styles are linked to specific age groups; we take for granted the connections of ethnicity and sound.' (Frith 1987: 134–5).

Willis (1978) drew parallels between the formal characteristics of early rock'n'roll and bike-boy culture, and the formal characteristics of progressive rock and hippy culture respectively. Hebdige (1979) drew parallels between the formal characteristics of punk style and punk's social location that were highly suggestive for a formal analysis of the music. Shepherd (1982) drew parallels between the formal characteristics of a range of popular musics from early blues to progressive rock and the social locations of these musics' producers and consumers in an attempt (which also

included a similar analysis of classical music) to theorize the relatedness of the musical field to the conditions of twentieth-century capitalism. Things had therefore seemed relatively simple during the 1960s and much of the 1970s. Rock was good because it was authentic to subcultural and counter-cultural values. These values were in opposition to the dynamics of capitalism and their expression through the actions of the music industry was to be welcomed. Rock was political. It was also either American or British in its cultural implications.

The notion of the structural homology, of the existence of parallels between the formal characteristics of popular music genres and the social locations and stylistic characteristics of subcultures and counter-cultures, thus became securely ensconced in rock scholarship. In order to validate rock, recourse had been made not only to high-culture discourses, but also to their necessary adjunct, discourses of the 'folk' (for a description and critique of these discourses as they relate to popular music see Middleton 1990: 127–69). As Frith observes, 'rock's claim to a form of aesthetic autonomy rests on a combination of folk and art arguments: as folk music rock is heard to represent the community of youth, as art music rock is heard as the sound of individual, creative sensibility' (Frith 1987: 136).

The notion of the structural homology has therefore been important in attempting to understand the social character of music's formal elements, and remains suggestive as this work continues. Middleton, for example, has said that he would 'like to hang on to the notion of homology in a qualified sense'. It seems likely, he says, 'that some signifying structures are more *easily* articulated to the interests of one group than are some others; similarly, that they are more easily articulated to the interests of one group than to those of another' (Middleton 1990: 10). Yet the notion has from the outset been problematic. It has led to the suspicion that music's social meanings were being read from the surface of music's formal characteristics, an approach that was being questioned, privately if not publicly, by the mid-1980s. Further, if music's meanings were in some sense negotiable, neither immanent in music's sounds nor given by 'outside' social forces, then the issue arose as to how music's sounds could be authentic to anything but their use in the here-and-now. The question, in other words, was that of what music was being authentic to (if anything) and where.

By the mid-1980s, therefore, initial critical *and* commonsense discourses of rock were beginning to fragment. Established discourses based on notions of opposition, national cultures and cultural 'meanings' were becoming uncomfortable. There was world music; the industry (or, more correctly, industries) was no longer so clearly dominated by the US (and, to a lesser extent, Britain); the industries were less concerned with the production and management of commodities than they were with the management of rights; governments which once held rock at arm's length

3

as socially and morally undesirable were beginning to realize that it was big business with policy implications (the Canadian government as early as 1970); technology, once the 'ear' and 'communicator' of popular music, was increasingly seen to be implicated in rock's aesthetics and politics and in matters of copyright management; finally radio, once rock's salesman, began facing challenges (the implications of which remain unclear) as music television entered the fray and rock's 'youth' market could no longer be taken as a stable given.

In the introduction to Part II of this volume, we suggest that we are not at the end of something 'in the radio–music relationship', but at a 'particular technological moment of cultural politics'. Given this, we argue, 'perhaps we should reread the past; perhaps we (we academic analysts, that is) have got the radio–music relationship wrong'. Such thinking could be emblematic for this volume. As academic analysts we are not at the end of an outmoded phase of scholarship, but at the beginning of new developments – developments which are presaged in this volume. These developments will require a rereading of the past and of past scholarship, but they will also (as Middleton hints) draw on the past and on past scholarship in deploying new territory. They will be pertinent, not just for the study of rock in its institutional and political settings (the principal orientation of this volume), but also for the study of rock and popular music *as music* and for the study of *all* musics, at least as they have been practised in the modern (and postmodern) worlds since the end of the eighteenth century.

This volume is primarily about government, broadcasting, technology, institutions and politics. The practice of music certainly cannot be understood as if it were independent of such forces. However, music is most clearly on the volume's agenda. Indeed, what we think is exciting about this volume is the sense it conveys that music can no longer be regarded as a 'thing': something that the music industries commodify, something that technology reproduces, something that radio sells, something that governments regulate. Perhaps the only 'thing' in music is its sound – a material phenomenon without which music could not exist, but a phenomenon to which it cannot and should not be reduced. Music is a process or, perhaps more accurately, a series of actions. Music arises from specific uses of sound – themselves conditioning – in the mediation of social, institutional and subjective processes. That is why, although this volume may not seem to be about music *per se*, the power of music breathes so tangibly and resolutely through its pages.

The realization that music is not something 'done unto', but a series of actions integrally conditioned by as well as conditioning the circumstances of their articulation, makes the continued critique of established discourses even more important. If, as Garofalo observes, 'culture – and popular music in particular – is taken seriously as a force in political struggle' (Garofalo 1992: 1), then the bases and consequences of that force will only

be comprehended if scholars, as Middleton puts it, 'break through the structures of power which . . . discursive authority erects' (Middleton 1990: 7). Frith has pointed the way in remarking that 'bourgeois/folk/commercial music discourses do not exist autonomously . . . their terms developed in relationships – in opposition – to each other; each represents a response to the shared problem of music-making in a capitalist society; each can be traced back, therefore, to the late eighteenth century' (Frith 1990: 100). This volume stands at a particular point in the politics of music's cultural analysis where the influence of old discourses is present but waning and new ways of thinking about music as culture are slowly being forged.

BIBLIOGRAPHY

Frith, Simon (1987) 'Toward an aesthetic of popular music', in Richard Leppert and Susan McClary (eds), *Music and Society: The Politics of Composition, Performance and Reception*, Cambridge: Cambridge University Press.

—— (1990) 'What is good music?', in John Shepherd (ed.), *Alternative Musicologies/Les Musicologies Alternatives*, special issue of *The Canadian University Music Review* 10(2): 92–102.

Garofalo, Reebee (1992) 'Introduction', in Reebee Garofalo (ed.), *Rockin' the Boat: Mass Music and Mass Movements*, Boston: South End Press.

Hebdige, Dick (1979) *Subculture: The Meaning of Style*, London: Methuen.

Leonard, Neil (1962) *Jazz and the white Americans*, Chicago: University of Chicago Press.

Middleton, Richard (1990) *Studying Popular Music*, Milton Keynes: Open University Press.

Shepherd, John (1982) 'A theoretical model for the sociomusicological analysis of popular music', *Popular Music* 2: 145–77.

Vulliamy, Graham (1977) 'Music and the mass culture debate', in John Shepherd, Phil Virden, Graham Vulliamy and Trevor Wishart (eds), *Whose Music? A Sociology of Musical Languages*, London: Latimer New Dimensions.

Willis, Paul (1978) *Profane Culture*, London: Routledge.

Part I

GOVERNMENT AND ROCK

INTRODUCTION

Government and rock: it's probably not the first connection one would make in describing the social or economic relations which structure the rock music industry in most western countries. Rock's ritual representation of itself as an oppositional, resistant form may not have entirely obscured its close articulation to capital but it has certainly established rock music as a 'dirty' category of social practice – from which governments have customarily kept their distance. The contributors to this section all document governments' wariness about including the rock industry (unlike the opera or the film industry) within national agendas for cultural or industrial policy. Yet despite what Simon Frith calls rock's 'buccaneering image', which situates it paradoxically as one of the least protected and most radically free market or 'commercial' of the culture industries, it is also true that rock music has enjoyed an indirect relationship with governments for a long time. In Australia, direct support is relatively recent but there, as in Canada, a local content quota for music broadcast on radio has existed for many years, operating as a crucial factor in maintaining a market for local musicians and composers. In Britain, according to Frith, 'the very emergence of a specific British rock music would have been impossible without the subsidized spaces, resources and audiences provided by art schools and the college circuit'. In the GDR, Peter Wicke and John Shepherd report that the rock industry was a central concern for state cultural policy precisely because of its political 'dirtiness', as a key site where cultural change might be managed. And, of course, the trade in recorded music and copyrights has long been a matter of international law, negotiated and regulated through national governments.

What the following chapters reveal, however, is that government intervention in the rock industry is becoming increasingly explicit, increasingly programmatic and institutional; within Europe, North America and Australia the role of government has become a crucial factor in the structural organization of rock music at the local, the national and ultimately at the global level. The kinds of interventions vary, as do the objectives nominated as their legitimate targets. Rock music's cultural

9

location as a 'youth culture' form, its construction as a 'problem' for those maintaining taste and order, has led to its incorporation into social welfare policies and programmes. Paul Rutten describes the placement of rock music upon such an agenda in his account of the Dutch industry's attempts to move itself off the government's social welfare budget and on to the arts budget. Rock's youthful demographic, as well as its often chaotic commercial conditions – the level of facilities in venues, the degree of unionization of musicians, the informality of fees and contracts, and so on – has seen it become popular as a site of job training within locally based industry development and employment programmes. Simon Frith's chapter outlines a series of such programmes funded by local, rather than national, government in the United Kingdom. Marcus Breen and Will Straw describe the placement of the rock industry within, respectively, Australia and Canada, as ultimately to do with the defence of national identity through the maintenance of the local music industry against the threat of domination, largely from America. And from America, Steve Jones reveals that Americans' fears of losing control of their own market are expressed in legislation around the issues of immigration, copyright and the regulation of the trade in imported records.

The variations and contrasts between the positions described and taken in these chapters are complex, but it is interesting to note the degree to which they vary according to the political, national and cultural context from which they emerge. Frith's piece is perhaps the most western European, linking with Rutten's in its highlighting of the importance of local industry structures for generating employment, as well as in its insistence on the need for the maintenance of local cultural difference – working to protect this difference from within the large globalizing 'leisure industries'. That this involves working with contradictions, Frith is happy to admit:

> But then rock musicians are used to working with contradictions, oriented as they are to both the locality, the community, and to the mass pop media, to radio and records, to stardom and sales. Making it locally and making it nationally have never been the same thing; 'selling out' has always been essential to the British rock career.

Such contradictions, organized as they are around notions of the local and the national and implicitly invoking constructions of the 'authentic' and the 'commercial', are thrown into sharp relief by the view from eastern Europe – from what was the GDR. Wicke and Shepherd's account of the incorporation of rock music into the state challenges many western assumptions about the nature of rock music and its industrial structure:

> the organization of rock culture in the GDR, as in other eastern European countries, provided a situation free of the commercialism

10

which leftist critics have often argued detracts from the supposed political authenticity and creative integrity of rock music in the West. While not suggesting that market forces guarantee political and cultural freedom, it is none the less possible to demonstrate that the imposition of a political and cultural system where commercial forces are forbidden necessarily gives rise to an undemocratic and hierarchical control of cultural life. If the production and distribution of cultural artefacts is not organized in some meaningful relationship to market forces, then the question arises as to the economic and valuative criteria which should underwrite processes of production and distribution, and the political mechanisms through which these criteria should be negotiated. Socialist cultural politics as developed in eastern Europe failed to give any meaningful answers to these questions.

What emerges from Wicke and Shepherd's chapter is almost the reverse of the other chapters in this section – a tale of the comprehensive integration of the rock music industry into the institutional and administrative structure of the state. Within that structure, the idea of 'commercialism' disappeared (there was no relation between audience demand, performers' popularity and sales, for instance); interestingly, Wicke and Shepherd argue, the inevitable outcome of this strategy was the explicit politicization of the music and the culture around it, a politicization they suggest played a central role in the GDR's destruction.

The lobbyists for the Dutch rock industry in Rutten's chapter are pursuing something rather like the situation Wicke and Shepherd describe: the achievement of cultural respectability for rock music in Holland, a respectability signified by a right to subsidies and state support as an acknowledgement of the music's importance to the national culture. The bifurcation in funding strategies Rutten outlines – at one extreme, an ever more elitist construction of rock as art and, at the other, the placement of rock music as a community, craft-based, amateur activity – reflects the contradictions in the industry's campaign and in the discourses used to situate rock music within the local, or national, culture.

Rutten's account implies that the preservation of 'the local' is the most important objective for the Dutch industry; Frith is more explicit when he claims that 'the national' no longer matters in cultural politics – the local and the global are what is important now. The 'postcolonial' perspectives from Straw and Breen, however, don't see it that way. For Breen, speaking from Australia, the globalization of the music industries holds specific problems for the nation: 'the operations of the transnationals pose real difficulties', he says, 'for postcolonial societies which, if they are not alert to the dangers, run the risk of inadvertently conceding intellectual and social spaces won through constant struggle for national, cultural and

11

economic identity'. Breen represents the push for government assistance to the Australian rock music industry in quite different terms to those used by the Dutch 'popcollectives'. 'Rock as art' is a very minor discourse within Australian history. Rather, the Australian government became interested in rock music's potential as an export industry, investing primarily in trade and training initiatives; Breen's account suggests that this is the result of pragmatic lobbying which ostensibly addressed one goal – economic development – while serving another much more romantic end – that of protecting the specificity of locally produced music.

Will Straw's chapter is a history of the English Canadian recording industry, rather than an account of government policy. Indeed, he notes that the Canadian government's support of the local industry has long been a point of resistance to the globalization of the music industries, is well documented by academic analysis, and provides a standard object of study within university courses on communications and the media. What Straw details is how Canadian recording companies have survived through underwriting their production of local material by operating as distributors for foreign producers. These are independent companies, therefore, who 'sell out' to the transnationals but who also serve as 'important' models of survival for local music producers. Significantly, even such commercially successful Canadian companies advocate protectionist regulation – continued government subsidies, and tighter Canadian content rules for radio. According to Straw, their contribution is more than a local one; 'the "independent" record companies which emerged in the 1970s [have] helped to give English Canadian music a place within ongoing debates over the substance of national identity'.

Of course, it is international law which threatens to make national, culturally protectionist strategies irrelevant. Increasingly, as Rutten points out, the music industry is realizing that the product it actually sells is not an object (tapes, records, CDs) but copying and performing rights. Increasingly, too, smaller countries such as Australia are recognizing that the point at which government intervention needs to occur is not through the regulation of production or distribution but in the drafting of national and international legal and trade agreements. As the problems multiply with the increase in technological options for recording and for playing back copyright lyrics and sounds, so the need for international agreements becomes more urgent.

It is perhaps ironic that this issue should be raised from within an account of the American music industry, given the place the Americans occupy within the demonologies of globalization. However, whereas the European and Australian accounts see the American industry as, more or less, a globalized structure, Steve Jones's chapter reveals that Americans' concerns for the preservation of their musical identity are not very different from those expressed by Marcus Breen's Australians. Their degree of

industrial muscle *is*, however, and it is significant that the responses to the perceived threats to the American industry are not developed through the 'soft' areas of cultural or social welfare policy, but through specific legislation on trade and immigration. Jones outlines a series of measures: they include restricting the access of foreign musicians and foreign recordings through immigration and trade laws, and sharpening copyright law so as to define specific sounds as individual property in order to combat technologies such as sampling. Within these measures, we can detect a move away from the protection of the national, and towards the protection of the individual's interest; what Jones describes is the development of a secure legal and competitive environment within which American musicians may sell their labour at home.

Jones's article is not the only one to highlight the importance of copyright, now and in the future, as the key mechanism for regulating the trade in music across national boundaries. Breen, Rutten and Straw also mention this. It would certainly appear that whereas the 1970s and 1980s placed rock music on policy agendas roughly contained within the range of industrial, cultural and social welfare options covered in this section, the 1990s are increasingly likely to subject the rock industry to the harder edge of governmental interest – as a problem of international law, and as a bargaining chip within arguments about the mythical 'level playing field' so continuously and chimerically pursued by the GATT talks over the last five years.

1

POPULAR MUSIC AND THE LOCAL STATE

Simon Frith

British governments have never shown much interest in pop music (even if ministers have always been happy to exploit photo opportunities with pop stars). At least since the Beatles, the British music business has been successful enough not to need industrial support, and pop has never been thought worthy of cultural subsidy. More than any other form of contemporary culture, it is thought to be *best* defined by market forces. The suggestion is made recurrently, for example (and most authoritatively in the latest government inquiry into broadcasting, the Peacock report), that as a public service broadcaster, the BBC has no brief to run Radio 1. Pop radio too should, by definition, be 'commercial'.

As the continuing arguments about Radio 1 make clear, though, British popular music has always been shaped by indirect state support. The post-punk development of British independent music would have been quite different without John Peel's determinedly non-commercial Radio 1 show; the very emergence of a specific British rock music would have been impossible without the subsidized spaces, resources and audiences provided by art schools and the college circuit.

The music industry itself (in the institutional person of its trade organization, the British Phonograph Industry or BPI) has always therefore had an ambiguous attitude to its own cultural status. On the one hand, it is happy to temper market competition with establishment deals (with the BBC, with the Musicians Union, with the copyright agencies); on the other hand, its assertive pursuit of market advantage leads to endless violations of its own rules (around chart hyping, for instance). On the one hand, it likes its buccaneering image; on the other hand, it deplores its association with excess.

The industry's poor 'image' was thus blamed for its failure to persuade the government to include a blank tape levy in the 1988 Copyright Act. The BPI proceeded to invest hugely in one of the Conservative government's pet schemes, a City Technology College focused on the performing arts scheduled to open in late 1991. The state/industry relation here is peculiar: the industry (for political and PR reasons) is supporting a state

14

project rather than the state supporting an industrial infrastructure. The suggestion remains, in government and industry alike, that whatever talents may emerge from the new School for the Performing Arts, their success will be a triumph of the 'free' market.

Now change focus, from the national to the local music scene. Here a quite different set of political arguments can be described. In the 1980s, the decade of Thatcherism, there was a burst of state intervention in music-making: popular music became the focus for both cultural and industrial policy. By the end of the decade John Street and Michael Stanley had found four different kinds of municipal musical investment: in *recording studios*, in *venues*, in *concert promotion* and in *training schemes*. Twenty-four local authorities were involved in one or other of these activities (Street and Stanley n.d.).

In this paper I want to consider what such activities imply – for popular music on the one hand, and for cultural policy on the other. What needs stressing is that British state policy on music is still a local phenomenon (the national culture of popular music has not changed). In considering local government in Britain in the 1980s, two points should be remembered. First, municipal councils were by and large Labour councils. They were therefore concerned to develop alternative policies to Thatcherism but had to operate under increasingly tight political and financial constraints. Second, the pressing economic problem in the cities concerned was how to replace jobs being lost in the manufacturing industry, how to benefit from the growing service sector.

These factors combined to produce what became known as 'culture industry policy', pioneered by the Greater London Council (and GLEB, the Greater London Enterprise Board) at the beginning of the 1980s, but developed by most of Britain's big city authorities after the GLC's abolition. The policy meant thinking about local culture in terms of employment and industry – how many jobs were there in the local arts? – and trying to develop new opportunities for artistic production – how many jobs could there be? The implications of this approach for popular music can best be explored through a case study.

CULTURE INDUSTRY POLICY: RED TAPE STUDIOS

The Sheffield 'Music Factory' project was originally drawn up by the City Council's Employment Department in response to lobbying by local musicians for rehearsal space and recording facilities. The project was conceived as 'a municipal enterprise venture enabling the City Council to co-ordinate and expand its existing involvement in musical education, the arts, recreation, employment and training into a new area of service activity'. In practice, however, the project was absorbed into local employment policy, as was clear in the statement of aims issued in July

1984. The proposed recording studio/rehearsal room complex was designed to

a) enhance the cultural and economic life of the city by providing a range of facilities, services, information, advice, training and tuition which would encourage people to play and listen to live and recorded music;
b) develop new skills and extend and increase opportunities for finding work for both adults and young people, both black and white, male and female, and make use of the new and increasing job opportunities available locally and nationally in an industry with growth potential;
c) facilitate greater and cheaper access for musicians, particularly the young and unemployed, to rehearsal space, tuition and training including methods of using electronic synthesizers and multi-track sound recording;
d) assist musicians in furthering their talents through a booking and referral agency, the making and promotion of demonstration tapes and records, and the provision of advice and information about publishing, management, job opportunities and the music industry.[1]

It might seem an obvious policy for a city suffering from the recession (and, in Sheffield's case, from the 'slimming' of the steel industry) to turn to an expanding service sector with clear youth opportunities, but the music industry had not previously been thought of as a *local* industry (the British music business is concentrated in London to a remarkable degree). Local government support of the arts had traditionally been a matter of educational rather than employment policy, more for the benefit of audiences than performers.

Sheffield policy-makers' new interest in music (in response to a demand that had been made by musicians for years) therefore marked a change in their thinking which had two sources. Locally, the idea of a 'Sheffield music industry' was inspired by the success of a number of Sheffield bands – Cabaret Voltaire, Human League, Heaven 17, Hula, Def Leppard, ABC. The council saw the benefit of association with their success, and began to investigate how to keep the wealth created by its pop stars in the city, whether by persuading local musicians to invest locally themselves, or through the council's own investment in local talent (through publishing contracts, for example). The policy was framed in terms of the local pop 'community', a community of both players and listeners; both groups, the council claimed, were presently 'exploited' by the major, London-based music companies.

More generally, Sheffield's music interest was an aspect of its version of culture industry policy. From this perspective, the arts were important economically to Sheffield not just as sources of employment but also as a way of making the city attractive – to tourists, to potential new investors and skilled service workers. The Music Factory project, in other words,

was intended not just to give music business work and training to the local unemployed, but also to give Sheffield the image of a 'music city'.

Red Tape was opened in 1986 by Neil Kinnock, then leader of the Labour Party, and Phil Oakey, leader of the Human League. At this point it consisted of just two rehearsal studios, but more immediately important than its facilities was the way Red Tape was integrated into a broader scheme. The studios were part of a 'Culture Industries Quarter', which was to include video, photographic and design resources, and space in the Red Tape building was let to local groups (Human League, Comsat Angels, Fon Records), each of which invested in its own commercially run recording centre.

There is no doubt about the subsequent success of Red Tape in its own terms – its expansion has continued as planned, and the Culture Industries Quarter does now consist of a variety of subsidized and commercial businesses which feed off each other: the private studios are available for trainee placements, and trainees are available as flexible studio labour. It is certainly arguable that as well as providing much needed resources (which have been used by a wide spectrum of musical and community groups), Sheffield has also succeeded in establishing a musical identity. An Employment Department memo in November 1990 noted that thanks to WARP and Modo records relocating from London, Sheffield had achieved a 3.2 per cent share of the British singles market, an indication that 'the City is on target to register as a major music production centre, increasingly recognized as such by the Media and Record industry'.

But perhaps the most significant effect of Red Tape has not been on the music market but on Labour Party thinking. By the end of the 1980s a number of major northern cities (Liverpool, Manchester, Newcastle-upon-Tyne, Glasgow, Coventry) had commissioned studies of their music scenes, invested in music training courses, and become determined to stop the 'leak' of local talent to London or Los Angeles. Even authorities in smaller towns, with less ambitious aims, took note of Sheffield's recording facilities (and its performing space, the Leadmill) – hence, for example, Norwich City Council's unexpected support of a rock venue campaign, against local residential opposition – while the Labour Party nationally launched Red Wedge, a youth/music support group which, in music policy terms, drew directly on GLC and Sheffield thinking.

MUSICAL COMMUNITIES: THE NATIONAL FEDERATION OF MUSIC PROJECTS

The original initiative for both Red Tape and the Norwich Waterfront came from local musicians, and in this section I want to examine the nature of local musical organizations.

By 1985 there was enough systematic local pop and rock lobbying

activity in Britain for the formation of an information network, the National Federation of Music Projects. To be eligible for membership a 'project' had to have 'an educational or training element; a policy of promoting live music; a co-operative/collective/municipal (rather than commercial) administrative structure; a commitment to the development of popular music; and a policy of cultural democracy, allowing musicians to control their own output'.

The Federation's subsequent survey of nearly 100 such projects (Frith and Kelly 1987) traced the following types of activity:

1. *Musicians' collectives*, organized around their musician members to help them play and/or record together.
2. *Private projects*, organized to encourage music-making but usually by people who were not themselves musicians. Their role was as enablers, putting on concerts, organizing workshops, etc., and they were 'private' in that their funding sources were individual subscriptions, gifts and takings rather than local authorities or charitable foundations.

 Members of both these groups defined themselves in opposition to the commercial mainstream and worked to sustain musical experiences (usually based on improvisation and multi-media work) that would not otherwise be available. Musicians' collectives were vital performing outlets for young bands in the early 1980s (an important source of postpunk eclecticism) and continue to be a source of militant anti-commercialism.
3. *Arts projects*, organized around the promotion of specific musical forms, these put on concerts and recitals, and recorded music (in most cases 'ethnic' music) that would not otherwise have been funded. Their aim was to supplement market forces (which meant, among other things, bringing performers to culturally 'deprived' areas). They were primarily funded by regional or local arts associations.
4. *Local authority projects*, funded by various forms of state grant (Urban Aid, the European Social Fund, the Manpower Services Commission), these were organized around the 'needs' of the 'community'. They provided resources for local people, and their clients were almost exclusively young – these projects were, in effect, extensions of the youth service, and young people's needs were defined in terms of boredom and delinquency as well as education and job opportunities.
5. *Unemployed projects*, organized around the specific task of training the unemployed for work in the music industry. Their emphasis was on music-making within the music business and not in opposition to it.

Most of the projects represented in the Federation came from groups 4 and 5, and most of the arguments at Federation meetings were about community and market interests. Was a project's primary purpose to give young people the skills to succeed commercially, or to enable local musicians to

develop different ways of doing things? Should projects be concerned with music for its own sake or with music as the basis for a paying career?

Such arguments became part of Labour Party cultural debate too, and, in line with its new-found pragmatism, by the end of the decade the trend was clearly towards job-training projects, away from the musicians' collectives. This was partly a reflection of where the money was (the European Social Fund, which insists on a training component in any scheme it supports, became a particularly important source of music project support) and partly an effect of client demand. The more radical projects, dependent on low-paid enthusiasm, had an unstable existence and most of the idealistic community schemes (like London's Firehouse, which initiated the Federation) foundered, while training specialists continue to thrive.

The resulting shift of emphasis – from musical expression to musical discipline, from process to product, from community to market, from alternative to mainstream – wasn't systematic (there is still no national policy in this area) and didn't reflect any particular pressure from the industry itself (what remains most striking is the lack of record company money in any project). In adapting their activities to political reality, local music schemes also had to pay attention to questions of access: 1980s Labour policy wasn't just about job opportunities, it was also about the equality of job opportunities, about minorities' rights. This was the way culture – black British culture, Asian British culture, women's culture, gay culture, youth culture – came back into culture industries' policy.

MAKING IT: OPPORTUNITIES FOR BLACK PEOPLE IN THE MUSIC BUSINESS

The paradox that faced local politicians writing their 1980s policies for 'young people and music' was that the value of that music was usually taken to be the result of young people's powerlessness. British pop had developed through the unexpected ways in which teenagers used cheap commodities for their own imaginative purposes and carved out their own collective spaces. The ideology of 'independence', in particular, meant challenging the usual rules of public provision and acquiescent consumption, and developing a do-it-yourself infrastructure of unofficial (and often illegal) sales and promotion – pirate radio, 'blues', bootleg tapes, sampled records, and so on.

The problem was that if necessity was the mother of invention, it was also often a culturally oppressive force. The indie scene in Britain, for example, is even more dominated by men than the mainstream, and the black British music world has always been fragile, subject to various forms of state harassment and commercial exploitation. The most talented black musicians and entrepreneurs have repeatedly been blocked off from the chance of making a continuous living from their work (hence the 1990s

importance of Soul II Soul, a production company in business as well as musical control).

The race problem in the 1980s music industry was described most exhaustively in 'Creating More Opportunities for Black People in the Music Business', a research report prepared by URBED in 1987 for the Inner Cities Directorate of the Department of the Environment. URBED found four barriers facing young black musicians and musical entrepreneurs: the centralization of the industry in London; its domination by a small number of global companies; the stereotyping of 'black music' as a minority interest; and informal recruiting systems throughout the business which were, in practice, highly resistant forms of institutional racism.

What the URBED report also described was a gap between the skills and abilities which young people developed in their own music scenes and the skills and abilities looked for in the mainstream business. If one way to bridge the gap was for industry to reconsider its prejudices and policies, another was to ensure that young musicians and hustlers at least presented themselves and their talents 'properly'. URBED thus argued that the problem for black performers wasn't just a shortage of material resources (venues, clubs, radio outlets, studios, rehearsal rooms, etc.), but also a lack of 'professionalism'. Hence the paradoxical argument that young people, the source of black British popular music, needed to be 'trained' to make it.

The URBED report was a government commission and not surprisingly, therefore, subordinated music to employment policy, but URBED's working assumption (common enough in local authority music schemes) was, nevertheless, problematic even in its own economic terms. Starting from the straight statistical point that the black music audience was not, in itself, big enough to support sufficient jobs, URBED argued that the government's task was to help give young blacks access to the white music market. But, as Simon Jones (1990) has argued, for most of its members the real problem of the black music world is how to sustain it as an alternative to the mainstream. Black youth culture (which includes white youth) is at its most creative, its most expressive – its most potentially profitable? – when using language, sound and style to signify, celebrate and organize difference. What musics like reggae and rap make available are ways of exploring and celebrating cultural margins. In this process the support and understanding of the local community may well matter rather more than official recognition or even than transitory chart success.

The confusion in the URBED report (which can stand in this context for a much broader set of political arguments about opportunities in the music business) is that while young musicians and entrepreneurs certainly are ambitious to make music a career, a basis for fame and fortune, their idea of success is not necessarily that measured by sales figures or professional respectability. For black and white rock musicians, in particular, there has

20

always been a tension between their self-definition as rebels against the commercial mainstream and their determination nevertheless to be stars.[2]

It should also be remembered in this context that do-it-yourself production, whether we're talking about sound systems or indie labels, is a form of small business, and that the most successful operators in this world are often so because they are the most competitive, the most ruthless, the most devious. From a local labour perspective, training in 'professional' skills can, therefore, become a way of curbing free-market excess, and both musically and economically, the suspicion remains that once the state gets in on the act, the meaning of rock – as an aggressively commercial music with an unpredictable cultural edge – is bound to change.

But then rock musicians are used to dealing with contradictions, oriented as they are both to the locality, the community, and to the mass pop media, to radio and records, to stardom and sales. Making it locally and making it nationally have never been the same thing: 'selling out' has always been essential to the British rock career.

A NEW MUSIC WORLD?

The systematic attempts to develop local music centres in Britain at the end of the 1980s coincided with the rise of global pop – whether in the multi-media marketing of new video stars like Madonna or in the western diffusion of 'world music'. In the international context, cities like Sheffield were in an anomalous position – part of the 'hegemonic' Anglo-American popular music business, but trying to work 'independently' within it. In this respect local British music policy had striking parallels with national music policies in other European countries. For small states like Holland or Denmark the issue was, equally, how to sustain local music production given inadequate local markets, how to compete for international sales without losing cultural identity, how to combine cultural and industrial interests.

Not surprisingly, if we trace the history of the most active state music agencies in Europe – Holland's popular music organization, SPN (Stichting Popmuziek Nederland), and Denmark's rock association, ROSA (Dansk Rock Samråd) – we find familiar details: both organizations emerged from musicians' lobbies; both combine welfare policy (giving young people something to do and somewhere to go) with industrial policy (giving local musicians and producers the backing needed to compete for and benefit from world sales); both try to keep in balance an argument about national culture (the unique qualities of Dutch or Danish music) and an argument about shared taste (the potential global sales appeal of Dutch rap or Danish heavy metal).

The Dutch and Danish models have been followed by other European countries, such as Finland and France, which use money raised by their

21

blank tape levies to fund information offices and export drives, to subsidize music and video production or to lobby against 'Anglo-American domination'. It is with respect to the import and export of music that Britain's local policy-makers are most obviously constrained, not just by their lack of resources – no local authority could afford to showcase its musicians abroad as Holland, Denmark, France (and Australia) have done – but also by their lack of restrictive measures on 'incoming' music (such as radio and television playlist quotas and differential copyright licence fees). British local authority impact is also restricted geographically – the nearest British parallel to SPN's or ROSA's touring policies (which are organized around subsidized venues and guarantees against loss for travelling bands) had to be organized by a commercial sponsor, a brewer: the Tennent's Live! scheme in Scotland uses exactly the same mix of support for venues and musicians.

What interests me here is less a detailed comparison between the various continental and local British music schemes, than the way in which the parallels have led to a European support system, a network organized around the ideology of 'independence'. Inspired initially by New York's New Music Seminar, which by the end of the 1980s had become the most important international platform from which to sell European rock wares, 'independent' music business events are now held annually in Berlin and Copenhagen. The first British version was staged in Glasgow in September 1990, funded by the Scottish Development Agency (a central government body for promoting economic enterprise which had also helped set up the Scottish Record Industry Association). In both aims and funding, New Music World occupied a 'regional' space midway between municipal initiatives in England and the centralized initiatives on the continent. But Scotland is also determinedly a nation, and from this ambiguous perspective – Scotland as a nation *and* a region (of Europe), Scotland as a nation *or* a region (of Britain) – the problems of a *local* music policy can be seen clearly.

To begin with, there is a contradiction between local culture and culture industry policies. Local culture policy assumes that there is some sort of local community, a community with a distinctive language and history. This is a difficult argument to push at a municipal level (what is the Sheffieldness of Sheffield groups?) and tends to be interpreted in broader class and ethnic terms (workers' music, Asian music), but even at the national level it can be restrictive. Scottish popular music, for example, comes to be defined as Scottish folk music, the music of the past (Scotland's richest small labels make their money selling 'traditional' pipe music to Americans, and 'Amazing Grace' is a necessary part of every pipe band's repertoire). Furthermore, 'Scottish' rock is most easily marked by language – the Gaelic speaking rock band Run Rig is more obviously Scottish than, say, Simple Minds.

If, alternatively, Scottish (or Dutch or Danish) music simply describes music made by Scots (or Dutch or Danes), then we're talking culture industry policy, as is obvious in Canadian and Australian airplay quota regulations. It doesn't matter what Canadian or Australian music sounds like, as long as it meets certain criteria of production (written by Canadians, performed by Canadians, produced in a Canadian studio). Cultural industry policy makes no reference to the expressive values of music, only to its economic potential (in policy terms, supporting the Scottish music industry is no different from supporting the Scottish steel industry). What is produced locally is determined by international market demand. As a Soviet state official once said to me (New Music World was negotiating to bring Soviet musicians to Glasgow), 'We've got rock, punk, reggae, heavy metal, jazz and funk. Just tell us what sort of groups you want.'

In practice, then, local music policy means accepting the music business *status quo*; the aim is to enable local bands to compete. At the same time, however, the European consensus is that such competition is fairest in the independent sector, 'independent' in this context referring less to the organization of production than to the spectrum of pop tastes. Both ROSA and SPN thus act as A&R (Artists and Repertoire) departments, supporting Dutch and Danish bands with international sales potential – that is, with the right degree of 'difference' (or independence) to appeal to the 'different' (or indie) market.

I draw two conclusions from this. First, the local is now equated with the different not by reference to local histories or traditions but in terms of a position in the global market-place. This is to lead policy-makers inevitably to issues of distribution and consumption. To support local venues (whether in Norwich or Nijmegen), local distributors (whether in Scotland or Victoria) and local radio stations (whether in Dominica or Finland) is to support not just one's own local music, but also 'local' music in general, 'different' music wherever it comes from. This is the culture industry challenge of the 1990s: to build up an international network of information and sound that can act as an open and unpredictable alternative to that presently being put in place by the global leisure corporations.

Second, as Iain Chambers (1990) has argued, we no longer live in a world in which the 'local' can stand for community, security and truth. It describes rather the *setting* for our shared experience of rootlessness and migration, for the constant movement of capital and labour, of signs and sounds. In technological terms anyway the world is becoming the local and the global: the national level no longer matters when every household has access to the global media flow, when every small producer can, in practice, directly service the global greed for images. In this context, British state music policy in the 1980s, when every initiative came from the local

level, was not so much peculiar as prescient. Today Sheffield, tomorrow the world!

NOTES

1 My research into local music policy was commissioned by the Gulbenkian Trust as part of its study of youth and the arts. See Willis (1990). For their help with the data collection thanks to my research assistants, Iain Gilhespie, Simon Jones and Mavis Bayton, to Paul Skelton and Tim Strickland (Sheffield) and to John Street.
2 See, for example, Cohen (1990) – a study of young musicians in Liverpool.

BIBLIOGRAPHY

Chambers, Iain (1990) *Border Dialogues*, London: Routledge.
Cohen, Sara (1990) *Rock Culture in Liverpool*, Oxford: Oxford University Press.
Frith, Simon and Kelly, Andy (1987) *A Survey of Music Projects*, National Foundation of Music Projects and Gulbenkian Trusts.
Jones, Simon (1990) 'Music and Symbolic Creativity', in Willis (1990).
Street, John and Stanley, Michael (n.d.) 'Local Authority Provision for Popular Music', unpublished paper, School of Economic and Social Studies, University of East Anglia.
Willis, Paul (ed.) (1990) *Common Culture*, Milton Keynes: Open University Press.

2

'THE CABARET IS DEAD': ROCK CULTURE AS STATE ENTERPRISE – THE POLITICAL ORGANIZATION OF ROCK IN EAST GERMANY[1]

Peter Wicke and John Shepherd

INTRODUCTION

When, in 1987, the GDR rock band Silly included a song entitled 'The Cabaret is Dead' on their album *Battalion d'amour* it was an omen of events to come in 1989. In this song Silly described the contradictory relationships that then existed between the party bureaucracy and GDR rock musicians. These relationships were portrayed as being played out in the form of a cabaret, a cabaret that was so absurd that the inevitable conclusion could only be its death. Where else in the world would politicians at the highest level (politicians within the Politburo) watch the lyrics of every rock song with great care, while presiding over a political system which afforded rock musicians sufficient institutional power to instigate the system's demise? The attempt to institutionalize rock culture as a state enterprise, to turn it into an organ of state-run political education, played a central role in the processes of disintegration which led to the country's dissolution. By imposing a highly restricted and conservative understanding of art which had its roots in the Enlightenment of the eighteenth century on the cultural life of a people within a modern industrialized society, the state and party bureaucracy created conditions in which manifestations of modern cultural life could be found only in the margins and cracks of the social system.

The events which led to the dissolution of the GDR are interesting in their own right. However, the purpose of this chapter is not to reconstruct these events (for a reconstruction, see Wicke 1992). It is to delineate the contradictory relationships obtaining between the state and rock culture which contributed to this dissolution. This delineation will throw considerable light on leftist political and cultural debates in the West concerning

commercialism, 'authenticity' and the political consequences of rock culture. For example, the organization of rock culture in the GDR, as in other eastern European countries, provided a situation free of the commercialism which leftist critics have often argued detracts from the supposed political authenticity and creative integrity of rock music in the West. While not suggesting that market forces guarantee political and cultural freedom, it is none the less possible to demonstrate that the imposition of a political and cultural system where commercial forces are forbidden necessarily gives rise to an undemocratic and hierarchical control of cultural life. If the production and distribution of cultural artefacts are not organized in some meaningful relationship to market forces, then the question arises as to the economic and valuative criteria which should underwrite processes of production and distribution, and the political mechanisms through which these criteria should be negotiated. Socialist cultural policies as developed in eastern Europe failed to give any meaningful answers to these questions.

THE BUREAUCRACY OF ROCK

From the beginning of the 1970s – when Erich Honecker came to power – there existed in the GDR a large and expensive set of state-run institutions (for example, all kinds of performance venues, the one agency for booking acts, the one record company, and the one radio and television network) whose purpose (*inter alia*) was to provide the support necessary for rock musicians. The aim behind these institutions was to develop and sustain a viable 'socialist' alternative to western rock culture within which rock musicians would be able to function and develop their creative abilities independently of commercial pressures. However, this alternative had a history of its own and did not result simply from the application of an uninflected Marxist-Leninist theory of socialism to the situation of culture in general and rock culture in particular. The battle against rock'n'roll music in which the state had been engaged since the 1950s was clearly being lost by the early 1970s. As early as the 1950s, the East German 'answers to Elvis' were to be found, not in urban centres, but in the cultural centres of small towns and villages where they were difficult to find and control. By the 1960s, thousands of beat groups had come into existence all over the country, creating serious headaches for the authorities. As soon as a beat group became visible, the authorities felt that they had to forbid its activities because they were not in accordance with GDR laws. These laws required that the workers who were expending their energies building socialism should be entertained only by highly qualified individuals with an appropriate degree from an artistic educational institution. The fact that these beat groups played western music only served to exacerbate the situation. However, as soon as one band was discovered

and its activities forbidden, its musicians would quickly disperse and form new bands.

But it was not only this battle which was lost at the beginning of the 1970s. The total isolation from the outside world imposed on East Germans by the building of both the Berlin Wall and the wall separating the GDR from the West created conditions within which the development of socialism could proceed unaffected by external events of any kind. This development involved the initiation of vast industrial projects without any tangible benefits for people in terms of their living conditions, as well as the unopposed creation of a huge bureaucratic system for the governing and running of the country. When Honecker took office in 1972, this system was disintegrating, particularly where young people were concerned. This gave rise to a situation in which it was simply impossible to avoid the formal sanctioning of cultural forms such as rock music which were of direct relevance to people's daily lives. Within the kind of socialist systems developed in eastern Europe, such sanctioning inevitably resulted in these cultural forms being integrated within state organizations created specifically for this task.

In 1973, the first step in this process was taken with the founding of the Committee for Entertainment Arts (Komitee für Unterhaltungskunst). Half of this Committee comprised representatives of various government institutions such as the Ministry of Culture, the State Media, local authorities and the party bureaucracy. The other half comprised representatives of the different branches of show business and mass culture. The intention behind structuring the Committee in this way was to create an institution that could function simultaneously as a governing body and a union, as well as provide an opportunity for artists to contribute to the development of a socialist alternative in mass entertainment. Thus, although the stimulus for creating the Committee for Entertainment Arts was to resolve the situation with the rock musicians, the result was to put in place a structure affecting the development and administration of all popular entertainment. Each form of mass entertainment (rock music, singer-songwriter music, jazz, big band music, circuses, comic acts, cabaret acts, discotheques) had its own section within the Committee. In practice, each section was constituted by all the artists working professionally within a particular genre of entertainment. All these sections together (comprising some 9,000 professional artists) constituted the Committee as a whole. These sections would elect representatives to the central council of the Committee, with the other half of the council being appointed by the Minister of Culture. The central council discussed all political and practical matters affecting mass entertainment within the GDR and, since representatives of all the relevant state institutions were included within its membership (appointed by the Minister of Culture), its decisions were binding. The actual functions of the Committee were therefore carried

out by the central council, and in this sense it was usual to think of the council as the Committee.

The deliberations of the Committee were guided by two principles. First, its thinking was securely grounded in traditional high-culture concepts of what constitutes 'good art'. The thinking was that workers should benefit from the best kind of entertainment possible, and what was considered best derived from traditional bourgeois notions of art. Such thinking was similar to that evidenced in Richard Hoggart's book, *The Uses of Literacy* (1957), in which he argued that the working class should have access to 'good art', but that such access was being blocked through the existence of mass entertainment. This kind of thinking was common among the old left in the late 1950s and 1960s. The difference, of course, was that it had few practical implications for the everyday lives of working-class people in the West. In the GDR, however, it did have such implications. It was securely rooted in the consciousnesses of the individuals appointed to the Committee by the Minister of Culture, individuals who had no real interest in, or first-hand knowledge of, popular entertainment, and who were eminently more powerful on the Committee than the artists elected by their peers. However, it was not so much the case that this dominant perspective changed substantially the everyday workings of popular entertainment. Various forms of popular entertainment such as rock music have their own economic and political dynamics which cannot be changed by ideological decree. The effect of attempting to organize popular entertainment according to the ideological precepts of high culture was rather to provide a series of irritants and impediments to these inherent economic and political dynamics.

The second principle which guided the thinking of the Committee, and which was linked to the first, was that popular entertainers as 'artists' should be kept free from commercial influences. In this respect, there are interesting parallels between East and West. In both political systems, art is taken to exist independently of commercial and hence political realities. In the West, traditional concepts of art are put into operation in a manner which is largely illusory. This is because art in the West has ultimately to be financed in the same way as any other enterprise: books have to be balanced and deficits dealt with according to the discipline of the market. In practice, therefore, the question of which art in the West attracts financial support is rarely decided independently of questions of cultural politics and ideology. The feature of western political systems which none the less allows the illusion to persist that artistic processes are intrinsically free of economic and political considerations is the relative independence of the state from the broader economic systems within which it is situated and to which, ultimately, it must also answer. In subsidizing art, the state can foster the illusion that it is simply administering the wealth of its citizenry on its behalf according to criteria which are artistic and eminently

not political. Corporations, which have more recently entered into the business of subsidizing art and 'high-quality' entertainment, can also argue that the criteria according to which their decisions are taken are artistic and essentially not economic. The illusion can thus persist that 'good' art is a-political, that financial support can be put in place on purely artistic grounds, and that financial and political questions do not figure inherently in artistic processes.

In a state system such as that of the GDR, all matters of finance were administered from within the system's political processes. As a consequence, there was no way in which decisions affecting the financing of art or entertainment could be argued to be made in a manner significantly independent of these processes. However, because the principles of a market economy were officially and formally expunged from the state's political processes, it became possible to administer money in a way which was in theory independent of the politics endemic in any market system. The flow of money to popular entertainment was therefore not ultimately constrained by financial considerations such as those operating in the West. It could therefore be an explicitly political decision that the criteria according to which money was handed out were not, in fact, political, but artistic. The proof of this lay precisely in the way in which money could be handed out in a patronizing fashion according to criteria having nothing to do with responsible financial management. If money became short, more could simply be printed (without the inevitable western consequence of inflation, because money in a political system such as that of the GDR was not related to value and did not have to be because of the legislated 'absence' of a market – prices of commodities were as arbitrarily fixed as was the cost of labour through wages).

Huge and complicated bureaucratic systems for the administration of art have tended not to be put in place in the West because the economic and political realities of market forces have not been completely ignored in the funding of artistic activities. However, because economic and political realities were, in effect, ignored in the way that the GDR supported art and entertainment, a huge and complicated bureaucratic system for the administration of art and entertainment was unavoidable. Once again, the consequence of these purely ideological processes (that is, ideological processes not grounded in the economic and political relations of endemic market forces) was less to change the actual workings of various forms of popular entertainment than it was to get in the way of them.

The point at issue here is central to an understanding of the cultural contradictions which contributed to the dissolution of the GDR. In any social system displaying a developed division of labour, market forces must develop to find a way to evaluate and reward the individual units of labour whose combination facilitates and results in the production of goods and the provision of services. In other words, individual units of labour have to

be assigned a realistic value in terms of which they can be related to one another (as they are in the overall labour process) and their fruits exchanged. The only rational way to effect this is in terms of the real cost of each unit of labour that is to be put into the production of goods and the provision of services. This cost, in effect, is constituted through what is needed in order to reproduce the labour force (to keep it alive and in a fit condition to work). However, the conditions according to which labour is reproduced are not simply given by nature, but are mediated culturally within any society. Since value is thus negotiated culturally within certain material constraints and not simply given, the assignment of value to labour is an intrinsically political process.

As a consequence, any notion of the economic value of an artefact or commodity has to flow from and be conceptualized in terms of an understanding of its negotiated, cultural value. If this point is not understood, and if a political economic system is put in place in which the value of commodities and the cost of labour through wages are arbitrarily decided without reference to endemic market forces, then two crucial consequences follow. First, formal political mechanisms need bear no relation to these endemic market forces (which have their own politics), and are thus free to become completely self-referring and self-reproducing and – without an external, cultural, political and economic court of appeal – to become essentially undemocratic and repressive. Second, since life in the everyday world (which includes real processes of production) develops its own political economy independent of the political structures imposed upon it, a fundamental contradiction arises in which neither the imposed nor the endemic political economies can function to reproduce adequately the conditions of people's everyday lives.

Various forms of popular entertainment in the GDR therefore evolved their own political economies which inevitably developed tensions with the structures put in place for their administration. The institutional infrastructure for rock music was put in place and maintained financially by the state without any reference to the music's endemic political economy. This meant that rock's infrastructure was planned and organized by the GDR state in complete independence from the processes it was intended to serve. The infrastructure thus served itself, which is the same as saying that it served nothing more than the internal economic processes of the state.

For instance, the state recording company (VEB Deutsche Schallplatte – the only one) was assigned a certain amount of money each year in order to produce records. The revenues from the sale of records, however, were administered by another state organization – the same one which administered revenues from all retail outlets in the country, regardless of what they sold. The point is that there existed a complete structural separation between the funding of production and the collection and application of sales revenues. The function of the retail outlets was to receive commodi-

ties, sell them and collect the revenues. The function of the record company was to produce records and provide them free to the retail organization which would then pass them on to specific outlets. The centrally planned budget for the record company and the centrally planned revenues which the retail organization was responsible for thus bore no direct relation to one another. The conventional wisdom was that such a separation of functions afforded a proper opportunity for the economy to be planned through state political processes in the best interests of the population, since it was at the level of central state planning that the necessary balance between costs and revenues could be achieved. The point that bears reiteration, however, is that such planning could, and always did, occur in complete disassociation from the endemic market forces that did exist. In the case of rock music, therefore, the administrative structures put in place by the state served as little more than a hindrance to the daily activities of rock musicians, determined as they were to a significant extent by the exigencies of endemic market forces.

For example, it was impossible for rock bands to ignore the cultural and musical needs of audiences. Only by addressing these needs could bands become popular and gain an increasing degree of artistic freedom, both in political terms and in relation to the musical expectations of audiences. It was therefore important for bands to create and play music that would reach mass audiences. Achieving this required the same kind of managerial and promotional skills as are required in the West, skills which are essentially entrepreneurial. However, competition between rock musicians in the GDR was not driven by a desire to achieve commercial success – which is what can follow in the West from skilled entrepreneurship – but by a desire to achieve cultural status, which in the GDR was not linked in any meaningful way to financial affluence. Loss of money was hardly an issue if bands in the GDR failed to operate successfully in 'the market-place'. Bands' incomes were linked to their professional category and the number of gigs they played (both decided by the state bureaucracies for administering rock music) and not, as in the West, to their ability to attract particular audiences at particular venues. Yet loss of cultural status could be very painful in a system where interest in money had been superseded by an interest in gaining and exercising cultural and political influence. While not aspiring to commercial success, GDR musicians were none the less required by the practicalities of achieving and maintaining cultural success to engage in exactly those entrepreneurial activities required in the West for commercial success. It was therefore impossible for musicians to separate the economics of production from the economics of consumption in their daily lives, despite the fact that they had been legislated as separate by the state. Rock musicians were thus required to operate in two quite separate worlds that could hardly help but be mutual irritants.

ROCK AS A STATE ACTIVITY

It becomes necessary to keep in mind this basic structural contradiction in looking in more detail at the workings of the state apparatus for rock music. Although setting up a significant bureaucratic system with which musicians had to deal every time they interacted with an institution related to the practice of rock music (for example, the one agency for booking acts, the one record company, and the one radio and television network), the state apparatus none the less succeeded in keeping rock musicians largely free from commercial forces. Through the separation of the economics of production and consumption, it was possible to set prices for live concerts and records, as well as the fee scale for musicians, in a fixed fashion that was in a completely arbitrary relationship to endemic market forces. Thus tickets for live concerts throughout the country were fixed at one price (5.05 GDR marks, with the 5 pfennigs – the 'cultural pfennigs' – going to a cultural fund for high culture!), regardless of the calibre of the musicians, and the size and situation of the venue. Any shortfall in revenues as against the costs of putting on a live concert was met by the state. Musicians also received a set fee for appearing at a live concert (according to a predetermined fee scale) regardless of the size and situation of the venue and the size of the audience.

This system therefore eradicated the usual western distinction between urban and rural venues, because it made no difference to the musicians whether they were playing in Berlin, Leipzig or Dresden, or in some remote village. The system also allowed musicians to be more experimental in the music they created and performed, since the money they received was not tied to the size of the audience. The only way for musicians to make more money, therefore, was to play more frequently. A similar system was put in place for the production of records. A predetermined number of albums was produced when a group made a recording, and the musicians were paid mechanical royalties on this predetermined number regardless of the number they actually sold.

The state system within which rock musicians had no alternative but to work thus provided them with a greater measure of 'artistic' freedom than would normally be obtained within the 'commercial' structures of the West. However, the space for the exercise of this freedom had to be negotiated through the deliberations of the Committee for Entertainment Arts. The negotiation of this freedom had both a practical and a political dimension. From a practical point of view, success for rock musicians (as opposed to popularity) rested not so much on audience reaction as it did on the ability of rock musicians to understand and manipulate the bureaucratic procedures within which they were inevitably placed. It was mastery of these procedures, for example, that could result in a group obtaining a high

number of appearances at live concerts or in having a high number of copies being set for the production of an album.

Rock musicians as a whole (rather than as individuals or individual groups) thus came to have a strong vested interest in participating in the deliberations of the Committee for Entertainment Arts, because it was through these deliberations that they could influence the procedures through which decisions in relation to individual groups were reached. An almost tragic consequence was that the most popular rock musicians (popular, that is, with audiences) were put by their less popular colleagues in the unenviable but inescapable situation of having to act like officers in a bureaucracy rather than as musicians in a favourable relationship with the people for whom they wrote and played. This situation was inescapable, not because success in negotiating for appearances at live concerts or for the predetermined number of albums to be produced depended on active participation within the Committee for Entertainment Arts, but because power within its deliberations was in direct proportion to the popularity of musicians with audiences. If the best kind of spaces were to be created within which all rock musicians could practise, then it became necessary for the most popular and successful musicians to become engaged in the writing of planning proposals, of documents concerned with matters of political and cultural policy, and documents concerned with strategies for developing the infrastructure for mass-mediated music. The power and influence of the most popular musicians within the Committee for Entertainment Arts was augmented if they were members of the party. For this reason, a good number of them joined.

The paradox inherent in the state-determined institutional structures within which rock musicians were able to negotiate for spaces of action was – at least from the point of view of the ideology of the state – that rock musicians were in effect given just as much opportunity to create spaces within which to distance themselves from the high-culture premises of this ideology as they were to create spaces within which to distance themselves from the everyday lives of audiences (by subscribing to these premises). The contradictions between the assumptions on which the state apparatus for rock music was established and the realities of endemic market forces in any case created structural spaces within which rock musicians could manoeuvre. The state apparatus aimed to control these spaces by making them subject to the political processes of the state. However, in setting up structures to administer and control these spaces, it was not possible for the state to create structures which would guarantee that rock musicians would manoeuvre in one direction rather than another. This was especially the case because audiences themselves intuitively realized the opportunities afforded rock musicians by the state-run system, and put pressure on the musicians to use these opportunities in certain political directions rather than just as a means of furthering their own careers. This active pressure

exerted on musicians by audiences fed, of course, into the influence that the most popular GDR musicians already had within the deliberations of the Committee for Entertainment Arts. This popularity and influence became politically charged and provided a politically effective channel through which ordinary young people in the GDR could give vent to their feelings and opinions. Young people encouraged rock musicians to express these feelings through their now institutionalized basis for power and through the lyrics of their songs. The content of lyrics became increasingly important for audiences, thus creating a situation that was the reverse of dominant trends in the West, where a band's sound is arguably connected in some very important ways to its success.

If it was necessary for rock musicians to be active within the deliberations of the Committee for Entertainment Arts for purely practical reasons, it is now evident why such activity became unavoidably political. The popularity of musicians with audiences was hardly a popularity that could remain politically innocent. This politically charged popularity, in turn, affected the bargaining power of musicians within the Committee. However, in order to be popular (which depended on being known), these musicians had to negotiate their way successfully through the bureaucratic procedures put in place by the Committee for deciding on the number of appearances that a group would have and the number of albums they would have issued. Clearly, there could be (and most certainly was in practice) pressure from the Minister of Culture's appointees on the Committee for the musicians to exercise their now politically charged and politically influential power in a conservative manner. The one lever these appointees had for pressuring musicians was an influence on the outcome of these bureaucratic procedures. This influence also extended to the procedures through which it was determined which musicians would receive apartments, cars and telephones (the normal waiting period for such basic features of western life in the GDR was approximately ten years), replacement parts for their equipment (which normally came from the West), permission to print posters, leaflets and promotional materials, permission to obtain passports and, most importantly, permission to travel to the West.

The musicians were placed in a position where they had to deal with the consequences of these structural contradictions. Since the most basic necessities for practising as a rock musician were controlled and supplied by the state, the musicians were hardly in a position where they could back away from politics and 'do their own thing'. As a consequence, the safest posture for the musicians to adopt was that of being the democratically elected representatives of their audiences. This posture was safe because the state authorities had little alternative but to accept this role for the musicians because of the delicate balance of power that existed within the GDR political system. There was more than just a rhetorical symbolic

significance to the fact that the annual rock festival in the GDR was held in the legislature (in the *Palast der Republik* which housed the *Volkskammer*). The symbolic significance had political substance and weight because of the real political power of the rock musicians. Unified state regimes are extremely sensitive to the exercise of mass power on the part of the people (a power to which the rock musicians were more than capable of giving significant expression in the particular case of the GDR). Since the economies of such regimes are built into their political systems and are not semi-independent of them, as they are in the West, there is no set of institutions (in this case economic) effectively independent of the state through which social and political stability can be maintained. In contrast, the power of rock musicians in the West is manifestly and inescapably mediated through economic processes and not through the political processes of the state.

As a consequence of all these institutional and political processes, rock music became part of the political discourse of the GDR. In this guise it was taken seriously by audiences, musicians and politicians. Politicians up to the highest levels watched the development of rock music very closely and reacted according to their conservative views. Those placed as highly as Honecker intervened to force musicians into negotiations over matters as detailed as the content of one line of a lyric. Yet regardless of all these attempts to negotiate politically GDR rock's basic contradictions, it was not possible to deal effectively with them. As a result, the state system of the GDR collapsed under the weight of its own cultural inertia. It was no coincidence that it was the rock musicians who were the first publicly to identify this inertia as a major political problem, and the first publicly to take the stand which precipitated irreversibly the political crisis that led to the end of the GDR (see Wicke 1992).

CONCLUSION

Events in the GDR demonstrate in a manner profiled much less graphically in the West how cultural processes meaningfully related to the everyday lives of people are fundamentally important to the survival of a society's political and economic fabric. This importance demonstrates how it is impossible to deal with culture's relatedness to processes of social pro-duction and reproduction in a purely abstract and theoretical manner. Abstract concepts such as 'authenticity' and 'commercialism' can become dangerous tools in the hands of policy-makers if their effectiveness and relevance is not tested against the actualities of political and economic processes inalienably implicated in artistic and cultural life.

Further, to conceive of artistic or cultural processes and commercial processes as separate and in opposition to one another is a theoretically suspect proposition whose social and historical roots go back to the

beginning of the nineteenth century. The industrial and commercial conditions of the modern nation-state guarantee that artistic and cultural processes are unavoidably commercial and thus inalienably political. The notions of 'authenticity' and 'commercialism' that have characterized the discourses of the 'classical', the 'folk' and the 'popular' in music have arisen as part of an attempt to avoid the real consequences of modernity as these have been manifest in both the West and the East. What is needed in scholarly work on rock in particular and on other forms of 'popular' music in general is less a retreat from (and an untheorized resistance to) 'the forces of commercialism' than an increasingly critical approach which seeks to understand these forces in a more complete and sophisticated way as indelible characteristics of the artistic and the cultural.

NOTES

1 Work on this chapter was made possible under the terms of an Exchange Agreement between the Humboldt University, Berlin, and Carleton University, Ottawa. Peter Wicke and John Shepherd would like to thank the authorities of their respective institutions for the creation of this Agreement which has resulted in this and other projects.

BIBLIOGRAPHY

Hoggart, Richard (1957) *The Uses of Literacy*, London: Chatto & Windus.
Wicke, Peter (1992) '"The times they are a-changing": rock music and political change in East Germany', in Reebee Garofalo (ed.), *Rockin' the Boat: Mass Music and Mass Movement*, Boston: South End Press.

3

POPULAR MUSIC POLICY: A CONTESTED AREA – THE DUTCH EXPERIENCE

Paul Rutten

INTRODUCTION

In this article, Dutch popular music policy is understood as a set of interventions in popular music practice by local, provincial and national authorities based on conceptions of popular music's cultural value and social meaning. The analysis of government popular music policy is taken up broadly here in that it is not confined to cultural policy. Government policy on popular music can be found in many political and discursive domains. For instance, there has been a steady and reasonably successful call upon national authorities from the national and international music industry to provide for legislation to optimize the industry's exploitation of musical authors and neighbouring rights, especially in response to the possibilities created by technological innovations. This is just one of the many ways governments intervene in the processes of the production, marketing and consumption of popular music – other than through cultural policy. However, popular music policy, in the broad definition used here, is not a logically consistent strategy of programmatic interventions carried out by authorities at all administrative levels. Rather, each branch of popular music policy is based on a specific conception of popular music and is thus articulated to the varied and often contradictory discursive domains in which popular music is situated.

Consequently, this chapter first tries to identify some of the discursive domains in which popular music is usually situated and which serve as frames of reference for popular music policy. Second, popular music and classical music are compared in this respect; the frames of reference used to assess popular and classical music's meaning and value are confronted and the policy implications of these different frames of reference are discussed. Thereafter follows a description and discussion of the most important branches of Dutch popular music policy.

FOUR NOTIONS OF POPULAR MUSIC, FOUR BRANCHES OF POLICY

Popular music as a problem

Rock music has been a crucial element in several youth culture movements and in that connection has regularly and successfully provoked law and order authorities. Furthermore, popular music's regular transgression of the unwritten laws of decency has limited whatever ambitions it might have had of achieving cultural respectability. As a consequence of its brushes with the law, both written and unwritten, popular music has become identified with legal problems, and in particular with the 'problem' of youth.

Youth as problem, popular music as the solution

Due to its role as a central element within youth culture, popular music has featured in government policy in a more positive way: it has been used as a tool for youth social welfare policy. Municipal support for youth clubs with rehearsal rooms and concert facilities has been seen as a way 'to keep youth off the streets'. Within such strategies, if youth was the problem, rock music provided the solution.

Popular music as a commercial product

The fact that popular music is produced and distributed through the market seems to disqualify it from inclusion in an arts policy; its commercial status seems incompatible with the still dominant romantic notion of the artist whose work is an authentic personal expression, independent of the surrounding social and economic networks. The tremendous growth of the recording market since the 1960s was the result of the commercial exploitation of pop and rock music. Yet, governments have been asked to provide, in particular, adequate rights protection for the record industry – both to enable the music industry to perform well economically and to assure that the artists get their share. Here, popular music belongs to individuals (authors or composers), to institutions (recording companies, music publishers), and to consumers who can buy it like any other commercial commodity.

Popular music as high culture

The most publicly debated form of government policy on popular music, at least on the national level in the Netherlands, is found in those formulations of cultural policy in which certain elements of rock music are

defined as art. Through its definition as an art form, popular music has been able to gain high-culture status and has thereby, under the guidance of the Dutch Rock Foundation, forced its way into the arts budgets, despite the fact that other ways of perceiving popular music have in many cases resisted the inclusion of popular music in arts policies.

As a result of these four separate but intersecting understandings, popular music has been considered (a) a cultural item which regularly causes 'moral panics', (b) a form of youth culture which can be used in social welfare policy, (c) an economic category, and (d) an art form.

ONE NOTION OF CLASSICAL MUSIC, ONE BRANCH OF POLICY

Compared with popular music, classical music is not perceived in very many ways. It is mostly situated in one discursive domain – that of the arts.[1] It is an illuminating exercise to examine the cultural construction of classical music through some of the terms sketched out above for popular music. It becomes clear that the dominant meaning of classical music as an art form does not account for the fact that classical music, just like popular music, is an economic product and a cultural artefact which has a social meaning for specific groups in society. In the policy process these last two characteristics are played down in favour of classical music's placement as art form – a characteristic which legitimates the financial support for symphonic orchestras and operas. The fact that classical music is marketed by the same music industry as markets popular music is never considered as a reason to withold such support. On the contrary, the fact that artists like Nigel Kennedy and Luciano Pavarotti sell huge quantities of albums is merely seen as positive development of mass tastes. Nigel Kennedy's punk-a-like outfit is welcomed as a way of opening up classical music to young people.

The social role performed by classical music has rarely been an object of study in the academic world; the study of popular music has been almost exclusively framed within such terms. However, despite the fact that one hardly ever witnesses street riots after classical music concerts or that classical music is rarely used as a tool in social welfare policy, there is still reason to believe that the practice of classical music has social implications. Pierre Bourdieu stresses the use of cultural artefacts for the purpose of distinguishing one social group from another – in this case, using classical music as a means of distinguishing oneself from the 'uncultivated masses' through the consumption of high, elite culture (Bourdieu 1984). The definition of classical music as art is part of the dominant meaning structures in society, of the hegemonic definitions of cultural value. When classical music is conceived of in some of the terms sketched out for popular music, it becomes clear that the conception of classical music

39

solely in terms of 'art' and 'high culture' is ideological. The meanings attached to cultural artefacts which circulate in society are in no way 'naturally' connected to the cultural objects. They are the outcome of social and cultural battles over meaning. The music policy debate should be conceived of as an arena where a battle over the meaning of musical genres is fought.

In the following sections, some concrete policy issues involving popular music will be discussed in order to illustrate the manifold ways in which popular music is perceived by authorities and subsequently acted upon through policy formation.

POPULAR MUSIC AS A PROBLEM: LAW AND ORDER POLICY

The moral panics surrounding popular culture forms and audiences pre-date the advent of rock'n'roll in western Europe. A catholic commentator in 1945 thought that jazz was 'disgusting' and pleaded for folkdance as

> an antidote against the jazz craze of which many young people are the victim. . . . Jazz is based on a foreign low musical culture. . . . A nation which educates its youth in such a way, dresses in a robe of fake-culture and proves its degeneration.
>
> (Smits van Waesberghe 1945: 227, my translation)

Jazz no longer has to deal with this problem. Together with the generation that grew up with it, and which has in some respects taken up key positions in society, jazz has acquired cultural respectability. In the Netherlands nowadays, most jazz, except the traditional dixie and big-band music, is like classical music in that it is defined in terms of art. For rock, however, it has been different.

In the mid-1950s, concerts by Lionel Hampton (March 1956) and the première of the movie *Rock around the Clock* (September 1956) were notable events in the history of moral panics surrounding popular culture in the Netherlands (Krantzi and Vercruijsse, 1959). Authorities were not particularly smart in handling trouble during and after these events. In Gouda, for instance, some trouble broke out during the showing of *Rock around the Clock* when it was played with the sound turned off. The person who made the decision apparently thought that the problem was in the music (ibid.: 30). Another public landmark in the history of rock'n'roll as cause for moral panic was the Rolling Stones concert in the prestigious Kurhaus in Scheveningen, which was stopped by the police after fifteen minutes because of the tumult that broke out in the hall. The interior of the Kurhaus was severely damaged. Despite the fact that in present times moral panics are more concerned with football hooliganism, musical forms of popular culture still get their share. Relatively new items of public

concern are the content of heavy metal and rap lyrics (the cases of Judas Priest and Two Live Crew) and drug (ab)use during raves and house parties. A more economically inspired panic was that of the Dutch Association of Bar and Restaurant Owners who called upon the authorities to take measures against the big illegal house parties attended by thousands of young people. There are usually no official licences for selling drinks at such events, and often there are insufficient sanitary provisions and safety exits. The association, of course, was most concerned at the loss of turn-over for official clubs and venues.

The fact that elements of popular culture did and still do cause 'trouble' in some way or another has generated calls for repressive measures to be taken by authorities against a broad range of phenomena such as offensive lyrics, drug (ab)use, noise and disturbances in the street before and after rock concerts.

YOUTH AS PROBLEM, POPULAR MUSIC AS A SOLUTION: SOCIAL WELFARE POLICY

In the course of the 1960s it became clear that rock and pop music were no passing fads. From the middle of the 1960s the Netherlands, as did many other western countries, witnessed the development of several youth cultures with pop and rock music as an important binding element. Holland has always had a fairly extended structure of 'youth work' provided by organizations operating within a religious or political framework: Catholic, Protestant, Socialist and Liberal. From the 1950s on, it had become clear that the post-war young generations were not always willing to integrate smoothly into the structures of modern society. Official concern was voiced in government publications such as 'A report on Research into the Mental State of Mass-youth' published under the title 'The Social Lawlessness of Youth' by the Ministry of Education, Arts and Science in 1952 (Ministerie van Onderwijs, Kunsten en Wetenschappen 1952). In the early 1970s, a new generation of youth workers built up a network of so-called 'open' youth centres. Together with some people from the earlier structures, these new youth workers brought pop and rock into the youth centres. These centres provided youth with their own 'place and space' outside the home in addition to the bars and commercial venues. Rehearsal rooms and concert facilities for rock bands were established. The centres were organized as foundations subsidized by local authorities out of the social welfare budgets, serving social as well as educational ends. The open youth centres and their appropriation of rock music came to be seen as an answer to the so-called 'youth problem'. On these grounds the expenditures on rock music were politically legitimated.

Some of the centres which were established in the early 1970s have in the course of the 1970s and 1980s developed into concert venues where the

social and educational youth work has become a secondary priority. The terms on which these centres are supported by local authorities reflect, in some cases, the change in the nature of the centres. In Amsterdam, for instance, two big clubs – 'Paradiso' and 'de Melkweg' – call themselves cultural centres nowadays and try to get rid of the notion that they are part of a youth culture. From the beginning of the 1980s they successfully lobbied for funding from the city's cultural budget instead of the social welfare budget. This lobby was at least partly pragmatically inspired by the turning of the financial tide in that local as well as national authorities were cutting their expenditure on social welfare. In other cities things turned out differently. Youth centres chose a strategy according to the size of the social welfare budget on the one hand and the arts budget on the other, as well as according to the number of local institutions claiming a share of each budget. A spokesperson of one centre claimed that most centres set out their strategies pragmatically:

> If in the city in which you operate you estimate that the budget for welfare is higher and you have a bigger chance to get money out of that budget than out of the budget for arts, you try to stay on the welfare budget. If not, you try to get recognized as a cultural institution.
>
> (Interview with the spokesperson, my translation)

In some cities the personnel and the accommodation costs are financed out of the welfare budget, whereas the subsidies for the programme come from the budget for arts and culture. An indication that there has been a change in the way pop and rock music are perceived by local administrators can be derived from the fact that almost all of the centres which have been established in the past ten years get funding from the arts budget while most of the centres which were established in the early 1970s are still funded from the social welfare budget. The fact that authorities in the late 1960s and early 1970s saw it as their task to support youth centres and their activities, and continued to do so in the following years, has resulted in an extensive network of clubs and venues in the Netherlands which provides a fairly broad range of pop and rock concerts outside the strictly commercial concert circuit.

Further pressure on local authorities to provide facilities came from local organizations of musicians, the so-called 'pop collectives', which developed in the early 1980s. These collectives were run by volunteers, mostly in some way or another connected to the local pop scene, who organized local bands in order to lobby for rehearsal facilities and educational possibilities for musicians. At the moment there are over ninety collectives in the Netherlands which together receive around 1 million guilders' support from municipal authorities out of social welfare as well as arts budgets. Pop collectives are often funded under the heading of 'amateur art' which

seems to be a kind of intermediate category between social welfare and professional art. A treatment as amateur art implies, as van Elderen puts it, that

> musicians do not only have to compete for money with other traditional art forms like classical music and even jazz, but with affairs of social work as well – to mention a few: the local football club, the jogging track, the meeting place of young Mediterranean immigrants, and the old ladies bookclub.
>
> (van Elderen 1989: 197)

In the course of the 1980s parallels to the local pop collectives, but at the provincial level, were established in eight of the twelve Dutch provinces. These organizations, constituted as foundations, put pressure on provincial authorities to establish a pop and rock policy. Their activities are manifold: they support the local pop collectives; some of them administer and execute a provincial stage plan which provides support for venues who book local bands; they provide relevant information to the collectives, venues and individual musicians; they organize workshops and courses, and they organize and support provincial pop and rock contests (Davidse 1991: 58–63). The provincial organizations are mostly led by a new phenomenon in the Dutch rock scene: the pop consultant.

The total expenditures of the Dutch provinces on pop and rock music amounted to 1,500,000 guilders in 1991. One province, Noord Holland, accounts for one-third of the total provincial spendings. Noord Holland does not have a provincial pop foundation but chose to execute a pop policy itself rather than putting it in the hands of an external organization (Christianen 1992).

POPULAR MUSIC AS A COMMERCIAL PRODUCT: COPYRIGHT LAW

Probably one of the most far-reaching forms of government intervention is the regulation of economic and cultural processes through legislation. A key area where such action has affected popular music is that of copyright law.[2]

It has been noted that the music industry's economic future lies more in the exploitation of copyright and performing rights than solely in the selling of sound carriers (Rutten 1991; Rutten and Oud 1991). Technological developments have provided consumers with the ability to make numerous copies of the original sound carrier – home-taping. In the digital future it is likely that the consumer will acquire more sophisticated methods for copying music. The increase in the use of music in radio and TV programmes, commercials, movies and in public places makes it essential for the music industry to become rights-owners instead of salespersons for sound carriers. As a music industry representative claimed in 1989,

'The music industry should stop considering itself as a producer of vinyl and cardboard. We are engaged in the business of marketing artists and their creative talent. We are right-owners' (Russ Curry quoted in Rutten 1991: 304).

One of the main activities of the International Federation of the Phonographic Industry (IFPI) and its national branches has been lobbying for the adaptation of copyright legislation to new technological developments and the proliferation of broadcast media. The general goal of this lobby is to provide for legislation which optimizes the exploitation of musical rights. First, this implies providing tools to combat piracy. Second, it involves legislation that imposes considerable fees on every secondary use of musical pieces recorded under the auspices of the music industry: these would include home-taping, public performance, radio airplay, and such public use of music as muzak.

Recently the music industry introduced an equivalent of the International Standard Book Number for sound recordings: the International Standard Recording Code (ISRC). It has been developed as a means of identifying sound and audiovisual recordings. The code is digitally added to the recording. It identifies recordings, not physical products ('carriers'). When IFPI sums up the benefits of the ISRC there remain few doubts about the purpose of the code:

> New technology is rapidly increasing the variety of media by which recordings reach the consumer and the recording industry needs to ensure it derives income from the *use* of its product (e.g. by broadcasters, cable/satellite operators, music banks, private copying) in addition to the sale of physical carriers (e.g. singles, LPs, cassettes, CDs).
>
> (IFPI 1991a: 2)

Through such measures, the national and international music industry is encouraging the national governments to provide for legislation which enables musicians and their labels to derive income from the use of their recordings.

Recently IFPI has declared the eastern European countries a 'priority area' (IFPI 1991b: 8–9). The fact that the music industry is still hesitant to invest in the former Communist countries has much to do with the music rights situation there. On Poland, IFPI reports: '[they are in a] disastrous situation as there is currently no law which gives direct protection to producers' rights. As a consequence the market in Poland is almost completely in pirate hands' (ibid.: 9). The NVPI, the Dutch IFPI branch, has in past years orchestrated a very active lobby for government legislation. The main objectives were: the Netherlands' acceptance of the conventions of Rome and Geneva (to combat piracy);[3] the establishment of a levy on blank tapes to compensate for losses due to home-taping;[4] a compensation for the (commercial) hiring out of sound carriers and the reduction of the

VAT rate on sound carriers from 17.5 per cent to 6 per cent. Some of these issues have been taken up, but only the issue of the levy on blank tapes has led to legislation up until now.

In its plea for a blank tape levy the federation of recording companies has been joined by the Dutch music publishers and organizations of authors and composers as well as performers' unions. One of the recording and publishing industries' main arguments was that due to financial losses local music production could be under threat, which could lead to the impoverishment of local music culture (cf. Roctus 1990). It was said that it would be increasingly hard for the Dutch music industry to record music, especially local products, because of the losses due to home-taping. According to NVPI, 'home-taping is the biggest threat to the music market since its origin. If there is no regulation, there will be disastrous consequences for the distribution of music culture' (NVPI, no date, my translation).

Since the beginning of 1992, blank tapes have been subject to a levy aimed at compensating artists and composers. Of the fees collected, 15 per cent go to a collective cultural fund for the support of local music production. The government, however, does not prescribe how this money is to be used. A small battle has been fought between the Ministry of Welfare, Health and Culture and the Ministry of Legal Affairs over the question of which organizations should have a say in the spending of the money. Should it only be those organizations which directly represent the copyright-holders (the position of the Ministry of Legal Affairs) or should organizations with a more cultural goal also have a say in the spending of the money (the position of the Ministry of Culture). According to recent answers given by the Dutch Minister of Culture, Mrs D'Ancona, to a member of parliament, a foundation board consisting of representatives of the right-holders' organizations will decide how the money will be spent. Here again, as in many other policy cases, the government only defines the contours of a policy and puts the actual policy problem in the hands of a private foundation.

ROCK MUSIC AS HIGH CULTURE: ARTS POLICY

In the mid-1970s, certain segments of Dutch rock culture tried to pull popular music into the domain of the arts by separating art rock from the mainstream chart-oriented commercial 'pop music'. This claim was voiced by the so-called Stichting Popmuziek Nederland (Dutch Rock Foundation – SPN), a national organization working in the field of pop and rock. A group of people, mainly engaged in rock music in the Amsterdam area, sent a 'Rock Plan' to the Dutch Minister of Culture on 24 February 1975, in which they asked for state support for non-commercial, artistic rock music:

An art form in which development is solely dependent on commercialism, can not be considered to be free and complete, because every genre that wants to develop should have the possibility of artistic innovation and should have the freedom to reach new audiences.

(SPN 1975a: 6, my translation)

The plan outlined the dilemma in which popular musicians then seemed to find themselves:

Every rock group is confronted with the choice: adapt to the norms of commercialism or die out. . . . Cash prevails over quality, saleability (the easy, the well known) beats creativity. In sum: the one who neither wants to adapt to the commercial pattern nor wants to starve has to look for an alternative.

(ibid.: 4, my translation)

The alternative was a centre, based in Amsterdam and opened on 1 January 1976, offering a whole set of provisions for rock music on a national scale and outside the commercial sphere. According to the authors of the plan, rock music until then had escaped the attention and engagement of the state. In the accompanying letter to the Minister, they claimed that

some opportunities have been missed, in artistic (the improvement of quality) as well as in cultural terms (the creation of new situations for audiences). Also integration into music and arts education has been completely neglected.

(SPN 1975b: 1, my translation)

The main argument of the SPN plan shows striking similarities with another plan called the 'Plan for Jazz in the Netherlands' which was submitted to the Minister of Culture in 1971 by a number of jazz musicians and organizers united in the Stichting Jazz in Nederland (Foundation for Jazz in the Netherlands, SJIN). Just as the SPN was to do for rock in 1975, the jazz lobby tried to gain cultural prestige and thus inclusion within the national arts budget by presenting jazz as an art form. The plan noted that jazz had developed from a popular genre to a more experimental musical genre based on improvisation; this development had attracted a new, but smaller audience.

It now connects to other forms of modern serious music and has lost a part of its former entertainment character. . . . It seems that the status of jazz music within the Dutch context has hindered a complete development of its possibilities. It is not justified that jazz and pop are treated as the same phenomenon in the press, on radio and TV and by government authorities. Jazz, and especially the new expressions of it, take a clear non-commercial position within our culture.

(SJIN 1971: 4–5, my translation)

The appeal to the Dutch authorities for the subsidization of jazz music through SJIN was successful; from 1975 onwards SPN has followed its example by lobbying for state support for pop and rock music. The government's main advisory committee on the arts, the Arts Council, gave a positive response to the Minister of Culture although it had some doubts concerning 'the possibility of an artistic judgement in this musical genre'. In 1977 SPN received its first subsidy of 50,000 guilders. Since then the amount has increased steadily – again, based on notions of pop and rock music being an amateur as well as a professional art form.

In 1980 the Christian Democrat Minister of Culture, Mrs Gardeniers, tried to disqualify rock music as a 'professional art form'. In a letter to the Arts Council she claimed that pop and rock music should mainly be understood in terms of their social and commercial, rather than their artistic, functions. Since, for pop and rock music, massive saleability of the product is the main object, artistic notions seemed to be of minor import- ance. According to Gardeniers, pop and rock music only deserved govern- ment subsidy as an amateur art form. This opinion was rejected by the Arts Council, with the result that the activities of SPN were supported finan- cially from the budgets for amateur as well as professional arts from then on.

In 1984 SPN received a subsidy of 200,000 guilders for the execution of a 'stage plan' as a result of a restructuring of the arts budget for music. This happened under the direction of another Christian Democratic Minister of Culture, Mr Brinkman. A part of the budget for symphonic music was cut to provide SPN with funding for the stage plan, including the underwriting of certain concerts by Dutch professional pop or rock bands with a fee which goes above 1,500 guilders. (A band is considered professional when a venue thinks it is worth paying 1,500 or more guilders.) The stage plan, however, only underwrites concerts which cost less then 5,000 guilders.

The total budget of the SPN in 1984 was 485,000 guilders; in 1991 the yearly SPN budget had risen to 1.5 million guilders, 0.4 per cent of the total arts budget of 400 million guilders. Around 1 million guilders of the SPN budget goes to the stage plan in which forty venues now participate. Jazz received around 2 million guilders from the arts budget in 1991, while opera received around 50 million guilders per year. Although SPN still uses the 'rock is art' conception for the legitimation of its policy, anti- commercialism takes a less prominent role in its more recent statements in press releases and policy plans compared with the early days of the Rock Plan of 1975.

Apart from the execution of the stage plan, SPN performs other activi- ties: it is a service institute for bands and musicians, it promotes a more prominent role for pop and rock music in music schools and conservator- ies, it promotes Dutch pop and rock among media and abroad (through support for touring Dutch bands) and it is setting up a pop and rock archive

(Davidse 1991: 48–56). In 1990 SPN launched a plan to set up a fund so that Dutch pop and rock productions could be funded out of the levy on blank tapes. It seems, however, that SPN cannot claim a part of the 15 per cent which should be devoted to the promotion of Dutch music culture since the Ministries of Legal Affairs and Culture have decided that only those organizations which directly represent copyright-holders can decide how the money can be used. Another important activity in the past few years has been the promotion of Dutch pop and rock at the most important event for 'independent music', the New Music Seminar in New York (co-financed by the Ministry of Culture and the Ministry of Economics). This activity has not been uncontested. A Dutch rock journalist and commentator in the country's leading music paper *Oor*, for instance, has challenged the benefit of SPN's yearly trip to New York and claimed that 'If the SPN was a commercially led company, it would – on the grounds of the real results for Dutch rock acts booked during the respective New Music Seminars – have been closed down and its personnel sent home' (van Nieuwenhoven 1991: 90, my translation).

It seems that SPN, in the course of its development in the past fifteen years, has sought to find a suitable position *vis-à-vis* the music industry on the one hand and the cultural authorities on the other. This has led to such reactions as that quoted above and that of the Arts Council which states in its most recent advice to the Minister of Culture that, in its view, SPN should not act like a commercial enterprise at all. Reactions to SPN policy illustrate that pop and rock culture, governmental arts institutions and commercialism stand in a peculiar, tense relationship to each other. SPN is confronted with a cultural field in which the market is the dominant mode of production and distribution, but it has to legitimize its activities as a publicly funded cultural organization by distancing itself from everything that approximates a commercial operation. The SPN policy can be described as a permanent necessary manoeuvring between different positions: on the one hand rejecting marketing principles because the one and only funding institution (the Ministry of Culture) demands this, and on the other hand necessarily dealing with the music market as an integral part of its field of operations. Ironically, those working within these arenas have no difficulty dealing with the commercial music industry but a mode of dealing with government support still seems to be lacking. Conversely, institutions like the Arts Council and the Ministry of Culture have their own problems dealing with the cultural industries. And yet, the relative success of SPN in conquering a small spot on the official Dutch cultural map is mainly due to the fact that it adopted the official discourse and made a stand for so-called artistic rock music which did not get a chance to develop within the commercial music industry. It thereby reproduced the high-culture versus mass-culture dichotomy within the domain of popular music (cf. Vulliamy 1977).

Cultural policy can be characterized as an arena in which the struggle over the value of cultural forms and genres takes place. What is at stake is that part of public spending which goes to the arts. The parties concerned try to get a piece of the cake, or to preserve what they have got, by providing the public authorities with legitimate grounds for allocating the money to them – grounds based on a specific discourse of cultural value. Social and political power in the form of vested interests is brought into the arena. In the development of a cultural policy at every administrative level, advisory boards play a key role. The members of those boards are drawn from the 'world of arts' itself and thereby represent existing and dominant discourses of cultural value. It is clear that in a situation like this new contenders in the fight over the funding for arts and culture have a hard time getting their share.

Cultural policy, therefore, should be conceived of as a politics of economic intervention which leads to financial support for, or government regulations concerning, certain sectors in society whose activities, from a specific ideological position, are valued highly and thereby set apart from others which are deemed to lack cultural value. Thus cultural politics can be conceived of as a struggle for getting or keeping cultural respectability or cultural value, a struggle for inclusion versus exclusion. Also, it is ultimately concerned with the regulation of money flows. That is to say, it is an intervention in the process of cultural production in such a way that cultural products which cannot survive in a market economy can be sustained as a result of government support and regulations, directly by the subsidization of artists and creators or indirectly in the provision of an infrastructure which provides for a specific category of cultural products to be produced. The SPN has integrated rock music in the 'arts discourse' and thereby won a place in the official arts budget.

It seems, however, that a government policy on pop and rock necessarily has to be set up from within a different paradigm from the one which is used in more traditional arts policies. Pop and rock policy has to deal with music as a valuable creative expression as well as a commercial product. The traditional discourses of cultural policy cannot cope with pop and rock music because they have no notion of commercial, popular culture. An increasingly important point of debate therefore becomes whether any form of culture which is produced and distributed through the market should be excluded from cultural policy or whether the terms on which cultural policy is formulated need to be revised. Since it is hard to imagine that the dominant paradigm of cultural policy will be reconsidered soon, the uneasy relationship between popular music and arts policy is likely to continue for the time being.

CONCLUDING REMARKS

In discussions on popular music policy, all the notions of popular music which have been raised in this article are present – they even mingle. The Dutch government is confronted with policy claims from many different angles and actors in society. Authorities are not able to cope with popular music in all its respects at once simply because the various claims with which they are confronted span a whole range of departments: social welfare, culture, law, economics. Dutch policy on popular music therefore consists of a chain of partly fragmented responses from different sectors of the government apparatus to a range of more or less organized claims from society. This piecemeal approach is bound to continue as long as popular music remains situated in as many different discursive domains as it is at the moment.

Music policy is based on the dominant social conceptions of music's value and meaning. These conceptions can be seen as constructions of reality and not necessarily as reflections of real circumstances. A future consistent cultural policy should be based on a more informed, valid and complete notion of cultural processes than the selectively perceived, highly ideological notions of culture on which cultural policies are based nowadays.

NOTES

1 Just to illustrate that the notion of art in itself is not uncontested, it is interesting to quote a critique on classical music practice once voiced from the perspective of a fan of authentic singer-songwriter rock music ('rock as art'): he called a symphonic orchestra a giant acoustic band which only plays cover-versions of well-known compositions.

2 The two most relevant branches of government legislation in this respect are concerned with copyright law and with broadcasting policy. The acting space of national governments concerning rights legislation is far more restricted than the space concerning broastcasting policy. The consequences of government policy and regulations concerning broadcasting for popular music practice won't be discussed any further in the context of this article.

3 Until recently the Netherlands were not party to the Rome convention which meant that piracy in itself was never a criminal offence in the Netherlands but was fought mainly by reference to infringement of author's right law. This made taking action against these practices harder. On 1 July 1993, the Netherlands became part of the Rome convention which implies legal recognition of neighbouring rights (concerning performers and producers of sound recordings).

4 On 1 October 1991, a law was passed in which a levy on blank tape was established to provide for compensation for the loss of author's rights due to home taping. On 1 July 1993, a similar law was passed establishing a fee for compensation of neighbouring rights.

BIBLIOGRAPHY

Bourdieu, Pierre (1984) *Distinction, a Social Critique of the Judgement of Taste*, London: Routledge Kegan Paul.

Christianen, Michael (1992) 'Knelpunten en Oplossingen voor de knelpunten binnen de amateur-beoefening van popmuziek', paper given at the symposium Popmuziek en Overheidsbeleid, Erasmus University, Rotterdam, January.

Davidse, Arjan (1991) *Overhead, het Popbeleid in Nederland*, unpublished MA thesis, Department of Communication, University of Amsterdam.

Elderen, P. Louis van (1989) 'Pop and government policy in the Netherlands', in Simon Frith (ed.), *World Music, Politics and Social Change*, Manchester: Manchester University Press.

IFPI (International Federation of the Phonographic Industry) (1991a) 'International Standard Recording Code (ISRC)', press release, 9 October 1991.

—— (1991b) 'Eastern Europe', *For the Record* (IFPI newsletter) 9(3), June/July: 8–9.

Krantz, D.E. and Vercruijsse, E.V.W. (1959) *De Jeugd in het Geding*, Amsterdam: De Bezige Bij.

Ministerie van Onderwijs, Kunsten en Wetenschappen (1952) *Maatschappelijke Verwildering der Jeugd, rapport betreffende het onderzoek naar de geestesgesteldheid van de massajeugd*, 's Gravenhage: Staatsdrukkerij en Uitgeverij Bedrijf.

Nieuwenhoven, Harry van (1991) 'De Tussenbalans', *Oor* 11, 1 June: 90.

NVPI (Nederlandse Vereniging van Producenten en Importeurs van Beeld – en Geluidsdragers – Dutch Association of Producers and Importers of Image and Soundcarriers) (n.d.) De Thuiskopie op 1 A–4tje, Hilversum: NVPI.

Roctus, Peter (1990) *De Absolute Maatstaf Verlaten? Cultuurpolitiek Usies en dopslag ter compensatie voor hometaping*, unpublished MA thesis, Institute for Mass Communication, Catholic University, Nijmegen.

Rutten, Paul (1991) 'Local popular music on the national and international markets', *Cultural Studies* 5(3), October: 294–305.

Rutten, Paul and Oud, Gerd Jan (1991) *Nederlandse Popmuziek op de Binnen- en Buitenlandse Markt*, Rijswijk: Ministerie van Welzijn, Volksgezondheid en Cultuur.

SJIN (Stichting Jazz in Nederland – The Dutch Jazz Foundation) (1971) *Plan voor de Jazz in Nederland*, Amsterdam: SJIN.

Smits van Waesberghe, J. (1945) 'Het dansprobleem der rijpende jeugd', *Katholiek Cultureel Tijdschrift* 1(7), November: 225–31.

SPN (Stichting Popmuziek Nederland – Dutch Rock Foundation) (1975a), *Het Pop plan (Je kan er altijd nog op dansen)*, Amsterdam: SPN.

—— (1975b) Accompanying letter with *Het Pop plan* (1975a) to the Minister of Culture, 24 February 1975.

—— (1988) *Beleidsplan 1989–1992*, Amsterdam: SPN.

—— (1990) *Oprichting Stimuleringsfonds Popmuziekproducties*, Amsterdam: SPN.

—— (1992) *Beleidsplan 1993–1996*, Amsterdam: SPN.

—— (n.d.) *Podiumplan*, folder, Amsterdam: SPN.

—— (n.d.) *Tour Support Regeling*, folder, Amsterdam: SPN.

Vulliamy, Graham (1977) 'Music and the mass culture debate', in John Shepherd, Phil Virden, Graham Vulliamy and Trevor Wishart (eds), *Whose Music? A Sociology of Musical Languages*, London: Latimer New Dimensions.

4

THE ENGLISH CANADIAN RECORDING INDUSTRY SINCE 1970[1]

Will Straw

When it is spoken of at all, the sound recording industry in Canada is discussed almost invariably in terms of those relationships (of subordination and interdependence) in which it finds itself *vis-à-vis* the international industry of multi-media conglomerates. There are good and clear reasons for this, rooted in the persistent Canadian impulse to link questions of institutional organization to those of a transformative public policy. In the still-embryonic scholarly literature dealing with the Canadian recording industry, however, one finds a tendency to gloss over basic questions having to do with the nature of recording companies, the processes by which they take shape out of music-related practices, and their relationships to a larger musical culture. The model of a 'record company' is normally accepted as given, and the implicit assumption within both journalistic and scholarly accounts is that Canadian record companies are simply firms which attempt, with less success, to do what multinational companies operating within Canada regularly achieve on a grander scale. This chapter attempts, in a very preliminary fashion, to raise certain questions concerning the status and historical emergence of recording companies within Canada, pointing towards a larger, more comprehensive history wherein the character of national musical industries might be delineated in finer detail.

In the study of national music industries, it is worth recalling that such industries normally rest upon informally organized cultures of music-related activity. This is a banal observation, but it serves to highlight differences between the recording industry and other cultural industries, such as those involved in broadcasting or the production of films. The television and film industries support forms of cultural activity which are unlikely to exist on a significant scale in their absence (outside the circumscribed spaces of experimental film and video) and they have come, over time, to be principal providers of the training on which a career within them depends. In contrast, music-related activities are perpetuated within and between a wide range of institutional and social spaces, by people who

52

are themselves likely to invest in the training and resources which they require. These activities are, at the same time, likely to unfold within artistic communities which resist definition, constituted as they are in the overlap between the education system, sites of entrepreneurial activity (such as bars or recording studios) and the more elusive spaces of urban bohemia.

It is in relation to these differences that divergences in the governmental treatment of individual cultural industries, in Canada as elsewhere, have taken shape. While the condition of most spheres of cultural activity has been designated a 'problem' at various points in recent Canadian history, the nature of the public responsibility which this problem is seen to incur has varied considerably from one sphere to another. The continued under-development and dependency of the film and television production indus-tries in Canada are commonly posited as failures *vis-à-vis* a national collectivity which suffers (knowingly or not) from a weakened national imaginary. These industries are to be nourished or summoned into being so that they may displace the popular appeal of others located elsewhere. In contrast, the condition of the music industries is more typically diagnosed in terms of its failures towards communities of producers and creators whose cultural presence within Canada, however fragmented, is persistent and recognized. For a quarter-century at least, critical discourse within Canada has asserted the richness of popular musical activity within Canada, and it is in relation to this richness that the achievements of public cultural policy are normally judged. While calls for public support or protection of a domestic film industry in English Canada often involve a rhetoric of scarcity, calling for an industry which would itself bring forth and sustain creative activity, arguments for the defence or expansion of the recording industry commonly begin by acknowledging the high level of activity which already exists.

This activity includes the operations of corporate entities involved in a variety of ways in the production, distribution and sale of recordings. Studies of the recording industry frequently take the existence of record companies as a point of departure, overlooking those processes through which what are commonly known as record 'labels' (i.e., companies en-gaged in signing artists and producing master tapes) emerge from variable combinations of other activities in which music or recordings are involved. In the Canadian case, as later sections of this chapter will seek to demon-strate, the sorts of activities out of which domestically owned record labels have typically grown have changed substantially over time, and their relationships, both to an indigenous musical culture and to an international recording industry, have likewise been transformed.

CANADIAN MUSIC AND PUBLIC POLICY

In an important study of the Canadian cultural industries published in 1983, the economist Paul Audley took note of the long-standing indifference of Canadian cultural policy-makers towards the music recording industry:

> By comparison with the attention which governments in Canada have accorded the magazine, book, film or broadcasting industries, the recording industry has, until very recently, been ignored. From an economic perspective, the industry is relatively small and categorized as part of the 'miscellaneous' manufacturing industry group, while as a cultural activity its significance has been largely overlooked by government.
>
> (Audley 1983: 141)

As it happened, the publication of Audley's remarks coincided with (and to a certain extent inspired) a series of public policy initiatives which would render them somewhat invalid. The situation Audley describes is one in which, as Karyna Laroche has pointed out, the Canadian government intervened to support the recording industry in indirect ways only, principally through the introduction in 1970 of regulations requiring radio broadcasters to include a specified quota of Canadian recordings within their programming (Laroche and Straw 1989). These regulations, and their effects, will not be discussed in detail here,[2] but it should be noted that the granting of broadcast licences in Canada has normally required a further promise by broadcasters to invest directly in the nurturing of local musical talent. Typically, until the 1980s, this investment resulted in talent-search contests organized by local radio stations, and in the production of compilation albums featuring the finalists – albums which languished, shortly after their release, in the delete bins of local record stores.

By the time of Audley's study, it was apparent that Canadian Content regulations for radio broadcasters and isolated gestures of support for local musical talent were insufficient stimuli to an industry suffering from a world-wide decline in record sales. This recognition coincided with the Canadian government's move to grant priority to the cultural industries overall within policies of economic development, and with the increased prominence of popular music within and across a variety of entertainment media (such as music video channels).[3] A more co-ordinated enterprise of support for the production and promotion of Canadian recordings was obviously required, and would take shape across a number of initiatives during the 1980s. The first of these came in 1982, when the Canadian Independent Record Producers Association and Canadian Music Publishers Association joined with several major radio broadcasters to create FACTOR, the Fund to Assist Canadian Talent on Record.

FACTOR, which established a jury system to evaluate applications from performers and producers, served initially as a channel through which radio broadcasters might direct the financial support which was already a condition of their licences. Its very existence, nevertheless, invited the granting of public monies, and in 1986 the Federal Department of Communications created the Sound Recording Development Program, which has channelled $5 million (Canadian) annually through FACTOR to the English Canadian recording system. (MusicAction, the French-language equivalent of FACTOR, was launched in 1985; it likewise receives funds annually from the Department of Communications.) These sums, originally intended for the production of master tapes and promotional videos, are now available for a variety of marketing and career-development purposes, such as participation in international music industry trade fairs.

The recent expansion of government policies intended to support the Canadian recording industry is not the central concern of this chapter, but the role of such policies in focusing public attention upon this industry should not go unnoted. By the beginning of the 1990s, forms of public subsidy for a domestic recording industry would stand as among the most high profile and popular of recent cultural policy initiatives within Canada. This new prominence of the music industries as a domain for public intervention has become evident in a variety of minor ways, as well. Statistical analyses of that industry's recent history are now easily available from the Federal government, and the recording industry has been an important point of reference within political debates over the Free Trade Agreement with the USA and cultural globalization more generally (e.g., Berland 1991.) As an object of academic scrutiny, the Canadian music industries turn up with increasing frequency on the curricula of courses within Communications and Music Departments.

What is striking, given these developments, is the continued absence of any substantial and up-to-date history of music recording in Canada. By 1992, one book-length study of the recording industry in English Canada had been published, and its account ended with the 1930s (Moogk 1975). In the case of Quebec, the situation is not much different.[4] This paucity of reference materials, set against the expanding shelf of books chronicling the histories of broadcasting and cinema in Canada, is regrettable, though the reasons for it are easily grasped. As an industry dominated throughout most of its history by small, short-lived companies or by the branch plants of companies based elsewhere, the Canadian recording industry has lacked the institutional continuities which might organize historical accounts or facilitate the research process. Just as until recently government regulators have used the broadcasting system as the exclusive channel through which support for Canadian recordings might be directed, recorded music in

Canada has been studied primarily in terms of its role as programming for this system.

The remainder of this chapter represents an attempt to map the broad outlines of a history of the English Canadian recording industry since 1970. If the early 1970s constitute a turning point in the development of a domestic recording industry in Canada, this is in part because of the introduction of 'Canadian Content' regulations for broadcasters, discussed earlier. This protectionist measure, whose success is widely acknowledged, was not, nevertheless, the only cause of important changes in the Canadian recording industries during the 1970s. Throughout this period, in addition, the organizational form of Canadian recording firms, and the nature of their links to the transnational music industries, would undergo major transformations. By tracing some of these shifts, across a number of individual cases, I hope to account for the distinctiveness of recent developments and to establish frameworks of analysis within which a larger, more comprehensive history of Canadian recording might be undertaken.

PRE-1970 ORGANIZATIONAL FORMS

From the 1950s through to the end of the 1960s, the Canadian music recording industry was a relatively underdeveloped and fragmented one. It resists historical reconstruction, in part because its low levels of corporate and geographical concentration have blocked the recognition of overall tendencies or the isolation of forms of corporate structure which might be called typical. Compared with those firms which emerged in the 1970s, most Canadian-owned recording companies during this period were not 'record labels' in the sense of being engaged exclusively or even predominantly in the signing of performers and recording of master tapes. More often, they were record pressing or distribution concerns which had moved into artists-and-repertory activity or the custom duplication of Canadian-made masters so as to maximize the revenue potential of existing operations. Profits from the pressing of foreign masters were drawn upon to underwrite the production of new recordings by Canadian-based performers; these recordings themselves might, in certain cases, be licensed to other firms for release in foreign territories.

To a certain extent, this fragmentation echoed the low level of corporate concentration within the US recording industry during this period.[5] Inasmuch as the Canadian record industry has derived a large portion of its revenues from the licensing of masters originating in the US, the viability of small firms in Canada has depended in part on the existence of large numbers of US companies whose product is available and attractive to them. Until the early 1970s, when major multinational firms established so-called 'branch' distribution networks across Canada, significant numbers of such companies existed within the US. Masters from Capitol Records, for

example, were pressed and distributed in Canada by the Musicana and Regal labels until the establishment of a Canadian subsidiary for Capitol in 1955 (Moogk 1980). Phonodisc (established in 1955) was, throughout the 1960s, the manufacturer and distributor of Motown Records, and Quality (established in 1950) pressed recordings licensed from MGM and a number of other US-based labels. The last two companies were among the most active in creating and distributing Canadian-based record labels, and were associated with significant Canadian successes through the 1960s, such as The Beaumarks' 'Clap Your Hands' (1960), Ronn Metcalfe's 'Twisting at the Woodchopper's Ball' (1961) and The Guess Who's 'Shakin' All Over' (1965).

By the 1970s, however, the viability of Canadian record labels based in the manufacturing or distribution sectors of the music industries had begun to wane. This was in large measure the result of a long-term process by which major, transnational firms consolidated their own 'branch' distribution activities across Canada – a development which mirrored similar patterns in the US, but whose effects on the Canadian situation were more complex.[6] The emergence within Canada of a distribution oligopoly dominated by foreign-owned firms precipitated the decline of large, Canadian-owned manufacturing and distribution firms throughout the 1970s, but not simply because the latter were no longer able to compete within their domestic market. Equally importantly, perhaps, the same process within the US had reduced the number of independent, unaffiliated labels whose product was available to Canadian firms for licensing. As smaller US companies (such as MGM or ABC Records) were absorbed within large media conglomerates throughout the late 1960s and early 1970s, their capacity to enter into separate agreements with foreign firms was diminished. As a result, the ability of Canadian firms indirectly to subsidize the production of Canadian recordings from the manufacturing and distribution of foreign repertory declined.

The effects of these changes are perhaps best observed using the example of Quality Records, known throughout much of its history as 'Canada's oldest and largest independent' (*Billboard* 1977).[7] Quality's success had rested upon the foundation of its manufacturing operations which, as recently as 1980, were estimated to be responsible for 20 per cent of all records pressed within Canada (*Billboard* 1980). As suggested, Quality was a significant issuer of Canadian recordings, supporting these in part through its licensing of successful US product lines. During the 1970s, however, it was forced to drop several of these lines as a result of moves toward concentration within the US and European record industries. In 1973, Quality lost the rights to MGM Records and its subsidiaries when PolyGram bought these labels and their distribution moved to Polydor within Canada. In 1977, the rights to a successful independent label, Casablanca, likewise shifted from Quality to Polydor. During this decade,

Quality attempted, in a variety of increasingly desperate ways, to stabilize its revenue base, most notably by seeking to sign those US labels which remained independent, but the number and profile of these were declining steadily. It also attempted, on two unsuccessful occasions, to set up its own US subsidiary, over-extending its resources in the process. In 1979, Quality succeeded in acquiring the rights to Motown Records in Canada, but the international shift of such rights to MCA in 1986 terminated this arrangement and provoked the company's collapse. Its manufacturing operations were sold to a growing CD pressing operation, Cinram, and Quality itself continued to exist primarily as a marketer of compilation albums promoted through television advertisements.

The virtual disappearance of Quality Records may stand as emblematic of a more general decline in levels of vertical integration within the Canadian recording industry. Canadian-owned companies involved in artist-and-repertory activities have in large measure confined themselves to such activities since the early 1970s, and pressing plants have been less likely to engage in the signing and recording of artists. As a 1988 report by the Canadian Independent Record Production Association pointed out, even foreign-owned labels which once owned manufacturing or retail operations in Canada had moved, over the preceding decade, to divest themselves of many of these interests, concentrating their activities within the distribution sector (CIRPA 1988). While record distribution has emerged, over the last twenty years, as the activity through which oligopolistic control is most effectively ensured, particularities of the Canadian situation have magnified its importance. The geographical expanse of Canada and the existence of two distinct linguistic communities have encouraged the development of distribution operations which are either regional in scope (such as those operating within Quebec), or directed towards dispersed, international markets (such as those for dance music recordings.) Most Canadian-owned distributors have confined themselves to such markets, leaving pan-national distribution as the province of multinational firms operating in Canada.

NEW FORMS OF INDEPENDENCE

In the wake of the developments described above, a different organizational model emerged within the English Canadian recording industry during the 1970s. This model was one in which a particular construction of small-scale entrepreneurial 'independence' took shape, reinforced regularly in journalistic profiles of record company heads which stressed their upstart, nationalistic impulses, and by the formation in 1975 of the Canadian Independent Record Production Association. Less readily acknowledged is the extent to which the emergence of this new class of record companies was inseparable, historically, from the consolidation by multinational firms

of a branch distribution system within Canada. The development of a domestic recording industry over the last two decades has depended in large measure on the institution of new forms of affiliation between small, Canadian-owned recording firms and large, foreign-owned distributors. In many cases, this development has followed patterns which one can observe elsewhere and which, in larger countries like the US, typically involve independent labels whose distinctiveness lies in their generic specializations rather than their national location. Nevertheless, it has had distinctive effects on the music industries in Canada, and on the ways in which their problems and successes are diagnosed.

The principal English Canadian record companies which formed or became prominent in the 1970s were not based in the manufacturing or distribution sectors of the recording industry, and in virtually all cases they have not involved themselves in those sectors. Typically, these firms emerged out of 'talent'-related activities, such as artist management or concert booking. In many cases, as well, their roots were in small-scale music-related enterprises of the late 1960s, such as folk music clubs or free-form FM radio stations. The initial success of these firms was usually dependent upon a core performer or small roster of acts with whom label owners were involved in managerial or other capacities. These artists were, for the most part, working within musical styles long enshrined as those in which Canadians have proved successful – in particular, the singer-songwriter and hard rock traditions. The normal longevity of these styles, and of performer careers within them, has partially ensured a certain level of stability for these firms, most of which have survived until the present day. (In addition, it has contributed to the sense that the recent history of popular music in Canada is best explored in auteurist terms, as the unfolding of a number of distinct careers – those of Gordon Lightfoot, Murray McLaughlin, the group Rush, and so on.)

Arguably, the first company to form along these lines was Aquarius, which was founded in Montreal in 1968 by individuals active in the local recording and concert booking industries. Its most prominent artists, for many years, were the hard rock band April Wine, who achieved a certain measure of success outside Canada. In 1970, True North records was co-founded in Toronto by a talent manager and the owner of the Riverboat, a prominent local coffee house. It has been associated with the recording careers of Bruce Cockburn and Murray McLaughlin, and, more broadly, with the contemporary folk styles for which those artists are known. Anthem Records, also from Toronto, began in 1977 as a production company for the hard rock group Rush, who are its owners, and expanded with regular signings over the next decade. Stoney Plain, a country-oriented label based in Edmonton, Alberta, was formed in 1976 by a specialist public radio disc jockey, and has combined the release of new recordings by Canadian country music performers with the distribution of

'roots' music recordings licensed from other countries. The most successful independent label in English Canada, Attic Records, has been owned since its beginnings by the manager of singer Gordon Lightfoot, though his managerial and record company activities were from the very beginning kept distinct, and Lightfoot's own recordings were released by a major multinational.

The specific details of these companies' histories are less important for our purposes than is the new mode of entrepreneurship which they represented. Inasmuch as their original assets were, in most cases, a contractual or informal connection to performers of recognized potential – or to a local musical scene – these labels conceived themselves as production houses rather than as vertically integrated recording firms involved in distribution or record pressing. (Integration has instead followed 'horizontal' lines, to include publishing, tour management and international licensing activities.) From their inception, these companies sought distribution through one of the multinational companies operating within Canada: London Records (Aquarius, Attic and Stoney Plain), CBS (True North), PolyGram (Anthem). In most cases, these affiliations would change over the next ten to fifteen years, but the underlying relationship of these firms to major distributors would not, nor would their relatively low investment in fixed assets, which gave them the flexibility necessary to change affiliations when it proved advantageous to do so.

Nevertheless, firms such as these have confronted tensions between their dual roles within the Canadian recording industry overall. On the one hand, as independently owned firms engaged in the signing of artists and production of records, they are normally compelled to operate in the international recording market, selling licences for their recordings in foreign territories and, on occasion, purchasing foreign masters for release in Canada. At the same time, as a result of their affiliation with major distributors, these firms have come increasingly to serve as the means by which multinational companies may establish a connection to a national musical culture without investing funds or allocating resources on their own. In a recent example, True North Records, which had been dormant for five years, was reactivated on the request of its distributor, Sony Music Canada, which suggested to its owner that he look around to see if any artists in Canada looked potentially successful (*The Record* 1991).

In understanding this tension, a second case study may prove useful. The success of Attic Records of Toronto, over a twenty-year period, is normally attributed to a strategy of diversification which it has followed since its founding (e.g., *Billboard* 1977). This diversification is evident, not only in the number and range of performers whose recordings it has released, but also in the diversity of markets in which it has been involved. While many of the Canadian labels discussed above have been active primarily in the production of recordings by high-profile singer-songwriters or heavy

60

metal groups – that is, in musical genres where performer careers are marked by higher than usual levels of stability and longevity – Attic has involved itself in markets as different as those for disco singles and albums of Irish traditional music. In doing so, it has succeeded in establishing a catalogue of steady-selling albums, while deriving significant revenues, in isolated cases, from the more turbulent markets for dance and pop musics.

In the mid-1970s, while its own records were distributed by London Records within Canada, Attic undertook to license a number of its performers within foreign territories. Patsy Gallant, for example, who had a hit record with 'From New York to LA' in 1977, was licensed to EMI in the UK and Private Stock in the US, and the terms of these licences normally involved publishing rights which Attic itself controlled. By the end of the 1970s, in fact, participation in the international trade shows was central to the strategies of a number of Canadian independent labels, whose own national market offered limited revenue potential. In this respect, Attic participates actively in those processes through which relatively decentralized networks between independent recording firms in dozens of countries are established and exploited. In 1991, for example, it entered into an agreement with the South Korean company Han Yang Records under whose terms the latter would release albums by a number of Canadian performers (such as The Nylons or Lee Aaron). In the same year, it acquired the rights to the Canadian release of masters from the US-based Scotti Bros label.

The histories of these independent firms have been marked by regular changes of affiliation, as they seek more advantageous guarantees of promotional support or cash advances from multinational distributors. In 1979, Attic switched its major label affiliation to CBS of Canada, distributing its records through that company's Epic, Portrait and Associated Labels marketing system, and continuing its own promotion at the level of individual radio stations. In 1982, Attic changed distributors once again, signing a two-year affiliation with Quality Records in return for a significant investment of money to be used in the signing of new acts. After five months, this arrangement – one of the few in recent years which linked a Canadian independent to a large, domestically owned distributor – was concluded by mutual consent, and Attic switched again, first to PolyGram and subsequently to A&M (which was itself bought by PolyGram in 1989). A&M's responsibility in the promotion of Attic recordings is reportedly defined in one line of the affiliation agreement between them, which specifies that A&M will treat recordings by Attic artists no differently from those of its own artists of equal stature.[8]

Changes of affiliation have not interfered to a significant degree with Attic's capacity to build up a roster of performers and back catalogue of recordings over time, though they might affect the manner in which this back catalogue is marketed.[9] Somewhat paradoxically, recent changes in

the sales patterns of popular music recordings may well alter the role of those independent Canadian recording companies which emerged in the early 1970s. While traditionally, as argued, their functional role within the international industry has been one of discovering and developing emergent performer careers, their current value is derived increasingly from the back catalogues which they have accumulated. In 1990 and 1991, one could argue that Attic's role *vis-à-vis* its multinational distributor was partly that of a specialized subsidiary, incurring a large part of the risk posed by musical forms, such as rap, wherein Canadian sales and performer careers were often uncertain. By 1992, Attic had withdrawn to a significant extent from these markets, as broadcast media programming policies and rising costs of promotion reduced or eliminated their profitability.[10] The expense incurred in launching new performers, the continued growth of the CD market, and growing dominance of the retail sector in Canada by large chains of catalogue-oriented stores have led many Canadian labels to concentrate on the marketing of their accumulated inventories of older recordings.

The recording firms discussed in this section offer important models in a number of respects. Their relationship with multinational distributors has served to guarantee a certain stability, while the restriction of their activities to those typically seen as creative has ensured their owners an observable prominence within the Canadian entertainment industries. At the same time, these firms are among those most active in lobbying for continued government subsidies for the recording industry, and for the maintenance or tightening of Canadian Content rules for radio broadcasters. Paradoxically, the dependence of these firms on distribution by major multinational companies has guaranteed a trans-Canadian presence for the recordings which they produce, inasmuch as there exist no Canadian-owned distributors operating on a similar scale.

At the time of their emergence, most of the companies described in this section were associated with musical currents and artists which have subsequently been canonized within histories of English Canadian popular music. The values present at their founding have continued to be those which shape the terms of music criticism in Canada, and through whose prism questions of public policy towards the music industries are typically framed. The valorization of artistic careers undertaken by the 'independent' record companies which emerged in the 1970s has helped to give English Canadian popular music a place within ongoing debates over the substance of a national cultural identity.[11] Those book-length treatments of recent Canadian popular music which do exist have tended to rely implicitly on literary models which stress the continuities within distinctive artistic visions (e.g. Adria 1990), and their irrepressibility within a national condition of economic and cultural dependence. The furore over the failure of Bryan Adams' recent album to qualify as Canadian Content for

broadcasting purposes – because its co-writer, producer and place of recording were not Canadian – offers evidence of the extent to which concern over the condition of the Canadian music industries has focused almost exclusively on the fate of individual performers.[12]

In a manner one might not have predicted, however, the role of independent record companies in Canada in producing a canon of perenially popular artists and recordings may work in the future to restrict their activities. It appears more and more likely that these firms will serve, within an internationalized industry, as repositories for a particular corpus of older Canadian recordings – most of which date from the 1970s and early 1980s – and that their capacity to engage in the active discovery and development of newer performers will diminish.[13] In this respect, such companies may become the latest in a long line of custodians of Canadian resources who witness the erosion of their value over time while innovation and change occur elsewhere.[14]

NOTES

1 Much of my research into the Canadian music industries over the last five years has been in collaboration with Jody Berland, and her contribution to anything I publish on the subject under my own name must be acknowledged. Karyna Laroche's work on Canadian public policy *vis-à-vis* the recording industries has been very helpful and inspiring. Chris Robinson, who tracked down much-needed information, has provided invaluable assistance.
2 For more extended discussions of 'Canadian Content' regulations, see Wright (1991).
3 For an overview of these shifts, see Berland and Straw (1991).
4 As in English Canada, existing histories of Quebec recording tend to focus on very early musical forms; see, for example, Labbé (1977). A recent overview of record labels in Quebec represents the most comprehensive attempt I have seen to study the overall corporate organization of the Quebec recording industry (Tremblay 1991.)
5 The decline in the overall level of corporate concentration within the US recording industry during the years 1958–72 is discussed in Belinfante and Johnson (1983).
6 The move to 'branch' distribution, through which major firms handled the distribution of recordings from their own and subsidiary labels – rather than relying on independent distributors – is discussed by Frith (1981: 139–40).
7 My description of record label histories, in this and later sections, is based on information gathered from *Billboard*, the US music industry trade magazine, and *RPM* and *The Record*, trade magazines published in Canada.
8 Personal conversation with Al Mair, President of Attic Records, February 1992.
9 In 1992, for example, Attic announced plans to release a compilation of greatest hits by The Nylons through PolyTel, the division of PolyGram which produces recordings for television marketing. Personal conversation with Al Mair, President of Attic Records, February 1992.
10 Al Mair, personal conversation. With the disappearance of vinyl production in Canada, Attic would normally import several hundred 12-inch single versions of dance records it planned to release in Canada, distributing them through the

disc jockey pool system for promotional play in dance clubs. Over the last year, however, as radio stations in Canada have turned away from dance-based formats, and the English-language music video network has limited the play of dance records to specialized programming slots, the probability that these records would break out of clubs into the mainstream market has declined. This has not, it should be noted, significantly reduced the sale of dance records within a market much more specialized than that in which Attic has normally involved itself.

11 I have argued elsewhere (Straw 1991) that attempts to define a specifically English Canadian musical tradition have resulted in regrettable oversights and blindspots.

12 In January 1992, during a world-wide tour, Adams called a press conference for the repeal of Canadian Content regulations on the grounds that if he, an obviously successful Canadian artist, could not qualify, these regulations were not effective as forms of support for Canadian music.

13 Increasingly, the activity of Canadian labels born in the late 1960s and early 1970s involves the reissuing of materials issued during the 1970s. Ownership of this material (rather than the ability to sign new artists) seems the principal reason for major label interest in them.

14 The early 1990s have seen more and more Canadian performers sign directly with the US head offices of multinational firms, bypassing both Canadian independent companies and the Canadian subsidiaries of these multinationals. For one account, see *Billboard* (1991).

BIBLIOGRAPHY

Adria, Marco (1990) *Music of our Times: Eight Canadian Singer-Songwriters*, Toronto: James Lorimer & Company.

Audley, Paul (1983) *Canada's Cultural Industries*, Toronto: James Lorimer & Company.

Belinfante, Alexander and Johnson, Richard L. (1983) 'An economic analysis of the US recorded music industry', in William S. Hendon and James L. Shanahan (eds), *Economics of Cultural Decisions*, Cambridge, Massachusetts: ABT Associates.

Berland, Jody (1991) 'Free trade and Canadian music: level playing field or scorched earth', *Cultural Studies* 5 (3), October: 317–25.

Berland, Jody and Straw, Will (1991) 'Getting down to business: cultural politics and policies in Canada', in Benjamin Singer (ed.), *Communications in Canadian Society*, Scarborough: Nelson Canada.

Billboard (1977) 'Labels strive for product balance', *Billboard* 29 October: C–5.

—— (1980) 'Indie labels push for tax incentives', *Billboard* 26 January: C4.

—— (1991) 'Many Canadian acts still outside the int'l spotlight', *Billboard* 23 March: 72.

CIRPA (1988) *Investor's Guide: An Overview of the Sound Recording Industry*, Toronto: The Canadian Independent Record Production Association.

FACTOR (1991) Untitled pamphlet, Toronto: The Fund to Assist Canadian Talent on Record.

Frith, Simon (1981) *Sound Effects*, New York: Pantheon.

Labbé, Gabriel (1977) *Les Pionniers du disque folklorique québécois 1920–1950*, Montreal: L'Aurore.

Laroche, Karyna and Straw, Will (1989) 'Radio and sound recording policy in Canada', *Australian–Canadian Studies* 7 (1–2): 163–6.

Moogk, Edward B. (1975) *Roll Back the Years: History of Canadian Recorded Sound and its Legacy*, Ottawa: National Library of Canada.

—— (1980) 'Capital Records – EMI of Canada Limited', in *The Encyclopedia of Music in Canada*, Toronto: University of Toronto Press.

The Record (1991) 'Hoskins reactivates True North label', *The Record* 4 March: 16.

Straw, Will (1991) 'Systems of articulation, logics of change: communities and scenes in popular music', *Cultural Studies* 5 (3), October: 368–88.

Tremblay, Danielle (1991) 'L'industrie du disque au Québec', *Moebius* 48, Spring: 101–23.

Wright, Robert (1991) '"Gimme shelter": observations on cultural protectionism and the recording industry in Canada', *Cultural Studies* 5 (3), October: 306–16.

5

MAKING MUSIC LOCAL

Marcus Breen

Government involvement in the music industry is often opposed for a mixture of reasons, both philosophical and practical. Intervention or regulation by governments or their statutory authorities are considered, by some, to hinder the free flow of creative talent. Free marketeers, by contrast, argue that 'free-fall' risk-taking in the music industry should not be interfered with, especially where there are large profits to be made. This entrepreneurial ethic has permeated the music industry world-wide and Australia, where music production and distribution are dominated by international corporations, is no exception. The Prices Surveillance Authority inquiry into the recording industry in Australia noted late in 1990 that the recording industry had been operating at a high level of profitability for a period of over twenty years (*Inquiry into the Prices of Sound Recordings* 1990: 126). Just as important, the industry as a whole, both nationally and internationally, is characterized by its buoyant expectations, constantly projecting continuing global sales growth. Bertelsmann Music Group's managing director, Rudi Gassner, thus predicted that world-wide sales across all carriers (compact discs, cassettes, mini-cassettes) would rise from their 1990 level of about 2 billion to reach 2.5 billion by 1996 (Gassner 1991).

Government involvement in the music industry often hardly seems necessary against this backdrop of high profitability and consistent growth. Arguments against government intervention have also often been made by workers in the industry on moral and political grounds. An American music writer has thus suggested that taking money from governments which undertake 'genocidal wars against peasant populations' would compromise musicians. Less global perspectives, however, have often prompted different assessments. Peter Garrett, lead singer of Midnight Oil, in responding to this suggestion, outlined a rationale for government involvement in the music industry that has proved particularly influential in Australia:

'Not every band has the commercial potential to exist on its own terms. Australia is a highly productive place musically. INXS,

Crowded House, Midnight Oil are real long-odds bands. If artists have no financial support and no means to get themselves heard, society is effectively blocking people with something to offer. Artists need encouragement and that should be the function of government. If you can't make your government accountable in any way and you think that Pepsi and the government are the same thing, which in this country [USA] they are, then I agree with you. But in Australia, it's not the same. We have government institutions there that support artists, especially artists who aren't mainstream, with no suggestion that they toe the line politically. If there were any suggestion of that there would be an artist revolution.'

(Young 1988: 84)

Garrett was speaking at a time when reformist Australian Labor Party governments at state and federal levels were putting into place the first institutions aimed at providing assistance to popular musicians and the popular music industry generally. The institutions, such as the Victorian Rock Foundation, Ausmusic (Australian Contemporary Music Development Company Ltd) and The Push, were created after lengthy investigations into the music industry. The investigations, such as *Australian Music on Radio* (1986) and *Patronage, Power and the Muse: Inquiry into Commonwealth Assistance to the Arts* (1987), were undertaken to assess how an indigenous music industry could be sustained and reinforced to maintain it against imported popular music. The encouragement of culturally relevant youth programmes based around music was just one outcome of these investigations, an outcome consistent with the Labor Party's tendency to support non-elitist creative programmes, or at least enthusiastically to endorse the principles of cultural pluralism.

A government policy interest in popular culture, however, is not new in Australia. There has been long-standing government support for the film industry which has often served as a model and focus for arguments in favour of similar patterns of support for the music industry. It is only recently, however, that popular music has been absorbed into the policy considerations of Australian governments as, in the period since the mid-1980s, a reformist Labor Party has incorporated popular music within the ambit of its arts and cultural policies. My purpose here is to assess the outcomes of this new policy environment for the Australian popular music industry. First, though, it will be useful to look at the rationales on which the case for government support of the music industry has been based and at the models that have been available to guide new policy initiatives in this area.

AUSTRALIAN POLITICAL CULTURE

Government interventions into popular music production in Australia have been premised on the view that the international music industry is incapable of adequately comprehending or supporting local music. In their endeavours to promote Australian popular music, various governments have subscribed to the belief that there is an Australian style of popular culture – a style that incorporates specific cultural practices, a localized political economy and distinctive everyday readings of cultural forms, all of which are held to contribute to the formation of a distinct national identity. The argument has been that room must be made for this 'Australian style' within the context of the free-market activities of the major record companies. The measures implemented to encourage an indigenous popular music industry in the period since the election, in 1983, of the Hawke federal Labour government have combined high ambition at a policy level regarding the role government might play in promoting such an industry with a pragmatic recognition that the major record companies have a significant place in the musical life of the nation and so must be regarded as partners in any such undertaking.

As a social democratic party, the Australian Labor Party (ALP) – when in office, at either federal or state level – has shown few qualms, recently, about accepting an interventionary and regulatory role in challenging the *status quo* of the global music industry and its impact on Australia. The direction of its policies has thus favoured government intervention in and regulation of the popular music industry where intervention is understood as the implementation of policy decisions by governments to restructure the industrial organization of the music industry in the national and public interest and where regulation refers to the creation of institutions to act as agents for the government in developing programmes within and for the music industry.

There have been many precedents and rationales for these kinds of governmental involvement in specific industrial sectors in the Australian context. Australia has a history of governments working as an adjunct to private enterprise, especially in the neo-Keynesian climate that prevailed for the greater part of the post-war period. Ken Davidson, economics editor of *The Age* and the foremost neo-Keynesian writer in Australia, thus continued to advocate this position during the late 1980s, when Australia was a hotbed of deregulationist enthusiasm. 'Australia', he said, 'has had a tradition of public sector involvement in railways, telecommunications, electricity, gas production and air transport because for one reason or another – size, risk, social obligation or lack of profit – private enterprise has been unwilling to do the job' (Davidson 1990).

It is from specifically antipodean conditions such as these – 'size, risk, social obligation or lack of profit' plus social justice considerations – that

the primary impetus for Australian government involvement in culture industries derives. Finding models for government intervention and regulation of such industries, however, is not always easy. In Australia, the film industry has provided a model for those advocating the implementation of neo-Keynesian policies in the music industry. As a high-risk venture (if seen in terms of its economics alone) the film industry has maintained an identity within Australia due to extensive and direct government financial support. The strong cultural argument in favour of film funding has been acknowledged since the late 1960s by the establishment of federal and state government institutions. But the public funding of industry *and* culture, however, always involves a tension. The 'anatomy' of 'this strange entity', called the film industry, according to Susan Dermody and Elizabeth Jacka, involves the 'commercial, publicly-funded production of cultural artefacts' which enter 'the social imaginary of this culture' (Dermody and Jacka 1988: 3). Government film bodies like Film Victoria and the New South Wales Film and Television Office, the South Australian Film Corporation, the Australian Film Commission, the Australian Film Institute and Film Australia have been important players in film and television production in Australia. All are fully government funded and are required to manage the tension between the strictly economic and the more distinctively cultural aspects and objectives of film and television policy.

A similar dualism has been involved in the positions adopted by trade unions in the music industry. Actors' Equity of Australia, the Musicians' Union of Australia and the Australian Theatrical and Amusement Employees Association have all played a significant role in calling on government to support the industry. In doing so, they have linked the creation of jobs for film workers and the maintenance of cultural identity, to the need for Australia to have 'a culturally distinctive and commercially viable film and television industry' (Crosby 1991). By linking employment, industrial infrastructural developments and cultural identity, Australian trade unions maintained the bedrock of this argument within the Labor Party during the 1980s. Government support for the Australian film industry acted over this period as a prompt for people in the Australian music industry. For example, Michael Gudinski, managing director of Mushroom Records – Australia's biggest independent record label – wanted to know why film had always been privileged in Australian cultural life at the expense of popular music (Breen 1988a: 15). His question was answered when state and federal governments commissioned a plethora of reports into the popular music industry beginning in the mid-1980s. In examining the economic and cultural value of popular music in Australia these investigations created the context in which it was possible to argue for the establishment of regulatory agencies.

Fuel was added to the embers of Keynesian economics in the deregulatory 1980s, when the Australian Council of Trade Unions (ACTU), the

peak trade union body, expressed an interest in the music industry. The ACTU summarized its position when, in a submission to the Prices Surveillance Authority, it noted that: 'The industry is characterized by extremes based on success and various industry arrangements that are beneficial to some but exploitative of others. . . . In a highly profitable industry the reward for the talent and creativity upon which it is based is demeaning' (ACTU 1991: 1). This recognition of the potential extremes of the music industry reinforced earlier calls for government action – not just of the music industry and not just in Australia either. If the ethos of the 1980s was predominantly deregulatory, the signs are that the 1990s will witness an increased commitment to the regulation of market forces. In Australia, both John Kerin and John Dawkins – Paul Keating's successors as Treasurer – have emphasized the need for markets to be regulated if important economic, social and cultural objectives are to be secured. On the world scale too, and with specific reference to the music industry, the need for the regulation of similar markets seems increasingly clear. The problems associated with increasingly large corporations like Sony owning both the song catalogues (purchased by Sony when it bought CBS) and the potential hardware for distribution of those songs are thus behind calls for regulatory policies to cover the increasingly interlinked, global media industries, of which the record industry is a major component.

It now seems clear, then, that intervention and regulation are necessary to lubricate the noisy grindings of the wheels of mixed economies, where regulatory regimes seek to preserve the public interest and social justice in the midst of private enterprise market imperatives. Increasingly, however, the regulators must coexist with progressively larger and more diversified transnational companies, for whom recorded music is just one aspect of global commercial activity – a consideration which has been of pressing relevance to the development of Australian music industry policies over the past decade.

PUBLIC INQUIRIES AND CONTENDING FORCES

It would be misleading to suggest that popular music had not been the subject of public inquiries and government policy considerations in Australia before the advent of ALP governments in the 1980s. The Australian *Copyright Act 1968*, for example, specifically mentioned music, suggesting that the problem of music copyright be considered by an inquiry. Twelve years later, the conservative federal government of Malcolm Fraser called for and released the *Report of the Inquiry by the Copyright Tribunal into the Royalty Payable in Respect of Records Generally* (1980). Interestingly, the inquiry made three recommendations, the first of which went to the core of much of the reasoning behind subsequent government interventions in the popular music industry. It

said, in part: 'The statutory royalty now payable in respect of records generally is not equitable and should be increased' (p. xiv). It had been frozen at 5 per cent since 1912. The agreed rate of increase was 1.75 per cent, bringing the mechanical royalty to 6.75 per cent of the retail selling price per record. Within the context of free-market economics, the statement that the royalty was 'inequitable' was a major victory for composers against record manufacturers in Australia. More importantly, it drew attention to the unreasonably exploitative methods used by record companies to maximize profits to the detriment of the creative personnel on whom they relied.

Official investigations, inquiries and recommendations are the necessary, although often tedious, processes of government. They cannot, however, be dismissed as bureaucratic indulgences, especially where open public debates provide a rare opportunity for the industry, the public and vested interests to raise their concerns and discuss a range of possible outcomes which vary in their implications for the relations between public benefit and corporate profit. The belief that the musical choices available to Australian audiences are seriously restricted has played an important role in prompting such inquiries in the Australian context. The high profitability of the restricted range of popular music which is made easily publicly accessible and visible by the media is, in part, an effect of consumers' ignorance of the broad spectrum of musical choices that is available to them. This lack of knowledge, in turn, derives from the nature of commodity marketing in such a high-consumption, fashion-conscious industry. Inquiries serve to air such concerns in public and bring pressure on the major record companies in an effort to have them improve their treatment of local industries. Of course, they may also take the further, more dramatic step of recommending the introduction of legislation that will favour particular often marginal sectors of the industry in the public interest.

But not all reports support or endorse an implicit or explicit policy of advancing public and performer access to popular music or to its financial rewards. In 1978, the Industries Assistance Commission (IAC) released an unsympathetic report titled *The Music Recording Industry in Australia*. Working at an industrial level only, the report sought to debunk any regulatory arguments that might be construed to support Australian music. It found that Australian music was part and parcel of the globalization of the popular music industry and that Australian music had no more claim to special cultural relevance for Australians than music from any other part of the world. This finding was handed down during the period of the conservative Fraser government, an administration that was largely unconcerned with, and unimpressed by, arguments concerning the role of culture in the formation of national identity. The Labour Party – more susceptible to the influence of radical nationalist cultural critics – has proved more

concerned with, and alert to, the national and popular aspects of cultural issues throughout the post-war period. It has been instrumentalities like the Australian Broadcasting Control Board and the Australian Broadcasting Tribunal (ABT), however, that have played a crucial mediating role in translating such political and cultural concerns into practicable policy agendas.

The Australian Broadcasting Control Board was given the responsibility, after the 1942 *Report of the Joint Committee on Wireless Broadcasting* (Gibson Committee), to introduce and oversee an Australian music content quota on Australian radio, with the intention of 'building up an Australian repertoire which is so highly necessary if a truly Australian musical culture is to be developed' (cited in *Australian Music on Radio* 1986: 24). It was this regulation that the 1978 IAC report had attempted to undermine. Since 1 July 1973, the Australian Broadcasting Control Board – subsequently to become the ABT – set the Australian performance quota at 10 per cent, under the direction of Senator Doug McClelland, Minister for the Media, who, early in 1973, anticipated that the quota would be 30 per cent by 1976. This did not occur (*Broadcasting and Television* 1973: 106). Nevertheless, the quota was increased in stages and reached 20 per cent in 1976, while further increases – namely the stipulation that 5 per cent of broadcast material be Australian compositions – were introduced in 1988. The need for Australian music on radio was reaffirmed by an ABT inquiry and report, which noted that rock music is 'a way of reflecting the concerns, interests, and aspirations of Australian society, as well as celebrating the creativity of that society' (*Australian Music on Radio* 1986: 17).

The historical development and institutionalization of this quota system has clearly reflected a lack of confidence in the ability or preparedness of the (radio) market-place to play Australian music on radio. Clearly, if the market-place were left to look after itself, there was felt to be no guarantee that Australian music would ever get airplay. Given the increasing globalization of the music industry in recent years, it was perspicacious of the committee to predict, in 1942, that record companies would have no interest in manufacturing Australian or local music. Similar judgements inform contemporary government assessments. A recent Minister for Communications, Kim Beazley, has thus accused the media in general of being concerned solely to maximize their profits by selling successful entertainment products from overseas, with no concern for 'the interests and aspirations of Australian society' (Beazley 1990). That the record companies should be 'forced' to manufacture Australian music for the demand created artificially through the Australian music quota, was a preemptive solution to the prospect of a non-existent indigenous recorded music industry. However, the quota system now has enthusiastic champions within the record industry. Commercial radio stations have been and still are vociferously opposed to this intervention, which they believe

impinges on their (free-market) right to play whatever music they like to maximize their audiences. But according to the Australian Record Industry Association's executive director Emmanuel Candi, '[The quota system] is one of the greatest bits of government regulation we've come across. It has great support across the industry . . . 10–15 years ago, the record companies put their hands into their pockets and invested in Australian music' (2nd Annual Radio and Records Conference, Melbourne, 1991).

But why had there been, and why does there remain, no guarantee that Australian music would be played on Australian radio without the installation of a quota system? The short answer is that the big six multinational record companies work and act globally, marketing their products wherever consumers will buy, with little or no concern for national identity. (The big six in Australia are Warners, BMG, EMI, Polygram, Sony, plus Rupert Murdoch's and News Corporation's local licensing label Festival.) The big six resist interventions that governments or their representative bodies, like the ABT, may make into their operations, aspiring to a position 'above' any regulation whatsoever, with the exception of copyright law which is in their interests. High-volume and high-velocity sales (one-quarter of total sales tend to occur in the first six months following the release of a recording) and increasingly confused cross or joint ownership arrangements make for real difficulties in the analysis and regulation of media industries. For example, now that Sony owns CBS and Matsushita owns MCA, how will the Japanese use the global fixation with American popular culture to maximize profits for Japanese multinationals? It may be correct to say that 'we can no longer understand international cultural influence as a force which emanates from the US, and is mediated through to us by some kind of transnational apparatus designed for that purpose' (Sinclair 1990). Be this as it may, the operations of the transnationals pose real difficulties for post-colonial societies which, if they are not alert to the dangers, run the risk of inadvertently conceding intellectual and social spaces won through constant struggle for national, cultural and economic identity.

These were the dominant intellectual and political frameworks which informed government inquiries into the music industry in the 1980s. Reports on the music industry, particularly the popular music industry, were issued at a rapid rate over this period. The 1986 ABT report, *Australian Music on Radio*, had been preceded by a 1985 ABT report *Young Australians and Music*, which examined the diversity of popular musics listened to by young people and their attitudes to music of Australian origin. It was undertaken for two reasons: to assist the ABT in its inquiry into Australian content (published in *Australian Music on Radio*) and to contribute to an International Youth Year study. Overall, these ABT investigations into the music quota provided evidence that Australian music was being played on radio with support from young

Australians. Both ABT reports facilitated the agenda-setting task of linking Australian music with the national aspirations of young Australians. Formalizing the location of music within those aspirations was to follow soon after.

In February 1986 the Australia Council ('the federal Government's arts funding advisory body') released the *Music Board Medium Range Plan 1985–1989*. This report, as Music Board director Richard Letts and Board chairperson Barry Conyngham said in the introduction, set 'a course of action for the Music Board of the Australia Council in its support of music development in Australia' and, among other things, argued for 'an 85 per cent real increase in subsidy available to Australian musical activity through the Music Board'. Through the release of reports of this kind, details about the popular music industry began to filter through to the public and become a point for discussion within the Australian Labor Party. To add further weight, in May 1987 the Australia Council released *The Australian Music Industry: An Economic Evaluation*, which put the case for subsidizing the music industry with an economic rationalist's quantitative precision:

> The music industry as a whole is worth over $1.5 billion a year and some 6,000 individuals derive an income from it (40,000 full time equivalent workers). This represents about 0.7 per cent of the total Australian economy. It is comparable for instance to the clothing and footwear manufacturing industry. It is larger than the textile industry which had a gross product of $1.1 billion and 34,000 workers.
>
> (*The Australian Music Industry: An Economic Evaluation* 1987: 1)

There was still more to come, in what could be construed as interventionary overkill, but is perhaps better viewed as an orchestrated attempt to provide incontrovertible evidence of the necessity for government regulatory initiatives across the music industry. In September 1987 the budget committee of Federal Parliament released *Patronage, Power and the Muse: Inquiry into Commonwealth Assistance to the Arts*, more commonly known as the McLeay Report. This report included rock music in its considerations and recommended, amongst other things, that contemporary musicians be assisted in their careers with business training, study and travel abroad. The report had more far-reaching implications. Gold (1987) noted that the report had two fundamental propositions: first, that government assistance to the arts is justified because the arts provide public benefits; and, second, that a democratic cultural strategy should aim at cultural diversity. Both were important in incorporating into policy debate a critique of, and alternative to, the high-culture bias which had hitherto dominated many cultural policy rhetorics and priorities. That said, there was some degree of ambiguity in the report in this regard. For one strain of its argument was to co-opt popular music into the high-cultural domain of 'the

arts' so that, thereby, it might derive legitimacy as a suitable publicly funded activity.

Economic considerations, however, continued to provide a significant rationale for interventionist strategies. Export potential became a focus for the federal government when, in 1986, a report was prepared by Austrade (Australian Trade Commission) for the then federal Minister for Trade, John Dawkins. It recommended introducing export marketing development grants, workshops to improve the professionalism of local musicians and the establishment of an Australian industry representatives panel. The report on the exportability of Australian rock was released on 26 November with Dawkins noting: 'There is a depth of talent in the Australian music industry which, given expert advice and marketing assistance can, I am confident, earn valuable export dollars for Australia as well as expanding employment prospects within the industry in Australia' (Press Release, 26 November 1986).

Rock music had never previously been a consideration in public discussions of export support or mainstream politics, except when providing convenient caricatures and moral targets for politicians. It could be argued that the Labor government, in showing itself prepared to accept the legitimacy of youth culture in its broadest possible sense and rock music's challenge to convention, was prepared to allow a challenge to the hegemony of acceptable sounds while, at the same time, incorporating rock music into the existing capitalist enterprise culture which dominated the industry (Breen 1988a). Certainly, although the scheme to export Australian rock was, in some respects, populist and patronizing, it was in line with other government economic policies. It fitted in well with existing Austrade initiatives directed at assisting Australia's international debt problem and seemed to be a much more engaging prospect into the bargain. As Archie Wilson, the manager of the Austrade music export branch said: 'It's a lot more fun than exporting tractor tyres' (Austrade seminar, 'Exporting to Europe', Sydney, 1989). It was also a policy linked hand-in-glove with the decision to assist rock music within Australia, and was mainly inspired by Kylie Minogue's success in Europe, and by Crowded House, INXS, Icehouse and Midnight Oil's efforts in the US. As such, it manifested the characteristics of interventionist neo-Keynesian economics, geared towards supporting a local industrial infrastructure, while developing export markets that would benefit the country. Other reports looked at the need to intervene at a state level to support localized rock music activities and initiate industry training. They include: *Is the Music Curriculum in Dire Straits?* (Victorian Ministry of Education, 1986); *Getting Started in the Victorian Rock Music Industry* (Youth Affairs Division of the Department of Labor and the Ministry for the Arts, 1988); and *A Strategy for the Development of the Western Australian Music Industry* (Technology

Division of the Technology and Industry Development Authority, 1988).

Whatever their individual shortcomings, the cumulative weight of these various inquiries and reports resulted in a widespread perception that the popular music industry infrastructure needed greater coherence and a clearer structure whereby national economic and cultural interests could be pursued. The prevailing conditions within the music industry – 'classic *laissez-faire* in action' – were no longer judged acceptable (Barnes 1990: 49–50). This created a climate which – with the assistance of active and effective lobbying by former Labor Party MP, Peter Steedman – resulted in the establishment of AUSMUSIC – the national rock music industry infrastructure organization.

In a period in which most industries were being deregulated with a view to internationalizing the Australian economy, this move to regulate the music industry (partially in order to increase its international competitiveness) was bold. AUSMUSIC was established in June 1988 and launched in Melbourne with $600,000 of seed funding from the federal government. Despite some confusion, its primary role was to be an agent for the reform of music teaching and education:

> AUSMUSIC is a non profit industry development organization for the Australian contemporary music industry. It was set up in mid-1988 with a charter to address any issue of consequence to the industry and with a particular mandate to improve education and training opportunities.
>
> (*AUSMUSIC Business Plan* 1990: 4)

AUSMUSIC developed and supported programmes that were linked to the education of popular musicians as well as to future generations of popular music consumers. Courses like 'Roll Over Beethoven' incorporated a schools performance and workshopping programme, explaining the history of contemporary music. This approach represented a radical rejection of music curricula and musicological teaching based on seventeenth- and eighteenth-century classical music. A Music Business Management course at Colleges of Technical and Further Education provided simple, yet otherwise unavailable material for people entering the music industry. 'Fresh Tracks' was an occasional collection of selected demonstration tapes which were packaged and sent to radio stations and record labels in order to generate interest from record labels in new Australian bands, while giving consumers who heard the tapes on radio an opportunity to appreciate that new sounds and ideas were being developed by Australian musicians.

The National Music Day on 24 November 1990 was the first of a proposed annual celebration of Australian music to be held on the fourth Saturday of November each year. *AUSMUSIC 90* featured thirty local

bands, most with established track records, in a nationally televised event of their live performances. Australian radio stations were asked to play Australian compositions and recordings all day, to help foster an awareness of Australian music of all kinds. 'All of this company's activities are aimed at the struggling end of the industry. *AUSMUSIC 90* was not about encouraging new talent. It was about raising money to encourage new talent' (*sic*), said executive director Pete Steedman in defence of the event (Magasanik 1991: 13). The 1990 Music Day was funded by Coca-Cola Pacific Pty Ltd & its Bottlers, which provided $1.5 million (probably closer to $3 million with the addition of all extras, like a summer advertising campaign featuring Kylie Minogue). $0.75 million went directly to AUSMUSIC to assist its programmes (ibid.). The need for this sponsorship derived in part from the fact that, by 1990, the government had required AUSMUSIC to be self-funding and part of the solution was to go to Coca-Cola. This success, however, was short-lived. When the 1991 Australian Music Day was held on 23 November, Coca-Cola did not provide sponsorship. Instead, the corporation was involved in establishing the Australian Music Awards, which were televised nationally on National Music Day. The arbitrary nature of such sponsorship is based on the fashion orientation of popular music's mass appeal. This means that extensive sponsorship programmes can often be generated only as one-off activities, where the sponsor gains maximum exposure from the newness of the event, but will not make a long-term commitment to the project. The possibly contradictory nature of the relationship between Coca-Cola sponsorship of *AUSMUSIC 90* and the federal government's seed funding for the creation of AUSMUSIC is an indicator of the difficulties posed by kickstarting programmes that have to find their own way once government funding stops. The reluctance of the major record companies to support an organization like AUSMUSIC reflects their distaste for government intervention and regulation of the music industry. This is a sub-theme of the complicated relations within the popular music industry, and within the government. For, while government intervention in the music industry has sought to mobilize and legitimize popular and youth culture, such interventions have not been without their contradictions. On the one hand, governments have challenged the conception that popular music is not mediated solely by free-enterprise ambitions, while, on the other, governments have been prepared to require organizations like AUSMUSIC to fund themselves, returning them to the free-enterprise imperative.

Complementing the national role of AUSMUSIC, the various state organizations that have been established in the wake of the mid-1980s inquiries fulfil a localized role. They include: the Victorian Rock Foundation (VRF), The Push and Western Australian Rock Music Industry Association (WARMIA), the South Australia 'Rock Pool', with less formalized Music Industry Associations in New South Wales,

Northern Territory, Tasmania and Queensland. All have direct links with AUSMUSIC, while receiving some programme funding from their state governments. The VRF, formed before AUSMUSIC, was the first of these organizations, with funds from Australia's Bicentennial celebrations in 1988 and a large grant from the State Bank of Victoria. This was a case of the state government providing the pump-priming investment, thereby legitimizing the popular music industry and facilitating (funding) entry for an unlikely newcomer such as the bank. According to its official aims the VRF is:

> to plan, oversee and manage a major festival of contemporary, popular music as a regular event – the Melbourne Music Festival; to represent and further the interests of the contemporary, popular music industry; to promote and enhance Victoria's image as a major centre for the development and production of contemporary music; to assist the development of the industry nationally by programs, projects, promotion, liaison and information exchange with the music industry and relevant government bodies; to demonstrate levels of excellence in Victorian contemporary entertainment.
>
> (VRF 1987)

These objectives are vague, yet ambitious, perhaps in keeping with the unknown potential of the popular music industry for policy-makers. The VRF has also supported suburban activities, such as an annual Ausyrock event, organized by the Croydon City Council, in the outer suburbs of Melbourne. In this area, where youth crime and delinquency have been in serious proportions, the Council also developed the safe train programme. This involved putting a juke box in one carriage and a local rock band in another carriage of a three-carriage commuter train, for the long Saturday night trip to and from the centre of Melbourne. Based on a French programme called *Bon Lei Son*, the reduction in train violence and crime were substantial.

The Push, also based in Victoria, provides high-school age people with alcohol-free environments where they can have the rock music experience of teenage celebration and perhaps rebellion. The Push operates clubs in regional Victoria and Melbourne, where young people put on bands, hold dances, indulge in some rap and meet other young people. It provides access to training, and has under its umbrella the Rock Music Support Service. This service helps musicians get into the industry, offering advice on rental, management and survival. It also provides a career path training which helps new entrants to the industry to avoid its exploitative excesses.

While the above programmes have been created after the election of Labor Party governments at the federal, state and local levels in Australia, the water has been somewhat muddied by recent developments in New South Wales. Australia's most populous state, New South Wales had no policy for popular music until, after the election of a conservative

government in 1988, an arts minister who had an interest in music created a 'Rock Initiatives' programme. In 1990, the New South Wales government thus put together a $50,000 package to support contemporary music. Further initiatives could be undertaken at a national level, following the Prices Surveillance Authority's *Inquiry into the Prices of Sound Recordings* (1990). At the time of writing it is not possible to detail what decisions will be made about the inquiry's recommendations, or the impact of those recommendations on the existing state and federal programmes if they are introduced. However, the most important recommendation in terms of the material discussed above is for a national Music Industry Advisory Council, which would co-ordinate the activities of, and provide continuous funding for, all the organizations discussed here. Such a council would form the final link in the chain, making the Australian music industry work as a unit at a federal, state and local level.

OUTCOMES AND PROSPECTS

The 'defensive cultural wall' argument has held relatively firm as the main basis for government interventions in the music industry in Australia. The transformative intent of such interventions has therefore been limited, leaving governments with the difficult task of intervening in the global music industry while allowing that industry to continue as the primary producer of music. Graeme Turner has pointed out that:

> Cultural policy must be interventionist. In short, the point to having a cultural policy on rock music would not be to work within normal market forces, but to circumvent and subvert them. The result could be that Australia continues to produce, not only consume, its own culture.
>
> (Turner 1989: 6)

Turner's claims about circumvention and subversion are problematic, suggesting that cultural policy should avoid existing systems, while I would suggest that a model involving support for local rock through the regulation of market forces has much to recommend it. Andrew Ross has noted that 'the links between social formations and cultural symbols-in-action' must be seen as part of one world, rather than as two separate spheres, otherwise the latter will spin off into hyperspace without reference to its partner (Ross 1990: 26). In other words, the temptation to avoid the difficult rock music industry and its 'normal market forces' in favour of purer policy solutions would, in many ways, be no solution at all. Nevertheless, the interventionist logic in the Australian context is clear, necessary and sustainable, lest those very market forces overwhelm the local as it attempts to become part of the market.

The debate about economic activity is part of an extended history of

cultural debates in Australia, with popular music joining the fray in the late 1980s. The debates have been based on a struggle by contending class and political interests to define and control economic activities as well as cultural and national identity and in doing so, have set the social agenda. The debates have swung between ALP reformist agendas (with its more radical 'left' branches referred to as the 'radical nationalists') and conservative *status quo* agendas, where arguments about high and low culture are prominent. The result has been a 'cultural war', fought between the offspring of the radical nationalist tradition and the conservative free marketeers. It was no surprise, therefore, that youth policy played an important part in the 1980s ALP's 'party platform' which included moves to intervene in and regulate the Australian popular music industry. The challenge was to find a strategy that would enhance the existing system, while simultaneously attacking it in order to develop, if necessary, a local system to run parallel to and feed off the existing one.

By bringing popular music into the sphere of public inquiries, the ALP shifted the ground from under the high-cultural establishment. In addition, by publicly examining popular music and its relevance to society, it took popular music into the unchartered domain of legitimate cultural activity. Until then the high-cultural arts like ballet, opera and orchestral music had held the cultural birthright to public funding, while the popular arts were considered dirty, self-sufficient and dependent on private enterprise. By requesting the interventions in the form of the inquiries outlined, the ALP did two things: it legitimized popular music, and it mortally wounded the privileged place of high culture in the debate about national identity and culture.

For their part, the regulatory agencies that have resulted from the interventionary inquiries into the music industry in Australia can be seen as manifestations of an Australian style of political culture. A fresh regulatory approach to popular music has been developed, aimed at encouraging the indigenous music industry to flourish in sheltering it from the domination of overseas interests. Importantly, young people have been given opportunities to incorporate popular music into their daily lives through classroom experiences and self-managed entertainment. While the agencies that were created as a result of the federal and state government inquiries grew out of a neo-Keynesian need for regulation based on a pump-priming model of public funding, future prospects for these organizations will depend on tripartite support from the industry and from reformist and conservative political parties alike. Conservative governments, if recent developments in New South Wales are a reliable guide, may break with their hands-off approach to popular music and support the regulatory agencies that have been established while encouraging corporate support as an adjunct to public funding. Although conservatives may disagree with the political economy of regulatory agencies, they may come to realize that agencies

like those established in Australia will have an increasingly important part to play in making culture relevant to young people as well as providing recreational activities for the young.

BIBLIOGRAPHY

Barnes, K. (1990) 'Top 40 Radio: A fragment of the imagination', in S. Frith (ed.), *Facing the Music. Essays on Pop, Rock and Culture*, London: Mandarin.
Beazley, K. (1990) Press Release, Parliament House, Canberra, 20 May.
—— (1991) 'Broadcasting – A Progress Report', 2nd Annual Radio and Records Conference, Melbourne, 22 February.
Breen, M.J. (1987) *Missing in Action: Australian Popular Music in Perspective*, vol. 1, Melbourne: Verbal Graphics.
—— (1988a) 'Music is rocking our export trade', *Herald* 9 June: 15.
—— (1988b) 'Oz rock', *Popular Music* 7(1): 98–100.
—— (1990) 'What defence for *Australian Music on Radio*: pop music quotas and national identity', *Australian Studies* 14, October: 27–37.
Broadcasting and Television (1973) 'Senator McClelland makes it clear – Australian radio for Australians', *Broadcasting and Television* 21 June: 103 and 105.
Crosby, M. (1991) Press Release, Actor's Equity, 14 February.
Davidson, K. (1990) 'Public or private: who does it better?', *The Age* 15 November: 13.
Dawkins, J. (1986) 'Export of Australian Rock Music', Press Release, Austrade, Canberra, 26 November.
Dermody, S. and Jacka, E. (1988) *The Imaginary Industry: Australian Film in the Late 1980s*, Sydney: Australian Film Television Radio School.
Gassner, R. (1991) 'Recession? What Recession?', New Music Seminar Lecture, July, New York.
Gershuny, J.I. and Miles, I.D. (1983) *The New Service Economy: The Transformation of Employment in Industrial Societies*, New York: Praeger.
Gold, S.S. (1987) 'Policy and administrative change in the arts in Australia', *Prometheus* 5 (1): 146–54.
Grossberg, L., Fry, T., Curthoys, A. and Patton, P. (1988) *It's a Sin: Essays on Postmodernism, Politics and Culture*, Sydney: Power Publications.
Kerin, J. (1991) 'Economics with an Irish accent', *The Age* 2 August: 10.
Magasanik, M. (1991) 'Playing smart for local musicians', *The Age* 15 March: 13.
Majone, G. (ed.) (1990) *De-regulation or Re-regulation? Regulatory Reform in Europe and the United States*, London: Pinter Publishers and New York: St Martin's Press.
Ross, A. (1990) 'Ballots, bullets or Batman: can cultural studies do the right thing?', *Screen* 31, Spring: 26–44.
Sinclair, J. (1990) *Imperialism, Internationalism, Nationalism: Advertising*, Australian Studies Association Conference, April, *Australian Studies* 15: 38–46.
Turner, G. (1989) 'Rock music, national culture and cultural policy', in Bennett, T. (ed.) *Rock Music Politics and Policy*, Institute for Cultural Policy Studies, Griffith University, Brisbane: 1–6.
Victorian Rock Foundation (1987) Memorandum Association.
Webb, M. (1990) 'Triple J Goes National: The ABC's Fourth Network', interview in *Communications Update* June: 8, 9, 16.
Young, C.M. (1988) 'Midnight Oil: band most likely to be assassinated by the CIA', *Musician* 122: 82–7.

REPORTS

AUSMUSIC Business Plan (1990), AUSMUSIC, Melbourne.

The Australian Music Industry: An Economic Evaluation (1987), report by Hans Guldberg for the Australia Council, Sydney.

Australian Music on Radio (1986), Australian Broadcasting Tribunal, Sydney.

Getting Started in the Victorian Rock Music Industry (1988), Youth Affairs Division, Department of Labour and the Victorian Ministry for the Arts, Victoria.

Inquiry into the Prices of Sound Recordings (1990), Prices Surveillance Authority, Report 35, 13 December.

Is the Music Curriculum in Dire Straits? (1986), Victorian Ministry of Education, Melbourne.

Music Board Medium Range Plan 1985–1989, Working Papers (1986), Music Board of the Australia Council, Sydney.

The Music Recording Industry in Australia (1978), Industries Assistance Commission, Australian Government Publishing Service, Canberra.

Patronage, Power and the Muse: Inquiry into Commonwealth Assistance in the Arts (1987), Australian Government Publishing Service, Canberra.

The Prices Surveillance Authority: the ACTU, Musicians' Union of Australia and Actors' Equity Summary of Current Position (1991), Australian Council of Trade Unions, 4 March.

PSA Finds Record Prices Excessive: Recommends Structural Reforms/Removal of Import Restrictions (1990), Prices Surveillance Authority, Press Release 54/90, 18 December.

PSA Welcomes Decision by Record Companies to Discontinue Legal Challenge (1990), Prices Surveillance Authority, Press Release 7/90, 2 April.

Report of the Inquiry by the Copyright Tribunal into the Royalty Payable in Respect of Records Generally (1980), Australian Government Publishing Service, Canberra.

Report of the Joint Committee on Wireless Broadcasting (1942), Gibson Committee, Canberra.

A Strategy for the Development of the Western Australia Music Industry (1988), Technology Division of the Technology and Industry Development Authority, Perth.

Young Australians and Music (1985), Australian Broadcasting Tribunal, Research Branch, Melbourne.

6

WHO FOUGHT THE LAW? THE AMERICAN MUSIC INDUSTRY AND THE GLOBAL POPULAR MUSIC MARKET

Steve Jones

INTRODUCTION

Popular music in America in the 1980s and 1990s has been characterized by an increased awareness of non-western music among musicians, music industry executives and music fans. 'World music' is the moniker for recordings employing non-western instruments and/or sounds, and it has become a recognized institutionalized musical category through its use in publications from the industry standard *Billboard* to punk fanzines like *Maximum Rock'n'Roll*. It is difficult to determine just what world music is, and easier to explain what it is not. Groups playing 'world music' such as 3 Mustaphas 3 and Dissidenten have achieved prominence, especially via college radio airplay, as have recordings of eastern European folk music (*Le Mystere des Voix Bulgares* on England's 4AD label is one of the most popular examples), African music (King Sunny Ade, Sonny Okosun), gamelan music, and pop/world music crossovers (Malcolm McLaren's recordings, for instance, or Paul Simon's recent recordings).

Coincident with the birth of 'world music', the American music industry finds itself competing in a global, 'internationalized' popular music market-place.[1] However, the music business has always been international, in so far as licensing agreements (to exploit sales of their investments) existed between record companies in different countries. Corporate acquisitions which place American record companies under foreign corporate control (e.g., Sony's purchase of Columbia's record and music publishing interests), and stiff competition from foreign record labels whose acts dominate the charts (e.g., Virgin Records' releases by Paula Abdul) are forcing a rethinking of the means by which popular music is exploited as an investment with global dividends. The investment is essentially the same as it ever was, represented by the 'song' or 'album'. But the dividends on these investments now come from a variety of sources, including the exploitation

of copyrights in emerging and new markets and the revision of trade agreements. Threats to these dividends come from legislative revisions that inhibit the ability to exploit copyright, and from new technology. Digital audio tape (DAT) and digital sampling open up new areas for exploitation by way of sales of new media and royalty options for copyright-holders, and increase the difficulty of enforcing copyright by making copying quick, easy and private.

It is against this backdrop that American record and music publishing companies (often owned by the same parent company), whether or not they are ultimately owned by corporations outside the US, are partaking in a flurry of legal activity that amounts to a cultural policy by default. That is, as cases involving the music business, trade, copyright, and immigration law are decided, precedents are set which affect the quantity and quality of popular music entering and leaving the US by legal means. The cases are argued, as should probably be expected, largely in terms of their perceived impact on the profit/loss margins of the parties involved, and rarely (possibly never) in regard to their impact on cultural production and consumption.

Additionally, corporate policies which affect the production, distribution and promotion of popular music may likewise be viewed as fragments of cultural policy. However, as with the legal issues to be discussed in this chapter, they too form a fragmented cultural policy dictated by the economics of the music industry, an industry beset by challenges brought about by its internationalization. And, difficult as it is to unravel the interests represented in such legal issues, it is virtually impossible to penetrate to the levels necessary to determine and unravel corporate policies. As a result, this chapter will focus on legal issues arising in the US related to the production, consumption and exploitation of popular music.

Thus far, court cases and legislation have focused on three discrete, though related, fronts: immigration law, copyright law and trade law. An unrelated fourth legal front with which the music industry is grappling in the US is censorship, which will not be considered in this chapter as it is not an issue arising in response to the globalization of the popular music market-place.[2]

POPULAR MUSIC AND THE US IMMIGRATION LAWS

During the 1980s, changes in US Immigration and Naturalization Service (INS) laws made it more difficult for non-US musicians to enter America and perform their music. Opposition to the changes has been scarce, perhaps due in part to the lack of publicity surrounding their adoption (despite prominent notice in a *Village Voice* article in December 1986).

The issue revolves primarily around H-1 work permits for entertainers. In the past, the INS required applicants for H-1 work permits to make their

way through a forest of paperwork and to include documentation (in the form of press clippings, recordings, etc.) that proved the entertainers' 'distinguished merit'. The wording in the INS law has changed, however, so that the term 'distinguished merit' has been replaced by 'pre-eminence'. If distinguished merit was difficult to document (the INS provided no definition of it), at least it had a vagueness to it that allowed broad interpretation. The implication of pre-eminence is that a performer must be popular – for all intents and purposes, a star. According to Char Eberly, who books groups for Sounds of Brazil, a New York club that features Latin American, African and Carribbean music:

> Currently the regulations for obtaining H-1 status are so difficult and time-consuming that many artists/petitioners who qualify are denied. The artist and petitioner become caught in a Catch-22 by factors such as 1) having to prove a level of 'stardom' to bureaucrats who know nothing of international music and its awards, festivals, history, etc.; 2) having to offer proof of advertising, promotion, and publicity before knowing if the artist will be allowed into the country to perform; and 3) having to offer proof of commercial success in the face of a system which makes commercial success extremely difficult to achieve.
>
> (Titus 1987: 9)

Among groups that have been affected by enactment of the new law are Britain's Blow Monkeys, Membranes and New Model Army, West Germany's Bochumer Ensemble, Poland's Stary Teatr, east European folk-jazz ensembles, the reggae group Third World, and countless African performers (among them guitarist Chief Commander Ebenezer Obey). The difficulty faced by those wishing to book those groups in the US is tremendous, since tours must be booked well before the INS bureaucracy grinds out a visa (or grinds to a halt).

The *Village Voice* article correctly placed the origins of the H-1 work permit in a 'union-conscious legislature bent on protecting American labour' (Berman 1986: 34). First drafted in 1952 to allow those with no intention of abandoning their own country to work temporarily in America, the H-1 permit was initially not difficult to obtain. But as the entertainment industry and its unions grew stronger, pressure on the INS to restrict H-1 permits mounted. The 1980s were characterized by music industry pressure on several legislative fronts (the Recording Industry Association of America (RIAA) has even moved its offices to Washington, DC, to be closer to the source of its lobbying efforts). It is not surprising, in the light of such efforts by the industry, that the INS has been subjected to industry pressure, especially when one considers the increase in record sales and radio play accompanying a concert tour. As Steven C. Bell, senior writer and editor of the *Immigration Law Review*, writes:

the US labour market is glutted with persons who seek careers in the various fields of the arts, most of whom are unemployed at any one time, and . . . no occupational field in the United States is more heavily unionized than the entertainment industry.

(Bell 1985: 421)

In fact, the INS has bowed so far to industry pressure that a foreign entertainer coming to the US to promote a recording by making unpaid television appearances must still file for a work permit. According to Bell, the unions 'play a crucial, and even decisive, role in the approval of an H-1 case' (ibid.: 430). INS rules include labour union consultation regarding the very definitions of 'distinguished merit' and 'pre-eminence' the INS is reluctant to make. Bell writes:

The INS regulations . . . state that the INS 'may' consult unions on these issues; INS Central Office policy is clear, however, that 'if there is the slightest doubt that the performer is of H-1 caliber, expert opinion must be requested from the unions involved in the specialty. . . . Consultation is a most important step in the adjudication process . . .'. Only when the foreign national is 'an entertainer of such renown that his name and reputation by itself establishes without any question that he is of distinguished merit and ability' is it unnecessary to seek an advisory opinion from the union . . .

(ibid.: 430–1)

American Federation of Musicians president Lew Mancini, to whom the INS turns in matters of establishing an H-1 applicant's pre-eminence, told an interviewer that he would consider an artist pre-eminent 'If they're showing chart position, and major venues are involved, or I'll recognize the promoter, or the critics' (Berman 1986: 38). One wonders if the Beatles and Rolling Stones would have been allowed into the US had the law been interpreted so strictly in the early 1960s.

Those accompanying an artist (roadies, sound mixers, etc.) are subject to the H-1 rules as well. A work permit category, H-2, allows temporary entry to those who 'perform temporary services of labour, if unemployed persons capable of performing such service of labour cannot be found in this country'.[3] The difficulty arises when one tries to show that there is no one in the US who is capable of performing a specific service.

Since the musicians' union is exclusively consulted by the INS in these matters, ultimately it is the union that really runs the show, collapsing issues of artistic merit into ones of commercial control or, at the very least, equating issues of artistic merit with commercial success. Access to live performance before an American audience is determined by union executives whose experience of music (as performers and audience members) may bear no relation to the music of those seeking work permits.

Moreover, if the final revision of INS law goes into effect, these issues will be further confused by quotas 'limiting to 25,000 the number of annual visa applications from nonsuperstar musicians, athletes and dancers' (Holland 1991a: 1). Making the limit more problematic is a revision requiring individual members of orchestras, dance troupes, ballet companies, and the like, to file for visas. In the past, one visa admitted an entire ensemble. Whither artistic merit for application number 25,001?

The greatest fear among US booking agencies and record companies is that the final revision of the INS law will provoke retaliation from other countries' unions and immigration services. The manager of several non-US rock and reggae acts said the INS

> is going to create a cultural trade war. It could cut domestic rock musicians' income in half by preventing them from traveling outside of America to earn money. The Dutch, the French, and the Canadians are already upset about this.
>
> (Verna 1991: 77)

In an era characterized by the continuation of Reaganite and Thatcherite policy, it is not surprising to find that trade unions in the United Kingdom and US have a reciprocal agreement. Union officials from each country keep track of performers to ensure that equal numbers are 'exchanged' (Deutsch 1987: 213–14).

The final revision of the INS law was not in place as of August 1991. It had been scheduled to take effect on 15 April 1991, but implementation was delayed until late 1991, due to review by the US Office of Management and Budget. Instrumental in that review are the RIAA, American Federation of Musicians (AFM), and American Federation of Labour (AFL). The RIAA is arguing for an easing of visa restrictions, the AFM is arguing for the continuation of current INS law (despite INS assurances that the AFM will be consulted under the new law as it was under the old), and the AFL is arguing for tighter restrictions on visas. The RIAA, recognizing the recording industry's need to compete globally, may thus be in for a direct confrontation with labour unions, an interesting comment on the decentring of the US as the dominant player in the production of popular music. Given such a shift, the visa struggle is less a struggle of music producers, and more a struggle of music 'distributors' striving for access to the American audience.

In many cases recently, the only means for a foreign artist to come to the US has been under the guise of a tourist visa. But it would not be surprising to find that modern recording techniques such as multitracking are being used to bypass the INS – it would be difficult to deny entry to a tape recording or a sample of an African singer, or a French horn section, for instance, sent to the US for additional recording, or for use during a performance. Indeed, such technology creates legal problems of its own.

TECHNOLOGY, MUSIC AND COPYRIGHT

Authorship, uniqueness, reproducibility and a host of other issues preoccupy business and legal transactions in the music industry. Within that framework, copyright has traditionally been regarded as an author's protection against the copying and pirating of music. It has also been a means for record companies and music publishers, who usually own the copyrights to songs, to insure income during periods of low sales, and to control the manufacture and distribution of recordings. Copyrights are bought, sold and exploited via licensing fees and royalties. New technologies that enable a diffusion of authorship and ready reproduction are making traditional copyright protection obsolete.

The United States government has provided a means of copyrighting music since passage of the Copyright Act of 1909. In 1972, an amendment to the Copyright Act provided for copyrighting of 'sound recordings'. Four years later, the 1976 Copyright Act provided copyright protection for both published and unpublished sound recordings. The 1976 Copyright Act defines sound recordings as:

> works that result from the fixation of a series of musical, spoken, or other sounds, but not including the sounds accompanying a motion picture or other audiovisual work, regardless of the nature of the material objects, such as disks, tapes, or other phonorecords, in which they are embodied.[4]

The most recent and best-publicized controversy over copyright concerns home taping of records and compact discs. The recording industry claimed that millions of dollars in sales and royalties were lost to home tapers who copied LPs on to cassettes for friends, or for resale (such piracy is commonplace in many parts of the world, especially in Asia, and the recording industry has organized teams of attorneys to aid law enforcement officials in anti-piracy efforts). Though beginning in the late 1970s, when the recording industry's sales slumped, copyright issues have taken on altogether new meanings with the development of digital recording and DAT. The problem was one inherent in digital recording of any sort – how to protect a product that is simultaneously creative and unique yet by definition copyable? Whereas analogue cassettes produced a noticeable loss of quality with each copy, digital recordings are free from such degradation. Currently, there exists a Serial Copying Management System (SCMS) built into consumer (but not professional) DAT recorders, inhibiting digital-to-digital copying. Analogue-to-analogue copying is not prevented, though, and since DAT offers such high-quality reproduction, many analogue-to-analogue copies can be made without significant loss of fidelity. In addition, development of the digital compact cassette (DCC) and optical mini-disk

mean new digital formats that present potential for copying and piracy.

The RIAA is currently funding research to invent a system that will prevent analogue-to-analogue copying using digital recorders. It has dropped its efforts to seek a tax on analogue audiotape and analogue recorders, a move that led to a recent agreement with the Electronics Industry Association's Consumer Electronics Group (EIA/CEG). The EIA/CEG has been at the forefront of groups opposed to RIAA-sponsored legislation in the US Congress seeking a tax on blank tapes and audio recorders to make up for revenue allegedly lost due to home taping. The EIA/CEG has agreed jointly to seek legislation with the RIAA 'requiring the hardware companies to pay [record] labels a royalty on blank audiotape and digital recording equipment to compensate for sales lost to home taping' (Holland and Nunziata 1991: 1). The agreement has led to legislation establishing a tax and royalty structure on digital recording formats. The EIA/CEG is attempting to encourage record companies to provide 'software' for its new digital audio products, and the RIAA is creating a new source of income for its members, estimated to be at least $100 million a year divided and distributed as follows:

> a detailed payment plan . . . channel[s] future royalties into two basic funds: one for performers and owners of the copyright in the sound recording, and the other for owners of the musical compositions. The two funds would be further broken down into the following percentages: 38.41% to record companies, 25.60% to featured artists, 16.66% to songwriters, and 16.66% to music publishers; 1.75% to the American Federation of Musicians for non-featured musicians; and 0.92% to the American Federation of Television and Radio Artists for nonfeatured vocalists.
>
> (ibid.: 80)

Passage of so-called 'tape tax' legislation came about because the most vocal and influential groups on each side have been reconciled. For the consumer this may mean an increase in the price of audiotape and recording equipment. For the industry it will mean a new, and large, source of income based on the exploitation of copyright by way of royalties.

Masked by the publicity surrounding home taping and copyright legislation, little has been made public about the nature of the problem facing copyright protection – the ownership of sound. Electronic instruments have enabled the creation of unique sounds, some by a very labour-intensive process, and the programmers and musicians who create the sounds are keeping close watch on copyright matters. The issues can roughly be divided into two categories, sampling and synthesis.

Samplers such as the Fairlight, Akai S900 and many others permit recording of sound events and subsequent manipulation and playback via a

keyboard. Thus a musician can sample the drum sounds from a recording of Turkish drumming, for instance, assign one drum to one key of the keyboard, another drum to another key, and so on. This of course does not mean that the musician can then play drums like the person on the recording, but he or she can achieve the same sound, and that is of crucial importance.

Andrew Goodwin (1990) and Simon Frith (1988) have accurately placed issues of sampling and copyright within the larger context of what Frith calls the 'industrialization of music'. The process of the technologizing of popular music must be understood within the history of the economics of the music industry, in the context of the evolution of property law and copyright.

Two forms of copyright can be filed for a published (i.e., publicly released) recording: a 'circle C' which denotes a copyright of a musical composition, and a 'circle P' which denotes copyright of a sound recording. As synthesist and programmer Bryan Bell has said, 'The circle P copyright is for the whole record album. The musical copyright is eight bars or whatever it is. The circle P is for anything that's on there for any amount of time. Sounds included' (Bell 1987). One can sense the joy of record company executives who became involved immediately. In general, the 'circle P' copyright is owned by the record company; will record companies claim ownership of sounds and samples? Considering the 'work for hire' clause in US copyright law (which allows an employer to claim copyright for any work done by an employee), it is likely.

It is also likely that the increased appearance of non-western sounds on US pop records (everything from chanting monks to tambouritzas) is due to sampling. Prior to the sampler, only a select group of pop stars (most notably the Beatles on their Indian-influenced recordings) were able to afford hiring session musicians to play exotic instruments. Such instruments are now, for the most part, but a floppy disk away.

Naturally, similar sounds can be achieved by synthesis, and one must ask if there is a difference at this point between a synthesized sound and a sampled sound if they sound the same. Given the difficulty in distinguishing the sound aurally, does it make sense to claim copyright infringement by sampling only? If we are to consider copyright infringement of a sound, should not synthesis be considered a means of infringement?

Again, issues of labour and income come to dominate the discourse concerning copyright. Reggae groups, for instance, use backing tracks dozens of times for different songs. These forms of 'versioning' are widespread. How should copyright be established in these cases? Wallis and Malm (1984) note that in many Third World countries, musicians record backing tracks that are used by producers for overdubbing singers and other instrumentalists. David Toop suggests that part of the reason for the use of backing tracks is economic. 'Versions are obviously a convenient

way of making records, as most of the ideas have already been worked out in the original' (Toop 1984: 111). US record companies argue that since they've paid for the original, which is now being re-used, some licensing set-up is in order. But this problem has not been solved in any routine, consistent fashion. Instead, when a group uses a sample from a previously released recording, it pays a percentage or fee to the copyright-holder. The trend is toward following guidelines established for compulsory licensing. If a recording has been publicly released it can be re-recorded, with a mandatory mechanical royalty to the copyright-holder. Mechanicals can add up to a large sum, as shown in the case of pre- and post-reunification Germany. Since reunification, all of Germany is covered by western copyright conventions. The German authors' rights society, GEMA, reported a $53 million increase in revenue (for a 1990 total of $478 million) in the first year after reunification (Spahr 1991: 2). In cases concerning obtaining permission to use a sample, negotiations are conducted on a case-by-case basis – sometimes after the release of a recording using a sample.

As copyright laws become more alike from country to country, and as new markets are exploited to their fullest, copyright-holders will seek new means of exploiting rights. Copyright has less to do with authors' protection and the establishment of an 'authentic' original and more to do with profit. New media like DAT and DCC not only allow increased income from sales of fifteen existing products in new formats (as the CD did) but also they generate income from mechanicals and will soon produce royalty income derived from hardware taxation.

Record companies have long recognized the importance of copyright as a means of producing income, and the RIAA is very actively engaged in international lobbying to bring copyright legislation to as favourable a position for copyright-holders as possible. In 1991, the RIAA was instrumental in the passage of new legislation in Mexico that revised that country's copyright law and may earn record companies some $75 million a year (Holland 1991b: 8). New legislation in Japan extends copyright protection in that country from thirty years to fifty years, and prohibits rental of recordings for one year from their release. It is estimated that the new law may gain record companies up to $1 billion annually (Clark-Meads and Holland 1991: 1). Copyright is clearly a high-stakes enterprise, and a source of income the importance of which may eventually rival that of record sales.

However, based as it is in property law, issues of authenticity and authorship still form the foundation of western copyright law, and therefore a revision is necessary before it can cope with new technology. A recent decision by the US copyright office to treat 'colourized' versions of black-and-white films as 'derivative works' if they show 'a minimum amount of individual, creative, human authorship'[5] may set a precedent for music copyrighting. It is possible that some minimum alteration may be

set, beyond which a song may be considered at least derivative if not original. The difficulty is in implementing such a limit. Copyright infringement cases are usually decided by jury trial. Could a tribunal of some sort be set up, a kind of audio Supreme Court, at which recordings are judged as copies, derivative or original? This is, of course, highly unlikely. And what of the precedents that have been set, the dozens of rock songs that derive from 'La Bamba', 'Louie Louie', 'Wild Thing', that use the same three chords, that exist as quite separate entities both in the eyes of copyright law and of the audience?

Since development of sound recording has reached a new technological level, record company attention is shifting to questions such as these – ones involving sound playback and related copyright considerations. The use of digital recorders, compact discs, DAT, hard disk drives and the forthcoming recordable CD is based not only on fidelity and mass storage, but also on rapid recovery of sound as well. Recording without playback is, for all intents and purposes, senseless, and it is playback and not recording that is, in the final analysis, of concern to copyright owners.

THE IMPORT BLOCKADE

With the discussion of sound and copyright as a background, it is possible to consider two cases regarding importation of sound recordings with US copyrights that threaten to block the availability of many recordings issued by non-US labels. The cases set a precedent for blocking importation of recordings (legally licensed for manufacture and distribution abroad) whose copyrights are held by American record companies.

In the first case, *Columbia Broadcasting System Inc.* v. *Scorpio Music Distributors Inc.*, decided on 17 August 1983, the court held that 'phonorecords manufactured abroad and imported by a third party intermediary without the consent of the copyright owner constituted unlawful importation of phonorecords under section 602 of the US Copyright Act . . . "importation" infringed the plaintiff's copyright in the phonorecords' (Sloane and Thorne 1986: 69). The second case, *Harms Music* v. *Jem Importers*, decided 26 March 1987, upheld the copyright of a music publisher against the importation of sound recordings containing the publisher's copyrighted songs. Out-of-court settlements between major labels and import distributors followed these cases.

Each case deals with what is commonly referred to as 'parallel imports', and they have had a chilling effect on US importers. Lawyers advised importers that:

> the prudent United States purchaser of phonorecords from abroad
> would have determined, before entering into a purchase agreement,
> the nature and extent of any American copyright owner's rights to the

phonorecords at issue. Since Scorpio Music, however, such a deter-
mination would be wise not only with respect to purchases from
abroad but also purchases within the United States because of the
possibility that the domestic purchaser would be found to be acting
within the chain of importation and deemed a contributory infringer.

(ibid.: 73)

Ostensibly, major labels and music publishers perceived a threat to their
profit margin created by importation of recordings that had been manufac-
tured more cheaply outside the US. It is more likely, however, that they
reasoned that US consumers had a limited budget for their products, and
that budget was stretched too thinly when imports were available to
consumers. Though unable to halt completely the importation of records
into the US, they damaged the importers to a greater or lesser extent.
Along the way they damaged the US independent record labels, as US
distributors (Caroline, Important, JEM, Rough Trade, Twin Cities) act as
importers but also generally stock 50 per cent independent label releases.
US independent labels have had a difficult time getting paid by distributors
anyway, and any financial difficulties placed on the distributors make their
way to the independent labels.

Record importing has never been an easy task to begin with. Import
duties on records are relatively high, and unlike printed materials, records
are not treated as perishable materials. It also takes some time for a
shipment of records to clear customs, all of which, in a market where
timing may be all-important, creates problems for the importer. According
to Andrew Graham-Stewart at Caroline Imports (one of the importers that
settled with a major label):

> The volume of imports is down, probably by 65–70%, and if we now
> are required to get a license from a US publisher in order to bring in
> 10, 15 or 20 copies of a particular record, it just isn't worth it. The
> traditional publishing houses have made it quite clear, so far, that
> they will absolutely enforce their legal rights. . . . The market is now
> limited to UK acts who write their own material and who have not
> signed a publishing deal for the US. . . . The implications, particu-
> larly for the UK independent record labels, must be seen as very
> serious indeed, given that a reasonable proportion of their income is
> derived from exports, particularly to the US.
>
> (Dunkley 1987: 10)

The implications are great for fans of hard-to-find American music that is
released by European labels such as Charly, Ace, Demon, and Pathe-
Marconi. In Europe there is a great appreciation for jazz and blues records
that have long been deleted from the catalogues of US record companies –
but whose copyrights those companies still hold. Presumably the average

person in Europe will be able to buy records by American artists that the American public will not have access to.

Emphasizing the multinational nature of the record industry, Warners, Sony and PolyGram have begun attempts to limit recordings exported from America by US distributors. A weaker dollar means that foreign wholesalers may purchase recordings from US distributors and have them shipped overseas for less than it costs to purchase them from the international arms of major labels. Such a practice weakens the profit and position of the non-US branch of the label. Though there has yet to be any testing of legal waters (and indeed there may not be legal recourse for the labels, as it is not in their power to create and enforce an international trade restriction), it is clearly a policy among the major record labels to monitor and ensure that their business is functional and profitable on a multinational level.

CONCLUSION

The issues presented here combine issues of artistic quality or merit with commercial success and corporate control.

One can perhaps understand the protectionist nature of these legal challenges by viewing the American music industry in the context of the global popular music market. Record sales may have increased overseas, but royalty payments on publishing and licensing become more difficult to obtain, and often they are divided among foreign copyright holders. Since a vast portion of a record company's income is from publishing and licensing, it is not surprising to see industry concern about record importation, foreign acts performing in the US, and so on. Such concern stems from an awareness of the profitability of exploiting markets by efficient, favourable and profitable use of copyright ownership.

The technology of popular music production is partially to blame for the record industry's mobilization of its legal forces, as it has changed the economics of the recording industry. In addition to a shift away from the US as the dominant player in the music business and toward an oligarchical multinational corporate structure, the concept of copyright has been turned on its head by digital sampling, non-US musicians' popularity has turned the heads of union leaders, and the success of imported recordings has prompted US record companies to retaliate.

As with all high-stakes legal wrangling, the likelihood of a win-win outcome is minimal. The lesson learned by the RIAA (and, by extension, the US record industry which it represents) appears to be the understanding that to achieve commercial success in the music business it is necessary to be less in the business of music and more in the business of business.

NOTES

1 I use the term 'internationalized' to mean the inclusion of non-western sounds and music in western popular music, the growing popularity of non-western music among popular music fans, and the growth of the music business into an industry dominated by transnational corporate interests. It is not intended to mean the exportation (exploitation) of western popular music to (in) Third World and other countries. The term 'popular music' is taken to include forms such as pop, rock, rock'n'roll, etc.
2 For information concerning censorship and the US music industry see S. Jones (1990) 'Ban(ne)d in the USA: popular music and censorship', *Journal of Communication Inquiry* 15(1), Summer: 5–20.
3 All references to the US Immigration Reform Act are from Section 101(a)(15)(H)(ii) of the United States Immigration Reform and Control Act of 1986 and subsequent congressional revisions.
4 All references to US copyright law are based on the 1976 Copyright Act of the United States of America 17 U.S.C 101 and subsequent congressional revisions.
5 Associated Press wire service report, 21 June 1987.

BIBLIOGRAPHY

Bell, B. (1987) Telephone Interview, 9 June.
Bell, S.C. (1985) 'Special procedures for the entry of alien entertainers', *1985 Entertainment, Publishing and the Arts Handbook*, New York: Clark Boardman Company Ltd.
Berman, L. (1986) 'Foreigners need not apply', *Village Voice* 30 December: 34–8.
Clark-Meads, J. and Holland, B. (1991) 'Japan boosts copyright protection', *Billboard* 11 May: 1 and 85.
Deutsch, H.D. (1987) *Employer's Complete Guide to Immigration*, Paramus, New Jersey: Prentice Hall Information Services.
Dunkley, A. (1987) 'Give me back my imports!', *Rockpool* 19 June: 10.
Frith, S. (1988) *Music For Pleasure*, New York: Routledge.
Goodwin, A. (1990) 'Sample and hold: pop music in the digital age of reproduction', in S. Frith and A. Goodwin (eds), *On Record*, New York: Pantheon.
Holland, B. (1991a) 'Tighter visa rules bad news for biz', *Billboard* 8 June: 1 and 86.
—— (1991b) 'New Mexican law recognizes US copyrights', *Billboard* 20 July: 8.
Holland, B. and Nunziata, S. (1991) 'Duping royalty pact signals new era', *Billboard* 20 July: 1 and 80.
Sloane, O.J. and Thorne, R. (1986) 'International aspects of United States copyright law: the music business', *1986 Entertainment, Publishing and the Arts Handbook*, New York: Clark Boardman Company Ltd.
Spahr, W. (1991) 'Mechanical-license income boosts GEMA to record year', *Billboard* 8 June: 2.
Titus, P. (1987) 'Issue by issue', *Option* September/October: 9.
Toop, D. (1984) *The Rap Attack: African Juice to New York Hip Hop*, London: Pluto; Boston: South End Press.
Verna, P. (1991) 'Fed quota law on visas may limit overseas acts', *Billboard* 15 June: 2 and 77.
Wallis, R. and Malm, K. (1984) *Big Sounds From Small Peoples*, New York: Pendragon Press.

Part II

BROADCASTING: MUSIC, POLICIES, CULTURES AND COMMUNITIES

INTRODUCTION

Popular music scholars have long realized that the music and broadcasting industries have a 'symbiotic' relationship (to use Paul Hirsch's term). In some respects it seems misleading even to treat them as separate media. The history of commercial radio is the history of music radio; the meaning of music radio is the meaning of the pop record. There are, indeed, twentieth-century music genres that are inconceivable without radio (crooning, rock'n'roll), just as there are musical genres which were shaped by their unfitness for broadcasting (reggae, house). At the same time, institutionally, the radio industry has never really been controlled by the music industry; the music industry has never really been dominated by broadcasting interests. The two industries are at once mutually reliant and mutually antagonistic; their relationship might be best characterized as mutual exploitation. In political terms, what makes this interesting is that such exploitation is regulated, one way or another, by the state. In as far as governments have a popular music policy, that is, it is invariably an aspect of broadcasting policy (so that both the UK and Canada, for example, now have legal definitions of 'pop' and 'rock' enshrined in their Broadcasting Acts).

From the listeners' perspective, then, radio has a somewhat ambiguous place in pop pleasures. It is both our access to music (to new records in particular) but also, in consequence, often seems rather to block access to the unknown or unexpected. Rock historians both celebrate radio (rock'n'-roll radio, pirate radio, college radio) and denounce it (Top 40, Radio 1, Golden Lite). In either case the assumption is that radio is essentially a secondary medium; first there is music, then there is a means of transmitting it. This common-sense view has, in turn, informed more academic accounts of the 'symbiotic' relationship involved – sociological studies of the recording industry begin with the organization of record production and consumption; radio is discussed alongside the other 'promotional' media (cinema, TV, the press, etc.).

The four chapters that follow challenge this common-sense view. At first reading, the implication is that the radio/music relationship has changed

for specific historical reasons – shifting demographics; the deregulation of broadcasting; the challenge of video promotion. Whatever the causes, there seems to be an agreement that we are at the end of something: Line Grenier (in Quebec) writes of 'the twilight of the popular record era'; Graeme Turner (in Australia) reports on 'the death of teen radio'; Roger Wallis and Krister Malm (in Sweden) consider the consequences of the dissolution of 'state monopoly radio'. What is of immediate interest, however, is Jody Berland's suggestion that what's involved here, as in her own Anglophone Canada, is not an ending, but another technological moment of cultural politics. Perhaps, then, we should reread the past; perhaps we (we academic analysts, that is) have got the radio/music relationship wrong.

Consider it this way: perhaps radio was always the primary medium – the commodity experience we (we rock fans, that is) consumed, music simply a means to that consumption. Put it another way: it was not the music which gave meaning to music radio, but music radio which gave meaning to the music. In examining the recent effects of format radio in Canada, Berland raises far-reaching questions about the experience of music radio, its organization of listeners' sense of space and time. Three of her questions are particularly pertinent for this book.

First, Berland points to the paradox that for commercial broadcasters the great advantage of playing records is that *no one listens to them*! We may hear them, but we can do so while driving, reading, cooking, talking, working, etc. Our attention is only needed for the messages in-between. For the radio listener, music's importance rests on its unimportance.

Second, Berland notes the peculiarly limited notion of the 'local' in local broadcasting (and again her arguments here are as applicable to the US or the UK as to Canada). There are local traffic reports, local weather bulletins, local advertisements, but there is no 'local' music. In Britain this means that one travels around the country hearing exactly the same tracks organized in exactly the same sequences on 'independent local radio' stations (there is as yet no national commercial station). These broadcasters subscribe to identical musical ideologies wherever they are located (and these days are increasingly organized as centrally owned chains anyway). In Canada the issue is to what extent 'Canadian' music stations should be obliged to play Canadian music (the issue discussed in detail by Line Grenier).

Third, Berland suggests that format radio makes explicit the underlying attitude of all commercial broadcasters: they are not in the business of meeting the demands of a music-loving audience already out there; they are in the business of putting together a radio-listening audience for advertisers and of using music to define their 'demographic'.

Berland roots the 1980s formatting of Canadian radio in two processes: privatization (as public service requirements were eased) and the 'natural-

ization of technological change', the way in which radio translates corporate strategy – shifts in the means of musical production and circulation – into the everyday banality of a DJ's chatter. The radio voice is friendly, the radio listener is neighbourly, and radio music itself is increasingly an abstract sound coming from no specific time or place at all.

This is the argument taken up in different ways by the remaining authors in this section. Line Grenier examines the effects of formatting on the relationship between broadcasters, the music industry, and the state in Quebec. Her essay focuses on the 1989 hearing of the Canadian Radio-Television and Telecommunications Commission (CRTC) which led to the 1990 regulation 'that at least 65 per cent of the vocal music played weekly by all Francophone AM and FM radio stations, irrespective of format or market, must be French-language song'.

Again, the 'local' arguments between the trade organizations of the broadcasting and music-related industries had a resonance beyond their immediate context. To begin with, as Grenier suggests, even a local music industry is ambiguous about the cultural weight of the term 'local', both wanting to protect its 'local' market from multinational competition while, at the same time, trying to come up with 'local' products that are competitive internationally. Local radio is thus faced with contrary demands: to play local music, but in a context – a format – that reflects its 'global' appeal. Local music-makers do not want to be labelled as local music-makers.

At the same time, the 'product' at issue in the CRTC hearing, the single record, is increasingly only in demand from radio stations anyway, which means that broadcasting outlets are becoming ever more significant sources of financial return from the ownership of musical rights – except in the dance music field, there is now no point in marketing a single except for airplay; there is no 'alternative' demand which radio is failing to meet. The single has become a purely promotional tool, designed as a radio (or video) slot, a commercial for a star or album, no longer in itself an object of desire.

The 'agreement' reached by the CRTC in its 'conciliation' of different music interests was, therefore, misleading. For the CRTC itself, the over-riding public service demand is to ensure that audience 'needs' are met and to preserve local culture, and, from its point of view, these ends are clearly also in the interest of Québécois broadcasters and record companies. From the point of view of the broadcasters the problem is the availability not of Francophone records as such, but of Francophone records 'compatible with the sound of the station'. The audience that matters is the radio audience, not the record-buying audience, which implies both that a Francophone service doesn't need to prove its 'Frenchness' by playing French-language records (and certainly not Québécois records) and that French-language records should be made to fit radio formats anyway. From the point of view of Québécois record companies, a locally flourishing

music industry is clearly of central importance to Francophone culture. But whether a flourishing music industry now means a radio single producing industry is a moot point.

Grenier suggests that the CRTC takes it for granted (like most sociological studies) that music's commodity and cultural forms are integrated in the single recorded song – its sales, its airplay, its 'popularity'. But the evidence at the CRTC hearing (and in the other chapters in this book) is that the popular record or single song system no longer works – which is one reason why music radio no longer seems to be a dynamic medium.

Graeme Turner comes to the same conclusion from a different starting point: the history of teen radio in Australia. The Top 40 format, he notes, dominated the country's airwaves from the 1950s to the mid-1980s; by late 1988 'there was not one Top 40 station serving the teenage audience in any Australian capital city'.

Like the other authors here, Turner locates one reason for this in policy change, in the centralization and rationalization of media ownership in Australia which followed the introduction of commercial FM in 1980: 'to all intents and purposes music radio in Australia is now AOR FM'. Competition for listeners and advertising revenue leads inevitably to more 'adult' programming for both demographic and logistical reasons: FM advertisers need older, more affluent listeners than Top 40 stations; the FM audience is organized, packaged and measured by techniques which subordinate playlists to market-research findings.

The most obvious feature of music radio in the 1980s in Britain, the US, Canada and Australia alike was the rapid growth in the percentage of airtime devoted to 'oldies' or 'classics', to the teenage music of the grown-up listener. For the record industry, the result was a marketing crisis. For thirty years or more the 'new' had been sold via its teen appeal; now the 'new' couldn't be sold at all. From Turner's perspective the cultural implications are stark: 'teenage' music (as an ideological rather than chronological category) described that element of popular culture which worked in one way or another as grit in the system. By the end of the 1980s this 'teenage niche' on commercial radio had been 'expunged'.

Berland, Grenier and Turner all suggest a historical model in which a policy change (the deregulation of broadcasting) subjects both radio and recording industries to an inexorable economic logic. Roger Wallis and Krister Malm (drawing primarily on Swedish and other European evidence) give this argument both schematic and polemical substance, claiming that radio privatization inevitably leads to a process of streamlining, networking and take-over. They are concerned, that is, to challenge the notion that to deregulate broadcasting is to increase broadcasters' 'independence' and listeners' 'choice'.

They make the simple point that the amount of radio listening time available in a country is finite. If more outlets mean more competition, in

an advertising-funded system this must mean the losers going out of business. In practice, they suggest, the rise of commercial radio in Europe has meant the decline of musical choice; in Sweden (as in France and the UK), to choose between commercial channels is to choose between ever finer gradations within an ever narrower range of sounds; to listen to commercial music radio is to listen only to records, as public service support of live performance and commissioned work is abandoned. Even so-called specialist or 'minority' music services are compelled to follow the same programming formulas. In Britain, for example, Jazz FM, the 'incremental' London commercial service, had dropped any attempt to play adventurous or difficult music within a year of its 1990 launch. Its output became a simple rotation of 3–4-minute 'jazz-influenced' tracks, its sound another version of AOR FM. Meanwhile Classic FM, Britain's first national commercial 'non-pop' service (on air from late 1992) plays 3–4-minute extracts of 'easy' classical music.

Wallis and Malm are the most uncompromising economic logicians here, but they do conclude with the observation that good records are made *despite* radio's constraints and, indeed, often as a challenge to them. We would add three comments to this.

First, it is worth noting that none of the essays in this section is about or from the US. Indeed all deplore the commercialization of radio as, implicitly, its Americanization – the US is seen as the source of formatting, call-out research, demographic marketing, etc. In the US, it seems, 'public service' requirements have never been significant. And yet for all the obvious turgidness of contemporary US format radio, there have been moments when and places where American music radio has had a vitality and impact never realized by state broadcasting systems. What was special about those circumstances? When do market forces work?

It should therefore be stressed, second, that the writers here are not, in the end, talking about radio determining musical meaning; rather, they are describing an important condition of popular music's existence. Furthermore, to condition creativity is not to destroy it; at any moment new musical sounds and new broadcasting forms can and do appear in the system's cracks and fissures.

Finally, we should not, then, overrate radio's power. Most music is never broadcast; most music listening is not radio listening. The most significant popular sounds of the last ten years, for example, rap and house, were *not* radio forms. Perhaps, then, the rock era, for which all these authors seem to be writing an obituary, marked a coincidence of interest not so much between broadcasters and record-makers, as between broadcasters and record-buyers, a coincidence of interest now realized nostalgically as we listen to radio to remind ourselves of when it mattered. For pop fans who are not from Top 40 or Rock FM generations this must indeed seem an unusual way of listening: who on earth would turn on the radio to hear anything *new*?

RADIO SPACE AND INDUSTRIAL TIME: THE CASE OF MUSIC FORMATS[1]

Jody Berland

RADIO AS A 'SECONDARY MEDIUM'

In the broadcasting industry, radio is commonly referred to as a 'secondary medium'. The phrase conveys the pragmatic view that no one cares whether you listen to radio so long as you do not turn it off. Since it was displaced by television, radio has been expected to accommodate itself technologically and discursively to every situation. Are you brushing your teeth, turning a corner, buying or selling jeans, or entering inventory into the computer? So much the better. Your broadcaster respects the fact that these important activities must come first. Radio is humble and friendly, it follows you everywhere. In any event, television makes more money.

This denigration of radio's potential in the guise of demographic pragmatism arouses my suspicions and my sympathy. Canadian history has long been shaped by a perceived affinity between the politics of radio and the possibilities of culture. They are bound up together by debates about the media and the nation-state, which originated with radio in the 1920s and continue unabated to the present; by influential critical analysis of the role of technologically and spatially mediated communication in the building of empires; and by continuous political and legislative crises, mainly focused on the broadcast media, concerning the possibility of lasting cultural difference in North American culture. In addition, and perhaps in response to all this, there is a popular myth that Canadian radio is the best in the world. I ascribe to it myself on most days.

But as the airwaves fall victim to the politics of privatization, radio is becoming progressively more 'popular'. Programming is defined by more and more sophisticated processes of audience research; it is increasingly framed by cross-media corporate strategies designed to cut costs, and to reach across ever-expanding space; and it is increasingly built around music formats. This 'popular' radio hopes that more people will listen, but not really. Format radio depends on distraction for its existence. Its primary goal is to accompany us through breakfast, travel and work without

stimulating either too much attention or any thought of turning it off. In this respect it is mutually interdependent on the daily life for which it provides the soundtrack; more specifically, it is designed to harmonize all the contradictions of domestic and working life that radio could illuminate and transform.

The radio text is heard across all the institutional, social, solitary and mobile corners of urban and rural experience. It leaves no one untouched. During an average week, 94 per cent of Canadians listen to radio at least once, and on average for nineteen hours; 95 per cent of this listening takes place as a secondary activity (Statistics Canada 1990: 1). This is fewer hours than we devote to television, but the more time we spend in cars (a salient issue, given recent cuts to rail service and public transport), the more time radio may be able to claim from us. (But will it? As new cars come equipped with increasingly sophisticated stereo cassette and portable CD players, and as teens opt for tapes over radio, is this radio making itself obsolete? This is more than a technological issue, as the following discussion suggests.) Almost 90 per cent of radio listening time in Canada is now claimed by commercial radio. This cumulative success of commercial radio would have been inconceivable without music; music is indispensable for its schedule, its income and its listeners.

The assumption that more or less continuous music is the ideal programme content for radio rests on the equally convenient assumption that radio listeners are mainly not listening very closely and that this is the 'natural' condition for radio communication. Thus the flow of music/commercials/talk offered by format radio has become inseparable from the mental image of wallpaper which shadows the concept of 'secondary medium'. This concept distinguishes radio from television on the basis of its mobility, ubiquitousness and habitual presence in work and other social contexts. The phrase 'secondary medium' forces us to remember that radio programmers, industry analysts and government researchers know very well where we are and what we are doing while we are listening to a particular station. It usefully reminds us that radio's role as carrier of recorded music is not determined solely by radio's (non-visual) technological capacities, but is equally a product of the radio apparatus as a social, institutional and economic entity that depends on the music industry for its own reproduction. At the same time, it should remind us – appropriately, perhaps, since this role is now declining – that the critical emphasis on radio as a promotional vehicle for records has tended to simplify our understanding of its complex nature.

The close identification of music and radio arose in the 1950s, when, in response to TV's dethroning of radio in the living room, records came to form the principal raw material of radio programming. Since TV took over not only radio's domestic space but also many of its entertainment conventions, the industry had to devise new programming and commercial func-

tions (as well as more mobile technologies) for radio. The record/DJ format arose partly because it was cheaper (no scriptwriters, union fees, sound effects, etc.) and partly because it attracted a new market of listeners – teens – who could be delivered to advertisers through radio rather than television. Music now provides well over 50 per cent of all radio airtime. Even the partial usurpation of music marketing by videos has not challenged radio's reliance on recorded music, whatever the genre. In effect radio has become a dependent medium, constrained by television on one side and the music industry on the other; its 'secondary' status is rooted historically and institutionally in that position.

The proportion of music in the radio schedule is much higher on FM, whose share of listeners has increased steadily since the mid-1970s. FM now claims over 40 per cent of listening time in Canada, and around 60 per cent among young listeners (BBM 1986; Mietkiewicz 1985). FM carries more music because of its superior transmitting technology and because its music formats help to construct and define the group most attractive to radio's advertisers: younger adults in urban areas. Recently FM stations have led the market in a number of Canadian cities. FM's success has corresponded with an increase in the number of available frequencies, an increase in the proportion of listening time devoted to music, the growth of corporate integration in the radio industry, the re-emergence of programme syndication, the introduction of satellite programme distribution and a decline in the airtime quota of Canadian music, which is gradually being shifted to the domain of marginal campus/community stations and the increasingly impoverished Canadian Broadcasting Corporation (CBC). The rise of FM is thus part of a larger change in which, as a result of technical, economic and administrative development, music has become the primary instrument of commercial radio's delocalization.

Yet radio continues to represent itself as the local medium, placing this theme at the centre of its commercial and regulative strategies, its daily schedule and its programming rhetoric. Rather than taking this rhetoric at its word, the following explores the 'work' of the music/radio text as part of a productive apparatus reconstructing both space and time.

FORMAT

Radio is a medium which constructs and presents its own identity through its production. Radio has no reality, write Hennion and Meadel (1986), except to produce the reality that it records; it is nothing but intermediary, and its reconstruction of the music catalogue is its way of constructing its own identity, or discursive context, and its audience. If radio exists 'only to make others present, an invisible machine for making the world visible to itself' (ibid.: 286), the community which speaks and is spoken through that medium is also constituted by it, and is formed by its structures, selections

and strategies. It is for this reason that radio comprises an ideal instrument for collective self-construction, for the enactment of a community's oral and musical history. Brecht (1990) argued that this role would be realized only when radio became a means of communication, rather than one of distribution. Contemporary radio functions as the latter, but it represents itself as the former. This rhetorical achievement is accomplished through music.

In North America, commercial radio is dominated by format stations in which the organization of music-programming mediates and differentiates station and listener identities. Formats were introduced because they could deliver relatively cheap programme/listener revenues to radio after the arrival of television. Their commercial consolidation was dependent on the development of transistor technologies, which allowed greater mobility and fragmentation among listeners, and of market research, which allowed broadcasters to be more specific about the listeners they were selling to advertisers. Today, the term 'format' has two related meanings; it describes 'the type of programming done by a station, such as Top-40 or all-news. It also refers to the routine, or the list of specific ingredients, found in a programme hour. This includes specific phrases to be spoken, programme content, and the order and manner of placement' (Johnson and Jones 1978: 112). Formatting ensures that a station is clearly distinguishable from other stations (unlike TV, which distinguishes programmes and times), through a clear musical identity constructed in harmony with the precise demographics and researched common tastes of the targeted audience. Formats have tended to become more specialized, largely because research methods have grown more sophisticated; listeners' loyalties are an effect, as much as cause, of this specialization process.

Format music programming styles thus appear to spring from and articulate a neutral marriage of musics (country and western, Top 40, etc.) and demographics, and to correspond opportunistically to already established listener tastes, whose profiles are discovered through the neutral science of market research. For broadcasters and regulators, the division of a given broadcasting area according to demographic typologies reflects a division in the needs and listening expectations of 'targeted' listeners, who have already been defined (and researched) as members of demographically discrete groups, who are conceived as firmly established in their musical tastes and listening habits, and who should be served, therefore, according to this line of thought, by an appropriately diversified and rationalized radio spectrum.

Every format follows a complex set of rules for programming, including the style and range of music selections, size and origin of playlist, quotas for musical repetition, relative numbers of current and past hits and their usual sequence, conventional relationships between music and speech, and so forth. A major change in any one of these is inconceivable without a

subsequent change in all of them and in the relationships amongst them. For instance, a switch from Middle of the Road (MOR) to contemporary hit radio (CHR) would demand (besides a new music director) a new on-air style, different news, a smaller playlist with higher weekly rotation and faster turnover of hits, and above all, a successful transition to new sources of advertising revenue for the less affluent but presumably larger market. Urban markets support an increasing number of pop-music format stations which compete for listeners and advertisers on the basis of finely researched distinctions notwithstanding some considerable crossover of music selections. An increased number of stations in a particular city certainly does not guarantee a wider range or diversity of music selections.

In Canada, FM formats are closely regulated. Broadcasters seeking a licence or renewal must commit themselves to a general format and prove both the viability and need for the chosen format in that particular city. Their 'Promise of Performance' must detail the type and range of popular music to be programmed, as well as the intended percentage of Canadian content, maximum repeat quotas for hits, proportions of hits to other musical selections (regulation prohibits more than 50 per cent, though as with most restrictions there are exemptions for Canadian selections), total commercial time, amount of 'foreground' programming, and so on. This regulation is intended to maintain musical diversity in FM programming, given an increasingly competitive market and the well-documented tendency for broadcasters to duplicate successful formats as long as they can draw sufficient advertising revenue (Glasser 1984). Through format regulation, commercial radio is supposed to be balanced between viable market conditions on the one hand, and non-market cultural objectives like musical diversity and Canadian content on the other. Such scrupulous management of the market offers a bureaucratically dense trace of the government's ostensible defence of 'public interest', which used to be represented by the public system.

Given format radio's tendency towards duplication, and the pressures on programmers to prefer mainstream and crossover hits whatever the format, the rationale for FM regulation is more evident than its success. Actual musical diversity is doing less well than the radio market which, while more or less stable in terms of total revenues, is heavily imbalanced (like the programming itself) between centre and margins, with major stations drawing huge revenues and many others continuing without reported profits for years at a time. New stations are still being licensed, though this does little to increase the range of music programming available; it merely intensifies the competition for advertising revenue and refines radio's production of audiences as more specialized commodities. In sum, the post-TV proliferation of stations and the refinement of research-based formats have contributed more to the expansion and rationalization of commercial revenues gained by the radio market as a

whole than to the substantive diversity of tastes that is claimed to warrant such proliferation, and which, in any case, tends to be created as much (or as little) as indulged by radio practices.

The organization of audiences by music format does rationalize the radio market, but this is not the same as diversifying or enriching radio programming. This would entail diversifying musical production itself, and diversifying the exposure of musics to specific audiences – the opposite of what has actually occurred in the evolution of music formats. Diversifying the production of music is achieved by diversifying the site of its production; that is, by making music recording and broadcasting more widely accessible to a range of musical practices and styles. These objectives are not the intention or the effect of contemporary radio music formats, whether or not they are addressed to listening markets who buy records.

THE MARKET

In recent years, radio production has been transformed by music television and other changes in the production and circulation of records; by more sophisticated methods of audience-testing and market research; by satellite and computer technology, and subsequent programme services; by concentration of ownership structures; and by the re-emergence of networks. In other words, the process of mediation between station and listener is itself the subject of economic and technical modernization, which has a direct influence on the radio 'text' itself. As this process is rationalized, so too is the text. What is important about the music, in that context, may be not so much what it says, but what it displaces, not so much whom it draws together, but how, and on what terms, and of course what it leaves out.

In 1989, the most successful formats were Adult Contemporary/Gold, MOR and, well behind these, Country, Album-oriented rock and Contemporary Hit Radio. The consolidation of Adult Contemporary on AM, and of Album-oriented rock on FM, as leading formats (following a gender distinction – women listen more to AM, men to FM), plus the slight decline of MOR on both AM and FM bands, and the relatively low standing of country and dance music formats on FM, in combination confirm the relative strength of formats featuring current singles, though this tendency – mainly a response to the influence of videos – is less marked than in the mid-1980s because of the resurgence of 'Gold' formats.

The rise of video as a marketing tool reduced the supply of new recordings, while video's emphasis on singles tended to marginalize the rest of the album in terms of radio airplay. In conjunction with the relative ageing of the population (and the consequent relative decline of record consumption), this has changed the role of radio in the distribution of records, especially Canadian-content records, which has further added to a decline

in their supply (Hahn 1985: 17). After music television went on the air, the number of records in circulation declined; by 1985, releases by new artists were down 45 per cent internationally compared with five years previously (Bergeron et al. 1986: 42). In Canada, the multinationals release current recordings selectively, following their commercial success in Britain or the US; this leads to further reduction of the number of records in circulation. While the number of records being released has decreased internationally, the proportion of national and international hits has risen in relation to local releases; this trend is exacerbated in Canada, where the music industry earns about 14 per cent of its revenues from Canadian record and tape sales.

There are several issues worth considering in relation to these developments. First, the size of the radio market as a whole has remained stable; people are not tuning in to FM from television or magazines, but from AM stations, which have been subject to a strict 30 per cent Canadian-content quota since 1971. FM stations (depending on format) tend to be subject to lower Canadian-content quotas, and are frequently criticized for unloading Canadian content into off-peak listening hours. The relative decline of AM radio means less airtime for Canadian music, which spells trouble for the already marginal Canadian recording industry (ibid.: 127). Competition from US stations also contributes to lower Canadian-content quotas, and probably reduced sales, in the border cities. Second, and in relation to this, formats that succeed in major markets affect listening patterns more widely. In addition to the dissemination of playlists from *Billboard*, or from major urban markets to smaller stations, and the rise of syndicated programmes distributed by satellite, people tune into stations in large metropolitan centres even when they do not live there themselves (BBM 1986; *Report of the Task Force on Broadcasting Policy* 1986: 24). The bigger the urban market, the more its stations function as magnets to listeners in surrounding areas, developing listening patterns from the centre outwards that are disproportionate in terms of the spatial distribution of the population. Because of this 'spill' effect, residents of smaller towns tend not to listen to their own stations.

This is not because urban stations play more regional music, or even a wider range of music selections. Since a large city is more fragmented, or, to put it another way, since urban stations are competing for a larger revenue base and draw on more precise audience research, radio-programming is more specialized. CHR, AC and AOR formats are more popular in big cities, where listeners (or perhaps their employers and shop-owners) seem to prefer more contemporary formats with a higher turnover and a smaller range, that is, tighter and faster playlists (CRTC 1987: sec. 8.3.3). Urban format specialization is also tied to a greater emphasis on nationally distributed records, which have international promotion in television, magazines and other contexts.

Stations in smaller towns are more open to, and more reliant on, locally or regionally produced recordings (Hahn 1985: 23–4). But they are being culturally and economically marginalized by the urban specialization process and its attraction to small-town listeners. The growth of FM may be encouraging this process, because the revenue for FM stations increases commensurately with the expansion of audience reach. In contrast, AM stations experience a declining rate of revenue increase as audience size increases (Babe 1985: 95–100). The marginalization of local music production (and other programme sources) is also being intensified by the erosion of the public broadcasting system, which, ironically, is invariably accompanied by rhetorical flourishes about the greater local sensitivity of commercial broadcasting. As everyone knows, private broadcasters produce far less local programming. The only tangible proof of commercial radio's local allegiance lies in the high proportion of advertising revenue drawn from local businesses – the direct reversal of television revenue, which is three-quarters nationally based (*Report of the Task Force on Broadcasting Policy* 1986: 396). The proportion of radio revenue derived from local advertisers has risen substantially, from 60 per cent in 1969, to over 73 per cent in 1984 (Babe 1985: 27).

The effect of all this is that urban stations are attracting a higher proportion of listeners, while programming a decreasing number of music selections. This means that more and more listeners are listening to fewer and fewer songs. This reflects, and helps to legitimate, the general trend towards spatial and economic centralization which characterizes radio in Canada and music production internationally.

SPACE AND TIME

If the hit parade had emerged by the time Harold Innis wrote *Empire and Communications* (1950), perhaps he would have offered some specific hypotheses about its spatial-temporal impact. In his work, media-produced relations between time and space have direct consequence for the growth of geopolitical formations and monopolies. Time-binding communications ensure continuity across time, and preserve memory, identity and hierarchy; space-binding media, such as telegraphs, roads and electronic media, permit more rapid dissemination of information across space, but erode local memory and the self-determination of peripheral groups. Commercial radio seems to follow this latter pattern through its hyperactive restructuring of the spatial soundscape, its impact on changing patterns of consumer-communities, and its role in the creation of international distribution systems, in much the same way that, in Innis's prognosis, the rise of print created the material-political foundations for the present era.

In fact format radio and the current changes in music radio occupy an interesting but paradoxical position in this picture. Radio was developed to

transmit across space, to overcome physical barriers and to make transitory messages broadly available; in this respect, it is a space-binding medium, ensuring the rapid, broad distribution of changing texts without restriction to an originary space or a cultural elite. On the other hand, it is aural, vernacular, immediate, transitory; its composite stream of music and speech, including local (if usually one-way) communication, has the capacity to nourish local identity and oral history, and to render these dynamic through contact with other spaces and cultures. This capacity for mediating the local with the new defines its styles of talk and construction of station identity. But format radio is thoroughly industrialized both in its temporal language and in its relations of production, which are increasingly technologically rationalized, and less and less local in origin or scale. This paradox allows format-based music radio to be omnisciently 'local' without arising from or contributing to local cultures.

Radio, like other media, is constituted (and constitutes us) spatially as much as by genre, signification, or mode of address. This thought is already half accomplished by the common emphasis on radio's resilient portability since the invention of transistors. Doesn't the birth of the hit parade form a homologous whole with cars, highways and scenic pull-offs, drive-in movies, blue jeans, and Coke? But the point can be taken further. In the radiophonic production of sound texts and local, if not locally autonomous audiences, it is possible to identify more precisely how 'spatial form and spatial strategy can be an active element of accumulation', as Doreen Massey (1984) argues in more general terms.

A number of elements in the production process spring to mind. Most broadly, radio provides an international distribution system for records. Music recording has become a globally integrated process within a centralized economic structure which shapes the conditions and locations of manufacture and distribution. The demand for currency in sound values produces an incentive for technological innovation that ensures, among other things, a process of continuous rationalization in studio production facilities and strategies. Recording, touring and the music press can all be mapped out in relation to a construct of centres and peripheries; you could argue that this map is materialized semiotically every time a musician displays his or her commercial success by moving to more sophisticated recording facilities, which almost invariably follows the move to a major label.

But here we are concerned with radio, which, on the surface at least, is a more dynamically local medium. Shifts in recording and listening technology and music marketing have reinforced commercial radio's dependency on the organizational rationalization of music programming, even where record promotion is not part of the station's demographic mandate. Responding to a competitive, media-saturated and increasingly deregulated environment, radio programmers are more inclined to turn to com-

puter programmes for music selection to cut programming costs, than to flex the boundaries of musical taste. Across Canada, over one hundred stations now relay rock or country music programmes by satellite from St Catherine, Ontario (south of Toronto), produced by Canadian Radio Networks (CRN). CRN claims four minutes an hour for national advertising sales, and formats six and a half minutes into each programme hour for local spots (Careless 1990). Otherwise the programmes are live, DJ-hosted, delivered cheaply and all night long, from what is often the other side of the country. 'In essence', writes a radio columnist for *Broadcaster*, 'it's a local station gone national. This illusion exists because CRN jocks steadfastly refuse to identify their location. As well, the service offers toll-free 1–800 request lines, so listeners can call in and talk to a jock, wherever they may be' (ibid.). The only drawback, for this columnist, is unemployment for hundreds of DJs. Two more CRN networks – CHR and oldies – are in the works.

Such mechanisms rationalize radio production across vast distances, in effect restricting local communication to advertisers. They also facilitate the economic security and spatial diffusion of monopolies, in the recording and electronic industries, which are more interested in opening up markets for new cultural hardware and its accompanying software than in the recording and marketing of a wide range of musics, or the potential contribution of such musics to patterns of urban communication. If ensuing radio practices assure listeners of their right to a certain powerful habitual pleasure, they also suppress equally fundamental rights: Lefebvre (1976: 35) speaks of *the right to the town* (how often do you hear DJs – aural icons of local culture – encouraging debates or actions on urban development, racism, pollution, daycare, land rights, public transport?) and *the right to be different* ('the right not to be classified forcibly into categories which have been determined by the necessarily homogenizing powers') which, he argues, are endangered by the economic and political management of urban space.

As we have seen, radio produces difference through format competition, but only that which is demographically and administratively profitable. More clearly evident is radio's management of urban space, perhaps its chief accomplishment, in its promotion of local business, its management of traffic, time and temperament in relation to rhythms of the working week.

RADIO SPACE AND TEMPORAL NARRATIVES

Like the radio schedule itself, with its strict markers of the hour, its subtly clocked rotation of current and past hits, its advance promotion of a new release, the music playlist functions as a kind of metalanguage of time. The playlist offers a grammar of temporality which draws in the listener and

produces him or her (economically, as a commodity; experientially, as a listener) as a member of a stylistic community defined, more and more, in inexorably temporal terms, rather than in relation to geographic or more explicitly substantive identification – assembled that is, in terms of the preferred speed and rate of musical consumption (cf. Straw 1988). The music playlist continuously (but variously) demarcates the present from the immediate or distant past. With its new hits, its repetitions and recyclings, its rising and falling stars, the playlist reinforces the space-bias of commercial radio by making diverse communities as listeners more and more the same, by spreading processes, values and decisions outwards from a technical and administrative centre, and by defining value in terms of rapid temporal change, competency in terms of knowledge of that change. The playlist is a central functional element within the radiophonic narrative which, paradoxically, constantly posits the local as its subject.

Radio's textual interaction of music and speech can be analysed as a type of narrative, one which simultaneously addresses and represents the specific targeted community. This makes the DJ or host a kind of narrator, and suggests that the combined elements of old and new songs, advertisements, news and weather on the hour, and so on, can be analysed as structural functions within the narrative, which is constructed through their specific combination. Where traditional tales are analysed as a structural combination of narrative elements condensed across time, we might consider contemporary radio narratives as the condensation of structural relations in and across space, in an interdependent relation of reverse proportionality to time. Space is collapsed because access to it (at least imaginatively) is expanded; time is speeded up and broken into contemporaneous moments within the still-tangible discipline of the working week. The construction of radio audiences is not then simply an abstract (if quantifiable) assemblage of listeners with similar tastes, but also a ritualized transformation of people's relationships to (and in) space and time. Radio creates a new sense of time, not directly parallel to previous kinds, an overt disciplining of the hours of the day which also permits a non-spatial movement in and out of its compulsions with the simultaneous suspension/intensification of marked time through music, and the return/casual proliferation of social time through talk.

Radio is often described as a surrogate or 'portable friend' (Dominick 1979: 99). Early psychological and market research established the truism that radio's functions are 'to "involve" the listener in the great and small events of the day; the provision of commonly shared experiences that can facilitate interpersonal experiences and also that can cement the solidarity of various subcultures . . . within a mass audience' (Mendelsohn 1979: 96). This companionable set of functions is attributed to radio's technical mobility, its mix of music and talk and the ways this 'represents' the collective choices and desires of its listeners, and its mode of address,

which establishes a simulated intimacy that is specific to the medium. Radio announcers are instructed to address their audience in the singular, never as a mass, and to establish a mood of friendly companionship for their listeners, often assumed to be women.

Popular radio offers a sense of accessibility to and interaction within its own community, distinguishing itself from television through highly conventional and elaborated strategies of representation. Such conventions work to establish and draw attention to the radio station as a live and local context. They include signposting ('Later we'll be talking to . . . Coming up: the new release from . . . You can hear it right here on . . .'), styles of interviewing, spontaneous patter, informal commentary on music selections and music-related gossip, station identifications (Montreal's CHOM-FM, member of the nationwide CHUM chain which also owns MuchMusic Television, calls itself 'the spirit of Montreal'), and so forth, all of which contribute to a sense of localness, immediacy and accessibility.

Radio's localness is emphasized in all textbooks and industry commentaries on on-air practice. Successful DJs account for their popularity by claiming special contact with the local scene. 'Radio is very much a local medium', advise Johnson and Jones (1978: 118), authors of a leading American textbook on modern radio station practices. In the same paragraph, they note that 'in fact, no local station really originates all of its programming material. Phonograph records are nationally distributed, as is the news from wire services. Most ideas are borrowed, not originated'. Stephen Barnard (1989: 92) observes that 'radio stations throughout the world use records as a major source of programme material for reasons of tradition, convenience, and economics', and notes the current trend among record companies to play down local talents and to encourage national trends at the local level. Thus broadcasters become what Babe (1985: 24) calls 'localizers' of international content.

If radio is local, most of what we hear – other than the weather forecast – is not. Nor is the sum of technological relations upon which contemporary radio depends. Some stations produce their own commercials, but the soundtrack for them is as often as not imported (in the case of CHOM, from California in a boxed CD set). We think of radio as a low-tech medium, but it is not an autonomous one. Its dependencies follow the same patterns of more advanced technologies wherein the cycle of technical innovation/democratization does not democratize access to production, but only to (some) information, which can thereby be disseminated more centrally. To put it with complete cynicism (meaning only partial truth), radio's atmosphere of local involvement is designed to attract the highest possible proportion of listening hours for sale to local advertisers, and thus to maintain and promote the particular local 'feel' that can attract both listeners and advertisers. Local relevance becomes

the shorthand for radio's competition with television, its dependency on advertising revenue from local sources, and its promotion of music sales at the local level.

In this context the DJ serves to personalize and thus to locate the station as more than an abstract mediation of records, advertisers and listeners. DJs are increasingly disempowered in terms of programming, and make fewer and fewer decisions about music and other content. But it falls to the DJ's voice to provide an index of radio as a live and local medium, to provide immediate evidence of the efficacy of its listeners' desires. It is through that voice that the community hears itself constituted, through that voice that radio assumes authorship of the community, woven into itself through its jokes, its advertisements, its gossip, all represented, recurringly and powerfully, as the map of local life.

CONCLUSION

In Canada, as elsewhere, privatization, networking and intensified competition in the broadcasting sphere contribute to what Carey (1975: 33) calls 'pervasive recentralization': a general shift of the location of authority to 'more distant, diffuse and abstract centres', thus eroding the 'effective capacity of proximate relations'. Commercial radio is constrained by an increasingly monopolized (and televisualized) distribution system for recorded music, and its programming is shaped by increasingly centralized hierarchical technical processes which it helps to valorize and reproduce. It posits listeners' desire as the engine of that set of social and technical relations. Through its mediation, it makes that account true.

Radio has unique capacities to map our symbolic and social environment. These capacities are considerably constrained by the national and international nature of music distribution and by radio's impetus towards technological rationalization. Radio mediates between local listeners and musical selections, but its forms of mediation, defined by the music format, can be heard as a naturalizing of technological change and the ongoing, sometimes violent displacement of its listeners. Its narrative depends on (though it also helps to diffuse) people's feelings about community, about territory, work and weekends, roads and traffic, memory and play, and what might be happening across town. Its special resource is the psychic investment of listeners in local space, whether they are isolated within it or driving across it; the displacement of this space in the radio airwaves has direct semiotic and structural implications in the shifting strategies of empire.

NOTES

1 An earlier version of this paper was published in *Popular Music* 9/2, 1990.

BIBLIOGRAPHY

Attali, Jacques (1985) *Noise: The Political Economy of Music*, Minneapolis, MN: University of Minnesota Press.

Babe, Robert (1985) *A Study of Radio: Economic/Financial Profile of Private Sector Radio Broadcasting in Canada*, prepared for the Task Force on Broadcasting Policy, Department of Communications, Ottawa.

Barnard, Stephen (1989) *On the Radio: Music Radio in Britain*, Milton Keynes: Open University Press.

Barnes, Ken (1988) 'Top 40: a fragment of the imagination', in Simon Frith (ed.), *Facing the Music*, New York: Pantheon.

Barthes, Roland (1977) *Image-Music-Text*, ed. and trans. Stephen Heath, Glasgow: Fontana/William Collins & Co.

BBM (Bureau of Broadcast Measurement) (1986) *A Review of Trends in Canadian Radio Listening 1976–1985*, Ottawa.

Bergeron, Denis, Chater, Brian and Roberts, John (1986) *Music and the Electronic Media in Canada*, Study for the Task Force on Broadcasting Policy, Ottawa.

Berland, Jody (1988) 'Locating listening: popular music, technological space, Canadian mediation', *Cultural Studies* 2(3): 343–58.

—— (1991) 'Towards a creative anachronism: radio, the state, and sound government', *Public* 4(5): 9–21. Reprinted in D. Augartus and D. Lander (eds) (1993) *Radio Rethink*, Banff: Walter Phillips.

Brecht, Bertolt (1990) 'Radio as an apparatus of communication', in Simon Frith and Andrew Goodwin (eds), *On Record*, New York: Pantheon.

Canadian Broadcasting Corporation (1989) *Radio Format Report*, Colleen Cronin: Toronto, CBC Research Office.

Careless, James (1990) 'Canadian radio networks: a service for budget-conscious broadcasters', *Broadcaster* November: 6–7.

Carey, James (1975) 'Canadian communication theory: extensions and interpretations of Harold Innis', in G.J. Robinson and D.F. Theall (eds), *Studies in Canadian Communications*, Montreal: McGill Programme in Communications.

—— (1989) *Communication as Culture*, Boston: Unwin and Hyman.

Crane, Jonathon (1986) 'Mainstream music and the masses', *Journal of Communication Inquiry* 10(3): 66–70.

Crisell, Andrew (1986) *Understanding Radio*, London: Methuen.

CRTC (Canadian Radio Television and Telecommunications Commission) (1987) *Listening Trends 1976–1986*, Ottawa: Mary Giordano, Broadcasting Directorate, Radio Policy Planning and Analysis Branch.

Dominick, Joseph R. (1979) 'The portable friend: peer group membership and radio usage', in Gary Gumpert and Robert Cathcart (eds), *Intermedia: Interpersonal Communication in a Media World*, New York: Oxford University Press.

Fornatale, P. and Mills, J. (1980) *Radio in the Television Age*, Woodstock, NY: Overlook.

Glasser, Theodor (1984) 'Competition and diversity among radio formats: legal and structural issues', *Journal of Broadcasting* 28: 122–42.

Hahn, Richard (1985) *A Study of the Supply of English Language Sound Recordings to Canadian Private Radio Stations*, Study for the Task Force on Broadcasting Policy, Ottawa.

Hennion, Antoine and Meadel, Cecile (1986) 'Programming music: radio as mediator', *Media Culture & Society* 8(3): 281–303.

Innis, Harold (1950) *Empire and Communications*, Oxford: Oxford University Press.

Johnson, J.S. and Jones, K. (1978) *Modern Radio Station Practices*, Belmont, CA: Wadsworth.

Lefebvre, Henri (1976) *The Survival of Capitalism: Reproductions of the Relations of Production*, London: Allison & Busby.

Liska, Peter (1988) 'Digital broadcast radio', *Broadcaster* July.

Massey, Doreen (1984) *Spatial Divisions of Labour: Social Structures and the Geography of Production*, London: Macmillan.

Mendelsohn, Harold (1979) 'Listening to Radio', in Gary Gumpert and Robert Cathcart (eds), *Intermedia: Interpersonal Communication in a Media World*, New York: Oxford University Press.

Mietkiewicz, Henry (1985) 'Radio a gamble for all except high rollers', *Toronto Star* 18 February.

Report of the Task Force on Broadcasting Policy (1986), Ottawa: Minister of Supply and Services.

Rothenbuhler, Eric (1987) 'Commercial radio and popular music: processes of selection and factors of influence,' in James Lull (ed.) *Popular Music and Communication*, Beverly Hills: Sage.

Statistics Canada (1990) 'Who listens to radio?', *Focus on Culture* 2(4): 1–3.

Straw, Will (1988) 'Music video in its contexts: popular music and post-modernism in the 1980s', *Popular Music* 7(3): 247–66.

Toronto Star (1988) 'Spinning too much Top 40 lands CKFM in hot water', *Toronto Star* 14 April: b1.

Toushek, Gary and Unger, M. (1988) 'Helping radio programmers: a computer system to handle the routine but vital tasks', *Broadcaster* September.

POLICING FRENCH-LANGUAGE MUSIC ON CANADIAN RADIO: THE TWILIGHT OF THE POPULAR RECORD ERA?

Line Grenier

A recently passed Canadian Radio-Television and Telecommunications Commission (CRTC) regulation stipulates that at least 65 per cent of the vocal music played weekly by all Francophone AM and FM radio stations, irrespective of format or market, must be French-language songs. This content requirement is the key feature of Canada's revised French-language popular music policy which came into effect on 1 July 1990. It was issued in February of the same year, three months after a Public Hearing held in Montreal at which representatives of various groups involved in music-making and broadcasting fervently expressed their views on this long-standing controversial issue. As the debates it generated show, the newest content exigency raised issues in keeping with the rationale of diversity underlying Canadian broadcasting policies. It also brought to the forefront questions concerning what popular music is and how it is evaluated, thus shedding a unique light on the process of its social construction.

The purpose of the following case study is to examine critically the interplay between broadcasters, policy- and music-makers in the social production of French-language popular music.[1] It focuses on the process through which these key mediators, by coming to terms with structural changes in broadcasting and music-related industries as well as with political developments in Quebec and Canada, are redefining popular music – a process whose stake, I argue, is the institution of canons of Québécois popular music in what may well come to be known as the post-popular record era.[2]

A TEN-YEAR SAGA

The French-language vocal music (FVM) policy was introduced in 1973, in accordance with the CRTC's ongoing attempt to safeguard, enrich and strengthen the cultural, political, social and economic fabric of Canada and

to provide 'the disparate groups in Canada's society . . . [with] a clear choice of different kinds of programmes which recognize their particular needs and concerns' (CRTC 1975: 3). This policy included the requirement that all privately owned Francophone radio stations set aside at least 75 per cent of the music broadcast between 6 a.m. and 6 p.m. for French-language songs while maintaining an overall daily total of 65 per cent.[3] The policy became a matter of heated controversy in the late 1970s, when Francophone broadcasters, who had been haphazardly complying with the rule, claimed that because of a decrease in the production of French-language recordings, there was no longer enough material available for them to meet the FVM requirement. While Quebec's music-makers acknowledged that the record industry was suffering from an economic slump, they none the less refused to give broadcasters their support, arguing that any reduction of the requirement would jeopardize the development of French Canadian popular music as well as marginalize further an industry already subordinate on the English-dominated international scene.

As a result of the broadcasters' sustained recriminations and the music-related industries' ongoing lobby, the original policy was amended several times.[4] In 1986 the CRTC agreed to lower the content requirement for a three-year experimental period during which incentive programmes for the production of French-language material were to be implemented. The public hearing held in 1989 was part of the assessment of the impact of these temporary measures. In the light of the results of the incentive programmes as well as the economic state of the industries involved, the purpose of the hearing was to give CRTC officials an opportunity to evaluate whether or not a return to the 65 per cent FVM requirement was a realistic measure.

In anticipation of this public consultation, the trade organizations of both broadcasting and music-related industries – ACRTF (Association canadienne de la radio et de la télévision de langue française) and ADISQ (Association du disque et de l'industrie du spectacle et de la vidéo du Québec) – joined forces for the very first time. They commissioned a comprehensive three-part study which dealt with the availability of French-language vocal music in the light of its economic and industrial context of production, with the distribution, broadcasting and promotion of French-language vocal music, as well as with the musical listening habits of French-speaking Quebecers. This joint venture did not, however, prevent the two groups from presenting distinct recommendations to the CRTC. Broadcasters used the data to reiterate their initial position: they recommended that 55 per cent French vocal music be required on AM stations and 65 per cent on FM, provided that these be calculated on a weekly basis and that exceptions be made in accordance with the format and market of particular FM stations. For their part, representatives from the music

industry found evidence in the study that a 65 per cent requirement ought to be applied to all stations, regardless of format or market, and that it ought to be calculated every four hours to ensure that Francophone music figures prominently during peak listening periods.

THE DEBATE IN PERSPECTIVE

With respect to the central theme of the discussions and the position of the main protagonists, the latest episode of this saga leaves an impression of *déjà vu*. The impression is, however, misleading. Because of the status of the CRTC as a federal regulatory body and of the importance of French-language popular music as one of the most highly praised signposts of the French factor in North America, contrasting economic, cultural and political interests have in fact been embodied in the FVM policy equation thus shaping the ways in which it has been defined and debated through the years by the various parties. Only by addressing this whole controversy as both the product of and a driving force behind the changing socio-historical conjuncture in which it took place can we understand the specific set of issues at stake in the recent discussions.

The debate occurred mainly in Quebec, the only predominantly Francophone Canadian province, during a decade marked by a long economic recession as well as unprecedented constitutional turmoil. This turmoil, amplified by the signing of the Free Trade Agreement with the United States, was accompanied by the recrudescence of language conflicts and by the radicalization of nationalist fervour in Quebec.[5] Issues of Canadian national unity and Québécois nationalism have thus pervaded the agenda of the policy-makers (and of other participants, albeit to varying degrees) and have given a strong political basis to what at first glance appear to be purely economic arguments concerning the availability of French-language musical products. During the same period, both the broadcasting and music-related industries underwent intense structural change which clearly had repercussions for the FVM policy controversy.

The Canadian broadcasting industry has been affected by a general trend towards spatial and economic centralization in keeping with the rapid expansion of networks, increased concentration of ownership structures, and improved market-research methods (Berland 1990). These developments, however, have had unique effects in Quebec,[6] where centralization has meant both a greater regional imbalance between stations with respect to market shares and profitability,[7] and increased competition within the Montreal economic market where privately owned Francophone and Anglophone stations compete for an advertising revenue base that has remained relatively stable over the last ten years. The competition has been particularly stiff between FM stations which, although better off financially than their AM competitors,[8] have had to cope with unprece-

dented format concentration (half of them share the same Middle of the Road (MOR) format). How to develop and maintain a station's (musical) identity became the crucial problem, especially for Francophone broadcasters who increasingly viewed the FVM requirement as a constraint which reduced their latitude in the face not only of their Anglophone competitors, but also of the other Francophone stations. The lack of Francophone material thus turned out to be one of the difficulties inherent in French-language programming in a highly competitive, centralized, fragmented and bilingual market.

From the perspective of music-related industries, the increased market concentration of multinational record companies, greater integration of majors with international multi-medias and entertainment conglomerates, as well as long economic recession were among the most striking developments of the 1980s. The decrease in record sales which accompanied the recession incited the majors to reduce the number of new releases and concentrate production and marketing resources on well-established artists and products. Canadian affiliates, responsible for more than 75 per cent of the albums released/produced in the country,[9] adopted similar strategies. Between 1978 and 1987, they reduced their participation in the production of Canadian content music[10] by more than 55 per cent and withdrew almost completely from the Francophone sector in which they had heavily invested during the more prosperous 1970s.[11] As a result of the fall-out from the recession, the production of foreign French-language albums in Quebec plummeted by 79 per cent over nine years. Moreover, the production of Québécois albums, which account for three-quarters of the total of French-language record sales, suffered a 53 per cent drop in 1978–9 after which it picked up to approximately seventy-five albums per year (still 10 per cent less than in 1978). The rapidly growing independent sector, composed of around twenty relatively young, small enterprises accounting for 85 per cent of record sales by local artists, played a key role in this recovery. The recession was not, however, the only problem faced by Quebec's music industry. In the years immediately following the referendum on Quebec's sovereignty, interest in so-called nationalist music, which had always been a mainstay of popular music in the province, waned. How to compete with multi-media conglomerates with meagre financial resources, and how to develop a Québécois Francophone popular music not based solely on nationalist sentiment yet meeting the new musical tastes of Quebecers, thus became a primary concern of the music industry.

In conjunction with the beginning of Francophone music video programming on the provincial scene (Musique Plus) and the rebirth of Top 40 radio, all of the aforementioned developments have left an indelible imprint on the field of popular music in Quebec. A new generation of pop stars contributed to the dawning of genres which, until recently, played second fiddle in a soundscape typically marked by western, *variété* and

chanson. This increased popularization of the Québécois socio-musical field has been the corollary of the consolidation of an indigenous music-related industry which came to dominate a local market controlled a decade ago by majors (see Langlois et al. 1990). 'For the first time in our history', argues Robert Pilon, president of Media Culture and main economic consultant to Quebec's record and media industry, 'there's a real music industry here' (Brunet 1991: F-24). This emergence has been instrumental in transforming the socio-economic organization of music production, distribution and consumption in Quebec and, hence, in aligning it with the dominant social form of popular music, that is, the popular record.

Standing for what most people have known as 'music' in northern-western societies since the 1930s-40s, the popular record represents more than a particular technology (digital sound recording) and a specific cultural commodity (vinyl records). Associated with the rise of format radio and with the emergence of both the pop audience and the teen market, the popular record conjures up a whole way of conceiving, making and using 'music', a complex set of social and economic relations which define the respective roles and powers of the various actors/mediators involved in the *mise en société* (Hennion 1988) of music – from artists to producers, from recording to publishing companies, from broadcasters to cultural policy-makers and popular music fans. The popular record is thus the typical embodiment of music as the final product of an industrial process which, as Simon Frith argues, is seen not as 'something that happens to music' but rather as 'a process in which music itself is made'.

> Twentieth-century popular music means the twentieth-century popular record; not the record of something (a song? a singer? a performance?) which exists independently of the music industry, but a form of communication which determines what songs, singers and performances are and can be.
>
> (Frith 1987: 54)

It is my contention that the ongoing discussions surrounding the FVM content requirement in Quebec have formed an integral part of the process through which the popular record form is reproduced and yet adapted to suit its cultural, economic and political specificity. I also hypothesize that what makes the most recent debate so crucial is that it took place at a time when the authority of the popular record over music social production had begun to erode.

It has been argued that recent changes in the industrial process of production of music defy the hegemony of this specific musical form of communication. The replacement of black vinyl records by cassettes and compact discs as popular music's principal medium is the most obvious of these changes. This technological shift, however, is inseparable from

other, perhaps more significant changes: the move from record sales to copyright exploitation as the basic source of income, the shift from radio to TV and video as main promotional devices, and the substitution of individual record buyers by television shows and advertisers as target consumers (ibid.: 76). These diverse yet convergent shifts put into question some of the pivotal bases of the popular record form by reworking the relationship between recorded and live music, artist and fans, radio formats and musical genres, radio and television audiences, to name but a few.

These developments are somewhat unsettling since they confront Quebec's still-fragile music industry with a new challenge. First, how to hold on to a socio-economic mode of organization of music which, with the legal support of policies aimed at protecting local products from foreign competition, has just begun to bear fruit and yet is falling into decline. Second, at the same time, how to keep up with recent international trends in order to avoid cutting off local products from broader and perhaps more lucrative markets. This situation accentuates the double-bind in which Quebec is caught: like other small nations, it feels the need to protect its local products from multinational conglomerates but aims none the less at generating its own international hits. As the following analysis will illustrate, the debate under study goes to the very heart of this double-bind. It brings together contrasted approaches to popular music whose confrontation illustrates the tensions and contradictions characteristic of this transitory period during which key actors are working for the reproduction of a social form of music which new musical realities may eventually render obsolete.

SIXTY-FIVE PER CENT OF WHAT? WHY? FOR WHOM?

This analysis focuses on the arguments invoked by the key participants in support of their respective positions – that is, on the discourse of CRTC officials, of Quebec's music-related industry's delegates from ADISQ and on broadcasters' representatives from ACRTF. By breaking down their arguments in three analytical categories which I will refer to as the rationale, the beneficiary and the object, I hope to demonstrate that the *raison d'être* of the FVM requirement is interpreted differently by the three protagonists, that the groups whose needs it aims to meet are defined in contrasted terms, and that the material basis of the content exigency is described no less distinctively.

CRTC: impartial conciliator turned master of ceremonies

In the Notice of Public Hearing released in August 1989, the CRTC asked potential participants to comment on issues of supply, on the enforcement

of the requirement of Canadian content, on the temporal basis of calculation of the requirement, and on possible exceptions to the policy (CRTC 1989a). Although theoretically they were concerned outsiders, Canadian policy-makers were thus active players in a debate whose area of contention they defined from the outset.

To understand the CRTC's position with regard to the FVM requirement involves examining it in light of the rationale of diversity underlying Canadian broadcasting policies in general. Embedded in Canada's orginal broadcasting policy instituted in the early 1930s, this rationale rests on the assumption that if private broadcasters were left to their own devices, standardization of radio services would be inevitable. Reflecting the persistent quest of political leaders for cultural sovereignty, various policies were developed to protect Canadian airwaves from further corporate (American) broadcasting penetration. In the face of the increased reliance of private broadcasters on the musical products of international record companies, new regulations such as those pertaining to Francophone vocal music were designed to curb the increasing homogenization of radio programmes that might result from excessive commercialization. Assuming that in order to expand their audiences, broadcasters must cater to the most popular of mainstream materials (read English-language popular music), this content exigency was also designed to prevent complete Anglicization of French-language radio.

Considering its battle against standardization and homogenization, the Commission apparently acts to safeguard cultural standards by maintaining a comprehensive radio service that suits the needs of Canadians and promotes, as much as possible, local and regional production. Accordingly, the ultimate goal of the FVM policy is the protection and reinforcement of French-speaking cultural communities who, as part of the Canadian public, deserve a radio service that answers to their particular needs. As the opening remarks of Keith Spicer (past chairman of the CRTC) at the 1989 hearing clearly show, the CRTC considers Francophone communities as the main beneficiaries of a policy which is meant to promote 'le Canada français' as an integral part of an officially bilingual and multicultural country. Spicer's statement left no doubt, however, that policy-makers were well aware that any efforts in this direction implied the fusion of cultural concerns with industrial imperatives:

> We are here today to discuss a subject that is by its nature a reflection of the human spirit, music. We are all aware of the importance of music in today's popular culture. But music is first and foremost a vital element of culture. It is also an industry and a business. It is the basis of two industries that have not always seen eye to eye on their respective roles in developing and promoting not just music, but French-language vocal music, and not just performers, but our per-

formers. We will be looking for ways to smoothen the relationship between the two industries; we will be looking for ways to reinforce the French-speaking culture here in the heart of Canada's French-language communities through concrete, viable, and practical solutions to the issues discussed.

(CRTC 1989b: 1)

The mixed system of private and public ownership characteristic of Canada's industrial broadcasting services amplifies this conundrum. The merger of broadcasting as cultural service and commercial enterprise took on a special twist in the case of the vocal music content policy.

Drawing on the centrality of popular music to radio, policy-makers assumed that a relatively high (65 per cent) requirement would force private broadcasters to set cultural objectives as an integral part of their commercial operations – an obligation they have in return for the privilege of holding a licence, hence, a public trust. But since the importance of popular music on the airwaves presumably reflects the broadcasters' analysis of the musical expectations of their target audience, they are pressured to address radio's commercial imperatives in relation to the wider political economy of the popular music market, and to consider the state of development of the record industry. The policy-makers cannot legally intervene directly in the field of popular music, but they can draw on the private broadcasting industries' dependency on the CRTC, as well as on the interdependence of radio producers and record-makers. Spicer refers to this relationship as 'an industrial and cultural symbiosis':

On the one hand, the record industry provides a 'product' that is essential for the broadcasters. The broadcast of the 'product' helps draw an audience for the broadcasters and helps encourage record sales and therefore revenue for the record producers. On the other hand, the cultural part revolves around the fundamental fact that the product is French-language vocal music. Performers, who sing in French, have their music recorded. These French-language songs are then broadcast and heard by millions of people, providing a unique French-language musical environment.

(ibid.: 1–2)

The CRTC thus assumes that the success of the FVM policy depends on the establishment of a closer and more harmonious partnership between two industries bound to each other by their common interests in French-language records. Accordingly, the specifics of the content requirement were defined in terms of records being the central material embodiment of this 'symbiosis'.

126

ACRTF: defendants begging for mercy

Throughout the debate, Francophone broadcasters played for heavy political stakes. Not only did they openly oppose the CRTC whose decision either way would have direct impact on their day-to-day operations, but also they adopted a stand unpopular with the general public. As a reporter with *La Presse* commented, ACRTF was perceived as 'the accused' against whom a suit of 'industrial egocentricism in the use of public airwaves' had been filed (Lemay 1989).[12] The 'charge' refers to the Association's recommendation to maintain a low FVM requirement as well as to what was considered as ACRTF's undue insistence that its members' most pressing concerns be given top priority in the FVM policy equation. In fact, ACRTF's 'plea' rested on the premise that, because of the structural and conjunctural problems they faced, Canadian Francophone broadcasters could not assume their share of the responsibility for the promotion of French-language music unless they were given as much latitude as possible by the CRTC.

ACRTF representatives insisted on the need to examine the content requirement in a global context since it constitutes only 'one link in a chain' that stretches 'from the production of French-language popular music to its commercialization' (ACRTF 1989: 7). The way in which this global context was further characterized clearly foregrounds the rationale of constriction underlying the broadcasters' viewpoint. On the one hand, the broadcasters' delegates pointed to the inherently contingent character of the FVM requirement by asserting that no content exigency, as high and as strictly enforced as it may be, could ensure in and of itself the promotion of Francophone vocal music in Canada which calls for the co-ordination of a whole series of marketing, distribution and production mechanisms. On the other hand, they stressed that broadcasters' contribution was dependent upon the input of all of the other organizations and industries involved but not necessarily subject to the same regulations. ACRTF argued that radio stations already provided fair exposure and contributed to the marketing of Francophone musical products (through free advertising time, financial aid for the production of video clips, talent searches, etc.). Their efforts could not, however, bring satisfactory results if retail prices of records were too high, if products were not effectively distributed to retailers and radio stations throughout the country, if governments did not support the initiatives of the private sector, and if the written press and television did not give French-language cultural production the attention it deserved.

ACRTF's main spokesmen at the hearing, Gilles Grégoire and Paul-Emile Beaulne, referred to the inescapable dependency of the broadcasting industry on the record industry with respect to supply as yet another constricting element but also noted the fundamental and long-standing

interdependence of the industries. They pressed for concerted action and suggested the creation of a permanent 'Record-Radio' liaison committee composed of delegates from both industries in order to ensure harmonious relations. This proposal demonstrated the willingness of broadcasters to intensify collaboration and harmonize exchanges with the record industry. Though it alluded to co-operation between equal partners, it also indicated ACRTF's view of the record industry as poaching on its territory, radio programming. Mr Beaulne asserted that the role of the broadcasting industry is to make sure that listeners are exposed to French-language material. This means neither playing as much Francophone material as possible nor playing it every which way. Rather, it means using French-language music to develop diversified quality programmes that will attract listeners who can identify with the station's particular programming style and (musical) content. In order to do so, broadcasters must rely on sufficient supply from the record industry, and they must have the latitude to process records according to their specific needs.

Asked to comment further on the issue of availability, Mr Beaulne referred to a recent survey (EEC 1989) according to which 73 per cent of Canadian Francophone broadcasters consider that despite the increase in Francophone record production since 1986, their 'main problem with respect to supply is still the insufficient number of Francophone musical selections that are compatible with the sound of the stations' (EEC 1989: 11). The repertory used by radio stations does not equal overall record production. On account of the existence of stations' own musical policy and their need to comply with CRTC regulations, only 51 per cent of the total number of French-language records available are selected for potential broadcast; only 63 per cent of these actually make it to playlists. From ACRTF's standpoint, the amount of music compatible with stations' respective sound should be the objective criteria used to establish the FVM requirement level. Since the size of the compatible repertoire is currently limited due to relatively low production rates, poor production quality of what might be considered classic Québécois hits, and the scarcity of dance and rock material, the FVM requirement should therefore remain at 55 per cent. Any increase would significantly reduce stations' latitude and lead to market saturation, overexposure of artists as well as increased standardization of programming across Francophone stations. These problems would in turn impact on radio audiences – main beneficiaries of the FVM policy – since saturation and standardization would accelerate the already existing problem of audience transfer from French- to English-language stations. Citing a study of Francophone listening habits in Quebec (CROP 1989), the broadcasters' representatives pointed out that in 1988, audience transfer increased to 18 per cent. In the 18–34 age category, which accounts for 50 per cent of radio listeners, there was a 13 per cent increase in the two year span. According to Mr Beaulne, by imposing different requirements

on French- and English-language stations, the CRTC is creating a cultural segmentation in the market that runs counter to the very objective of the FVM content requirement. Given that Francophone consumer demand for music is not confined to French-language products, increasing the FVM to 65 per cent would further alienate the target audience and make it virtually impossible for Francophone stations to compete with Anglophone ones. Radio's commercial objective, he added, is not to sell records but to maximize their audience. He explained that individual purchases of Francophone records do not increase according to radio listening hours, thus highlighting that record sales and radio broadcasting are neither as necessarily nor as closely related as people tend to assume – the largest record consumers being individuals who spend only between six and fifteen hours per week listening to broadcast music.

ADISQ: corporate interests as voice of the people

Portrayed by the media as 'main public prosecutor', Quebec's music-related industries maintained the most widely held position by asking that more air exposure be given to local Francophone music. ADISQ spokesmen Robert Ménard (chairman), André Di Cesare (producer) and Robert Pilon (private economic consultant) discussed the mechanics of the FVM content exigency mostly on economic grounds. But they also appealed to national sentiments throughout their presentation, leaving no doubt as to the organization's political agenda in this debate.

According to ADISQ, Quebec's recording and broadcasting industries are in a relatively good financial state and, therefore, there is no reasonable justification for maintaining the 55 per cent FVM requirement. Representatives claimed that a return to the 65 per cent FVM exigency was all the more desirable since it induced all of the actors involved to 'face the challenge of *la vie française* in Quebec' (ADISQ 1989: 29). Describing the hearing as a 'crucial historical event' whose outcome was bound to have 'a major impact on the future of French-language *chanson* in Canada and on the future of Québécois culture more generally' (ibid.: 3), ADISQ chairman Robert Ménard further emphasized the political connotation of the debate by claiming that it was a test of the true meaning of Quebec as a 'distinct society' within the Canadian federation (Lemay 1989).[13]

In keeping with the rationale underlying the organization's viewpoint, the music trade's arguments rested on the premise that a clear predominance of Francophone vocal music on radio is absolutely necessary in order to safeguard the specificity of Québécois culture. Embedded in this rationale of specificity is the assumption that while any Francophone vocal music can contribute to the development and survival of French-language culture in Canada, Québécois *chanson*, as the cultural embodiment of Canada's only Francophone majority, remains the main driving force in

this process. For this reason, music-makers supported the 65 per cent FVM requirement on the basis that it would give priority to Francophone music on radio but also recommended that 50 per cent of the French-language music broadcast be Canadian so that the position of Québécois vocal music on radio is strengthened.[14] If the provision of artistic direction as well as commercial and industrial infrastructure for Québécois creators and performers is the cultural obligation of ADISQ and its members, the provision of 'an attractive showcase for our Québécois music and songs' (quoted in CRTC 1990: 11) must be Canadian and especially French-language broadcasters' responsibility.

Music industry representatives argued that to play more French-language music is in the best interests of broadcasters. Given that Quebecers have an indisputable attachment to their own music (they spend an average of $28 billion annually on Francophone records, 75 per cent of this on Québécois products), and that a fair portion of the population (40 per cent according to the CROP survey) feels there is not enough Québécois Francophone music played on radio, they claimed that it is reasonable to argue that radio audiences would certainly welcome such a change. Moreover, broadcasters could attract up to 32 per cent more listeners by increasing the number of Francophone selections – and only 18 per cent more by broadcasting more Anglophone products. Comparing the long-standing popularity of prime-time soap operas (*téléromans*) on television with that of Québécois *chanson* on radio, they asserted that just as prime-time soaps generate important advertising revenues, 'an increase in the programming of Québécois popular music could contribute to the prosperity of the broadcasting industry' (ADISQ 1989: 26)

ADISQ did not deny that its members would probably benefit financially as much as, if not more than, the broadcasting industry from increased radio exposure of Francophone vocal music, but its representatives insisted that the CRTC's content exigency was 'virtually the only legal protection of an industry which is so vital to Canadian culture, that is, the recording industry' (ibid.: 27). Their contention was that Quebec's music industry specifically needs as much protection as Québécois culture more generally since it occupies as marginal a position on the international scene as French-language culture does within the North American context: it is, after all, a relatively young industry composed of relatively small independent labels operating in markets largely controlled by huge multinational conglomerates. ADISQ's allusions to the relative precariousness of the corporate interests it represents were, however, coupled with statements that pointed to its members' achievements as all the more impressive given the little financial support they receive from public funding agencies.

> Quebec's independent record industry managed on its own, and with extremely limited resources, to meet the challenge not only of sur-

vival but success of French-language vocal music in Canada in the midst of a double recession: a general economic recession as well as a recession within the record market.

(ibid.: 27)

This type of argument paved the way for ADISQ's comments on the sensitive issue of supply. ADISQ spokespeople repeated several times that problems of supply had been solved, that they were no longer a true obstacle to a return to the 65 per cent FVM content requirement. They took great care in explaining that, due to financial consolidation of independent companies, emergence of national distributors, sophistication of recording studio's technical equipment, refinement of production skills (due to adequate training of new producers by more experienced ones), and the creative maturation of musicians, song-writers and performers, the record industry in Quebec now had the necessary infrastructure and expertise which enabled it to satisfy radio's demand in all musical genres. In short, the music trade in Quebec has gone from craftsmanship to industrial standards. While this development, they admitted, had not yet led to any growth in the production of records,[15] more French-language musical products were none the less available as a result of a significant increase in the quality of production as a whole. This improvement was evidenced by the renewed interest on the part of multinational companies in Francophone Québécois material, the increase in sales revenues and the export of Francophone vocal music from Quebec. But the most potent evidence, Ménard and Di Cesare added, concerns the number of cuts per album being broadcast by radio stations: in 1983, an average of 2.04 songs were played, whereas in 1988 3.50 were broadcast. Therefore, despite a relatively stable volume of records produced, the organization's members have managed to supply radio stations with more quality material than ever before.

Individual songs were also at the core of ADISQ's attempts to dissipate the CRTC's worries concerning abusive use of repetition by broadcasters. Chairman Ménard explained, for instance, that the negative impact of high song-turnover was no longer to be feared. Referring, by way of example, to the recent staggering mega-success of singer-songwriter Roch Voisine (whose single 'Hélène' sold over 200,000 copies in less than five months), he elicited an all-round laugh when he asserted that if this is the nature of overexposure, other Québécois artists should be so fated.[16] Questioning the broadcasters' protective attitude, he also asked why Francophone artists would suffer from having their music broadcast up to eighteen times per week if Anglophones didn't. This suggests that, from ADISQ's standpoint, although more repetition might be detrimental to one-hit artists, the potential benefit to the whole industry more than compensates for the 'sacrifice' of a few.

131

THE 'POPULAR RECORD' REVISITED: REPRODUCTION AND RESISTANCE

The disparate viewpoints on the FVM policy are consistent with the distinct interests of the participants as economic and political agents implicated in the social construction of popular music in Quebec. Their divergent understandings of the rationale, the beneficiary and the object of the FVM content requirement (see Figure 1) point to some of the key mediations involved in this process which articulate distinct ways of conceiving music, founded respectively on the logic of supply and demand, a redefinition of the boundaries between radio sound and recorded music, and the permutation and sequencing of single-song units. I will argue that the constant reiteration of and confrontation between these approaches is instrumental in producing Québécois Francophone popular music as a social phenomenon, and hence in reproducing the ideological basis of the popular record form which, in the final analysis, catalyses the whole debate.

| | *Viewpoints* | | |
Approaches to music	RATIONALE	BENEFICIARY	OBJECT
SUPPLY & DEMAND (CRTC)	Diversity	French-speaking communities	Records
RADIO SOUND/ RECORDED MUSIC (ACRTF)	Constriction	18–34 age-group audiences	Programme-oriented products
SINGLE-SONG UNITS' PERMUTATION (ADISQ)	Specificity	Québécois music-lovers	Cuts per album

Figure 1

The CRTC's discussion of musical issues parallels the culture/industry dualism underlying its entire discourse on broadcasting. The term 'music' denotes either a vital element of the distinct way-of-life of any given community or a commodity whose production, distribution and consumption, in the form of records, are subordinated to the rules of the economic market. The two usages, however, are conflated since in either case the argument rests upon the same logic of supply and demand. When discussing music from a cultural standpoint, policy-makers tend to present themselves as suppliers whose FVM policy works to meet the demand of French-speaking communities for diversified radio services as a key to their

(musical) cultural development. From an industrial standpoint, music producers are portrayed as suppliers whose products – French-language records – meet the demand of Francophone consumers for adequate airplay of French-language popular music on radio as a key factor influencing their consumption of local music. Made subject to the same logic, not only do cultural development and consumption of French-language records become almost interchangeable 'demands', but also the interests of the record industry and of the regulatory body, as 'suppliers' with the same goal (answering French-speaking communities' need for diversity), appear to coincide. This coincidence, however, is not a calculated result of policy-makers' concerted efforts but the inevitable outcome of their approach, which equates music with records as its true, ultimate embodiment. As the CRTC's argumentation concerning French-language music illustrates, records are clearly given priority over concerts, sheet music or videos as the key musical medium and commodity (if not also as sound recording/storage technology). But viewed as the realization of the culture/industry conflation, records thus also represent the regulating principle of the entire socio-musical system.

The CRTC's supply-and-demand approach presupposes an industrial space within which music appears to follow a linear path through production, distribution, diffusion and consumption. 'The truth of music', as Frith puts it, is presumably set once and for all during the production stage, and only at that stage. Music is then mistakenly regarded as the 'starting point' rather than 'the final product of the industrial process' (Frith 1987: 54). Accordingly producers, as owners of the means of production and distribution of music, are assumed to occupy the determining position in the industrialization process. Radio broadcasters, as intermediaries between producers and consumers, appear to take a back seat. This distribution of power between the agents involved is but one of the properties of an industrial space which the CRTC appears to define in accordance with the structural characteristics of the music industry typical of the golden age of the popular record – profit-making organized around record sales as well as radio-based marketing and promotion strategies, to name a few. As a consequence, the regulatory body conceives music's popularity in terms of record sales and radio airplay, thus assuming that in the context of a market economy and commercial broadcasting, they should 'naturally' follow fairly stable and homogeneous patterns (Lull 1987).

A derivative of the popular record form which it therefore reproduces, the supply-and-demand approach suggests that the CRTC is increasingly relying on the private sector to fulfil its cultural obligations. In fact, this strategic move is consistent with the recent modification of the state's agenda with regard to broadcasting in general, which shifted the priority from creating and operating a national broadcasting network to encouraging the development of national audiovisual industries (Tremblay and

Lacroix 1991: 17). Considering that in other sectors, however, this new strategy has generally meant disengagement on the part of the state, less direct intervention and increased deregulation, the CRTC's decision to strengthen the norms and regulations pertaining to the FVM content requirement may appear erratic. The CRTC either changed significantly or abandoned altogether those policies pertaining to traditional and cable television which it viewed as a hindrance to national industries whose development it sought to encourage. As Tremblay and Lacroix have argued, these policies had become counterproductive because they were no longer consistent with the most recent economic and technological developments in these two industrial sectors. Applying the same basic reasoning, it is arguable that the FVM policy and content requirement were maintained by the CRTC on the grounds that it is consistent with the internationally predominant musical form of communication, the popular record. In fact, the CRTC apparently wishes to kill two birds with one stone. First, to protect Québécois music-related industries at home by ensuring adequate diffusion of their products. Second, to encourage their potential development abroad by evaluating their performance on the basis of the very criteria that have presumably enabled their (predominantly Anglophone) international competitors to achieve outstanding success on the world market but whose hegemony it means to curb.

Given the approach to music upon which it rests, the FVM policy appears to favour the record producers' interests to the detriment of Francophone commercial broadcasters'. In fact, the policy takes into account the interests of broadcasters but only within the confines of the popular record system, hence in strict accordance with the important yet subordinated role they are assumed to play. To a large extent, radio's confinement to being simply music's main machine of popularization is what ACRTF's oppositional stance in this debate is based on. The Association's argumentation and its underlying rationale of constriction reveals the broadcasters' tendency to view the FVM policy as something of a straitjacket. If the ACRTF's understanding of the beneficiary and object of the FVM content requirement expresses its members' most pressing concerns, it does so by pointing to some of the contradictions embedded in the socio-musical system which the CRTC aims at establishing and reproducing by means of the FVM policy.

First, to identify the 18–34 age-group as main beneficiary is to challenge the assumption that broadcasters and record companies need to collaborate because they share similar objectives with regard to their target consumers. Even though it remains an integral part of the dominant discourse on broadcasting, this claim has become increasingly difficult to substantiate. Since the early 1980s, not only are advertisers urging radio stations to pursue older audiences who are not active record buyers, but also those stations which direct their attention towards teens and young adults – the

core of record buyers – are increasingly playing music which is not necessarily present on current charts (see Straw 1988: 248).

Second, to define programme-oriented products as key material objects of the FVM content requirement means focusing on the specificity of the broadcasting process and distinguishing it from music's marketing or selling process. The ACRTF rejects the assumption that radio is a mere transmitter, thus emphasizing the creative character of programming practices through which broadcasters constantly transform 'an external product into a radio product that meets its needs'. Radio tends to be considered 'the medium per excellence' which 'never stops mixing what it borrows in order to produce itself' (Hennion and Meadel 1986: 285–6). Given the importance it attributes to programming issues, the ACRTF appears to question the postulate that the homology which presumably exists between musical taste cultures and socio-economic groupings – upon which the CRTC's rationale of diversity and format regulations are based – predates radio programming (Berland 1987). Finally, the broadcasters' trade organization points out the paradox embedded in the CRTC's format system: how can a US-inspired system reflect Québécois rather than American consuming tastes and habits, if not musical styles?

In the final analysis the broadcasters' trade organization, in its attempts to dissociate its members' interests from those of music-related industry people, separates radio audiences from consumers of records and other music-related products, and the musical repertory available for broadcast from overall record production. The outcome of these convergent shifts is, I argue, a redefinition of the boundaries between radio sound and recorded music as two distinct components of the Québécois soundscape. The ACRTF's approach suggests that French-language radio mediates listeners' experience of French-language popular music in ways the popular record cannot. By shifting the focus from music to radio production, the ACRTF is in fact attempting to escape the confines of the popular record form – an attempt which appears to be aided and abetted by ADISQ in so far as it too puts the emphasis on programming, if for different reasons.

In keeping with the CRTC's supply-and-demand model, ADISQ centres its argumentation on the highly sensitive issue of availability but reworks the framework within which it is usually addressed. By replacing records with broadcasted 'cuts per album' as the determining criteria, this displacement of the unit of measurement also affects the moment at which availability is assessed. Availability is no longer measured at the production (records released) or consumption end (records purchased) of the industrial process, but at the diffusion stage (units broadcast). The need for close collaboration between broadcasters and music producers is thus further accentuated by ADISQ which reiterates the centrality of radio airplay within music's popularization process. Music trade people are thereby acknowledging, if implicitly, the importance of the selection and

filtering process involved in radio programming. By virtue of the new criteria used by ADISQ, availability raises issues of quality over and above questions of size and volume. 'Cuts' are viewed as an index of both the artistic and technical quality of the album on which they appear. Moreover, the total number of broadcasted 'cuts per album' is assumed to attest to the quality of record production as a whole, thus substantiating ADISQ's claim that Québécois music has never been better.

As the latter inference from broadcasted 'cuts' to the entire musical production already suggests, ADISQ's reworking of the notion of availability has implications far beyond the technical calculation of the FVM content requirement since it suggests a particular way of conceiving music based on the permutation and sequencing of individual songs – 'cuts' – considered musical events in themselves. Songs are viewed as discrete and independent meaningful units, as relatively homogeneous (the 3–5-minute pop song) raw materials out of which albums, radio and music television programmes are made. Although this requires further study, I hypothesize that ADISQ's focus on songs is consistent with production, promotion and marketing strategies typical of the new Québécois mainstream pop which surfaced in the early to mid-1980s. This mainstream pop differs but is none the less related to the one that developed in English-speaking North America in 1982–3 (Straw 1988) with respect to the conditions under which they emerged (the beginning of music video programming and the rebirth of Top 40 radio) and their emphasis on individual musical pieces rather than records proper. Music-related industries in Quebec used to rely almost exclusively on the sustained interest of the public in a few well-known artists, their biography, their career and, in the case of *chansonniers*, their political agenda as well. Drawing on Straw's analysis (ibid.: 253), it is arguable that, with the advance of this mainstream pop, they also began to function on the basis of the success of individual songs by new star performer figures who tend to be of the flash-in-the-pan variety. Although still concerned with maintaining an acceptable level of record production, music-related industries now pay a great deal of attention to single-song units and their inclusion on radio and television, as an increasing share of their profits come from the exploitation of publishing copyrights.

Only by examining it in relation to this song-oriented framework can we fully grasp ADISQ's understanding of the beneficiary and rationale of the FVM policy. The identification of Québécois music-lovers as main beneficiaries draws on the long-standing and taken-for-granted attachment of Francophones to Québécois popular music whose modern history (1950–60 onwards) tends to be associated closely with the rise of the nationalist movement. But what is most striking in the ADISQ view is not its obvious political appeal so much as its elusiveness. In contrast to the other participants, ADISQ's case makes no reference to particular market

segments or audiences, and is not tied with any special group of consumers. In this context, the word 'Québécois' may well mean Francophone but it is probably used in an inclusive rather than exclusive sense. In fact, this relative lack of precision is consistent with music-related industries' attempt to diversify and broaden their market beyond record consumers and radio audiences in order to reach music video viewers, concert-goers and movie fans as well – in other words, everyone who is exposed to songs regardless of the medium or the commodity involved.

A similar reasoning can be applied to ADISQ's understanding of the rationale of the FVM content requirement and of the political and nationalist connotations embodied in the term *chanson*. '*Chanson*' denotes either an individual musical piece with lyrics (*une/des chansons* – a song/songs) or a lyric-oriented genre (*la chanson*). A strong political flavour has traditionally been attached to the latter usage in Quebec as *la chanson* was assumed to be not simply an influential popular genre but the only authentically Québécois music – in contrast to US-inspired genres and styles. While there is still a high correlation between *la chanson* and Québécois (especially Francophone) music, the hierarchical genre distinction is not as strong as it once was, due in part to the development of a local music industry and the rise of a new generation of artists which contributed to the dawning of diverse genres and styles. As a result, the word can now be used to describe popular music that is created/made in Quebec (i.e., *la chanson d'ici*) regardless of any distinction of genre. ADISQ's rationale of specificity appears to be defined accordingly. ADISQ deems Quebec to be a consolidated musical space and appears to consider irrelevant any internal distinctions (apart, perhaps, from language).

The critical examination of its argument reveals that although ADISQ sides alternately with policy-makers and broadcasters, it has an agenda of its own which is oriented toward neither the reproduction of, nor the resistance to the popular record form, but involves rather its gradual and progressive transmutation. ADISQ appears to build on the popular record as an institutionalized and well-established musical form of communication, thus securing the ideological and economic foundations of the socio-musical system of which it is an offspring. ADISQ's approach to music based on discrete single-song units and their permutation does not challenge the well-established assumption that music constitutes the genesis of the industrial process rather than its final product. On the contrary, by suggesting that songs are finished products whose self-contained musical properties are impervious to the context in which they are played or diffused, the music trade organization further lends credence to it. However, ADISQ's displacement of records as the centre of this power/ knowledge system creates disturbances as it imposes a reordering of the popular record form from within. The song-based approach thus redefines the respective roles of and relationships between the various industries

involved since the placement of single units within sequences on radio and music television programmes, in dance clubs, motion picture soundtracks and live concerts outweighs, to some extent, the mere production of records. The permutation and passage of songs across numerous and disparate channels also implies the proliferation of discourses on music which affect the ways in which 'popularity' is defined and further dismantles the link between song, album and performer-identity which the popular record helped to establish (Straw 1988).

On the basis of the decision rendered by the CRTC in February 1990, the confrontation surrounding the FVM policy and content requirement appears to have ended in a draw, if slightly to the advantage of ADISQ. Indeed, as ADISQ had hoped, the CRTC raised the FVM content requirement to 65 per cent without exceptions based on format or market. The decision also leaned toward the position of the ACRTF so far as maintaining calculation on a weekly basis and refusal to include a Canadian content requirement within French-language music were concerned. In a way, the whole issue appears to be back at square one as if fifteen years of technological, economic, social and political changes hadn't transformed Québécois popular music and the ways in which it is conceived/perceived, or the industries involved, their structure and modes of production. The above critical examination of the participants' argumentation and their respective approaches to music sheds a completely different light on the outcome of the debate. Although the *status quo* of the popular record form has been maintained, the foundations may be weakened. The CRTC accepted ADISQ's alternative definition of availability and by doing so implicitly recognized and legitimated the single-song-based view of music. Transmutation of popular music's modern idiom is undeniably already in progress and favours the single-song unit as the standard for the institution of future canons of Québécois popular music.

NOTES

1 The analysis draws from ethnographic notes of the public hearing in Montreal, 17–18 November 1989; from the written statements presented by ADISQ and ACRTF to the CRTC; from CRTC documents pertaining to French-language popular music policy; and from press coverage of the debates by specialized magazines in Quebec and by Montreal daily newspapers.
2 I would like to thank the Social Sciences and Humanities Research Council of Canada for its financial support as well as Roger de la Garde and Roch Hurtubise for comments on an earlier draft of this chapter. To a very special 'linguistic consultant', Val Morrison, my deepest gratitude.
3 Anglophone stations were required to broadcast a minimum of 5 per cent of French-language material – a level which has not since been modified.
4 The 75 per cent day-time requirement was abolished in 1980. In 1983, the CRTC agreed to a case-by-case reduction of the overall daily requirement (from 65 to 55 per cent) for rock and country-oriented stations which were the most

severely affected by the decrease in production. Two years later, a consultative committee composed of delegates from the record and radio industries, the performing arts and both the federal and provincial governments was created whose mandate was to examine the overall situation of French-language vocal music. In 1986, after the committee had elicited studies which corroborated the broadcasters' assertions by confirming that fewer French-language recordings were produced, the minimum level was lowered to 55 per cent for all AM stations and for a third of the Francophone FM stations which asked for a reduction. It should be added that since Canada's overall FM broadcasting policy is currently under review, the French-language vocal music requirement is likely to be modified again in the near future.

5 In 1982, under Trudeau's liberal government, the constitution of Canada was repatriated but without the consent of Quebec's separatist Parti Québécois government led by Lévesque. These events paved the way for the Meech-Lake Accord, Mulroney's Conservative proposal which defined the conditions under which Quebec would repatriate the constitution. At the time of the Montreal hearing, in November 1989, fierce disputes were still raging over this proposal which was rejected in the end. In Quebec, the failure of these negotiations contributed a strong second wind to the nationalist movement which lost momentum after a referendum on the sovereignty of the province was defeated in 1980. A recent survey indicated that 56 per cent of Quebecers claimed to have lost faith in the Canadian confederation and were in favour of independence for the province. The idea received increased support outside the province as well, with 28 per cent of Canadians in favour of an independent Quebec in 1989, compared with 11 per cent in 1968 (Gallup Canada 1989).

6 In 1987, there were ninety-seven privately owned radio stations in Quebec. While seventy of these were on the AM band (72 per cent), they attracted only 45 per cent of the total radio listening hours in Quebec. Twenty-four stations were located in the Montreal area and occupied more than half of the whole radio market with respect to listening hours. The broadcasting industry is predominantly Francophone but 20 per cent of all listening hours go to the eight English-speaking stations (seven of which are Montreal-based). While AC (Adult Contemporary) and MOR (Middle of the Road) were the most popular AM formats, MOR occupied the forefront on the FM band (twelve out of twenty-three stations).

7 The average profitability rate (net income after taxes divided by total income) for stations outside the Montreal area was 2.7 compared with 5.6 for Montreal-based stations. Despite the fact that the industry as a whole was doing well, 38 per cent of all stations experienced financial loss. The latter were mainly FM stations located outside Montreal and AM stations located in the Montreal area. With respect to market shares, Montreal stations get 49 per cent of the total radio listening hours in Quebec as well as a quarter of all advertising revenue (EEC 1989: 18).

8 In 1986, all AM stations in Montreal had an average rate of profitability of -8.5. AM stations located outside Montreal, however, made profits, with an average rate of 5.1. An opposite situation prevailed in the case of FM stations: those in Montreal had an average rate of 26.4, but those outside Quebec's most populated region had a rate of profitability of -0.6 (EEC 1989: 17).

9 They released 2,608 albums in 1977 and 2,138 albums in 1987. From 1980 to 1987, an average of 2,191 albums were released annually, that is, 17 per cent less than the annual average of 2,645 albums for 1977 and 1978. See Leclerc et al. (1989: 87–91).

10 In order to meet CRTC's Canadian content definition, the selection must have at least two of the following characteristics: music composed by a Canadian; lyrics written by a Canadian; instrumentation or lyrics performed by a Canadian; live performance wholly performed in Canada and broadcast live in Canada or recorded in Canada. See Minister of Supply and Services (1986: 126).

11 Majors' affiliates in Canada produced/released 180 French-language LPs in 1978, but only 38 in 1987 (ADISQ 1989: 11).

12 Translated from the original.

13 Ménard refers to one of the most contested demands of the provincial government during the Meech-Lake debate, that is, that Quebec be recognized as a 'distinct society' within the Canadian constitution.

14 While the CRTC did not formally enforce this recommendation, it strongly encouraged broadcasters to accord the most attention possible to Canadian products.

15 A claim that was later confirmed by Statistics Canada. See Minister of Supply and Services 1990.

16 It is interesting to note that less than six years ago, some Québécois artists at the height of their popularity feared the impact of over-exposure and admitted to virtually having begged radio stations not to play their songs too often. See Grenier (1990).

BIBLIOGRAPHY

ACRTF (Association canadienne de la radio et de la télévision de langue française) (1989) *Le défi des années 90*, Mémoire présenté dans le cadre des audiences du CRTC sur la musique vocale francophone, November, Montreal.

ADISQ (Association du disque et de l'industrie du spectacle et de la vidéo du Québec) (1989) *Musique populaire de langue française*, Mémoire présenté au CRTC en vue de l'audience publique du 7 novembre 1989, October, Montreal.

Berland, Jody (1987) 'Regulating differences: music, radio and the regulatory double bind', *Rolling Notes*, IASPM-Canada working papers.

— (1990) 'Radio space and industrial time: music formats, local narratives and technological mediation', *Popular Music* 9(2): 179–92.

Brunet, Alain (1991) 'The Québécois sound. An expression of heterogeneity', *Billboard* 27 July: F-8/F-24.

CROP (1989) *Les habitudes d'écoute de la musique chez les Québécois francophones*, Montreal: Sondages CROP Inc.

CRTC (Canadian Radio Television and Telecommunications Commission) (1975) 'FM radio in Canada: a policy to ensure a varied and comprehensive radio service', Policy statement, Ottawa.

— (1989a) *Notice of Public Hearing 1989–8*, 11 August, Ottawa.

— (1989b) *Speech. Opening Remarks by Mr Keith Spicer, Chairman*, 7 November, Montreal.

— (1990) *Public Notice 19900–21*, 19 February, Ottawa.

EEC (Etude Economique Conseil) (1989) *L'approvisionnement, la diffusion et la promotion de la musique vocale francophone. Rapport final*, July, Montreal.

Frith, Simon (1987) 'The industrialization of popular music', in J. Lull (ed.), *Popular Music and Communication*, Newbury Park: Sage.

Gallup Canada (1989) *Support for Separatism Reaches All-Time High*, Toronto: Gallup Canada Inc.

Grenier, Line (1990) 'Radio broadcasting in Canada: the case of transformat

music', *Popular Music* 9(2).

Hennion, Antoine (1988) *Comment la musique vient aux enfants*, Paris: Anthropos.

Hennion, Antoine and Meadel Cécile, (1986) 'Programming music: radio as mediator', *Media, Culture & Society* 8(3): 281–303.

Langlois, S. et al. (1990) *Le Québec en tendances 1960–1990*, Quebec: Institut québécois de recherche sur la culture.

Leclerc, J., De Falkensteen, F., Tremblay, R. and Ethier, D. (1989) *Disponibilité de la musique vocale de langue française au Canada: le contexte économique et industriel*, Montreal: Media Culture and ADISQ.

Lemay, Daniel (1989) 'Pour insuffisance de preuves, la radio réclame le statu quo', *La Presse* (Montreal) 9 November: C-2.

Lull, James (1987) 'Popular music and communication: an introduction', in J. Lull (ed.), *Popular Music and Communication*, Newbury Park: Sage.

Minister of Supply and Services (1986) *Report of the Task Force on Broadcasting Policy*, Government of Canada, Ottawa.

—— (1990) *Sound Recording 1987–88. Cultural Statistics*, Government of Canada, Ottawa.

Straw, Will (1988) 'Music video in its contexts: popular music and post-modernism in the 1980s', *Popular Music* 7(3): 247–66.

Tremblay, G. and Lacroix, J.-G. (1991) *Télévision. Deuxième dynastie*, Quebec: Presses de l'Université du Québec.

9

WHO KILLED THE RADIO STAR?
THE DEATH OF TEEN RADIO
IN AUSTRALIA

Graeme Turner

Since the beginning of rock'n'roll, commercial music programming has been dominated by the formats of 'teen radio' – Top 40 hits played in 24-hour rotation for an audience demographic of 10–25. In the mid-1950s, the Top 40 format bankrolled the radio industry in many countries where radio's viability had been threatened by the spread of broadcast television and the consequent loss of advertisers and audiences. Teen radio was no passing fad; it continued to be a powerful programming format well into the 1980s.

The appeal of teen radio may be primarily, but is not solely, to the young; as Simon Frith and Stephen Barnard have both pointed out, the format's continuing success is traceable to this fact (Frith 1978; Barnard 1989). Indeed, the median age of the audience for Radio 1 in Britain, the Top 40 station both Frith and Barnard refer to, is 25, not 13. This is undoubtedly a commercial benefit but it is also a potentially worrying cultural contradiction; in the case of Radio 1, while the audience demographic is getting progressively older, its discourses remain those of 'the young'. The disjunction is one radio programmers have to address and justify:

> The network's official argument is that chart music has a much broader appeal than its sales figures and the apparent narrowness of the market suggest, but the only evidence for this is the success of Radio 1 itself; the policy is self-fulfilling. A wiser conclusion to draw is that Radio 1 is trapped in a tradition of its own making: having started in 1967 from the premise that 'pop radio', pirate style, could appeal beyond the immediate teenage audience, and having largely kept that original audience as the network grew older, Radio 1 still finds itself having to justify itself as a pop network without age limits.
> (Barnard 1989: 126)

A few years ago, it might have been tempting to see this contradiction between the social situation of radio audiences and the discourses used to

address them as the radio variant of what John Hartley calls the 'paedocratic regime' of television (Hartley 1987). Television, Hartley argues, constructs its viewers as children – offering them the childish pleasures of play, fantasy and story, and discursively calling out 'Hi Kids' every time the set is turned on. Television texts are constructed through a continual interplay between the new and the familiar, the pleasures of repetition and recognition highly foregrounded. Their narratives and spectacles are almost pedagogically organized; TV tells the audience how to understand what is happening on the screen through audience reaction shots, laugh tracks and the like. Hartley argues that such a discursive regime is actually constitutive of television, and characterizes the way television is understood not just by producers and audiences but also by critics and regulatory bodies. Critics want to warn us, as if we were helpless before the power of the message, while regulators want to protect us from the unpleasant and the too pleasant. Teen radio, at one time, seemed to offer the same paradigmatic case – a case which suggested that the discourses of teen radio had become the constitutive discourses of commercial music radio. Teen radio *was* music radio; that is why Radio 1 could still address the same audience in the same terms in 1990 as it did in 1967 even though both Radio 1 and its audience were more than twenty years older.

So far, there is no Australian equivalent of Barnard's history of music radio in Britain, *On the Radio*, but if such a book did exist it would argue even more strongly for the centrality of teen radio to the Australian industry and to Australian popular culture from the 1950s to the late 1980s. In Australia, Top 40 programming enabled radio to survive television, which commenced broadcasting in 1956, and secured a loyal teenage audience which remained with the medium as it grew older. The close, if complex and often contradictory, relations Barnard describes between Top 40 radio and the record industry in Britain are largely pertinent in Australia, too – although the colonial status of the Australian music industry does produce very different structural problems. Youth subcultures, and sites for youth culture, were articulated to radio in Australia as elsewhere: where Top 40 radio boomed out over the terraces before football matches in England, it drifted over the sands at surf beaches in Australia all weekend long.

However, there is now an urgent provocation for rethinking the institutional and industrial centrality of teen radio in Australia. Gradually, since the introduction of commercial FM radio in 1980, and increasingly rapidly since the upheavals in media ownership in 1986–7, teen radio has disappeared from metropolitan Australian radio. When the last Top 40 station in Melbourne converted to an 'Easy Listening' format in late 1988, we inhabited a moment when, for the first time in more than thirty years, there was not one Top 40 station serving the teenage audience in any Australian capital city.

The range of music formats on Australian radio has never been wide. Top 40 format, Middle of the Road (MOR, which once meant Frank Sinatra but now could as easily mean the Beatles), and Easy Listening (a mixture of soft ballad rock and light pops orchestra music – what the Americans call 'mellow') have dominated metropolitan stations on the AM band. Country music has had some representation but is primarily viable in rural areas, while some metropolitan stations mix golden oldies with large amounts of sport or talk. On the FM band there is essentially one commercial format–album oriented rock (AOR), the playlist shared by current 'new' music and 'classic' or nostalgia tracks. FM radio has been phenomenonally successful in Australia, expanding the size of the radio audience, seizing up to 50 per cent of that audience in each capital city, and spurning a forlorn challenge mounted through the late introduction of AM stereo. The number of commercial FM stations has recently been increased; but most cities still divide up the majority of the radio audience between two FM stations – leaving the remainder to be shared among at least half a dozen commercial stations on the AM band, two non-commercial national stations on the AM band and two more on the FM band, and a varying number of public access, educational and special-interest stations spread over both bands. The power of FM was recently graphically underlined when 3KZ in Melbourne switched from the AM to the FM band and increased its total audience share by 28 per cent in the first ratings period after the conversion (Peters 1990).

The dominance of FM in the Australian industry has been paralleled by an unprecedentedly comprehensive centralization of ownership and control; virtually all the metropolitan markets are now battlegrounds for the competition between two empires, Hoyts Media and Austereo, who each own an FM licence in all east coast capitals. In most cases, there is no other commercial FM competition. Both Hoyts and Austereo network their stations nationally, book advertising nationally, achieve economies of scale in news and promotions, and adopt a consistent corporate image and format from city to city. It is their programming format, however, not the networked company structure, which is most imitated in the industry and which is seen to be the reason for the success of FM radio.

To all intents and purposes, then, music radio in Australia is now AOR FM. Teen radio has vanished and the 'rock memories' and 'Easy Listening' formats are bleeding to death; the two stations currently programming classic hits and Easy Listening in Melbourne are at the bottom of the ratings, dividing up less than 5 per cent of the available audience between them. Current government policy is to expand the FM band, offering new licences and converting some AM licences. It is possible that this might change the industrial conditions and threaten the dominance of AOR FM programming. So far, this has not happened. Indeed, in Brisbane, where the new station BIO5-FM challenged long-time market-leaders Triple M,

the new station simply copied the format of the older station and took the precaution of poaching key on- and off-air staff to help them get it right. Triple M buckled, moved its format slightly downmarket and lost nearly 50 per cent of its audience share.

The wholesale conversion to AOR music programming has also seen significant changes in the way playlists are produced. Where once record sales were carefully monitored to produce the playlist and the weekly Top 40, both record sales and Top 40 placings are of limited relevance now. As Greg Smith, Austereo's national programme director, puts it: 'Five years ago, before radio was so research oriented, stations could just do Top 40 stuff and play the hit songs. . . . Now, the number one song is not always suitable' (Kerekas 1990). Now it is possible to have a big hit (saleswise) and not get any airplay on the FM band; Australia's sweetheart, Kylie Minogue, had a number two in 1988 without airplay and has faced, increasingly, the same problem with every single since then. Mike Perso, programme director at FOX FM in Melbourne, argues that 'What people buy in record stores is not what they want to listen to on radio. We are anxious to get as much new stuff on as possible, but only if the audience can tolerate it. We are guided by our research . . . it says we are doing what they want' (Davis 1989). We will get back to research and 'doing what they want', later.

As Perso's remark might suggest, there has been a change in the construction of the audience for whom the playlist is produced. Like teen radio, AOR FM has catered for an ageing demographic; unlike the audience for teen radio, however, FM's audience does not seem to change its tastes or look for the thrill of the new. FM's audience listened to the Eagles in the 1970s on its record players, it tuned in to FM in the 1980s so it could listen to the Eagles on its car radios, and now it is the 1990s it *still* wants to listen to the Eagles – perhaps so it can remember the 1970s. According to Greg Smith, FM's problem with new music is the 'large age-group for which radio caters: '"Our audience is basically under 40 years. The problem lies in the fact that while under-17s enjoy a particular type of music, this has a turn-off factor for the older age groups. In the meantime, if we programme music aimed at the older age groups, the under-17s don't mind it either"' (Davis 1989). Once the teenage market was seen as lucrative but industry wisdom now says otherwise; teenagers are considered to have limited spending power. Currently, the young adult demographic is driving the market because it is thought (wrongly, according to some research) to have the most disposable income of any social group (Shoebridge 1989).

None of these changes has occurred without being noticed or resisted. *Rolling Stone* devoted an editorial to the issue back in 1988, newspaper features have attacked the trend to 'radio bland', columnists have accused radio of shooting itself in the foot by disenfranchising a key section of their

constituency, and meetings have been called to protest at a related change of format for the ABC 'youth' station Triple J (about which more shortly) (Creswell 1988; Davis 1989; Shoebridge 1989). Pop enthusiasts have lamented the 'tranquillization' of the 'wild and woolly beast' of rock'n'roll and the purveying of 'pap'; 'now', says rock historian Glenn A. Baker, 'you don't hear much that makes you glad to be alive' (Davis 1989). In *Radio in Australia* (1989), John Potts attacked the state of music radio as deeply conservative in its lack of encouragement for Australian musicians, the sameness and repetitiveness of formats, and its sexism; all of these problems are much worse now than when he wrote his book. But while many in the industry are prepared to admit that the situation should not be 'allowed' to continue, no one is prepared to be the first to break the mould, change to a more adventurous format, and risk taking a bath in the ratings. No one denies, however, that the move from a rock/youth/pop/singles-oriented music market to an oldies/older/album-oriented market has profound consequences for the music industry as a whole, not just music radio.

Symptoms of analogous situations are visible in other national industries, and certain of the causes of the Australian situation have their roots outside the Australian context. The demographic 'creep' which has afflicted the rock and pop radio audience is a phenomenon radio stations everywhere confront. Stephen Barnard describes such a condition in British commercial radio:

> Here in the late 1980s, radio gatekeepers increasingly find themselves wrestling with an ever-growing, ever-ageing audience made up of many different musical communities. The old homogeneity – or what the programmers always assumed was a homogeneity – of tastes began breaking down around the time that punk made its breakthrough, and one solution (strengthened, of course, by commercial consideration) has been for ILR stations to narrow their demographics still further.
>
> (Barnard 1989: 134)

The effect of such strategies has been particularly severe for the market once assumed to be the objective of radio's commercial intentions – teenagers. In addition, this dismantling of the teenager as a market entity has not been confined to radio:

> The early years of the 1980s have seen fairly dramatic declines in the circulation of teenage publications, the closure of youth-oriented stores like Now, and a marked drop in the purchase of records by young people, while the decline (of 28 per cent) in the teenage population projected for 1984–94, coupled with the likelihood of continuing high levels of youth unemployment, has been enough to

146

prompt fashion manufacturers and the music industry itself to investigate other, in the long term clearly more profitable markets.

(ibid.: 176–7)

The elision between youth fashion and 'work-out' wear which collapses the teenage market into an adult, yuppie market seems to be one of many further instances of this significant cultural shift.

Among other transnational factors, the role of music video in the modification of music radio should also be considered. In Australia, one newspaper article on the 'blanding' of radio accused music videos of 'killing the radio star', and there is some truth in this accusation (Barber 1988). Internationally it is the case that radio no longer 'breaks' new acts as once it did, and that some of this power has been transferred to video. Correspondingly, radio has retreated from the domain of 'the new' into that of nostalgia, the 'classic track'. John Potts notes the fact that the 'proportion of old songs to new, played on radio, has increased as rock music itself has aged':

Emphasis on nostalgia – the 'golden age' of rock – has grown while TV video shows and dance clubs have to some extent usurped radio's role of breaking new hits.

(Potts 1989: 40)

Simon Frith has argued that the rise of music video has also supplanted traditional 'youth' television. Such shows as *The Tube* in Britain and *Countdown* in Australia have disappeared. Their disappearance is connected to another disappearance – that of clear differences between the way TV addressed its youthful audience and the way rock music constructed this same audience: 'the audience for rock and the audience for TV are set up to be the same thing' (Frith 1988: 214). This represents a fundamental change in rock music's relation to its audience, and I will return to this topic towards the end of this chapter.

Although such transnational shifts are implicated in it, the death of teen radio in Australia has been substantially influenced by local determinants. The last three or four years in Australia have witnessed a major series of shake-ups in the media industries – shake-ups which have largely been at the level of ownership and, consequently, have affected profitability but which have also had significant effects on the nature and distribution of media products. Among the factors which concern us in this discussion are changes in industrial structure, and in the relation between radio and national advertisers.

In 1988 the federal government announced its National Plan for the Development of Metropolitan Radio Services. Among other things, this plan involved the staggered introduction of new commercial FM licences in each metropolitan market, as well as the conversion of some existing

commercial AM licences to the FM band. Licences were to be awarded by tender, with the licence going to the highest bidder rather than to the best prospective service (as had hitherto been the official practice). The incentive of a spot on the FM band was exploited shamelessly by a government keen to hose out some of the weaker AM stations and to claw back some private money through the auctioning of the FM licences.

The environment into which this plan was introduced is important. Already, another separate government intervention had increased competition for national advertising. The so-called 'aggregation' or 'equalization' of regional television added a new station to most non-metropolitan markets by aggregating the services supplied by several stations in hitherto separate markets; its most immediate effects were to threaten the viability of all local commercial TV and to install the first genuine television networks in Australia. Aggregated regional stations no longer served their area as directly as before, they were linked to a network which sold its advertising time nationally, and they were in pursuit of the same advertising dollars traditionally claimed by metropolitan stations. Competition for media advertising across the board increased dramatically.

If regulatory policies had turned up the heat on media proprietors, other commercial pressures were also making business difficult. The late 1980s media shake-up had been about changes in ownership – changes inspired by high levels of debt in cash-poor industries and a rash of curiously naive personal infatuations with the putative power of the media. Extraordinary as it may seem, between 1986 and 1990, the majority of radio and television stations in Australia changed owners; the majority of the new owners had no previous interest or experience in the media. The oldest and largest radio network (Macquarie) was stripped of its assets and sold off in bits. Two of the three national television networks went into receivership, and the much-vaunted Aussat satellite delivery system, upon which the policy of aggregation (and the future of Pay-TV) had been built, was put up for sale. By the end of this period, it is entirely understandable that those media proprietors left in business were not looking to take risks.

The result of the National Radio Plan in such an environment has been seriously to threaten the profitability of many radio stations. Competition for advertising, high levels of debt installed with the change of ownership, exploitation of the cash flow of radio to support the agglomerated interests of the new owners, inflated prices paid for FM licences as a consequence of the controversial tendering system, and the continuing uncertainty about the regulatory (or deregulatory) climate – all of these have increased an already conservative competitive culture's wariness of risk-taking and contempt for the government's ability to think through policy issues. So profound has been the suspicion and concern that even the lure of the FM licence has lost its lustre. As the prices paid for licences have soared, a number of applicants for conversion from AM to FM have decided the

costs are simply too high and have withdrawn from the auction. The National Radio Plan looks set simply to consolidate the power of the major FM networks, thus defeating its policy objective of opening up the industry to new players; and it looks like destroying that sector of the market it sought most to deregulate – the AM band. The plan is probably unique in that it has suffered the disadvantages of overregulation and deregulation simultaneously. One cannot entirely blame the government, however, as the new media owners have contributed to their own problems through their absurdly high debt levels, naive expectations of the profitability of their purchases, and their complex corporate structures which tied all of their enterprises into one, potentially disastrous bundle. Whatever case one wants to make about it, it is clear that the media environment over the last few years in Australia has been bizarre by any standards. Rather than settling down to normalcy, however, the climate of uncertainty within the industries now seems to have been more or less internalized as a fact of industrial life.

Ironically, during the mid-1980s the trends had all been going the other way. There had been a noticeable 'demassification' of radio, with radio's dependence on local advertising growing – television was the major carrier of national advertising – and its relation to its audience taking on increasingly local and regional discourses. Sydney had a station which talked only to the western suburbs; the ABC's youth station, Triple J, had established a secure audience for 'serious' rock music and a reputation for breaking classy Australian bands (Midnight Oil and INXS are among the bands usually cited); and FM was soaking up those who liked rock music but no longer cared about the hit parade. In five years this trend has been turned around: all radio stations seem to be competing for the same audience and thus the same advertisers, radio's share of national advertising has increased dramatically, and attrition among the media owners has turned Australian FM radio into a duopoly.

Of all the local factors contributing to the death of teen radio, the one which interests me most has had the most direct effect on the narrowing of playlists, on discursively framing the radio audience for music programmers, and on the production of the individual station's image. This is the move away from programming by record sales and 'gut instinct', away from a tight articulation to the record companies, and towards a major investment in a particular kind of audience research. Once a relatively routine industrial practice, these days audience research is 'what's hot' and those who aren't into it yet are planning to get into it as soon as they can.

As I noted earlier, monitoring record sales used to be seen as the normal way of keeping in touch with the music audience, but all that has changed. Music radio no longer understands its constituency through musical categories, and no longer measures it through record sales. Nor is it interested in building a reputation for tipping hits, for keeping ahead of tastes;

instead, the idea is to 'track' tastes, following them up and informing advertisers of their connections with other aspects of 'lifestyle'. Playlists no longer change weekly in response to the movements in the charts; most changes now are modifications of the rate of rotation (the number of times it is played over 24 hours, or over a week) of particular tracks on the list. It is a shift the industry talks about explicitly and confidently; typical is this brief history from Greg Smith of Austereo:

> In the 60s and early 70s contemporary music stations heavily relied on gut instincts and Top 40 charts, based on information supplied by record retailers, to construct a playlist.
>
> As more radio stations came into the market, it became apparent that you couldn't be all things to all people and specific targeting was born. The quest for more information really came to the fore in the late 70s, and with new programming methods.
>
> Today, stations vary in the way they create playlists. Factors they consider include chart information, station image, requests, national trends, artists' previous track record, music videos, gut instinct and callout (music) research.
>
> <div align="right">(Smith 1990: 38)</div>

Interestingly, he explains the shift through reference to more individualized, tailored, less 'mass' programming – even though the programming which results is less varied and serves a wider demographic than previously.

While most stations use a variety of research methods – focus groups, auditorium music tests, audience tracking, and 'lifestyle' research – it is the callout research which I consider the most significant influence in this programming strategy. Callout research involves playing the hook of a song or series of songs down the telephone to listeners. The song hooks are very brief – say, 10 seconds in duration – and respondents are asked questions to determine the degree of recognition, popularity and 'burnout' produced by that particular track. The method is of little use for new music, and is primarily used to determine the rotation of a track already on the playlist. Callout research has not only established recognition as the primary determinant in programming decisions, but it has also 'bred' new forms of programming. The installation of 'feedback lines' (answering machines on which listeners can record messages which later go to air in small batches), the promotion of listeners' polls on 'fave tracks', and lately the broadcasting of listeners' comments collected during polling, have incorporated audience research into programming content itself while offering the audience direct participation in the playlisting of records for its station. In all cases, this audience research is an enquiry into what is *already* being played, into what is *already* recognizable, into what the audience *already* likes about the station.

The conservatism of Top 40 playlisting has long been a standard target for critics of music programming on radio (Barnard 1989: 118, 127). Indeed, in Australia, FM radio originally established itself in opposition to Top 40 playlists, and the high-powered advertising of teen radio. FM's early playlists were broader and more varied, the rate of rotation was low, and the number of advertisements was comparatively restricted. But traditional Top 40 playlisting was downright eclectic compared with the rigidity of the programming currently being produced by callout research – a playlist which endlessly reproduces the same classic cuts, the same 'hits' over and over again not just day after day but month after month. Indeed, the predictability of FM programming has been so firmly established in our cultural inventory that it is the subject of an elaborate parody on Australian TV: in the ABC's *The Money or the Gun*, the same song is performed over and over again, week after week, by different artists and in different generic arrangements. The song is that staple of FM radio, Led Zeppelin's 'Stairway to Heaven', and it has so far been performed by a wide range of singers – from gospel groups to Rolf Harris.

Callout research does not just call up the listener, it calls up the past. The playlist it delivers privileges not the new but the nostalgic, not today but yesterday, not 'now' but 'then' – narrowing the discourses of rock music, and the thematics of radio. These privileged discourses and thematics are not at all consonant with those of youth cultures generally, and certainly not easily contained within the conventional discourses of the teenager. Unlike the wider economy of pleasures within popular culture – where the familiarity of repetition competes with the possibilities of the new and the unfamiliar – the pleasures circulating within music radio now are highly regulated. Those on offer are almost entirely familiar, ritualized, self-reflexive, celebrating the already known and recognized over the unknown, the 'yet-to-be-recognized'.

The rationale for this new regime in music programming has already been invoked in this chapter – 'giving people what they want'. Mythologies about the new market context – the fragmented, fiercely competitive market which demands fine tuning of the format – have built up rapidly; consequently this homogenizing, conservative programming strategy can be represented as a modern (even postmodern), scientific, responsible (because responsive) and professionalizing development in an industry hitherto resistant to change. The special status of rock music and in particular the special factors previously assumed to structure the relationship between rock music and its audience are set aside as romantic nonsense so that music programming, and rock music itself, can be understood, simply, as entertainment. The licence for this is 'what the audience tells us', the motivation impeccably democratic.

The 'recognition factor' foregrounded in callout research narrows the definitions of 'acceptable' music within AOR FM programming. Much new

music, such as English House music, has little chance of being heard. Even major international acts who do not fit the format, such as Madonna, Michael Jackson, or Prince, do not receive airplay. One might think that local acts are likely to be better served. Australian artists are protected by a quota which stipulates that 20 per cent of music played on radio has to be local in origin; however, this quota can easily be achieved through the rotation of 'classic tracks' and very little new Australian music makes it on to the radio at all:

> The dilemma for bands, especially for those new on the scene, is that they cannot 'make it' unless they receive airplay, but the present obsession with 'old is best' ensures that stations will not play records unless the artists are already recognized.
>
> (Davis 1989)

As we know, in all music formats, which artists are already recognized, and what systems of repetition they set up, limit the kinds of new material likely to be heard. In FM now, the system itself is shrinking:

> But it is not only the hits of former years now receiving the majority of airplay; it is also the 'old style' of music. 'At the moment, if you are not basically the old type of pub rock, you won't make it' says Ian 'Molly' Meldrum, Australia's original rock guru and former *Countdown* anchorman. 'Look at Johnny Diesel, Jimmy Barnes, Noiseworks. What annoys me is there are so many forms of music that have been developed in this country which just aren't being played.'
>
> (ibid.)

Where once such a problem might have affected only the 'alternative' or 'serious' bands such as Midnight Oil or Painters and Dockers, this current situation also affects teen bands, pop bands with no other thought in mind than chart success. Teen acts – Kylie Minogue, Jason Donovan, Indecent Obsession – might be seen frequently on TV but they cannot get played on radio; it is a curious phenomenon that sees a hitherto dominant mode of entertainment being silenced on the very medium through which it established itself. Indeed, it might be tempting to argue that this is no great loss. If Midnight Oil gets played instead of Kylie Minogue, how can that be bad? The dominant musical mode has been displaced, so why try to revive it? However, 'the dominant' is not a textual form or a musical genre, it is a structural relationship; and teenage music now occupies the structural position it held in the mid-1950s – when it was subordinated, repressed, and thus potentially subversive.

The paradox underlying all of this is graphically demonstrated by the upheavals in the 'alternative' youth music station, Triple J. Triple J's discursive and institutional origins are in the 1970s, servicing an audience

which would not have been seen dead buying a charting single, saw rock music as an ethical and political force rather than a medium of entertainment, and wanted a radio station which catered for a range of specialized but related tastes. The context for such a station has changed radically, since the really marginalized audience now is the chart-watching teenager. As Neil Shoebridge has argued, radio is in danger of alienating a whole generation of listeners who find little on the airwaves to attract them or within which they recognize themselves: 'the bonding that took place between a teenager and his/her radio station ten years ago does not happen today' (Shoebridge 1989). Triple J has recently undergone a change of format, sacking some of its most senior on-air staff and announcing its intention of targeting an audience of 15–24-year-olds – a move down the demographic ladder, if not an unequivocal commitment to the teen radio audience. While this has been attacked as a sellout by the station's traditional supporters, it can be seen as a logical move if the station still wants to provide an alternative to the dominant patterns of commercial programming. The fact that this has coincided with a move to network the station nationally, and with the hiring of a former commercial FM station marketing consultant, has meant that it is widely considered to be 'caving in' to ratings. The strategy seems more complicated than that, however; at the least, it acknowledges the disenfranchisement of a large section of the radio audience and attempts to do something about it.

Teen radio has been crucial to the development of rock music, although one is wary of essentializing assumptions generating nostalgia at the passing of a particular form of music radio. There is a case, though, for reviewing some of the connections between this audience and the music. Among the important aspects of teen radio was the clear definition of an age group and a group of subcultures as the target for the music. This provided the substance for some of the identifications between rock music and resistance that Larry Grossberg has interrogated (Grossberg 1989). Rock music has repeatedly represented itself through signifiers of a politics of resistance, of opposition to straight, adult, mainstream culture. Of course, while it did this through a mainstream capitalist industry tied directly to the major communication and retailing networks it could hardly be entirely convincing, but it became an important signifying strategy within rock music's construction of itself. The politics of resistance might have been connected with some 'golden age of rock' in the past, and there has certainly been a continuing dialectic of resistance and incorporation in the history of the relationship between small independent recording enterprises and the major players in the industry; but among the formations which supported a view of rock and pop music as intrinsically oppositional was the homology argued to exist between the music and its major audience – teenagers. The raucous, pervasive, invasive and eroticized pleasures of rock music and of teenagers in general were found on the same

cultural terrain and thus meant many of the same things. As rock music has become music for adults, it has cut itself off from such associations: it has acquired aesthetic traditions and pretensions, it has increasingly separated melody from rhythm as its central formal element (so it is possible to like a wide range of rock music from Talking Heads to Billy Joel but hate the very sound of rap), and video and radio have increasingly displaced the live event as the medium of circulation to the adult fan.

Most importantly, though, the privileging of the new, the relentless cycle of fashion itself, seems to have been most firmly embedded in rock music when it was constructed as a teenage/youthful/resistant form. In audience-researched radio, the new is something to be approached with caution – and then often awkwardly and incompetently: Steve Barnard uses the example of ILR's failure to deal with punk when it arrived. At a time 'when pop music was opening up in a participatory sense, with new bands proliferating and new venues and recording outlets . . . springing up to service them', local commercial radio in Britain was worrying about alienating its mainstream audience. Its failure to understand punk led 'to a loss of credibility among younger audiences' (Barnard 1989: 133–4). The caution he describes in the 1970s is even more apparent now, so that current Australian radio plays almost none of the music that dominates the dance clubs in the cities every night.

Teen radio does not seem to me to have been merely a stage in rock music's continuing journey towards maturity. Rather, I am inclined to agree with some comments Simon Frith has made – comments I rejected at first reading, but which seem entirely appropriate now:

> I am now quite sure that the rock era is over. People will go on playing and enjoying rock music, of course (although the label is increasingly vague), but the music business is no longer organized around rock, around the selling of records of a particular sort of musical event to young people.
>
> (Frith 1988: 1)

Frith suggests that maybe rock was the 'last romantic attempt to preserve ways of music-making . . . that had been made obsolete by technology and capital', and that its failure is clear in what is now the categoric 'reconciliation' of rock and capital. This is not to mourn the death of an 'authentic' rock culture, the scourge of other, more explicitly consumerist, popular cultures. Rather, it is to recognize what may always have been true, the fact that there is now very little difference between the rock music industry and (say) the television industry. Both are entertainment industries, they construct their audience in entirely similar ways. The expunging of the teenage niche is the last element, the removal of which collapses the industries together and makes nonsense of any vestigial romanticizing of rock music as in any way special. And while the effect on rock music may

154

seem important, the obliteration of the teenager as a market force may in the long run turn out to be the most significant cultural shift of all.

Saying this, I am aware how it attributes an inexorable logic to the market-place, how it throws music radio to the wolves. This should be corrected, since I am describing a set of programming strategies that are by no means natural or permanent, and a set of policy frameworks that are clearly neither. I am certainly not suggesting that intervention at the cultural policy level, for instance, is either unnecessary or futile. Rock music on radio in Australia is in need of help. Those in the industry admit it, the government claims it has already given it, and all wait for the mythical coming of the new players who might devise some new rules. The change in music radio formats in Australia has not simply been a case of the market having its way or of a new method of research inevitably producing programming formats; it has also been a case of a badly co-ordinated series of policy initiatives producing profound effects which have actually made it harder for the market to provide a living for those trapped in it. The death of teen radio is far from being the worst outcome workers in the Australian media have suffered over the last three or four years. But it does remind us that policy can initiate change, even if it also reminds us of the dangers of making policy without fully understanding the changes it is likely to produce.

BIBLIOGRAPHY

Barber, Lynden (1988) 'Video killed the radio star', *Sydney Morning Herald: The Guide* 2 June.

Barnard, Stephen (1989) *On the Radio*, Milton Keynes: Open University Press.

Creswell, Toby (1988) 'Editorial', *Rolling Stone Australia* 421: 9.

Davis, Kylie (1989) 'Tuning in to Radio Bland', *The Weekend Australian* 13–14 May: 6.

Frith, Simon (1978) *The Sociology of Rock*, London: Constable.

—— (1988) *Music for Pleasure*, London: Polity.

Grossberg, Lawrence (1989) 'Rock resistance and the resistance to rock', in Tony Bennett (ed.), *Rock Music: Politics and Policy*, Brisbane: Institute of Cultural Policy Studies.

Hartley, John (1987) 'Invisible fictions: television audiences, paedocracy, pleasure', *Textual Practice* 1(2): 121–38.

Kerekas, Andrea (1990) 'Why radio research now plays the tune', *B & T* September.

Peters, Bob (1990) 'A preliminary analysis of the impact of FM conversion on the Melbourne radio market', *Metro* 83: 33–7.

Potts, John (1989) *Radio in Australia*, Sydney: University of New South Wales Press.

Shoebridge, Neil (1989) 'Shoebridge', *Business Review Weekly* 11(42): 95.

Smith, Greg (1990) 'Radio research', *Metro* 83: 38–9.

10

FROM STATE MONOPOLY TO COMMERCIAL OLIGOPOLY. EUROPEAN BROADCASTING POLICIES AND POPULAR MUSIC OUTPUT OVER THE AIRWAVES

Roger Wallis and Krister Malm

Writing in a 1991 newcomer to the trade press, *Music Business International* (MBI), one Bob Tyler (described as a 'radio specialist') attempted a short analysis of the growth of European broadcasting (Tyler 1991). The radio explosion witnessed throughout western Europe during the 1980s, according to Tyler, followed 'two or three schools'. By 1991, the Italians and the French were 'already up and running'; the Scandinavians were 'late developers'. Tyler's explanation was that 'simply put, one school has suffered too much deregulation too soon, while the other has had too little too late'.

This statement caught our attention for a number of reasons. Many writers have documented the uncontrolled growth of radio (and frequencies used) in Italy (Grandi 1982: 2–7; McQuail 1986: 158–9). A factual aspect of Scandinavian relevance is that radio broadcasting in late-starting Sweden *has* increased from 20,000 hours a year back in 1970, when there were only three national channels, to a 1991 figure of over 400,000 hours. Some 300,000 of these new hours of radio are the result of deregulation: since 1980 non-profit-making associations have been allowed to broadcast via small, so-called 'neighbourhood radio' transmitters (Wallis 1990a). Sweden did not formally legalise commercially financed radio until April 1993 – in actual fact, numerous operators of 'pirate' commercial stations had experienced little difficulty finding suitable loopholes in the previous Neighbourhood Radio Law. Maybe the apparent absence of conventional commercial radio stations is what Tyler was referring to when he described Sweden as a 'late starter' in the European radio game.

Tyler's statement, in short, embodies some interesting assumptions about *deregulation*. One is that deregulation of the airwaves is a universal

European phenomenon which has been occurring at different rates in different countries, as governments have felt the desire to remove the protective status enjoyed by most traditional public service broadcasting institutions. At face value, we can agree with this. The deregulation fervour of the Reagan era in the US was eagerly administered by the Federal Communications Commission. Its head, Mark Fowler, is on record as stating that radio and TV receivers can be likened to any household appliance – a radio is a toaster with sound popping out of it (O'Connor 1987). These ideas caught on in Europe, where broadcasting has increasingly been regarded as 'an internationally tradable-service, as an industry, with viewers/listeners being redefined as consumers seeking an expansion of choice whilst programmes are viewed as products needing more coherent and aggressive marketing' (Dyson and Humphreys 1988: 306). Such trends were also supported ideologically by the publication of various tracts. Amongst the more notable are the volume *Freedom in Broadcasting* (Veljanovski 1989) from the Institute of Economic Affairs think-tank in London, and Elstein's paper calling for an 'end to protection' (Elstein 1986: 81ff).

It cannot be denied that technological and economic factors helped to make some measure of deregulation more or less inevitable. Satellites, transmitting first television and then radio programmes across frontiers, proved that national legislation could no longer protect a broadcasting corporation's monopoly status. Access to fairly cheap transmitting and studio equipment also attracted numerous entrepreneurs and enthusiasts wishing to have a go at radio. Radio was bound to grow irrespective of restrictions imposed by regulatory authorities. The Swedish government's apparent inability to adapt legislation and interpret policy in terms of changes in the media environment led to a situation in which the groups with the best financial resources and technical know-how rather than the democratically elected representatives of the people decided the pace of development.

By 1991, Swedish Neighbourhood Radio, conceived ten years earlier as the ultimate in decentralized, small-scale radio, had been more or less taken over by a few large organizations. The Board set up to oversee Neighbourhood Radio activities had become entirely toothless. Longstanding government policy to encourage media access to local music and culture suddenly lost its significance, with the Swedish music output of the old Broadcasting Corporation being dwarfed by scores of new stations playing non-stop international Top 40 hits.

Interestingly enough, a very similar development could be observed in France where small-scale Radio Libre became large-scale Radio Libre dominated by a few major chains of stations playing very little French music. Europe could hardly have ended up further away from the mid-1980s vision of two media researchers of 'a truly exciting future for radio

157

. . . local radio does not have to be boring, amateurish or trivial. Nor does it have to be the clone of the big city network pumping out an endless supply of plastic music presented by plastic personalities' (Crookes and Vittet-Phillipe 1986: 158). The contrary is exactly what has happened!

Let us return once again to our starting point, the statement by Bob Tyler. It encompasses further assumptions that deregulation is in the interests of the radio consumer (providing more freedom of choice), and that there is some *ideal* level of deregulation – this follows from his assertion that some countries have had too much and some too little. The *ideal* level, it would seem, would be that needed to create 'a stable media force'. Here, Tyler presumably means a medium organized to attract a sufficiently large part of the advertising cake to be able to pay for the running expenses of a large number of radio stations. He accepts, in other words, a close relationship between programme content and advertisers' willingness to buy time.

Those lobbying for deregulation (usually the same as those who wish to do business with radio, rarely groups representing radio consumers!) often use terms such as *freedom* and *independence*. Those keen to force the pace of deregulation frequently maintain that such terms are attractive alternatives to the values of regulated, public-service broadcasting. In a succinct analysis of such rhetoric, as it has featured in the Irish radio debate, Mulryan highlights its pitfalls:

> On the right, there is the risk that we get taken in by the fact that commercial radio never calls itself commercial, let alone capitalist. It uses public-relation type descriptions like *free* and *independent* and often contrasts itself to *monopoly* or *State* control. This is of course pure rhetoric. Their essential function is the generation of private profit for their owners' investment. By contrast, public-service institutions are in effect non-profit making, so that revenue is devoted almost wholly to production and the development of the service.
>
> (Mulryan 1988: 148)

Mulryan is also fully aware of the dangers of accepting too easily any assumption that there is a direct correspondence between the State and the public interest:

> The State and its authorities cannot be said to represent the entire warring chess board. As we scream towards the 21st century, the old one-dimensional identification of the State with public interest has become highly questionable. We are now in an era where market forces control the media and the access to the airwaves.
>
> (ibid.: 149)

We can add to Mulryan's observations two further points. Allowing more entrepreneurs to enter the fray does not necessarily mean that the listener

has a greater freedom of choice. An equally likely outcome is 'more of the same'. The same Top 40 fare is packaged in different ways, with different presenters/personalities; the differences are matters of style, not content. Maybe this is why statistics show that Americans who can choose from 50 stations only listen on average to 2.7 per week (PSI 1991: 44).

Another relevant fact is that radio listening at some point must reach saturation levels. Between 1985 and 1990, radio output in Britain increased by 65 per cent, but the average time spent listening increased by only 17 per cent. The number of listeners who listened to the radio on an average day was 78 per cent in 1987, a figure unchanged since 1980 (ibid.: 49–52).

Table 1 Radio listening and radio output in Sweden

Year	Radio listening		Radio production (hrs/week)			
	Average listeners/day %	*Average mins/day*	*National Radio*	*Local Radio*	*Neighbourhood Radio*	*Total*
1981	69	111	372	381	699	1452
1982	68	107	378	424	727	1529
1983	71	124	379	458	1175	2012
1984	65	NA	377	485	1423	2285
1985	73	131	377	607	2450	3434
1986	74	133	380	688	3055	4883
1987	77	129	380	858	3815	5053
1988	76	125	380	954	4686	6020
1989	77	134	432	1153	5033	6618
1990	78	132	432	1384	5250	7066
1991	NA	NA(est.)	430	1500	5700	7630

Sources: Swedish Radio's audience research dept (PUB), Neighbourhood Radio Board. Estimates of average listening figures are based on telephone interviews.

Similar trends have been reported from Sweden with the average radio listenership increasing from 73 per cent in 1979 (as local radio was introduced) to level out around the UK figure of 78 per cent by 1987 (the 1990 Swedish figure is, indeed, still 78 per cent!). Whilst radio output in Sweden increased from approximately 70,000 hours per annum in 1980 to almost 400,000 ten years later, an increase of over 500 per cent, the average time spent in communion with one's radio, according to the results of interviews carried out by Swedish Radio's research department, only increased from 115 to 134 minutes (Carlsson and Anshelm 1991: 166).

Table 1 illustrates the listening plateau. Increased output has led only to a minor increase in listening, and of greater interest in the context of music policy is the means used to create this explosive growth of output.

MUSIC ON THE RADIO IN SWEDEN

Sweden's three national channels consist of Programme 1 (mainly speech), Programme 2 (classical/serious music and immigrant programmes) and the 24-hour light music/pop channel, Programme 3 (P3) with a 70 per cent music content, which some 60 per cent of the population say they listen to at least once a week. Swedish P3 predates the BBC's Radio 1 but was also created when legislation forced maritime pirate radio stations off the air (to advertise on such stations was made a criminal offence). The establishment of such a channel in the late 1960s marked a shift away from an educational view of radio to one where entertainment and relaxation were acceptable goals and rewards for broadcasters and listeners.

With the exception of the marginal effect of AM transmissions from Radio Luxembourg, P3 remained the sole popular music trend-setter in Sweden throughout the 1970s and well into the 1980s. The radical 'Swedish Music Movement', which emerged as a network of musician-controlled phonogram companies and music clubs around 1970, relied heavily on the support of a handful of producers/presenters on P3 exposing their musical products, even though the management at the time was less than favourably disposed to any songs sung in Swedish which questioned the *status quo* (Wallis and Malm 1984: 121–31). Throughout this period the channel devoted substantial pecuniary and technical resources to recording its own live sessions, thus in effect decreasing its dependency on the commercial phonogram industry for programme material and actually increasing the amount of local/national music on the channel (most live sessions featured Swedish artists and music).

Several developments in the early and mid-1980s were to change the status of P3. Satellite channels brought the latest pop songs by superstars to a growing number of cabled residential areas. Swedish rock and pop fans no longer had to rely on their national radio channel to find out the latest about international music show business. 'Local' radio was expanded as the country was divided up into twenty-four local radio regions. Neighbourhood radio was beginning to grow – all the newcomers realized that recorded music was the cheapest filler of time. National radio was slow to adapt to the new situation.

Sweden's twenty-four local radio stations are public service, non-commercial entities organized within the Swedish Broadcasting Corporation. Most of them got their own transmitters and exclusive frequencies in the latter half of the 1980s – this explains the rapid growth in their output. With the public purse getting squeezed for public service broadcasting, little money was available for programme production on local radio. Output was maintained, as one might expect, by playing more commercial phonograms. Gramophone records accounted for 1,500 hours or 7 per cent of local radio output when the first stations opened back in

1979; by 1990 the figures were 24,000 hours per annum or 33 per cent of output (Sveriges Radio 1990).

Large blocks of transmission time filled mainly with popular music on disc also accounted for the rapid growth in Neighbourhood radio from 1985 onwards – most of these operators could be termed as 'pre-commercial', in other words, they were using the Neighbourhood radio structure to prepare for and establish their role in a future Swedish commercial radio environment. That Neighbourhood radio after ten years of expansion bore little resemblance to the original political intentions (it was meant to be a small-scale electronic notice-board for local activities) did not seem to worry the country's media politicians; they too were caught up in the 'freedom' and 'independence' euphoria. Certainly in Sweden, the notion of media activities being in the interest and service of the general public has waned right across the political spectrum.

MORE RADIO – MORE OR LESS CHOICE?

From the above data it stands to reason that if 'increased choice' is a reality, appreciated by the listeners, then audiences for each programme must get smaller, which in turn will mean smaller resources for programme production (since advertising revenue is so closely linked to audience size). The same goes for traditional public service broadcasters if increased hours of transmission take precedence over maintaining quality and investment levels. Cheaper technical costs for making programmes resulting from easier access to low-price/good-quality technology can hardly compensate for the relative drop in programme-making funds when increases in income do not keep pace with increased hours of output.

The public service ethos of determining programme costs independently of expected audience size has little or no relevance in a deregulated radio environment where market forces rule supreme. Far too often, quantity rather than quality becomes the guiding principle of broadcasting policy – perhaps this is one reason behind the apparent demise of public service broadcasting. At any rate, neither public service minded politicians nor existing public service broadcasters have been particularly adept at bringing the flaws in the freedom/independence debate to the attention of the general public. Those entrepreneurs who have declared that the concept of public service is outdated or even irrelevant have met with very little opposition from the arts community or even from groups of concerned citizens in general.

This is not to say that music dissemination in the old days of European monopoly broadcasting corporations was without its problems. Such corporations were rarely the first to give airtime to new forms of pop and rock music. Their studio doors were opened only after a groundswell had been created on the live circuits or via phonogram sales. Concern with the moral

or artistic standards of the nation was often cited as a justification for their reticence in these matters. Producers regarded themselves as reflectors of events in the entertainment industries rather than discoverers, initiators or supporters of creative activities in the broader field of popular culture. Enjoying protective monopoly status, they could reside safely in their ivory towers. Morgan, in a provocative outburst, has thus described the BBC as an operation 'infused with an interesting mixture of arrogance and panic, plus a degree of paranoia' (Morgan 1986: 23).

With other players entering the arena, the protected status of public broadcasters can no longer be taken for granted. Surviving institutions which rely on licence fees to keep themselves afloat have been faced with a dilemma: namely, whether their primary goal should be to retain audiences, or whether it should be to maintain a strictly public service structure, producing programmes the broadcasters think are good rather than programmes they think will achieve high ratings. Occasionally the two goals are compatible, but almost all public broadcasters see their national pop music channels as means of retaining the mass audience, which not infrequently means offering the same musical fare as their new commercial competitors. The argument is that by proving to the politicians that they can run a popular music channel attracting the masses, public service broadcasters can persuade governments to go along with licence fee increases to pay for the more expensive, more elitist speech and classical music channels. This view is strengthened by the belief that popular music is entertainment rather than culture, that pop records merely provide a bridge between two pieces of speech output. Keeping the listeners at all costs is seen as a more important goal than, say, developing a national pop channel with a distinctly national cultural profile. This has certainly been the case in Sweden and many other smaller European countries.

Sweden's P3, for instance, did not react to the fourfold increase in small radio stations playing mainly international Top 40 material by changing the make-up of its own music output. Changes applied, rather, to the style of presentation. Competitions with give-aways such as P3 T-shirts, bags, radios, etc. became the order of the day (a policy also chosen by the channel's new, small-scale competitors). From 1984 through to 1988, a heavy reliance on international Anglo-American hits remained more or less stable – even a growing interest in World music was hardly reflected in programme statistics (see Table 2). Swedish music content actually dropped, in spite of a clause in the Corporation's new 1986 franchise, the so-called Swedish Radio Law, demanding that action be 'taken by the Board of Governors should the Swedish content of programmes decrease'. There was no discernible effort to create a new *national* music policy for this channel, to give more prominence to local and national music, despite much lobbying from the Swedish music community (including a two-day

strike at Midsummer, 1989, when Swedish composers refused to allow the national radio channels to play their works).

Table 2 underlines the remarkable stability in the output of P3 as regards Anglo-American content. The only discernible trend (in the breakdown of genres) is a move towards more pop, possibly at the expense of popular classics. This reflects a move in programming towards a slicker, more up-tempo presentation which is facilitated by pop hits rather than by playing more selections of either Heavy Metal rock, raucous punk or Middle of the Road, Henri Mancini-style evergreens.

Table 2 Music output of Swedish national radio, P3, by country of origin and music genre

Country of origin of phonograms	% of phonograms played on P3			
	1984 March	1986 October	1987 October	1988 October
Sweden	29.1	35.1	35.5	33.9
Scandinavia	3.4	3.2	2.6	2.2
UK	17.8	16.1	17.5	17.0
US	33.9	32.0	32.3	34.8
W Germany	3.0	2.1	2.3	2.1
France	2.7	3.1	2.6	2.6
Italy	1.7	1.3	1.1	1.2
rest of Europe	5.8	3.5	2.4	2.8
rest of world	2.7	3.6	3.7	3.3

Genre of music played	% of phonograms played on P3			
	1984	1986	1987	1988
General light music	33.6	39.1	36.0	36.9
Pop	25.9	28.9	34.6	29.6
Rock	16.1	11.3	10.8	12.4
Jazz/country	16.1	13.8	14.8	16.8
Easy classics	6.5	5.5	2.3	2.0
Signatures	1.4	1.4	1.5	1.3

Source: Statistics from Sveriges Riksradio (Swedish National Radio) based on annual three-week samples. Phonograms have accounted for approximately 90 per cent of music output on P3 throughout this period.

Up to 1992, Swedish National radio did not have two popular music channels and thus, unlike the BBC in Britain, could not divide popular music output into channels for older and younger age groups. This changed in early 1993. P3 became an exclusive channel for younger listeners; the management defined them as being 'under 37½' years of age (a somewhat artificial limit conceived by statisticians at the Corporation's audience research department). Music for older listeners was moved to non prime-time slots on a new channel, P4, created by amalgamating the existing local or regional stations. Prior to this change, a manager in the P3 organization had maintained:

This is the first time we've experienced real competition. We will continue to be the only national channel. The bigger artists will prefer to be interviewed by us. Our new magazine programme won't be a reservation for odd music styles, it will present a mix of music which is more exciting than that offered by SAF-radio . . . if we look at Programme 3 as a whole, it looks as though programmes which don't have high ratings will either have to be moved to other times, discontinued or changed.

(Kearly quoted in Dagens Nyheter 1991: B4)[1]

The above statement hardly indicates a rejuvenation of the concept of 'public service' broadcasting amongst those in charge of P3. The sole aim is to beat commercial competitors by doing the same thing (but better). There is little room in such a policy for specific cultural obligations towards local or national popular music.

Indeed, it is hard to find any link between the ups and downs in the output of Swedish phonograms on Swedish national radio and the output of the Swedish phonogram industry during this period. New releases of Swedish LPs remained constant at around 700 per annum during the three years 1986–8, thanks in part to a system of production grants linked originally to a tax on blank tapes. Subsidies cover, on average, about 41 per cent of production costs for around 100 Swedish LPs per annum (Kulturraadet 1989: 50). The majority of these subsidized LPs, however, received little radio exposure and were sold in small quantities (on average less than 3,000 copies during the first year of release). Official cultural policy in Sweden to support local phonogram productions was thus not 'in tune' with the cultural policy being exercised by gatekeepers within the country's public service broadcasting organization. The latter gatekeepers would no doubt maintain the irrelevance of this observation – their job, they would say, is to choose the records they think the radio public might enjoy, not to serve the ends of cultural or industrial policy.

1994 will see yet another phase in the Swedish move towards near-total deregulation of radio. Franchises will be sold off in public auctions (an approach which was proposed, but later dropped by the Thatcher government in the UK). One can predict that this will force radio stations to play the cheapest music, for instance, where copyright dues are low or absent. Another prediction is that unwise and badly managed bidders will win and then go bankrupt (Tunstall 1992).

DEREGULATION: COMMON EUROPEAN TRENDS

The observations and postulates above do not apply only to a Swedish or a 'small country/small language area' situation. There is plenty of evidence to suggest a common trend in the European deregulation of radio; an

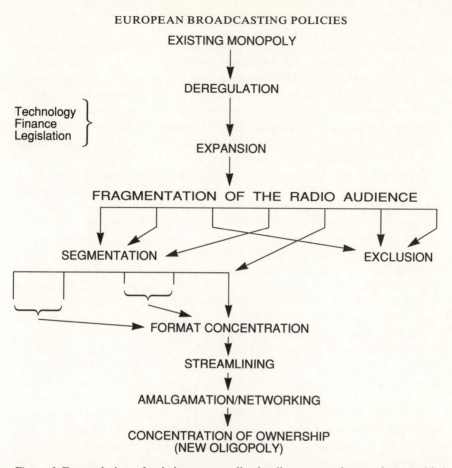

Figure 1 Deregulation of existing monopolies leading to new forms of ownership/ format concentration

initial increase of available programming soon reverts, via a process of streamlining, into an output with relatively few choices, but with a regrouping of the power structure as regards those who control the media. As regards music output, this has not led to the great plethora of voices, sounds and styles which the fans of deregulation promise under the 'freedom of choice' umbrella. Figure 1 represents our attempt to chart the development of popular music output as channels increase, as formats come and go, and as ownership and control moves from one power centre to others.

Deregulation fervour eats away at the protected status of traditional national public broadcasters. The prime movers are not just market economists and entrepreneurs looking for new business opportunities; the record industry and even pop and rock enthusiasts preferring the anarchistic route of pirate radio have also hastened this trend (cf. Mulryan 1988; Wallis 1990a). At times the public broadcasters themselves have probably contributed to the process through arrogance and aloofness.

The mode of *expansion* is affected by a number of variables. Access to *technology* and *finance* are the most important; *legislation* can limit the speed of expansion but only to a certain extent. In the absence of restricting legislation (such as franchise application procedures for attractive frequencies which place stiff demands on would-be operators), those with financial and technical resources decide the rules of the game. The same applies if legislation is out of date, inappropriate for the technical realities of satellite distribution, for example.

Expansion of services leads to a *fragmentation* of the audience as a large number of new and different programmes can be heard. Some become more popular than others leading to a *segmentation* of services. Programme styles and contents which are assumed to be more likely to attract listeners tend to dominate. Others die a quick death leading to *exclusion* of certain music styles (cf. Wallis and Malm 1988: 272).

As audience ratings come through, the process of *format concentration* (e.g., Golden Oldies/Top 40/Middle of the Road) increases. *Streamlining* of output continues as less commercially successful stations observe and copy more successful ones. The strength of this process has been thoroughly illustrated in Britain where a number of licences have been granted to so-called 'incremental stations' based on franchise application promises to play certain non-mainstream styles of music. Most of these have departed from their stated intentions during peak listening hours, playing run-of-the-mill Top 40 material to attract advertising revenue.

By and by, stations with high ratings generate a substantial income and those with financial resources attempt to take control. This leads to a process of *amalgamation* through *ownership concentration*. In the European context, this brings us back more or less to square one. The monolithic, monopoly corporation has been replaced by a new, small group of commercial owners.

If national, non-commercial radio channels merely see their role as to compete on the same terms, with similar formats and styles as their commercial counterparts, then there can be little reason to support their continued existence. If, on the other hand, they can give new life to the concept of 'public service' broadcasting, widening horizons rather than giving more of the same, then a new lease of life could be around the corner. Some restructuring of our broadcasting institutions, however, will be inevitable. Not only will attitudes have to change, but also work practices.

Public broadcasters will also have to question the role they should play in the music industry as a whole, particularly the nature of their mutual dependency on or informal integration with the phonogram industry (Wallis 1990b: 39). The phonogram industry is relying more and more on secondary sources of income, for example via publishing and neighbouring rights, rather than earning its money solely through sales of phonograms. In

Sweden, such secondary incomes almost balance the profits earned from selling vinyl discs, CDs and recorded cassettes (Wallis 1991). Dues radio stations have to pay for playing commercial phonograms can be expected to rise sharply. At some point, recording and transmitting live music sessions might become an attractive financial proposition – this presupposes the use of modern small-scale, high-quality technology which is less labour intensive and requires less studio space. This is an area in which our traditional broadcasters with their large buildings and work-forces have found it hard to adapt to modern times and opportunities. Success, however, could provide a unique new competence.

One small caveat must be added at this final point. Should national radio channels assume 'responsibility' for popular culture, then an overdose of patronage might be an unwanted and unexpected side effect. If BBC Radio 1 had been willing to give immediate heavy rotation treatment to, say, the Sex Pistols' 'God Save The Queen' the day it was released, then the disc would probably never have been conceived. Popular culture, if it is to be progressive, must embody an element of opposition to the establishment, provocatively questioning the *status quo*.

NOTES

1 SAF-radio is the collective term for neighbourhood radio pop stations in Sweden's three largest cities paid for by the Swedish Employers Federation as part of their lobbying campaign for the introduction of commercial radio in Sweden.

BIBLIOGRAPHY

Carlsson, U. and Anshelm, M. (1991) *Media Sverige '91*, Gothenburg: Gothenburg University/Nordicom.

Crookes, P. and Vittet-Phillipe, P. (1986) *Local Radio and Regional Development in Europe* Manchester: European Institute for the Media.

Dagens Nyheter (1991) *National Radio Aims for Young Listeners* (in Swedish), 21 July, B: 4, Stockholm.

Dyson, K. and Humphreys, P. (1988) *Broadcast and New Media Policies in Western Europe*, London: Routledge.

Elstein, D. (1986) 'An end to protection', in C. MacCabe and O. Stewart (eds), *The BBC and Public Service Broadcasting*, Manchester: Manchester University Press.

Grandi, R. (1982) *The Role of Local Radio in Promoting Creative Talents*, Strasbourg: Council of Europe, Council for Cultural Co-operation, Report CC-GP 11(82).

Kulturraadet (Swedish National Council for Cultural Affairs) (1989) *Music on Phonograms* (in Swedish), Report 1989 (1), Stockholm.

McQuail, D. (1986) 'Commercialization', in D. McQuail and K. Siune (eds), *New Media Politics*, London: Sage.

Morgan, J. (1986) 'The BBC and the concept of public broadcasting', in C.

MacCabe and O. Stewart (eds), *The BBC and Public Service Broadcasting*, Manchester: Manchester University Press.

Mulryan, P. (1988) *Radio Radio – The Story of Independent, Local, Community and Pirate Radio in Ireland*, Dublin: Borderline Publications.

O'Connor, J. (1987) 'The FCC designs a new toaster', *New York Times* 23 August.

PSI (Policy Studies Institute) (1991) *Cultural Trends 1991*, ed. Feist/Eckstein, London: Policy Research Institute.

Sveriges Lokalradio (1988) *Local Radio paa egen frekvens* (Local Radio gets its own frequencies), Stockholm: Swedish Local Radio Company.

Sveriges Radio (1990) *Government Funding Request*, Stockholm.

Tunstall, J. (1992) Official Letter to Swedish Society of Popular Music Composers, Stockholm.

Tyler, R. (1991) 'European radio's growing pains', *Music Business International* 2, April: 21.

Veljanovski, C. (ed) (1989) *Freedom in Broadcasting*, London: Institute of Economic Affairs.

Wallis, R. (1990a) *Music, Music Everywhere and So Much of it the Same*, Working paper 57, Gothenburg: Dept. of Journalism and Mass Communication, Gothenburg University.

—— (1990b) *Internationalization, Localization and Integration. The Changing Structure of the Music Industry and its Relevance for Smaller Countries and Cultures*, Gothenburg: Dept. of Journalism and Mass Communication, Gothenburg University.

—— (1991) *The Global Cultural Industries – Common Trends and System Defects*, Address to 6th International Conference on Popular Music Studies, IASPM, Berlin, July (publication pending).

Wallis, R. and Malm, K. (1984) *Big Sounds from Small Peoples*, London: Constable.

—— (1988) 'Push-pull for the video-clip: a systems approach to the relationship between the phonogram/video industry and music television', *Popular Music* 7(3), 267–85 Cambridge: Cambridge University Press.

Part III

ROCK AND POLITICS

INTRODUCTION

It is perhaps paradoxical, given the general concerns and structure of this collection, to have a section explicitly claiming the title 'rock and politics'. Many of the papers in other sections – and in fact, the other sections themselves – might legitimately claim the mantle of politics. What, then, distinguishes the five essays gathered here and justifies their immediate identification with questions of politics? What binds them together despite their different styles, discourses, and agendas – both theoretical and political?

The answer is deceptively simple: all of these essays start with questions of 'aesthetics' (even if some later reject these questions) or, more accurately, with the relationship between the textuality of music, style and performance on the one hand, and a socio-political reality which exceeds and escapes the musical text on the other. In more traditional terms, each essay begins with the question of whether and how one can read the politics of music off the musical text itself. Interestingly, all of the authors seem to agree, albeit in different ways and in different terms, that music does not innocently and directly reveal its politics to critical scrutiny. In one way or another, and to differing degrees, all of the authors argue that politics is not an aesthetic issue or at least cannot be approached in fundamentally aesthetic terms.

It is fair to say that each of the five essays wants to connect music to events, structures, struggles and developments taking place outside the sonorial world of music, if not outside the meaningful world of culture. In this, these essays all address the basic issue that has come to be identified with cultural studies: the nature of the mediated relationship between forms and structures of cultural practices, and processes and structures of social life. One way of treating these essays, then, is to read them as statements of diverse positions in cultural studies, diverse theoretical perspectives on the problems of reading culture politically.

Yet there is another way to read these essays, one more deeply rooted in the languages of popular music itself (although it actually marks the much broader terrain of cultural legitimacy and the debates that have constantly

171

tried to distinguish between folk, popular, middlebrow, mass and 'high' cultures). The key term here is 'authenticity' and it is interesting to note that this term appears in every one of the essays, and even where it seems to play a minor role (as in Bayton's and Grossberg's contributions), its force is still central if somewhat muted.

'Authenticity' is a slippery term for it maps two relationships simultaneously: on the one hand, it provides a measure of the relationship between a musical text or practice and its production. Here authenticity speaks of the 'experience' or social identity of the musicians *vis-à-vis* the aesthetics of the text, or perhaps their commitment to the music as both an ideological and affective production. It functions as a commonsensical approach to the sociology of musical production, in which sociology is often reduced to biography. On the other hand, it also functions as a quotidien theory of the sociology of consumption. Here 'authenticity' takes the measure of the music's relationship to its audience by questioning whether different audiences are 'properly' appreciating specific musics (or are even capable of appreciating them in the 'proper' ways).

Use of the term 'proper' here signals an even more difficult ambiguity that operates within and often animates debates around 'authenticity', for the term is part of the commonsense language of popular music cultures, fans and artists alike, especially (but not limited to) those who locate their tastes outside of or perhaps in opposition to some imaginary mainstream. Such people traditionally draw a line between their own preferred music (musical practices, sites and sources of production, communities of consumption) and that which has 'sold out' to or been 'co-opted' by the musical mainstream. Thus, the language of authenticity encodes a certain kind of elitism into the heart of popular music: the fans, or musicians or critics who speak with the authority of 'authenticity' on their side justify their tastes, relegating the unauthentic to the realm of a poor, undesired and even evil relative.

Although the term 'authenticity' itself does not appear frequently in the essays by Grossberg and Bayton, it is indeed central to the concerns of these two very different pieces. Bayton is concerned with understanding the relationship between feminist politics and women's musical practices. From interviews and participant observation, Bayton describes the direct impact which feminism has had on a wide range of women musicians across time and styles. Here 'authenticity' can be seen as the project of creating an 'alternative musical world' based on the assumption that 'one's method of work [which is now to be shaped by and reflect one's commitment to feminist politics] tends to affect the product'. Thus, at every level of musical practice, from the social relations among band members, and between the band and the audience, to musical styles, appearance, and the kinds of gigs they play, Bayton argues that these women attempt to create

172

some direct – and, in this sense, authentic – relationship between their musical and political commitments.

Grossberg's essay, on the other hand, attempts to place the question of authenticity squarely at the centre, not only of rock music in general, but also of current debates around and attacks on rock. He argues that rock's emergence was built upon the construction of a mutually exclusive difference between everyday life and authenticity. 'Everyday life' here refers to the product of a historically produced transformation from a daily life marked by a unifying and transcendent style (which gives every detail meaning) to a daily existence marked only by principles of repetition and recurrence (and ultimately, boredom). Authenticity, in the context of everyday life, registers the assignation of value to those who, it is assumed, still exist to some degree outside of, or manage to evade, the structures of everyday life. Rock's politics, both in the 1950s and today, Grossberg argues, have to be understood as being limited by this differentiating structure. Thus, authenticity is a constitutive moment of rock, not in the sense that it ever has or can exist, but in the sense that it constructs the political mythology of rock, the terrain on which rock's affective and territorializing power has to be played out and struggled over.

But it is the essays by Harley, Garofalo and Lawe Davies that most clearly raise the complex question of authenticity. These essays both reinforce and argue against one another, not because they embody differing tastes – in the end, the different places, practices and musics they write about guarantee no easy way to juxtapose their tastes – nor even for their different assumptions about the nature of musical production and its political sociology, but because, in the final analysis, they represent rather different takes on the problem of authenticity and politics.

Harley is concerned with technological practices as they impinge upon, shape and ultimately come to constitute musical practices; yet his arguments apply more broadly. He locates 'authenticity' and celebratory appropriation as the two poles of a dichotomy that is continuously reproduced within every instance and every plane – aesthetics, genre, technology, politics and place – of music history. Authenticity embodies a negative impulse, a scepticism, which seeks to differentiate but which often simply rejects new technological practices and their effects as 'unauthentic' when measured against a propriety embodied in older generations' (which is not to say pretechnological) musical practices. Harley attempts to deconstruct the dichotomy and refuse either pole by emphasizing the diversity and dispersion of the effects of any musical practice against the useless search for the appropriate origins or the proper boundaries which could allow us either to celebrate or to bemoan its impact on popular music. In fact, Harley suggests that the arguments around each new generation of technology, most recently samplers with their 'ability to quote and recontextualize fragments of music, have followed the logic of previous genres

173

that they sample or emulate'. The debate goes on in the same dichotomous terms, despite the 'absurdity of defining what [authentic] music is or should be'.

While Harley's most interesting and powerful arguments concern the question of place and ethnicity in contemporary dance music, he correctly notes that the question of technological change and authenticity intersects quite directly with other issues of authenticity, specifically questions of crossovers and covers, which are the primary concern of Garofalo's contribution. The real issue of crossovers, for Garofalo, is that black musicians are held to a higher standard if they want to be judged a success, since they must first succeed on the black music charts and then 'cross over' and succeed on the pop (read 'white') charts.

Garofalo offers an important distinction which can help us further understand the claim to authenticity and its role in defining the politics of popular music, for such claims can be grounded aesthetically, economically, or sociologically. That is, one can be describing the aesthetic, generic or textual conditions necessary to define, for example, black music. Or one can recognize that black music is a marketing category. Or one can take black music to be defined by its place in a 'community forged by common political, economic and geographic conditions'. The first leads us to discuss the sounds of particular musics and whether authentic (black) music has to sound a particular way. The second causes us to consider the exploitation, not only of black musicians but also of black audiences as well, and the possibilities of black capitalism (and self-determination) in the music industry. The third opens up questions of the relations between cultural practices and cultural identities. Unfortunately, in many discussions the three issues all too easily slide into one another. Harley clearly rejects the first; Nelson George is most concerned with the second.

But it is the third option (although never entirely consistently) that Garofalo proposes, partly as a way of avoiding the naive assumption that black music is defined by some intrinsic connection to a genetically constituted race. Rather, he suggests that the relation between race and culture, between black music and black people, is articulated within a particular socio-historical context: 'There is simply an unusual degree of fit between race and culture in the case of black popular music' because 'black popular culture is so intimately connected to the experience of slavery and subsequent oppression that it is necessarily linked to the struggles of a particular racial group, not on the basis of their genetic characteristics but because of their shared social experience'. While this is a crucial move in debates about authenticity, the question of participation in a common experience might be thought of either as too deterministic, leading us back to a genetic conception of race (assuming that all and only blacks have shared such experiences), or as too vague (just how much shared oppression is necessary for participation?). If, on the other hand, race is cultural, then what are

174

the constitutive conditions which enable someone – a musician or fan – 'authentically' to identify with, produce or appreciate black music?

In fact, the question of crossovers is not so easily separated from broader issues of authenticity: issues of co-optation (when a marginal or underground band 'crosses over' into the mainstream, usually by signing with a major record label which promotes it or by adopting its music in some way to the requirements of the mainstream market) and issues of covers (most problematic when a white musician records an apparently 'watered down' or 'white' version of a song originally performed by a black musician).

Lawe Davies provides an interesting counterpoint to Garofalo: while both attempt to put some distance between race and culture, Lawe Davies starts with this distance as a taken-for-granted feature of Australian Aboriginal music. 'While the political and social marginality of Australian Aboriginal people is quite distinctive and recognizable, it doesn't always find its way into the music.' There can be no discussion of authenticity as long as it is judged aesthetically and stylistically, or even in terms of band membership. Aboriginality is as much a matter of style, of recognition, of 'attitude' and, hence, authenticity has always to be understood contextually; it, like the Aboriginality it bespeaks, is always articulated out of and into specific conditions. 'Whether or not the music speaks overtly of Aboriginality, it is likely to be part of a broader social narrative of Aboriginality constructed intertextually.' Lawe Davies cautions against putting too much weight on the iconic markers of Aboriginality which are always potentially involved in exoticizing and 'orientalizing' Aboriginal culture and identity and can themselves be deployed to smother specific political claims and demands (as when urban Aborigines are compared with rural cultures and judged 'unauthentic').

Finally, Lawe Davies argues that 'Aboriginality' must be understood as an affective presence which is manifested in different ways, in the different musical, cultural and political alliances that are constantly forming and transforming themselves at different times. Even for non-Aboriginal white bands, it is possible that 'Aboriginality isn't absent'. Thus, at different moments, the meaning and effectivity of authenticity are different, empowering their producers and consumers in a variety of ways. 'Landrights, black solidarity, special and sacred knowledges, broken hearts and true love move transgressively beneath the authoritarian gaze of the dominant white culture. It's lambada with politics . . . Obviously there is a huge difference between "feeling the politics" at an isolated cultural moment like a rock gig, and seeing that moment translate into fundamental shifts in broader social relations. Yet the temptation to make this broader claim seems legitimate, largely because of how the apparatus for Aboriginal rock is constituted, and the history of its formation.' The fact that the 'apparatus' of Aboriginal music, like that of rock, is not uniform, either in space or time, means that there is a constant struggle to articulate Aboriginality

and its contextual political effectivity. For Lawe Davies, the question of crossover can only be addressed within the specific moment of the history of the formation, as it moves from performance, to recorded music, to a taken-for-granted place in Australian culture. Here the crossover represents 'a marginalized community taking up a strategic (and more central) position', a position which embodies and enables a struggle to shift 'the logic' of Aboriginal oppression.

Clearly the complexity of determining the 'authenticity' of any music is but an instance of the broader problematic of cultural studies or of any project which seeks to understand the political implications of the social conditions of the production and consumption of specific cultural forms and practices. Recent work in cultural studies has proposed the concept of 'articulation' to describe the non-necessary relationships within a social formation. An articulated relationship is a contextually produced effect which is itself a possible site of struggle. Too often, however, articulation is taken as a solution to the problem as if merely stating that the relationship is articulated is sufficient. But articulation is not an answer; it is merely a new way of posing the question, one which makes our tasks as cultural critics all the more difficult. It is to this challenge that the five essays gathered here respond and each, in its own way, attempts to offer a vision of the practice of cultural criticism. Each offers us some new ways of beginning to approach the question of the role and effect of popular music in contemporary society.

11

FEMINIST MUSICAL PRACTICE: PROBLEMS AND CONTRADICTIONS

Mavis Bayton

Women have been largely excluded from popular music-making and rele-
gated to the role of fan. Women performers have been more prominent in
commercial 'pop' and 'folk' than in 'rock', but their place in all these
worlds has been predominantly that of vocalist rather than instrumentalist.
A range of material and ideological forces have kept women in this
circumscribed space. Those few women who have become musicians have
somehow managed to find a way through these constraints. It is my
argument that feminism has acted as a major route into music-making,
providing the opportunity, motivation and material resources for women's
participation.[1] However, feminism is not a monolithic, unchanging, or
easily defined movement and feminists' attitudes towards popular music
have varied. Indeed, within the practice of popular music some of the key
paradoxes of the contemporary movement can be seen being played out.

This article is based on a doctoral research project investigating the
careers of women musicians and all-women bands. The research grew out
of my own experience of playing in English all-women and mixed bands
from 1978 until 1985. As my musical career moved from absolute beginner
to semi-professional musician, I also made the transition from observant
participation to participant observation (keeping a diary, taping meetings
and practices, etc.). I then widened my exploration and carried out a series
of long, taped, in-depth interviews with women musicians, forty-two in all.
I had no formal sampling frame as the total number of female musicians in
England was, and is, unknown. (Bands and their composition are, after all,
essentially transient.) However, I did try to obtain some degree of repre-
sentativeness in terms of region, instruments played, musical style,[2] dom-
estic status, social class, ethnicity, education, sexual politics, age (20–47
years) and career stage (novice to professional). These interviews were
carried out in the period 1982–5. I also carried out interviews (and was an
observer) at a variety of women's music projects and workshops up to
1988.

The majority of academic writing about popular music has been about

the end product: records. There has been little empirical work on musicians and the processes of music-making. Finnegan (1989) includes rock/pop in her pioneering, wide-ranging ethnographic study of all kinds of grass-roots music-making. Stith-Bennett's work (1980) is also notable, but it is solely about men. Cohen's research (1991) is also about men, but usefully illuminates the way in which male musicians exclude women from their bands. There are also some good writers on female jazz musicians, for example Dahl (1984). The interviewing of female rock/pop musicians has been largely left to journalists; Steward and Garratt (1984) provide an informative account of women within the music industry. But journalists tend to concentrate on the stars rather than on the majority of music-makers, who are local and amateur. Women's vocal groups have been (rightly) celebrated by Greig (1989). Female instrumentalists, however, remain notably under-researched. My interest has been in the ethnographic documentation of the 'invisible' activities of female grass-roots music-makers and, in particular, of instrumentalists.

A ROUTE INTO MUSIC-MAKING

Feminism has meant different things to different people at different times. Many more women have been influenced by it and espouse its tenets than would readily call themselves 'feminists'. Yet, in my research I have found that a large proportion of female music-makers do define themselves as broadly 'feminist'. Furthermore, a substantial number of women have embarked on musical careers because of an explicit commitment to feminism or through contact with feminist networks. For instance, Angela, a professional musician who began playing in a feminist band in 1976 and who has since played in a variety of bands (both all-women and mixed) asserted:

'I don't think I would have started playing in bands if I hadn't become involved in the women's movement.'

Feminists entered rock music-making for a number of reasons. For some, the main motivation was political. Being in an all-women band was a means of communicating a feminist world view. For many others, with long-held musical aspirations, feminism gave the necessary confidence and support to make the transition from fan to performer.

Early 'second-wave' feminism – the late 1960s and early 1970s 'Women's Liberation Movement' – encouraged women to break down sexist stereotypes, claim equality with men, and invade traditional 'male' enclaves. If men could play rock music, so could women. Moreover, the radical new women-only socials which were burgeoning in the cities demanded all-women bands – bands that would provide alternative lyrics and challenge the ideological hegemony of masculinism. When the first feminist rock

178

bands emerged, the women involved, in turn, set up women's music workshops to encourage other women to play.

The women's movement converted many women from non-musicians to music-makers, and created a sympathetic 'space' for their early endeavours. One of the main features of the movement was that it provided a forum in which women's voices could be heard, even if those voices were initially inarticulate, confused, or lacking in confidence. Women-only gigs formed a non-threatening environment for fledgling bands. Thus it was that women's bands which started off tentative and unskilled were given support and encouragement. It was enough, at first, that women were playing at all.

A FEMINIST COUNTER-CULTURE

Excluded from the mainstream (male) rock world, 1970s feminists created an alternative musical world of their own. This world offered the chance to rewrite the rules: of lyrics, of band membership and organization, of the gig, of the stage, and even of the music itself. Feminists enthusiastically and optimistically promoted alternative values: collectivism and co-operation instead of competitive individualism; participative democracy and equality instead of hierarchy. The general feminist belief that 'the personal is political', derived from the American students' movement, when transposed into rock worked to break down the barriers between band life and 'personal' life. The 'professionalism' of the typical male band was rejected in favour of an approach which minimized the boundary between the band and the rest of women's lives. Some of the early feminist bands were often variants of women's groups in the general sense, deliberately engaging in consciousness-raising as well as playing music together. Jean recalls her first experience in a feminist band back in 1976:

> 'We met once a week and we used to talk after every rehearsal. We were all really eager to talk to each other. We just used to talk and talk and talk. We just used to sit around the table and it was amazing. . . . We used to take turns. It became more like a consciousness-raising thing as well as a band. We were really close.'

The politics of the personal was also reflected in the need to write alternative lyrics. Women have written about topics not generally appropriated to popular music: menstruation, housework, lesbianism, motherhood, the menopause. Most women have preferred to write their own numbers rather than do (male) 'standards' and, indeed, songwriting has become normative for feminist bands. If covers are performed, they are invariably altered and subverted – 'he' becomes 'she', and so on. Love songs become especially politicized.

The belief that one's methods of work tend to affect the product has led

179

to attempts for band-members to interact within bands in new ways. For example, 'showing off' is considered to be deviant whereas in male music-making it is normative. Some feminist performers have gone to great lengths in order to avoid being seen as special or different from their 'sisters' in the audience, as Angela recalled:

> 'When we first started the band, we found certain things very difficult. Like, we weren't sure whether we should play on a stage, and we weren't sure about having lights on us, and we didn't think the audience should be in darkness. . . . There's definitely a differentiation I've never been able to quite come to grips with: the whole thing between the audience and the group. Because you can't really get into this thing of "we're all here together enjoying ourselves", because it's not quite like that . . . they've actually paid to see you and you're getting paid for playing. You're in a different position.'

Feminist musicians have been concerned with the quality of their relationships, as well as with their music. Co-operation is stressed, as is giving each other space for expression and trying not to put other women down. Bands have had political policies on the manual labour of 'roadying' and 'setting up', insisting that everyone should do it equally.

Rock bands are structurally pitched into competition with each other for gigs, for financial rewards, and for acclaim by the press and public. Bands on the same 'bill' are, conventionally, competing for status. Many people who go to gigs tend to miss the first ('support') acts and only turn up to see the 'main band'. Some feminist bands have tried to abolish the 'headlining' problem by rotating the order of play between the bands. For example, Jean (guitarist in a well-established jazz-influenced band on the women's circuit) commented:

> 'We got fed up with this "Who's supporting?" and "Who's headlining?" And we say, "As far as the women's movement's concerned, that's just straight shit! What we're gonna do is take it in turns." And that's what we've done ever since. . . . I really think that these are discussions that we have really prompted in the women's movement, that people really don't think about. They're really political in other aspects of their life, but when it comes to music they're really blocked. Any time we've organized gigs, this has been going on behind the scenes. . . . Any bands that we come in contact with get told the same thing, and few of them disagree. . . . That's how you deal with your sisters.'

These feminist ideals are not simply imprinted on band practice but they are aspired to, and translated into everyday life to varying degrees. Inevitably there are contradictions and tensions and these have to be negotiated and lived. Furthermore, feminist music ideology has, to a

degree, drawn on other alternative forms of musical discourse. Some of these cultural beliefs and practices have been common to punk, left-wing and anarchist bands.[3] Indeed, such cross-fertilization is inevitable. But feminist music is largely the offspring of feminism in general, spawned in the heady political days of the late 1960s. My argument here is twofold. First, feminism, both as a route into music-making and as an alternative music discourse, has been underexamined compared with the predominantly male alternative forms of punk and left-wing music. Second, feminist music practice has, in some ways, been more radical than these other forms. For example, for feminists, 'personal politics' meant that children were brought to practices and gigs. It was unheard of for male musicians to do this, even those in 'political' bands. Indeed, it is still uncommon.

Like punks, feminists have rewritten the rules of public performance; they have challenged the spatial norms of the gig. They have treated their audiences differently, and gigs have been physically transformed. But they have done this in a different way from punk bands. By speaking and singing to the women in the audience – by prioritizing them – feminist bands have challenged the traditional taken-for-granted dominance of men at gigs. For example, Anne (keyboard player in an all-women 'power-pop' band, 1978–81) said:

> 'One thing I've found, women at mixed gigs tend to come up to the front. So the people who can actually see you are women. . . . And I very much talk to the women. I play to the women, definitely . . . because women have been ignored by rock music, generally, apart from just as sex objects, and it's nice to treat them differently.'

IMAGE

Feminist musicians have been acutely concerned with the political implications of their appearance and stage presentation. They have chosen to disrupt, subvert or challenge the hegemonic discourse of female rock sexuality. Thus, in the 1970s and early 1980s many feminists totally rejected mini-skirts, low necklines, high heels and cosmetics. However, the semiotics of image have proved highly problematic for the female musician. What a particular item of clothing 'says' depends on a shifting context of meanings and, of course, all signs are polysemic. Feminists have wanted to avoid being seen as sex-objects, but they have still wanted to look attractive and the resulting space for manoeuvre has proved to be narrow. For instance, Helen (drummer in a mixed 'indie' band, 1983–84) maintained:

> 'I like the idea of women being assertive and slightly aggressive because I think we've all repressed it.'

And yet women did not wish to look masculine. Angela stated:

'I don't want to come across as being too butch. On the other hand, I don't want to be seen as too "fem".'

This wish to avoid either extreme of gendered image was a dilemma for many feminists. Sue (bass player in a variety of bands, mixed and all-women, since 1976) commented that:

'It's like the whole issue of "what's a feminist culture?" It's all male-defined and it's a question of how do you get round that.'

One view which was held by many feminists was that one should be as normal or natural as possible on stage and eschew stage clothes as such. For example, Jean said:

'You can see who is and who isn't a feminist. Because when they get up on stage they tart themselves up and they pose and pout. . . . We get up and we play and we are ourselves. We're not trying to project an image. We're not being false. What you see is what we're like all the rest of the time. I don't wear stage clothes. . . . I don't think you should look too different on stage, 'cause I think there are people in the audience who think, "God! They are so different. I could never be like that." I think it's important that the audience recognizes that you're just ordinary people, like they are.'

The idea of wearing 'normal' clothes on stage is another attempt to break down the performer/audience divide, to demystify and deromanticize the performance. But however the performer dresses, she is making some sort of statement just by getting on stage, as Veronica (guitarist/singer in a mixed punk band since 1976) pointed out:

'You're making a total statement. You're asking for attention. You're asking people to look at you and hear you. And you're throwing away an opportunity if you don't work with that. You're saying something whether you like it or not.'

Likewise, it is impossible to be 'natural', for clothing of any kind (and even nakedness) is a cultural statement.

A parallel question concerning cosmetics also presents itself to every woman who starts gigging. Again, views were polarized amongst my informants. Generally speaking, the positions held were identical to those regarding clothes. One view amongst feminists was that the wearing of cosmetics of any kind, either on- or off-stage, was ideologically unsound. It was making yourself over in the ('unnatural') male-created image of what a woman should look like; it was worn basically to please men. For example, Jean said:

'I am totally and utterly opposed to make-up of any kind. . . . It's not a thing of being boring and we should all look the same and nobody

182

should have fun, but I don't think the whole point of make-up is for fun, [but] to make women look a particular way and have a look which actually has very little to do with women. . . . It's a caricature of a woman.'

But some feminists defend the use of cosmetics, arguing that it all hinges on why, and to what effect, you are using them, as Veronica pointed out:

'Well, I think there are ways of presenting yourself on stage that are unsound. But I don't think that the way I use make-up or clothes is unsound. I'm not trying to make myself anxious to please. That's where it's ideologically unsound; if I was just doing it so I would please the men. But I do it in a completely different way. I usually put a lot of make-up on and it's all run by the end of the set. And I work with that. I use make-up that runs easily, 'cause I sweat. I start off with a mask, a beautiful face, and the make-up gets ravaged.'

Of course, it is not only feminists who have been concerned with questions of 'authenticity' and 'naturalness'. The roots of this discourse go back to the nineteenth century in art. In music in the post-war period, beat musicians pursued authenticity (Frith and Horne 1987); hippies valued 'naturalness'; and punks promoted 'ugliness' and attacked conventional notions of sexuality, allowing a wider variety of female bodies on to the rock stage. Unlike beats, hippies and male mainstream punks, however, feminists were directly and explicitly attacking dominant gender ideology. In the early 1970s, feminism often involved a total rejection of all gendered cultural practices and artefacts, as in Jean's case.

However, by the late 1970s a more liberal and populist view was emerging within feminism, which challenged the normative 'uniform' of dungarees and boots (Wilson 1985). Feminist bands actively debated the rights and wrongs of mini-skirts and cosmetics. Many erstwhile 'hardliners' began to experiment with their stage presentation of self. For punk feminists like Veronica, the solution was a savage irony in their exaggerated embrace of the conventional trappings of femininity. Some lesbian feminists solved the problem by treating mixed and women-only gigs differently. They would not wear skirts at mixed gigs but felt free to wear 'feminine' clothes at women-only gigs. Often a number of reasons are combined: the refusal to 'dress up' for men; the wish to avoid conforming to sexist stereotypes; the need to avoid sexual approaches from men; and safety. Dressing in a skirt and 'feminine' clothes makes most women feel more at risk, whereas dressing in tough and traditionally masculine clothes often makes women feel tough themselves, a feeling which might be necessary for some women performing to a mixed audience.

Apart from clothes and cosmetics, there are other less obvious issues connected with stage presentation – issues to do with body movements,

posture and the interaction between a musician and her instrument. Concerned to avoid presenting themselves as sex objects for men, feminists also rejected stereotypical 'male' poses on stage. Many feminists drew a distinction between 'sexy' and 'sensual', but faced with so many ideological and practical dilemmas the performer can end up being so self-conscious that she just does not move at all. For example, Wendy (keyboard player in a mixed 'indie' band, which formed in 1984) stated:

'I don't want to convey anything. . . . So I've just tended to stand still – which I don't really enjoy doing.'

Feminist guitarists have perhaps the worst problem, avoiding the male guitar-hero stance: guitar-as-phallus or guitar-as-woman, etc. For instance, Angela commented:

'For guys, the lower you play it, the more it is a phallus. It can never be a phallus if you play it high. It's the rock thing, when you have it slung right down there, where it becomes a phallus. Women don't often seem to play guitars and basses so low down. . . . I don't think it's true that women can't do it. I think there are very few women who would *choose* to do it, feminist or not, actually. . . . I think a lot of women find using your guitar like that very obnoxious or objection-able, and if you're a feminist it's that much worse, because you can see that much more in it.'

The problem is partly one of a lack of female role models. Although a musician might not be consciously copying anyone, there is no doubt that unconscious influences are at work. Wendy said that:

'For women, there are very few people that you can identify with. It's just very difficult to look to other people for precedents and ideas. Most of the bands I look to are almost entirely male.'

The middle-aged punk feminist Veronica developed a solution to this problem: irony. She subverted the meaning of the macho guitar hero movements of both mainstream rock and male punk and political bands:

'I know when I go in for some big chords that this is what men do. And my feeling when I do it is irony, because I know that you don't have to strut around to make a good sound. I know that you can do it anyway. For boys to see a woman doing it is feeding them an image they haven't had before.'

A 'FEMALE MUSIC'?

As the 1970s wore on, the 'Women's Liberation Movement' became 'the women's movement' and then the term 'feminism' subsumed them both.

184

The movement was growing and, in the process, fragmenting. Many varieties of feminism were sprouting up. In the late 1970s the development of revolutionary feminism signalled a move away from the early strategy of breaking into men's terrain and towards separatism. Within popular music, this reinforced the development of alternative institutional structures.

At the same time, however, radical separatism buttressed an 'essentialist' world view which had important ramifications for feminist music-making. Certain styles of music were deemed to be intrinsically 'male' and thus inappropriate terrain for feminist musicians. Some feminists considered all electric music to be 'male', because of its loudness and the way in which the panoply of amplification devices distances the performers from the audience.

The consequent attempts positively to define a 'female' music proved to be impossible. It was far easier to specify what 'women's music' was not: loud, noisy, driving 'cock rock'. Thus, so-called female music had to be lighter and softer. But, beyond that, there was little agreement. Sarah (vocalist and percussionist in a feminist pop band which formed in 1979) suggested that:

> 'It's less heavy, less throbbing . . . there's a concern for lyrics to be heard and not just a technological slur.'

Kate (guitarist/vocalist/keyboard player in a mixed post-punk band which formed in 1980) felt that:

> 'Female music's a bit warmer. It tends to be less rock'n'roll. Women play less aggressively, generally. They caress it more, and men rock it and slap it. Women tend to like off-beat rhythms. That's why it's rare to find a women's rock'n'roll band.'

The problem was that so much music had been labelled 'male' that only the folk area was considered ideologically safe. Paradoxically, then, the feminist challenge looked likely to result in retreat from rock and amplified music altogether.

Moreover, descriptions of music slid easily into discussions of performance, instead. For instance, Pat (guitarist in the same band as Sarah) expressed the view that:

> 'Well, all male music isn't, presumably, about wanking off on your instrument, but I think quite a lot of it is. And, maybe, competing with other players in the band – obviously, women's music isn't like that. . . . It's definitely a thing apart.'

Of all styles of music, 'heavy metal' has been viewed as the epitome of 'maleness' and only a tiny minority of women have played in this musical style. In the early 1980s there were no more than half a dozen all-women heavy metal bands in the whole of the UK. I interviewed members of one

of these bands. Aware of the criticisms, they adamantly defended their right to play in this genre and saw no contradiction between playing heavy metal and feminism. Eva felt that:

'A lot of people see heavy metal as being very aggressive, [but] I don't see myself as being very aggressive, really. I love all that racket. A lot of women . . . tend to play very sort of ethereal music, very spiritual. I like physical, lusty, earthy, passionate music. I was at a rhythm workshop a while back, and the woman who was taking it described the 4/4 snare drum beat as a white, male, militaristic, fascist, patriarchal rhythm, and I think that's a bit heavy, man! . . . Is there any such thing as female music and male music? I don't know. Women are seen as more intuitive, and I don't think this is a natural phenomenon. I think women and men have equal capacity for logic and rationality, and an equal capacity for intuition.'

For feminists who took this position, what was important was how the noise was used – what the songs were about, for example. That is what demarcated feminist heavy rock from 'male' heavy rock.

This debate, which came to the boil in the early 1980s and which still lingers on, is an interesting manifestation of the wider contradiction within feminism of, on the one hand, wanting to do what men do, and, on the other, wanting to create something altogether different, which expresses women's 'femaleness'. This is currently called the 'sameness/difference' or 'equality-difference' debate (see, for example, Bacchi 1990 and Scott 1990).

Women who strongly resist the notion that women should play quieter, gentler music argue that it is based on the sexist stereotype of conventional femininity. For such women, it is bad enough male musicians and male audiences telling them that they should not (or cannot) play heavy rock, without feminists reiterating the message. If all existing ways of playing and being on stage were rejected as being 'male', then there would be very little space for women to manoeuvre.

Musical essentialism lives on in some quarters, but it is no longer an orthodoxy, having been strongly challenged by women who wanted to make loud powerful music and bitterly resented the expectation that, as feminists, they should restrict themselves to being 'spiritual'. Women's liberation had been associated with the freedom of women to express themselves, but more recent feminism seemed, to many women, to be about prohibition. It was, above all, punk feminists like Veronica who protested these views and kept women musicians on the rock stage:

'It took a year before I turned my guitar volume up . . . because I was still scared of it, of making a noise to that extent. I turned the knobs down on my guitar for a whole year. And, then, suddenly I thought, "Fuck it. I'm not going to do that anymore." . . . I get a buzz out of

handling big energy and I think it can be subverted. . . . I've learnt how to make a big noise only recently, and I like it. And I'm not going to be told by any boy that I'm on their preserves and get off! . . . I don't feel that because I've got a big voice I'm any less of a woman. . . . I mean, a woman lion can roar just as loud as a male lion. . . . For me it's undercutting a whole lot of conditioning. . . . And, I believe, collectively, women have a right to this. . . . I feel it's some sort of celebration of something very animal and basic. . . . I understand the function of men making a lot of noise. . . . What I object to is that they do it on our backs, and at our expense, and keep us out. That's why the opposite of saying "Get off our territory!" is; I want *every* woman who wants to make a big noise to get on with it too.'

The question of what type of music should be performed, then, highlights some of the key paradoxes of contemporary feminism: 'It acknowledges diversity among women while positing that women recognize their unity. It requires gender consciousness for its basis, yet calls for the elimination of prescribed gender roles' (Cott 1986).

AUDIENCE

Women-only gigs have played an important role for feminist musicians. Indeed, some women's bands refuse to perform at mixed gigs. Others clearly preferred and prioritized women-only gigs. Some musicians said they felt safer at women's gigs because there were fewer fights, threats, and less violence in general. Lesbians in particular found it safer to be 'out' at women's gigs than in a mixed context. There was also a general agreement that audiences at women-only gigs were far less critical than those at mixed audiences. Where this was beneficial at first, it became unsatisfying for musicians as they gained in expertise and confidence. Anne commented:

'We've played some pretty awful women-only gigs, and people have still said, "Far out!" And that quite pisses me off.'

Playing to all-women audiences has its political limitations and was felt, by many bands, to be restrictive. It was 'playing to the converted' or 'playing in the gay ghetto'. In consequence, feminist musicians have often held ambivalent feelings about women-only gigs.

One particular twist to this issue was that, in the late 1970s and early 1980s, all-women audiences tended to want dance music rather than anything else. This was because gigs fulfilled very important social functions, especially for lesbian feminists. There were very few places where they could meet other women and relax in a safe environment. Listening to the music took a firm second place to dancing, meeting new lovers, dating, and

so on. Bands who played more 'serious' music, bands you had to listen to carefully, were less popular. Furthermore, many of these gigs were at the end of events like demonstrations. Thus the emphasis was on the gig as a social event to wind up the day, and women were there who did not normally go to gigs and who, perhaps, were not all that interested in popular music.

Some bands I interviewed said that they had not been as well received at all-women events as at mixed ones. Ironically enough, this was the experience of a number of lesbian separatist bands. For example, Fiona (PA engineer with a feminist band since 1977) recalled:

'Originally we played boppy music. We were a bop band for women-only gigs, and it was all wonderful. But then the musicians got fed up with playing that kind of music, and they didn't want to do it any more. And we got a bit of criticism for that – that we were getting too professional. . . . Women said, "Why don't you play that old stuff?" Our answer would be, "What were you doing three years ago? Why aren't you still doing that?" . . . It was a false kind of audience, in a way. They went along for the gig, and it wouldn't matter particularly what we were playing. It was the gig, and for a women-only event, and for the women's movement.'

However, women-only events were supportive for fledgling bands and, conversely, many a band was formed from scratch to supply live music for a key women's event. But the number of such gigs has been severely restricted in the UK by one specific phenomenon: the shortage of female sound engineers. Because of the entrenched sexism of male PA crews, feminist bands have typically sought to take control of their own sound and having a woman doing the mixing has been a political principle. Obviously, for women-only gigs, it has been a practical necessity. Yet very few women can 'mix', let alone understand how all the equipment works and trouble-shoot if technical difficulties emerge. In the early 1980s there was only one all-female PA company in England and it was unable to meet the demand for its services. Thus, many bands had problems with their sound at women-only gigs: no 'mixing', inadequate equipment, and so on. Likewise, many all-women events had to make do with a disco.

GOING PROFESSIONAL

'Professionalism' has been a critical issue in women's music-making careers. Some feminist musicians who were trying to make a living from music by playing full-time had professional attitudes, in the sense that they strived to reach a high standard of musicianship. Many other feminists, however, were deeply opposed to this and, indeed, saw themselves as 'anti-professional'. One reason for this was that, by the early 1980s, 'professio-

nalism' was being categorized (along with technology, science, objectivity, and a lot else) as essentially 'male' by radical feminists. Feminist musicians who were playing full-time, however, were proud of their hard-earned skills and ability to play as well as men in a male-dominated field. They did not consider professional skills to be 'male' or elitist. Jane (rock/jazz drummer) commented:

> 'A lot of women seem to be into this thing of just being able to play anything, without ever having played before. I agree, some people can do that and it sounds good. . . . But I don't think any old kind of noise is music. I can't see the criticism of being "too professional". . . . I know lots of women musicians who really want to improve their style, their technique and their playing. But, in some ways, they get criticized for that, because you should just stay on one level, so that everybody thinks they can do it. . . . The times I've heard that criticism!'

Women like Jane began playing at a time when feminist values urged women's acquisition of traditional 'male' skills. Having daringly led the way into rock and developed considerable expertise, they then found themselves castigated as being 'male'.

Another, linked problem for experienced feminist musicians has been the shortage of skilled instrumentalists with whom to play. Commitment to playing only with women can sometimes clash with the desire to play with more talented musicians. For example, Eva felt that:

> 'The way to get better is to play with people who are better than you. And the trouble with playing in all-women bands, and restricting yourself only to women, is that, because there are so few women, there are bound to be some musical and personal compromises that you have to make. And the best people around are, generally, going to be men, because there are more of them who play. I'm not for one minute suggesting that women can't be as good as men, but because of numbers it works out that way. So, by restricting oneself to only women, you're putting yourself down, in a sense, by not having the greatest number of possibilities to expand your experience and talents. I think that's a big problem. And a lot of the best women, and the women that have got on best, have been one woman in a male band.'

The dilemmas and contradictions intensify the further a band moves along the continuum from 'playing for fun' to being fully professional. The pressure to make a living or to produce 'hit' records can conflict with feminist principles. The 'leadership' issue, for instance, appears in a more acute form. Committed to a high level of democracy, most feminist bands have felt ambivalent about getting a 'manager'. The tendency has been to

appoint an 'administrator' or 'co-ordinator' instead, and for reasons of autonomy, the majority of feminists have decided not to sign contracts with record companies. Anne recalled that:

> 'We were quite worried that if we signed to a major they would try and change us beyond all recognition and, especially, try and present an image of us which we weren't happy with . . . like the Belle Stars, who all wear the same clothes on stage. We would never have done that! And I think they would probably have tried to make us do gigs that we might not necessarily have wanted to do.'

For any band, the alternative to signing a deal with a record company is to tackle record-making on a DIY basis. This means financing the recording costs oneself, from studio time to 'pressing'. It means setting up one's own label in order to bring the record to the public, designing and printing the sleeve, packing the records by hand and, finally, distributing them. This DIY option is open to all bands – male, mixed, female, feminist and non-feminist – but out of all the bands I interviewed or came into contact with during my seven years of gigging, the only all-women bands who were doing this were explicitly feminist ones. Angela pointed out that:

> 'There's this notion that you can get involved with record companies and somehow get your politics out. . . . I just think it would be an inevitable compromise and would just be watered down and point-less. . . . With big record companies you never have control of what you're doing; they'll always control you.'

So her band brought out its own records on its own label:

> 'Jean and me started the record label two years ago. . . . And the idea wasn't just for our band. It was a feminist label with a specific kind of feminist politics: anti-capitalism and the straight music busi-ness, and the charts, and all that kind of stuff. . . . We just said, "We're gonna have a label" and we did. That's all you need to do. We went along and copyrighted the name, and got somebody to draw a [logo] we liked. And that was it.'

Apart from finance, promotion seems to be the main support which the DIY band misses out on. Angela's band did all its own promotion and distribution, making use of Women's Revolutions Per Minute – a success-ful feminist independent distributor of women's music. The records they distribute do not get into the 'chart shops', and so cannot become commer-cial hits, but neither are they expected to be. Sales may be slow but women's music does get to be heard, in this way, around the UK. WRPM sprang out of the same late 1970s feminist culture which spawned so many all-women bands. But feminist distribution in the UK has been nowhere near as vigorous as in the US, where such labels proliferate.

DIY record production is only viable if bands can get the finance together, usually via benefits, gigs and donations from friends, well-wishers, and charity. Costs are gradually recouped from record sales, but, as promotion is usually only in the form of gigging, the process tends to be slow. The avoidance of conventional management and of record company deals deprives feminist bands of finance, compounding women's relative lack of funds compared with men.

Whilst getting a hit record and appearing on 'Top of the Pops' is not the avowed aim of most feminist bands, by staying outside the mainstream their audience has been severely curtailed. There has been a marked absence, for instance, of lesbian bands in the national media, whereas gay male performers and bands have had chart successes and appeared on television. There seems to be a fundamental contradiction between being a feminist band and being a chart band. On the other hand, feminist musicians have shown that it is perfectly possible to establish a satisfying (if poorly remunerated) professional musical career, and a stable 'musician' identity, based primarily on gigging and session work. In contrast to the many chart bands who have one or two hits and then vanish without trace, many of these women have been playing for a considerable time.

There are very few professional all-women bands, indeed there is a limited number of professional women instrumentalists in general. This is a reflection, in the main, of the narrow base from which they develop: the small number of women taking up rock instruments. I have found that gender constraints operate most strongly in the early stages of women's musical careers, and it is then that feminism has its major impact.

Despite its inherent contradictions, feminism has been a major force in getting women into popular music-making. It has given women access to instruments and provided safe women-only spaces for the learning of skills as well as rehearsal and performance; it has challenged ingrained 'techno-phobia' and given women the confidence to believe that, like the boys, they can be music-makers rather than simply music fans. Feminism has been a long-lasting oppositional and enabling force within popular music.

NOTES

1 There has been no single 'typical' female route into rock/pop music-making. My research suggests that other significant factors operating (sometimes in combination) have included family, boyfriends, punk rock, lesbianism, classical music and drama.

2 Regarding style, on the national level of professional, commercially successful bands (the focus of the vast majority of academic and journalistic writing) one can distinguish a seemingly concrete succession of changes in musical style: pub rock, punk, new-wave, dance, etc. However, on the local (and non-professional) level this notion of 'stages' breaks down and musical styles become both more contemporaneous and more diverse. (This has also been noted by Ruth Finnegan

(1989) in her local study of Milton Keynes.) Thus, amongst my interviewees in the 1980s were exponents of rock, heavy rock, new wave, reggae, pop, power pop, jazz-rock, dance music, and a band of middle-aged women who played 1960s 'beat' music. At that time there also existed all-women R'n'B bands, electronic bands, acoustic groups, etc. It is also true that much of the music crossed conventional boundaries and defied easy classification. This may be partly because bands starting out tend to experiment with, and across, musical categories as part of a learning process of self, and corporate, discovery.

3 Of course, these are not mutually exclusive categories: some punks *were* feminists and many feminists played in 'post-punk' bands. Also, the 'moment' of punk motivated some women to play an instrument, and made it easier for women who already played to get heard. However, the majority of instrumentalists in punk, left-wing and anarchist bands were male.

BIBLIOGRAPHY

Bacchi, C.L. (1990) *Same Difference. Feminism and Sexual Difference*, London: Allen & Unwin.

Cohen, S. (1991) *Rock Culture in Liverpool*, Oxford: Clarendon Press.

Cott, N. (1986) 'Feminist theory and feminist movements: the past before us', in J. Mitchell and A. Oakley (eds), *What Is Feminism?*, Oxford: blackwell.

Dahl, L. (1984) *Stormy Weather: The Music and Lives of a Century of Jazz Women*, New York: Pantheon.

Finnegan, R. (1989) *The Hidden Musicians: Music-Making in an English Town*, Cambridge: Cambridge University Press.

Frith, S. and Horne, H. (1987) *Art into Pop*, London and New York: Methuen.

Greig, C. (1989) *Will You Still Love Me Tomorrow?*, London: Virago.

Scott, J.W. (1990) 'Deconstructing equality-versus-difference: or, the uses of post-structuralist theory for feminism', in M. Hirsch and E.F. Keller (eds) *Conflicts in Feminism*, New York and London: Routledge.

Segal, L. (1987) *Is the Future Female? Troubled Thoughts on Contemporary Feminism*, London: Virago.

Steward, S. and Garratt, S. (1984) *Signed, Sealed and Delivered: True Life Stories of Women in Pop*, London: Pluto Press.

Stith-Bennett, H. (1980) *On Becoming a Rock Musician*, Massachusetts: University of Massachusetts Press.

Wilson, E. (1985) *Adorned in Dreams: Fashion and Modernity*, London: Virago.

12

THE FRAMING OF ROCK: ROCK AND THE NEW CONSERVATISM

Lawrence Grossberg

I am interested here in the recent explosion of publicly legitimated attacks on rock, in the paradoxes signalled by the specific forms of their appearances, alliances and reception, and in the possible reasons for their political deployment.[1] That such attacks have appeared before does not guarantee that their reappearance carries the same meaning, or produces the same effects, or even signals the same political agendas. One needs to map some of the ways these attacks function in larger circuits of culture and power, which is not the same as uncovering the intentions of those producing the attacks. After all, the agendas 'behind' different attacks may vary between and even within particular groups. The different groups responsible for and supporting the attacks are not the only players in the game and, despite their best efforts, they cannot guarantee the effects of their actions. Constructing such a map means organizing a wide range of cultural texts and logics around the attacks on rock, without claiming that the attacks are necessarily at the centre.

Obviously these attacks can be seen as part of a sustained movement – orchestrated in part by various fractions of a new conservative alliance (including the 'New Right') and winning various degrees of public support – to constrain, police, and even regulate (read censor!) the production, distribution and consumption of art and popular culture in the United States. Such efforts are clearly related to a number of important political and ideological struggles: to redefine 'freedom' and reconstitute the boundaries of civil liberties; to (re)regulate sexual and gender roles (involving the construction of ever more violent anti-feminist and homophobic positions); to monitor and even isolate particular segments of the population, especially various racial and ethnic minorities who, along with women and children, make up the vast majority of the poor; and to discipline the working class (e.g., through attacks on unions) in order to (de)regulate an international consumer economy dedicated to the increasing accumulation of wealth.

Many of these struggles can themselves be seen as part of the larger project of regulating the possibilities of pleasure and identity as the basis of

political opposition by dismantling the cultural and political field constructed in the 1960s. There is no doubt that the 'autonomy of blacks, women and young people – to mention three groups whose emergence gave the 1960s their distinct identity – is under siege again' (Goldstein 1990: 23). (We might include gays and lesbians, chicanos, etc.). The field of struggle constructed by the various countermovements of the 1960s depended upon the articulation of politics and pleasure, of popular culture and social identity. Pleasure became a source of power and a political demand, enabled by the very marginality of those struggling. The new conservatism clearly sees the need to regulate pleasure, to re-establish the discipline it believes necessary for the reproduction of the social order and the production of capital (e.g., the family). But collapsing the attacks on sex, drugs, consumerism and rock into a single project fails to acknowledge the sophisticated and strategic understanding of the media and popular culture with which the new conservatives often operate. In addition, despite the many similarities among the various attempts at censorship and the various struggles to discipline the population, assimilating the attacks on rock too quickly may in fact make it harder to understand the specific political struggles to which they point.

Surprisingly, given the comparative successes of the anti-rock campaigns, there has been relatively little public opposition, from either the industry or fans. In the past, such attacks often became the occasion for an increased public celebration of, and self-asssertion within, the various rock cultures, for in a way, they proved the power of rock. Since attacks on rock have existed for most of its history, the question is less why the current attacks exist than why they have become so acceptable.

Even more paradoxically, the attacks have become publicly acceptable (and even commonsensical) and, within limits, frighteningly effective at just the moment when rock has clearly and unambiguously become a part of the dominant, mainstream culture. That is, the attacks on rock have reappeared with great force and urgency just when rock seems to have lost any power to resist, let alone threaten or change the existing relations of power. It seems rather obvious that rock, in the United States at least, has been 'colonized' by the economic interests of capitalism, and incorporated into the routinized daily life of capitalist, patriarchal and racist relations. It is all over television; it provides the background music for advertising, films and even shopping. The result, according to many critics and fans, is that rock is losing its cutting edge, its ability to encapsulate and articulate resistance, even its marginality. It has become 'establishment culture'.

Someone might object to this characterization by pointing to the proliferation of explicitly political musics, causes and events. Yet, there is little evidence that this increasing politicization of musicians has any significant impact on the relations between the music and the daily lives of its consumers and fans who often simply refuse the explicit political concerns

194

of the bands and the music. It is becoming difficult to see where and how rock is, or could be, articulated to progressive political commitments. The once generally shared assumption that the two intersected at some point, a point that placed rock on the margins, in alliance, however tenuous, with various populist political struggles, seems to have disappeared.

STRATEGIES OF THE ATTACK ON ROCK

Understanding the attacks on rock requires recognizing that they are multiple and contradictory. I will begin by describing three different forms or strategies of attack, which originate in different social groups, with different political agendas: the first demands a complete and total rejection of rock music and culture; the second attempts to discriminate between the acceptable and the unacceptable, to police the boundary by locating rock within the relations of domestic power; the third tries to appropriate rock in order to change its 'ownership'. Only after this will I ask how they are effectively assembled within and connected to a larger conservative agenda.

Consider the following quotation as a statement of the first:

> Picture a thirteen year old boy sitting in the living room of his family home doing his math assignment while wearing his Walkman head-phones or watching MTV. He enjoys the liberties hard won over centuries by the alliance of philosophic genius and political heroism, consecrated by the blood of martyrs; he is provided with comfort and leisure by the most productive economy ever known to mankind; science has penetrated the secrets of nature in order to provide him with the marvellous, lifelike electronic sound and image reproduction he is enjoying. And in what does all this progress culminate? A pubescent child whose body throbs with orgasmic rhythms; whose feelings are made articulate in hymns to the joys of onanism or the killing of parents; whose ambition is to win fame and wealth in imitating the drag-queen who makes the music. In short, life is made into a nonstop, commercially prepackaged masturbational fantasy.
>
> (Bloom 1987: 74–5)

This passage is actually quite similar to those produced and disseminated by the Christian fundamentalist movement. Both Bloom and the funda-mentalists see rock – the music and its culture – as responsible for a certain fall from grace, although they differ on where we have fallen from, as well as on the cure and the desired end. Bloom is part of the elitist fraction of the new conservatism which advocates a value-based education grounded in the 'great books' of the western (white, male) tradition. Fundamentalist Christians are more populist, focusing on the potential of televangelism to defeat the evils of secular humanism. According to the fundamentalist

rhetoric, rock – 'all of rock music, even the mellow sounding stuff' – is part of a 'bizarre and fiendish plot designed by Satan's antichrist system' to 'lull the youth of the world' (Greenwald n.d.). This has been firmly embodied in the notion that rock fans have to be monitored and even 'deprogrammed', an idea which has been increasingly realized in the creation of centres and experts for such purposes, with the co-operation of law enforcement agencies and medical institutions (Brown and Hendee 1989).

The second strategy is best exemplified by the activities of the Parents' Music Resource Centre (PMRC) which attempts to police the boundaries of rock and to place the power to define what is 'proper' or 'appropriate' music in the domestic authority of the parent (and, to some extent, the patriarchal government). The PMRC, founded in 1985 by four Washington wives (including the spouses of Senator Albert Gore and Secretary of State James Baker), has constructed a campaign designed to 'educate' parents about certain 'alarming new trends' in rock music. The rhetoric of their attack is often predicated on a comparison of early and contemporary rock. By conveniently forgetting the attacks which were (and are) levelled against the music they defend, and by selectively ignoring more controversial examples of classic rock, they are able to celebrate their own youth culture while attacking its contemporary forms: 'Too many of today's rock artists – through radio, records, television videos, videocassettes – advocate aggressive and hostile rebellion, the abuse of drugs and alcohol, irresponsible sexuality, sexual perversions, violence and involvement in the occult' (PMRC n.d.).

The PMRC advocates voluntary labels – they have actually opposed the efforts of various state legislatures to mandate labels – on all rock releases. They describe this as a demand for 'truth in packaging' so that both children and parents know what is being purchased and consumed in the face of rock's harmful effects. Although they admit that there is no statistical evidence against rock, they adduce anecdotal evidence to 'document' rock's evil impact, usually in the form of suicide or murder, and often with occult or satanic overtones. The increasing suicide rate among adolescents (up 300 per cent since the 1950s) is taken as proof of rock's detrimental effects, ignoring not only the impact of other social factors but also the fact that they themselves (and the vast majority of post-war youth) were also raised on rock.

The efforts of the PMRC have not been confined to such lobbying and proselytizing efforts; it has supported and encouraged legal and economic activities aimed against rock (*Rock and Roll Confidential* 1991). Obviously, the threat of such legal proceedings (e.g., recent cases involved the Dead Kennedys, Two Live Crew and Judas Priest) has created an atmosphere of uncertainty for many bands, labels and distributors.

However, it is the third form of attack which is the most insidious for it appears to celebrate (at least certain forms of) rock, but only by consider-

ably reconstructing its very meanings and significance. This is perhaps the ultimate affirmation of Tom Carson's (1988) statement that one 'can't associate pop with any sort of disenfranchisement when its headquarters is the white House'.

As George Bush's campaign manager and as chairman of the Republican National Party, Lee Atwater championed the use of popular media and marketing strategies. He also claimed a special place for rock! He organized an inaugural party – 'The Concert for Young Americans' – which was also billed as a Celebration of Rhythm and Blues. Envision, if you can, the President entering and leaving to the sounds of 'Soul Man', his brief appearance highlighted by the gift of an electric guitar, something which Bush obviously had no idea how to embrace. Lee Atwater was on stage, jamming with some of the greatest black (and white) musicians of our time!

Following that, Atwater's rock career continued apace. He appeared on *Late Night with David Letterman* as a guest member of Paul Schaeffer's band. He performed in various rock and blues venues, both solo and with a variety of other performers, and he released a 'rhythm and blues' album in 1990 (which, gratefully, flopped). Two comments are worth making here: first, we must assume that Atwater's entrance into rock culture was planned or, at least, sanctioned by the image-makers and marketers of the Republican Party. Second, Atwater was living out a new image of the rock fantasy: how to be rich, powerful and manipulative (and to have apparently all the wrong politics) and be a rock star.

ROCK AND THE STRUGGLE OVER YOUTH

How are we to mark the point at which these three strategies intersect, or even whether they do? How are we to understand why such discourses have appeared where they have at just this moment, in the history not only of rock, but also of the nation. The very success of these attacks must in some ways lead us to reassess our assumption about the political possibilities of rock. One possible starting part is the arguments – built around the relation between rock and youth, and its challenge to the family and to the nation – in both Bloom (1987) and Gore (1987).

Bloom's argument, while explicitly concerned with an elitist minority – 'the good students in the better universities' – is a broad attack on the current generations of youth and, even more, on the current position of youth. In 1965, Bloom wrote optimistically about his students:

These students are a kind of democratic version of an aristocracy. The unbroken prosperity of the last twenty years gives them the confidence that they can always make a living. So they are ready to undertake any career or adventure if it can be made to appear serious. The ties of tradition, family and financial responsibility are

weak. And along with all this, goes an open, generous character. They tend to be excellent students and extremely grateful for anything they learn. A look at this social group tends to favor a hopeful prognosis for the country's moral and intellectual health.

(Bloom 1987: 49)

Twenty years later, Bloom's prognosis had altered significantly: 'Today's select students know so much less, are so much more cut off from the tradition, are so much slacker intellectually, that they make their predecessors look like prodigies of culture' (ibid.: 51). What are the causes and stakes of this crisis? In the first instance, the youth culture of the 1960s is to blame. Bloom offhandedly dismisses the politics of the 1960s as merely the result of the absence of a liberal education as if, had they only been reading the classics and thinking Socratically, they would not have fallen into the political positions which came to define an important part of their lives – political positions which 'wasted that marvellous energy and tension, leaving the students' souls exhausted and flaccid, capable of calculating, but not of passionate insight' (ibid.: 49–50).

But there is more at stake, for the real question is 'what it means to be an American'. Bloom argues that the political tradition of the United States 'is unambiguous; its meaning is articulated in simple, rational speech that is immediately comprehensible and powerfully persuasive to all normal human beings. America tells one story: the unbroken, ineluctable progress of freedom and equality' (ibid.: 55). If 'it is possible to become an American in a day', this is because there are 'no real outsiders' (ibid.: 53) here for our national identity depends only on the history of our commitment to freedom and equality rather than to any shared culture or tradition. This is

very different from the kinds of attachment required for traditional communities where myth and passion as well as severe discipline, authority and the extended family produced an instinctive, unqualified, even fanatic patriotism, unlike the reflected, rational, calm, even self-interested loyalty – not so much to the country but to the form of government and its rational principles – required in the United States.

(ibid.: 27)

But the devil has entered America in the form of a new 'openness' which has driven out the local deities, 'leaving only the speechless, meaningless country' (ibid.: 56). This new 'relativism' is pervasive; it has undermined all forms of authority, rationality and value. But more importantly, the sources of this new relativism are equally pervasive. If the stakes in Bloom's argument involve more than just how we educate our best youth, its prescriptive politics are not really about education at all, but about the struggle over youth and popular culture in the contemporary world:

Along with the constant newness of everything and the ceaseless moving from place to place, first radio, then television, have assaulted and overturned *the privacy of the home, the real American privacy*, which permitted the development of a higher and more independent life within democratic society. . . . It is not so much the low quality of the fare provided that is troubling. It is much more the difficulty of imagining any order of taste, any way of life with pleasures and learning that naturally fit the lives of the family's members, keeping itself distinct from the popular culture and resisting the visions of what is admirable and interesting with which they are bombarded from within the household itself.

(ibid.: 59, my italic)

Bloom tells us that he had originally supported his students' tastes in rock because it appealed to real feelings. But somewhere, as rock came to dominate the 'meaningful inner life' of his students, Bloom concluded that it was 'barbaric'. Great music is supposed to harness the passions to reason, but rock music appeals only to 'sexual desire undeveloped and untutored' (ibid.: 73) and has dispelled 'any clear view of what adulthood or maturity is' (ibid.: 77). Rock music 'ruins the imagination of young people and makes it very difficult for them to have a passionate relationship to the art and thought that are the substance of liberal education' (ibid.: 79). But the effects of rock music are even more serious:

Rock music provides premature ecstacy and, in this respect, it is like the drugs with which it is allied. The student will get over this music, or at least the exclusive passion for it. But they will do so in the same way Freud says that men accept the reality principle – as something harsh, grim and essentially unattractive, a mere necessity. These students will assiduously study economics or the professions and the Michael Jackson costume will slip off to reveal a Brooks Brothers suit beneath. They will want to get ahead and live comfortably. But this life is as empty and false as the one they left behind . . . as long as they have the Walkman on, they cannot hear what the great tradition has to say. And after its prolonged use, when they take it off, they find they are deaf.

(ibid.: 80–1)

Bloom is here frighteningly perceptive: rock does reorganize the possibilities of our affective relation to the world. Furthermore, it has constructed a certain postmodern relativism which cuts through the very heart and soul of the nation. But it is the immaturity of rock's passion, the fact that somehow it places youth outside social control, the family, the academy and even the nation that seems, ultimately, to frighten Bloom the most.

199

Judging from the title of Gore's (1987) book (*Raising PG Kids in an X-Rated Society*), one might reasonably expect a handbook for how to deal with children in the modern world. But Gore is not concerned with child-rearing practices, or the condition of children, but with 're-asserting some control over the cultural environment in which our children are raised' (Gore 1987: 13). Here the regulation of culture and of cultural consumption collapse into the same project. There is thus a political agenda, and a conception of America (and of the threats facing it) which is strikingly similar to Bloom's:

> The dilemma for society is how to preserve personal and family values in a nation of diverse tastes. Tensions exist in any free society. But the freedom we enjoy rests on a foundation of individual liberty and shared moral values. Even as the shifting structure of the family and other social changes disrupt old patterns, we must reassert our values. . . . People of all political persuasions – conservatives, moderates and liberals alike – need to dedicate themselves once again to preserving the moral foundation of our society.
>
> (ibid.: 12)

This crisis is intimately linked to the social production of childhood and youth. It is not coincidental that the first substantive chapter is entitled 'Where have all the children gone?' with its obvious echoes of the 1960s folk revival and its explicit suggestion that it is the definition and place of childhood that is at stake. Gore's strategy is threefold: first, she refuses to distinguish between children and adolescents. Even though she acknowledges that 'teenagers are endowed with the emotions, passions, and physical capabilities of adults', she emphasizes that they lack 'the adult judgement to harness them'. Consequently, they can be treated as nothing more than 'children in transition' (ibid.: 41). Second, she suggests that children need 'the security of definable boundaries' (ibid.: 41). The problem is where one locates those boundaries, and how one puts them into place in the modern world.

This requires a conception of childhood and it is this, more than anything, that Gore offers: an image of

> fragility and innocence . . . children are special gifts and deserve to be treated with love and respect, gentleness and honesty. They deserve security and guidance about living, loving and relating to other people. And they deserve vigilant protection from the excesses of adult society.
>
> (ibid.: 46)

However, it is not adult society which threatens children, but their own. It is here that her third strategy is so crucial, for after acknowledging that there seems to be a crisis in the ways society relates to children (e.g., child

molestation and abuse) and in the ways children relate to society (e.g., suicide, drug and alcohol abuse, homicide), it is all a matter of the cultural environment, those popular media messages which children take as their own, and which Gore finds so reprehensible.

These texts clearly suggest that there is a struggle taking place over the meaning, ownership and control of the category of youth and its power within competing conceptions of American identity. But interpreting the attacks on rock as a struggle over youth (and the nation) merely throws us back into the paradox of the selectivity of the attacks (why only certain representations of violence and sexuality? why only certain forms and media of popular culture?) as well as into what can only be described as the hypocrisy of the new puritanism: it is apparently more concerned with images than with realities (e.g., of the state of children). Moreover, this interpretation ignores the third strategy which appropriates rock to the new conservatism. It is necessary, I believe, to look elsewhere for the significance of the attacks on rock, and the struggles over youth, to locate them within struggles taking place in other domains and on other planes.

ROCK AND THE LIMITS OF POLITICS

Rock has had a variety of political positions, powers and effects since its emergence in the 1950s. Its history includes a series of interrupted struggles to articulate (or disarticulate) particular sounds, texts, genres and styles to specific meanings, social positions and ideologies and, from there, to specific political positions and effects, or to the 'necessary absence' of politics at a particular conjuncture. Sometimes its politics have involved the organization of individual experience, or the configurations of everyday life, or the structure of social relationships and differences, or even, on rare occasions, the explicit distribution of political and economic power. But unless we begin by acknowledging the constraints and limits operating on the articulation of rock to politics, we are likely to fall back into a naively romantic view which simply assumes that rock was and is supposed to be resistant, oppositional, or somehow located outside the political mainstream of American culture.

Consider the political, social and economic climate of the post-war United States: an unstable and unequally distributed economic prosperity and optimism; the conversion of the productive apparatus to consumerist goals; a corporate compromise between labour and capital mediated by the State (committed to extending civil liberties in order to expand the consumer population); and most importantly, a peculiar version of liberalism ('the end of ideology') built upon a precarious assumption that difference mattered culturally and socially but not politically. The result was a powerful context of change, regulated by an image of the proper form of mobility: amelioration in both social and economic terms. This was a

gradual process which had to be earned and which, when successfully completed, would reproduce the unity of the political consensus in the image of the social and cultural mainstream. Of course, this mobility was counterbalanced by a very real quietism or conservatism which pervaded every aspect of the nation's life.

It was against the image of this social conservatism that the romantic vision of rock as an inherent statement of political resistance or, at least, an expression of alienation, was formed. I want, instead, to emphasize the ways this context constrained the political possibilities of rock so that it was difficult, if not impossible, for rock to enter into any explicit ideological struggle or political resistance. Rock did not challenge the ideological consensus of American life, but it did attempt to escape the quietism of culture and everyday life. This has in fact always been the limit of rock's politics.

There is little evidence that rock rejected the dominant liberal consensus of American society, or its major ideological assumptions, including sexism, racism and classism. It is not merely that most fans lived somewhere inside the vast centre of US society, it is also that they imagined themselves remaining within it (or even, moving more toward the centre in so far as it defined the middle-class image of success). This is not to claim that rock fans wanted to grow up living the same lives as their parents – but then what modern generation has? They assumed that the centre would change, but their imagination of such changes was itself defined by the ameliorism of the dominant consensus. Nowhere in this was there any room for ideological questions. Rock's politics were firmly located within the commitment to mobility and consumerism, perhaps not as ends in themselves but as the necessary conditions for a life of fun – that is, rock culture never renounced the normative passion for comfort and success. Since they were caught in the space between the discipline and boredom of the school and the family (the two dominant sites of youth's policing), rock fans used rock to imagine their own space of enjoyment, pleasure and fun, a space regulated only by the norms of the rock culture itself. But this space was not a replacement for school or family (although it may have suggested the possibility of less rigid organizations for these institutions). Being a rock fan certainly did not entail, and only rarely involved even imagining, the possibility of leaving school – it remained the necessary path to secure the consumerist life style and its associated pleasures – or renouncing family and a domestic future.

Rock rarely rejected the domestic image of daily life, including the privileged position it gave to men in both gender and sexual relations. Yet while rock, as well as the image of the rocker, were often positioned outside the family, the vast majority of songs and fans reproduced the desire for love and the stable relationships of the nuclear family. Equally, while rock did create a space in which women's sexuality and pleasure were

publicly legitimated, it was often romanticized and almost always defined in relation to the male partner, viewer or listener. This does not deny that the sexual power of rock music, performance and dance was new to its fans, nor that it was seen, by its fans but even more by the mainstream population, as a rupture in, even a threat to, the quiet regulation of sensuality and sexuality.

Similarly, the dominant class politics remained largely in place, reinflected only through romantic fantasies of different class experiences, and of the possibilities which these implied for the members of each class to escape the structures of control and discipline of their own class. So too regarding race relations, rock was firmly located within the ambiguity of the dominant consensus: both ameliorative and racist, rock's relations to black music, performers and audiences have always been highly selective. The apparent absence of a gap between black and white music and musical taste in the 1950s says more about the organization of the economics of distribution (limited repertoires of available musics, limited numbers of venues for performance, etc.) than it does about the politics of the rock culture itself. Again, this does not deny that rock – performers, performances and fans – did position itself significantly further along the ameliorative ladder of improved race relations. But it did not challenge the taken-for-granted terms of the ideologically and institutionally constructed racism of the US, and it most certainly did not offer any critique of the dominant ideology.

Yet once again, to the extent that this was seen – not by rock fans as much as by the mainstream adult culture – as having allowed the interracial mobility implicit in the rhetoric of the liberal consensus to be accomplished more quickly than their racism desired, rock was seen as something of a political challenge. It was precisely because rock so innocently accepted its place within the liberal consensus that it was so easily embroiled in and articulated to political struggles, but always by others. Thus, I am not claiming that rock did not challenge, upset, distance itself from the dominant social systems of power and discipline. I am claiming that rock's challenge was rarely articulated by or from within the rock culture itself but always by those outside, and to some extent, opposed to it. Its politicization resulted primarily from the sustained attacks it elicited rather than from its own activities or intentions. Perhaps those who opposed rock recognized that it was not quiet aesthetically, culturally or socially; perhaps they were afraid that its attempt to upset the consensual economy of cultural taste and pleasure would have wider social ramifications.

In any case, the result was that the rock formation often found itself articulated outside the very consensus in which it still located itself. We might say that rock was politicized 'behind its back'. In their effort to fight back against rock's expulsion from the mainstream, rock fans and musicians did sometimes politicize it further, and this was not always only the

result of their attempts to protect it and themselves. Nor was it merely because they occasionally realized that they wanted to fight for the very things for which it was being attacked. It was just as often because it was exciting, if not fun, to be placed – temporarily at least – in the position of troublemaker. It was a way for youth to assert its own place. Ultimately, rock's distance from the mainstream, and its dissonant voice within it, were the result of the way rock mattered to its fans, and of the things that it made matter as well.

ROCK, EVERYDAY LIFE AND THE POLITICS OF TERRITORY

The specificity of rock as a form of popular culture depends upon its special relation to everyday life, a relation that makes it particularly important in the current political context. But 'everyday life' is more than just daily life: it is an historical structure of power. Following Lefebvre (1984), it is an historically produced plane of existence which is built upon principles of repetition, redundancy, recurrence (and ultimately, boredom). Everyday life is possible only if every principle of transcendence – creating a style which gives unity to daily life and meaning to every detail – is eliminated. It is, in a sense, a structure of discipline by which people's daily practices are subjected to the demands of a comfortable predictability and routinization. But everyday life is also a luxury, not merely because of the real pleasure and comfort of its stability, but also because it is unequally distributed. As odd as it may sound, not everyone has an everyday life (but everyone does live a daily life); it is a privilege determined largely but not entirely in economic terms. Rock is music produced by and for a population already living in everyday life, but it is always about the possibility of transcending the specific configuration of everyday life within which it is active. Lefebvre in fact draws a close parallel between music and everyday life: 'Music is movement, flow, time, and yet it is based on recurrence' (Lefebvre 1984: 19). When he asks whether music 'express[es] the secret nature of everyday life, or compensates, on the contrary, for its triviality and superficiality?' our answer must be that it does both. In fact, it is precisely in attempting to transcend particular forms of recurrence (everyday life) that music articulates its power.

The ways in which rock was articulated by its conditions of possibility in the 1950s constrained it so that it could only seek to transcend the specific configuration of everyday life – the specific forms of repetition, mundanity and triviality characterizing the everyday life in which it found itself imprisoned. That is, rock did not seek to transcend everyday life itself, to open itself out on to other planes of political, social and economic existence. It operated with and within, it took for granted, the luxury and privilege of everyday life as the condition of possibility of its own struggle

against the mundanity of its everyday life. At best, rock sought to change the possibilities – the rhythms – within everyday life itself. It did not construct for itself a space outside everyday life.

Instead, it appropriated as its own the markers of places outside everyday life which other musics, other voices, had constructed. These voices and the places they marked became the signs of authenticity within the everyday life of rock culture, but they were the voices of peoples who apparently had no everyday life, who seemed to exist outside the privileged spaces of the repetitiously mundane world of rock culture. Rock then attacked, or at least attempted to transcend, its own everyday life, its own conditions of possibility, by appropriating the images and sounds of an authenticity constituted outside, and in part by the very absence of, everyday life.

Rock is not merely white boys singing the blues; it is the sound of those who are imprisoned within everyday life, who cannot imagine its negation (and only ambiguously desire it), trying to produce the sounds of those who have no everyday life. Consequently, rock can only rarely and with difficulty address questions of politics, society or economics directly; its politics are often determined by those moments when political realities impinge upon its everyday life (e.g, the draft rather than the fact of a genocidal war being waged against the Vietnamese) or when it can be reduced to a question of everyday life (e.g., it can protest the suffering of blacks under apartheid but it cannot acknowledge the internal political economic system which sustains apartheid and a multitude of other repressive regimes). Its most powerfully resonant music comes when it acknowledges that it can only see the realities of such questions through the structures of its everyday life (e.g., the best countercultural music, and the most powerful punk music). Thus, in writing that 'American rock music now is a form of easy listening' (Frith 1990: 91), there is a sense in which it has always been true but only now is it becoming blatantly obvious.

But why does such music need to be disciplined? Why has it become a site of struggle and contestation? Here we might begin by reminding ourselves of the unique relation of music and power and the power of music. 'Ambiguous and fragile, ostensibly secondary and of minor importance, [music] has invaded our world and daily life. Today, it is unavoidable, as if, in a world now devoid of meaning, a background noise were increasingly necessary to give people a sense of security' (Attali 1985: 3).

The fact that music gives people a sense of security is obvious. But *how* does music give people a sense of security? To say that the answer has to do with music's ability to 'move' or stir people is too vapid an understatement, for it treats music's power in purely figurative terms. Obviously, it is true that music somehow calls people emotionally. Would it not then be more accurate to say that music is the most powerful affective agency in human life; music seems, almost independently of our intentions, to produce and orchestrate our moods, both qualitatively and quantitatively. We might

turn, for an image of this power, to Deleuze and Guattari's 'refrain' of creation, made manifest in the construction of the musical refrain itself:

> A child in the dark, gripped with fear, comforts himself by singing under his breath. He walks and halts to his song. Lost, he takes shelter, or orients himself with his little song as best he can. The song is like a rough sketch of a calming and stabilizing, calm and stable, center in the heart of chaos. . . . Now we are at home. But home does not preexist: it was necessary to draw a circle around that uncertain and fragile center, to organize a limited space. Many, very diverse, components have a part in this, landmarks and marks of all kinds. . . . Sonorous or vocal components are very important: a wall of sound, or at least a wall with some sonic bricks in it. A child hums to summon the strength for the schoolwork she has to hand in. A housewife sings to herself, or listens to the radio, as she marshals the antichaos forces of her work. Radios and television sets are like sound walls around every household and mark territories (the neighbor complains when it gets too loud). For sublime deeds like the foundation of a city or the fabrication of a golem, one draws a circle, or better yet walks in a circle as in a children's dance, combining rhythmic vowels and consonants. . . . A mistake in speed, rhythm, or harmony would be catastrophic because it would bring back the forces of chaos, destroying both creator and creation.
>
> (Deleuze and Guattari 1987: 311)

Here they are attributing to music an enormous territorializing power. In my own terms, it is music which founds place. It is music which calls forth our investments and hence, our affective anchors into reality. It is music which affectively locates us in the world by constructing the rhythms of our stopping and going. When we stop, when the music enables us to stop, we ourselves are positioned, not by an already existing stable identity, but by the wall which our music (our affect) constructs around a bit of space. We are protected now to engage in whatever activities are necessary, and enabled to move on in ways that were not possible before, since the wall reconstructs the space outside just as surely as it constitutes a place inside. Everyday life is itself organized by the rhythms of places and spaces, and by the specific configurations of places. Thus, we can describe music as a 'territorializing machine' which articulates the mattering maps by which everyday life becomes navigable and hence, liveable.

To some extent, the attacks on rock can be seen as a struggle over the mattering maps which rock culture has put into place. The new conservatism requires a different map of what matters in everyday life, a different set of investments in specific ideological values, and a different organization of stability and mobility. But this does not explain the attempts to discipline and appropriate rock, rather than simply rejecting or regulating

it. If music generally – and by extension, popular culture – functions as a territorializing machine, why is rock privileged in these struggles? Part of the answer lies perhaps in rock's place in the general terrain of post-war popular culture. It is (or at least has been until recently), in some very real sense, the central vector of contemporary cultural life; it is rock which often defines the leading edge of both empowerment and disempowerment, of excitement and cynicism.

I believe that there is yet another – more strategic – reason for the struggle over rock. Rock is, after all, more than just a territorializing machine; it is also a deterritorializing machine. Its power lies in its ability not only to construct maps of everyday life, but also to deconstruct such maps as well. Rock can celebrate insecurity and instability even as it constructs secure spaces. It can challenge the particular stabilities of any organization of everyday life. It can seek to rock the cultural and quotidien boat. Rock's energy comes precisely from its constant production of what Deleuze and Guattari (1987) refer to as 'lines of flight', disarticulating through music the codes which guarantee the repeatability necessary to both power and everyday life. In a way, rock is always trying to escape the prison of its own everyday life, although it never understands that on the other side of everyday life lies another realm of economic and political power. Rock is constantly producing lines of flight which can challenge not only specific territorializations, but also the very desirability of territoriality. It is rock's lines of flight that provide the basis for its appearance as politicized. It is rock's lines of flight that have, at various moments, enabled it to define, galvanize and articulate a sense of anger, dissatisfaction and protest.

How are we to bring these two notions together? How are we to make sense of the claim that rock is a primary agency of both territorializing and deterritorializing forces? But isn't that just what rock's use of rhythm is about? Is that not the very function of rhythm in rock: to regulate the relations of place and space, of territorializing and deterritorializing? In rock, mobility precedes, and is more basic than, stability. Energy is more precious than security. Space takes precedence over place.

Rock operates with a necessary contradiction: territorializing and deterritorializing, lines of articulation and lines of flight. Its history – often interpreted by both fans and critics as a cycle of authentic and co-opted sounds – is a struggle between these two vectors of its effects. The form of rock's power and of its ability to organize affective alliances depends upon which of these two vectors is dominant. But it is always the deterritorializing lines of flight which constitute rock's operation as a political force and which place it outside the mainstream (and everyday life) even as it is trapped within it.

It is rock's production of lines of flight that the new conservatism is attempting to discipline in order to construct a different machine, one in

which deterritorialization is in the serve of territorialization, in which lines of flight bend back upon themselves to become lines of articulation: space and place, stability and mobility, the differences no longer matter. Such a machine might be described as a disciplined mobilization. A disciplined mobilization is a particular dynamic structuring of everyday places and spaces, a closed circuit of mobility. Once you have entered into its spaces, there are no longer any frontiers or boundaries to cross. Every line of flight leads one back into the same circuits of mobility and stability. Instead everyday life becomes a transit compulsion in which sites of investment (places) are transformed into sites of mobility, and mobility itself is constrained to operate within the trajectories defined by such places. One can only live within such a machine as if moving along a Möbius strip. There is no longer an outside or an inside, only the constant movement itself. A disciplined mobilization signals the triumph of an unconstrained mobility which is nothing but a principle of constraint. In more practical terms, it is a depoliticizing machine which reduces reality to the possibilities of everyday life.

Perhaps, then, it makes sense that the attacks on rock appeared at just the moment they did, when rock culture has been called back to its roots in rhythm and dance, when club rock so powerfully dominates the culture, and when the most powerful pleasures in rock seem to be produced out of the contradictions between the central and powerful rhythms and the increasingly less memorable 'sound-track' melodies. In fact, we might consider that punk's self-referential attack on rock helped to undermine rock's ability to establish any place. In a sense, punk transformed rock into a disciplined mobilization of sorts (and in that sense, may have unintentionally played into the hands of the contemporary forces of conservatism and capitalism). The possibility of such a close relationship between rock and this particular cultural structure makes sense when we consider the way in which youth, the audience of rock, has been constructed in the post-war US: shuttled around with no place of its own.

NOTES

1 This paper draws on material from my (1992) book, *We Gotta Get Out of This Place: Popular Conservatism and Postmodern Culture*, New York: Routledge. I would like to thank Tony Bennett for his helpful editorial suggestions and Meaghan Morris for suggesting the link between Lefebvre and Deleuze and Guattari.

BIBLIOGRAPHY

Attali, Jacques (1985) *Noise: The Political Economy of Music*, trans. Brian Massumi, Minneapolis: University of Minnesota Press.

Bloom, Allan (1987) *The Closing of the American Mind*, New York: Simon & Schuster.

Brown, E.E. and Hendee, W.R. (1989) 'Adolescents and their music', *Journal of the American Medical Association* 262: 1659–63.

Carson, Tom (1988) 'What we do is secret: your guide to the post-whatever', *Village Voice Rock and Roll Quarterly* Fall.

Deleuze, Gilles and Guattari, Felix (1987) *A Thousand Plateaus: Capitalism and Schizophrenia*, trans. Brian Massumi, Minneapolis: University of Minnesota Press.

Frith, Simon (1990) 'Britbeat', *Village Voice* 24 April.

Goldstein, Richard (1990) 'Swept away: in the wake of Bush', *Village Voice* 10 January.

Gore, Tipper (1987) *Raising PG Kids in an X-Rated Society*, Nashville: Abingdon Press.

Greenwald, Gary (n.d.) *Rock a Bye Bye Baby*, audio tape, The Eagle's Nest.

Lefebvre, Henri (1984) *Everyday Life in the Modern World*, trans. Sacha Rabinovitch, New Brunswick: Transaction.

PMRC (Parents' Music Resource Centre) (n.d.) 'Letter', Washington, DC.

Rock and Roll Confidential (1991) 'Editorial', in *You've Got a Right to Rock: Don't Let Them Take It Away*, Los Angeles.

13

BEAT IN THE SYSTEM
Ross Harley

TECHNOLOGICAL BIZARRE

Much of the writing in the popular press and in critical publications alike shares the view that the advent of digital samplers and other related technology has fundamentally changed the way that contemporary music is produced and consumed. Of this there is no doubt. Discussion has centred primarily around dance music (mostly house and hip hop) which has been at the forefront of experimentation with new recording and playback machines. It has become a journalistic commonplace to declare that today's avant-garde music is a blend of hardcore modernism and wilful pop concocted by dancefloor experimentalists – a bizarre technological marriage of Stockhausen and Waterman. Relatively inexpensive (and hence increasingly accessible) devices such as sequencers, samplers, digital effects processors, multi-track recorders, MIDI instruments, drum machines, hi-fi videos, CD ROM machines, CD players, DAT recorders and so on have quickly been seized upon by producers, musicians and consumers alike. Most significantly, this new digital equipment is able endlessly to 'sample', manipulate, cut and paste, reorganize and redistribute copies of sounds that are exact duplicates of 'originals'. In such a context, it is little wonder that enormous claims are being made for this new era of digital music.

Although advances in digital electronics have had a remarkable effect on the development of new musical forms, we are sometimes tempted to take an unnecessarily extreme position regarding the recent 'digitalization' of sound. In the first instance, our views are couched in celebratory terms that see sampling as the postmodern musical equivalent of the death of the author, leading to the democratization of sound and the breaking down of rigid capitalistic conceptions of ownership, characterized by an egalitarian do-it-yourself ethos. Such is the 'rock version of the postmodern condition: a media complex in which music only has meaning as long as it keeps circulating, authentic sounds are only recognized by their place in a system

of signs, and rock history only matters as a resource for recurrent pastiche'
(Frith 1988: 161).

Alternatively, the widespread use of digital recording processes is seen
more sceptically as the revenge of technology and its unscrupulous users on
the moral rights and future careers of original recording artists. Not only
are the real musicians no longer needed as part of the recording process,
but also their work is blatantly stolen and misused, adding outright theft to
the long list of exploitative practices in popular music – especially black
music, from blues, gospel, R & B and jazz to soul, rap and funk. Based
primarily upon romantic notions of authenticity and a distrust of machine-
made music going back to the 1970s, such a view hears only the erasure of
ethnicity, the destruction of 'soul' and the loss of cultural control to the
corporate producers and executives. Nelson George epitomizes this view
when he says that synthesizers 'of every description, drum machines, and
plain old electric keyboards began making . . . human rhythm sections
nonessential to the recording process. For producers this was heaven. No
more rehearsals. Low session fees. . . . But this influx of technology didn't
make the music any better. No indeed' (George 1988: 181).

Based on technological determinist lines, such views perceive changes in
musical form and style as the direct result of new inventions, of new
systems and machines owned by particular interests. Whether they are in
the service of creative artists or the exploitative white multinationals is of
little importance. As both positions directly equate musical outcomes with
technological means, it is easy to ignore the more fundamental changes
that might be happening in music utilizing digital technology, to underplay
the historical and cultural relations that have contributed directly to the
rise of a variety of apparently new musical forms seemingly spawned by a
particular technology (whether this be the electric guitar, the amplifier, the
synthesizer, the drum machine, the sequencer or the sampler).

A combination of the celebratory and sceptical views presents a more
productive set of possibilities that perhaps come closer to an understanding
of how new technologies and pop music are related:

> Why spend a lifetime trying to sound like James Brown when you can
> rip him off? In the 1960s ripping off the riffs of R & B was an amoral
> crime. Pop tolerated fullscale exploitation as black American music
> was systematically pillaged by white performers. Modern theft is
> democratic, a two-way process in a desegregated dance-hall: hip hop
> steals from heavy metal, house steals from Europop and British indie
> bands steal from their own latterday heroes. Troublefunk steal from
> Kraftwerk, JM Silk steal from Depeche Mode, and the Age of
> Chance steal from everyone.
>
> (Cosgrove 1987: 24)

Stuart Cosgrove's description, however debatable his claims may be,

211

suggests that the processes of change in technologies and musical genres are not simply one-way. Although he at first appears caught between the poles of a romantic postmodernism and a conviction that sampling is part of an ongoing tradition of stealing from blacks (albeit a 'democratic' reversal), he can also be seen to offer a more productive insight. In highlighting some of the ways that the *use* of music has changed since the 1960s, Cosgrove underscores an important part of the technology-in-pop equation – cross-fertilization of musical styles may be old news, but its cultural inscription in the use of particular technologies is being radically altered.

The following account of how contemporary dance and pop music has intersected with developments in music technology is based on the premise that such 'inscriptions' only make sense when seen as part of a wider cultural/musical scenario. If musical culture has been affected by changes in technology, we should trace the use of technologically related devices and resulting sounds across a number of different histories of music, genre, technology, politics and place.

THE NEW DIGITAL UNDERGROUND

As has been evidenced throughout this century, the fate of technological invention is inextricably bound up with patterns of production and consumption. In this regard, digital technologies need to be considered as a continuation of those historical developments going back to the beginning of this century. Today's digital culture has emerged from the shadows of former edifices that have not completely disappeared. As part of the logic of capitalism, however late that may be, the music industry's own continuity is shored up by an ever-changing array of fetishistic commodities exchanged for profit. Put simply, new technologies enliven flagging consumer interest and initiate fresh desires that promise to be fulfilled by the acquisition of new objects, in the form of what is now commonly referred to as 'hardware' and 'software'.

Such a fetishistic scenario could only invite pessimism were it not for the fact that new technologies also provide producers and consumers with the means to resist corporate control of music. This contradiction – that technology revives at the same time that it threatens capitalism – lies at the heart of the opposition between the celebratory and sceptical views of digital sampling. Though part of a materially describable terrain, the 'basic conditions of recording and playback do, however, constitute a strategically unstable system, a malleable (even reversible) structure through which all recorded music must pass' (Corbett 1990: 99).

This 'malleable structure' is itself characterized by a process of constant change that is also fundamentally repetitive. Patterns of production and consumption have tended to repeat themselves over this past century's

staggering turnover of entertainment technology. Couched in a pseudo-military language, the perennial 'battles' over formats and processes always involve 'wars', 'defeats' and 'triumphs' – magnetic tape triumphs over direct-to-disc mastering, VHS defeats Beta video tape, CDs emerge victorious over vinyl, etc. In contrast, the vitality of most musical genres, from rock'n'roll to heavy metal, from funk to hip hop, relies heavily upon those they borrow from. Such an unstable system is also increasingly categorized by the disintegration of the difference between producers and consumers, witnessed for example by the rise of the DJ as rebuilder of pop songs into dance hits. Similarly, the boundaries that have traditionally existed between genres are no longer clear-cut or definitive. Far from signalling the end of categorization and the death of historically grounded musical forms, these developments have given rise to a variety of new forms that might 'recreate the old codes in order to reinsert communication into them. Inventing new codes, inventing the message at the same time as the language' (Attali 1985: 134).

Changes in the recording and reception of popular music demand that we develop new ways to account for musical transformation. Such an approach seeks to analyse the products of the 'digital revolution' in its proper context, to recognize recent developments as a continuation of previous sound technologies by other means, while venturing beyond 'the ritual incantation of pastiche' commonly associated with postmodernist accounts (Goodwin 1990: 258).

If we are to analyse the role that technology plays in contemporary pop music, we must first and foremost concentrate on the conditions that make this music possible at all. Following Alan Durant, we can say that

> music is never simply led by technological invention. . . . Rather, technological developments take on their particular character only in specific instantiations within prevailing, but also changing, social relations and contexts. They lead to networks of reactions, responses and effects that cannot be predicted merely from the resources or design of the technology itself.
>
> (Durant 1991: 180)

WHAT MATTER WHO'S SINGING?

John Mowitt (1987) approaches this problematic via a discussion of the Benjamin/Adorno debate over the role and function of contemporary music. While Benjamin celebrated the principle of the fragment and the concept of distraction as a critical activity opposed to contemplation (an older view associated with the preservation of a work's 'aura'), Adorno bemoaned 'the fetish-character of music and the regression of listening'. According to Mowitt, Adorno recognized that 'listening, as a sensory and

cognitive structure of experience, occurs within the reception institutions organized by the capitalist mode of production. Characteristic of these institutions is their reflection of the fragmentation and exchangeability that defines this mode of production' (ibid.: 187).

Staged well in advance of the vast technological changes before us now were even contemplated, this debate is nevertheless relevant to our present condition. Although at loggerheads with each other, both Benjamin and Adorno underscored the importance of the shift from a literary culture based on singular works and performances to one that can endlessly reproduce artefacts outside a system that sees writing as a privileged supplement to music.

The recording studio and the phonograph inaugurated a musical culture that is organized primarily around reception. The advent of electronic recording devices has all but done away with much of the need for musical notation (with the exception of classical musicians and, curiously, computers that use the same principles and notations on display screens and print-outs). In its place we have the recording studio which, along with the individual electronic instruments that music is made with, functions as the instrumentality through which music is composed and recorded. Ever since R & B and rock 'n' roll did away with the dependence of popular music performances on strict arrangements and an ability to read sheet music, musical notation has been increasingly replaced by devices that are capable of arranging music as if it were unmediated by any form of signification. More recently recording practices have come to rely on systems such as MIDI, which can control and synchronize a number of independent machines (say a keyboard, a sequencer and a drum machine) in order to compose directly on those instruments. Inverting the priority of musical production over consumption, electronic recording establishes a listener who is characterized by an apparatus that precedes him/her.

Following Mowitt's logic, it makes perfect sense to focus our attention upon the site that now assumes a central position in the construction of contemporary pop music:

> To emphasize the importance of reproductive technology when analysing the social significance of music is to privilege the moment of reception in cultural experience.

> (ibid.: 173)

Today, the combination of a number of discontinuous recorded performances produces the musical 'text'. Musical production and consumption have been technically fused, with reproductive technologies disrupting the discourses of signification, originality, collectivity and authenticity. 'At the same time, the process common to many technological developments where the technology is redirected toward purposes other than those for

which it was originally foreseen . . . [has] made possible new creative relationships in the making of those new kinds of texts' (Durant 1989: 253).

The fragmentation and exchangeability of contemporary compositional processes have given rise to new kinds of music and audiences that do not necessarily surrender to traditional patterns of identification. If the notion of aura still has a pertinence in debates about authorship and authenticity in dance music, then we need to specify how these categories are currently being transformed and deployed. A concrete example of this can be found in the evolution of house music.

Since it bleeped and sampled its way on to the dance scene in the late 1980s, house has come to stand for everything associated with the contradictory jumble of styles, attitudes and origins that define contemporary pop music. Likened to the sound of a cultural blender running at warp speed, house is variously championed for breaking down the traditional divisions between various genres of music, disparaged for its disco-like repetition and production-line rhythms and melodies, and singled out as the catalyst that binds together a new society of global groovers. Intrinsically connected to the rise of DJ and club scenes – fed on a staple diet of all-night soul grooves, disco cut-ups, and an assortment of other genres – house music attempted to create seemingly endless compositions of montaged dance tracks for a sophisticated urban audience.

Disco – that most maligned hybrid of 1970s black dance and white techno-pop – has its roots equally in Philadelphia, Florida, Munich, Italy and France, and can be seen as one of the precursors to house music. It was a sound born of an unholy alliance between the smooth strings, Latin percussion and slick arrangements of Kenny Gamble and Leon Huff's early 1970s Philly sound and the high-tech, high sex and high tack of songs such as Silver Convention's 'Fly Robbin Fly', the first Eurodisco crossover hit from Munich. This brand of disco was seen by many to have 'all the personality and warmth of a microwave. The songwriters who appeared during this time inherited the crown of Jesse Stone, Smokey Robinson, Isaac Hayes, and David Porter. Did they embellish it? No, they dropped it, and danced around the broken pieces' (George 1988: 181).

Since then, the success of 1980s Italo house records like black Box's 'Ride On Time', Starlight Sensation's 'Numero Uno', and The 49ers' 'Touch Me', has done little to shake off the reputation European producers have as poor soul-imitators, despite emerging as a force to be reckoned with on the international dancefloor.[1] In the 1970s, before the advent of digital sampling, Italian groups such as Change carefully mimicked the sounds of Nile Rogers' hyper-disco band Chic with expert precision. In order to add the necessary Philly sheen to their Euro products, they used American vocalists like Luther Vandross, Diva Gray and Fonzi Thornton to churn out soul-inspired melodies. Today such exercises have become a matter of digital duplication, involving less emphasis on the perfection of a

215

style and a great deal more on the entrepreneurial and legal difficulties that have emerged – even as the need for 'original' musicians has disappeared. Whereas in the 1970s it was mostly a matter of imitating a style of black American music, in the 1980s it became a matter of musical and authorial cut and paste.

In an era of digital exchangeability, the use of pilfered rhythm- and vocal-tracks from obscure soul and disco records formed the basic compositional practice for these European DJs-turned-producers. Many of the most successful figures in the recording scene are also extremely well-known club DJs, whose skills and knowledge have been recast with the help of new digital technologies. The difficulties that began to arise were not, as black Box quickly realized, to do with mastering the new digital techniques. When 1970s disco divas like Loleatta Holloway started discovering that the group had sampled *her* vocal, and used it (uncredited and without rights or royalties) as the hook that gave black Box a Number One hit, complicated legal and financial problems came to the fore. As far as the canonic tale is concerned, once Holloway heard her sampled vocal – on the dancefloor no less – she flew straight to Europe to demand compensation, returning to the US with a percentage of world rights and a new record contract. Like many of the soul survivors of the 1970s whose careers were often made by the European disco scene in the first place and who have experienced something of a revival as a result of the rare groove phenomenon, her records are most prized among DJs looking for 'authentic' soul titbits to mix in with the automated techno-grooves of some of their less inspired dancefloor tracks.

It is also worth noting that black Box were just as surprised as Holloway was to find out who actually sang the vocal. The vocal track was in all likelihood lifted from an unlabelled bootleg of *a capella* mixes on the album 'DJs Essentials Inc.; Acappella Anonymous Volume 1', which included more than a dozen instrument-free vocals, among them Loleatta Holloway's 'Love Sensation'. A careful listen to a number of songs recorded around the same period – including German-based 'duo' Snap's UK Number One 'The Power', which features an ad lib from Jocelyn Brown's 1986 single 'Love's Gonna Get You', and Manchester's Happy Mondays' 'Hallelujah', which uses samples from The Southroad Connection's 'In The Morning' – reveals that the vocals were all taken from this very same album.

The relationship between aura, authenticity and authorship here is clearly quite different from that which pertained to earlier forms of popular music – which is not to say that those categories have no function whatsoever. As we have seen, though it is not always possible to locate authenticity in a performing subject, 'authors' are still able to claim certain (no longer exclusive) rights to their technologically reproducible 'aura'.

Just as the Italo house scene seems to reflect Foucault's well-known

anticipation of 'a culture where discourse would circulate without any need for an author' (Foucault 1977: 138), these producers have at the same time been confronted by the system of dependencies upon which the function of the author actually relies. To modify Foucault's famous quotation of Beckett at the end of his influential essay, 'What matter who's singing?' so long as it can be processed by an array of small black boxes, and slightly larger accounting machines.

BRING THE NOISE

Critics are not all agreed as to whether digital sampling has in fact disposed of the power of originary subjects and their recorded 'auras'. For Andrew Goodwin, the current musical moment at first glance appears uncannily akin to Benjamin's analysis come true – audiences are no longer concerned with the original recorded moment. Yet rather than finding that the aura has been done away with by (modernist) means of mass reproduction and fragmentation, he suggests that what digital devices present to us is, on the contrary, its mass reproduction:

> In the age of mass production, Benjamin stated that the audience is no longer concerned with an original textual moment. In the age of digital reproduction the notion of 'aura' is further demystified by the fact that *everyone* may purchase an 'original'. Digital recording techniques now ensure that there . . . is no discernible difference between the sound recorded in the studio and the signal reproduced on the consumer's CD system. This is something new: the mass production of the aura.
>
> (Goodwin 1990: 259)

Goodwin quite correctly acknowledges that digital systems have their roots in analogue inventions, and provides a convincing and well-documented account of this transformation. Tracing the shifts in the use of electronic synthesizers, sequencers and drum machines to their gradual incorporation into MIDI and digital musical devices, he amply demonstrates the failings of overly abstracted postmodern and Benjaminite accounts of contemporary pop. How, for example, according to Benjamin's logic, could we explain the degree to which we have grown accustomed to the idea of 'connecting *machines* to *funkiness*' (ibid.: 263), as is now the case with much contemporary dance music and pop? We can extend Goodwin's idea to the realm of contemporary dance music, noting that particular genres and techniques have arisen from a symbiotic relation between previous forms of production/consumption and the new recording and listening technologies.

Instead of delivering us the ultimate in 'auraless' music, Goodwin argues that digital technologies merely allow for authorship and the fetishization of 'original' sounds to return in a different guise, and as strong as ever. CDs allow everyone to possess a clean, noiseless copy of the musician's

aura, and as modern technologies become more naturalized, audiences are happy to consider pop stars increasingly as creative programmers and technicians. This is certainly true of Italo house. The genre is also less susceptible to earlier critiques of disco as an automated and alienating appropriation of soul, as it literally copies 'genuine' uncut funk instead of trying, unsuccessfully, to emulate it – it is Loleatta Holloway we are hearing, not merely a pale imitation. In a manner that outstrips its theorization, even sample-based pop music reinstates creativity and authenticity in new and imaginative ways. 'The Age of Plunder is in fact one in which pop *recuperates* its history, rather than denying it' (ibid.: 271).

In an unforeseen fashion, sampling has often given artists a much-needed shot in the arm – one thinks of James Brown's repackagings, the return of Maceo Parker to recording, Evelyn 'Champagne' King's new solo career, and Jocelyn Brown's guesting with UK dance group Incognito. Far from ruining an artist's career, the advent of sampling has elevated the status of a number of much-sampled performers, if not exactly increasing their bank balance.

In a similar fashion, failed careers are sometimes revived by remixers, if only for a short while. With the assistance of MIDI timecode, remixers have invented a new kind of sync between players and machines, pulling songs apart, adding and subtracting from the track however they like. Dimples D, a rapper from New York who had cut a couple of unsuccessful tracks with producer Marley Marl in the mid-1980s, had chart success suddenly thrust upon her with a remix of a song called 'Sucker DJ'. Without her knowledge, the Dutch remixer Ben Liebrand completely reconstructed the track, keeping only the vocal and adding the irresistibly catchy hook from the 'I Dream of Genie' theme. The transformed song went to Number One, Dimples D left her job as a desk clerk in New York, and the follow-up album was soon forgotten.

That sample-based music recuperates its history is no contradiction or surprise. If new musical genres invent their message at the same time as they invent their language, they do so in an overtly self-conscious fashion. The New York based hip hop group De La Soul provides an interesting case in point. The production of its 1989 LP *Three Feet High and Rising* inaugurated a new style of hip hop that opened the door for the success of other eccentric outfits such as The Jungle Brothers, A Tribe Called Quest, Digital Underground, Third Base, and the Dream Warriors. De La Soul's début LP was unexpectedly hailed as the *Sergeant Pepper* of rap, bending the rules of sequencing, referencing and sampling to shape a new form of music. Sonic space was opened up, tracks varied in length, rhyming became more relaxed and informal, and a whacky brand of humour was introduced. Combining references to the gamut of musical and prosaic styles, groups like De La Soul developed an engaging journey through a dense network of oral and musical traditions. As with the more militant hip

hoppers such as X-Clan, Public Enemy and KRS-1, their tracks acknowledge a rich musical history that is invoked even as it is being reformulated. In listening to the records produced by these outfits, one is reminded that 'language alone cannot do justice to the dispersal and flow of black cultures and philosophies over the past two centuries . . . [t]hat words, unaided, cannot embrace the density and play of allusions in which black expressive practices rejoice' (Rose 1990: 141).

DJ producer Prince Paul is usually credited for introducing this relaxed and effortless sound that is the antithesis of the hardcore assault primarily associated with rap. But in pursuing this line, the group did not utilize the hip hop ballad style for which rappers such as LL Cool J were so disparaged (particularly his 'I Need Love'). Using a bunch of messed up, crackly 45s, a discontinued Casio RZ1 drum machine for two or three of the tracks, and an Akai S900 sampler, Prince Paul recorded virtually the entire LP in his home studio. Everything was done with a couple of cassette decks, a mixer, two turntables, and a Casio SK1 before going to the studio to mix down. Drum machines were used over the top of other drum loops in order to keep the sources unidentifiable – a practice that is now quite common.

The resulting loopy grooves and spaced-out oddities exhibit a wide range of musical references, providing the basis for samples from Steely Dan to Liberace, from Johnny Cash to Walt Disney. By recording in simple yet efficient home studio environments, the production was able to be based on a try anything approach, instead of being reliant on the usual metal riffs and James Brown samples. De La Soul combined a long-standing black vaudevillian tradition with the talk-over style of George Clinton and Funkadelic, introducing a new wit and fluidity to the hardcore hip hop approach. Greg Tate sees such invention as an inherent aspect of black music, arguing that this

> apparent inexhaustibility of black music's power to take formal leaps . . . suggests subconscious rather than conceptually self-conscious sources of inspiration. But while black musicians continue to place a premium on improvisation – song production's answer to automatic writing – as a means to tap into the fecund dynamism of black oral and physical culture, they have, since the time of Duke Ellington, approached history as something to cannibalize and revamp.
>
> (Tate 1990: 153)

Despite the fact that Tate sees the sources for inspiration as subconscious rather than deliberately self-conscious, he is right in situating creativity in the processes of 'automatic writing' – in this case, digital recording. However, in the sample age De La Soul's new-found style instantly placed it at the front line of legal battles over payment for sampled sounds. A million dollar law suit was brought against the group by ex-Turtles mem-

bers over the appearance of their 'You Showed Me' on 'Transmitting Live From Mars', consisting of sixty-six seconds of the four-bar Turtles loop, plus overdubs played over a French-language record. The release of the group's second LP, *De La Soul Is Dead*, was consequently delayed for months while the use of various samples was negotiated. After being through a number of legal suits as a result of unacknowledged lifts on the first album, the freedom of the home recording studio was quickly exchanged for a corporate policing of untramelled *détournement* that is only legally allowable if paid for – in full.

The legal issues involved here are quite clear – unacknowledged use of other artists' recording is illegal – and the practical matters of resolving these issues now constitute a major aspect of band management and record company activity. These days most music business lawyers are forced to seek permission to use samples (even if this is after the release of the track). Few musicians or producers are still willing to take the risk that they will not be detected.

Italo house group The Mixmaster's sample-collage, 'Grand Piano', provides an illustration of such a song. Involving nine record companies and a who's who line-up of artists including Joe Tex, Coldcut, Tyree and Holloway herself, the task of negotiation took weeks of faxing through red tape to sort out the arrangements. Yet the legal wrangles show no sign of slowing the rate at which samples are used in contemporary house, hip hop and pop music. Instead, the practice of negotiating and clearing rights has been all but completely institutionalized by the major record companies.[2]

The legal and economic debates that have arisen since the advent of sampling have helped to highlight the fact that dance music has for some time now been based on the wholesale use of existing musical material, whether it be a drum track from an old Ohio Players track, or the unmistakable screams of James Brown. Rather than legislating against such developments, the industry has gradually written these changes into its own 'system'. There is a lot of money to be made out of legal suits, and the record companies are the last ones to forget the old showbiz adage, 'where there's a hit, there's a writ'. The management offices of James Brown epitomize such changes, reputedly taking action against so many hundreds of people that they have established a sliding scale of fees based on the duration of the sample. The author effect is still fundamentally preserved by the economic imperatives of the music industry. The connection between the 'aura' and the value of originality may have been radically transformed by technological advances under capitalism, and yet it still remains. Under the material conditions of contemporary dance music production, we have to acknowledge that the author function is both preserved and transformed.

If one can still refer to the mass reproducibility of 'aura' in such music, it does not apply to the digitally sampled fragments that characterize hip

hop. The 'hyper-fidelity' effects of digital recording and playback formats are not the same as the digital processes used by hip hop, which neither fetishizes the original moment of the sampled recording, nor eliminates the traces of the medium. Crackles, pops, scratches and distortion (which function to authenticate a source, to reference the 'original' vinyl medium or to add an element of irony) are an inherent part of the nature of many samples in hip hop, which relies for its existence on two-way processes that bring the noise of past musical fragments back into a new relation of musical and cultural components.

HEY DJ!

As Simon Frith (1987: 56–7) has shown, there would seem to be no guarantees for the fate of inventions that have taken recorded sounds and images from the nineteenth century into the present. The emergence and development of the record industry, for example, was inextricably tied to a struggle over the form that the 'hardware' and 'software' (initially seen as a way to demonstrate the capabilities of the machinery) would take. Whether the phonograph or the gramophone would win the allegiance of a market was only resolved after years of fierce competition. It was during this crucial period that the 'quality' of the machines would be determined by the 'quality' and appeal of the recordings used to demonstrate the devices. That the developers of the gramophone (unlike Edison in regard to the eventually outmoded phonograph) foresaw the machine's potential entertainment value, beyond the vaudeville circuit, doubtless contributed greatly to its eventual 'triumph' over the phonograph. In a pattern that has been repeated in similarly unforeseeable ways, companies began to realize that the potential for marketing entertainment recordings was considerable. New products follow the momentum of a particular logic that is determined by available forms of consumption, which at 'a certain moment in the development of a new electronic medium . . . changes' (ibid.: 57).

Who could have guessed that phonogram turntables would ultimately provide the founding technology of a hardcore street music like rap? Over the last two decades, relatively primitive DJing techniques have developed from rough and ready agitprop sound collaging to a sophisticated digitally sampled equivalent. When used in a certain way, the turntable can give rise to distinctive sounds that none the less form part of a continuous musical lineage. In this sense, a shift in the logic and use of machines actually heightens the degree to which such practices can be reproduced, repeated and disseminated.

We see this in the early 1980s, for example, when DJs in Detroit and Chicago (who invented the house genre) would mix drum machines, samplers and sequencers together with funky black soul tracks. They also played German and Italian imports alongside the usual American material.

The key influences included tracks like 'Tittle Tattle' by Barri Centro and 'Dirty Talk' by Klein & MBO – Euro disco which used heavily sequenced bass lines. Songs such as these came from the side of Italian music influenced by British groups such as Depeche Mode and Human League. As house developed from these primitive records and began to be imported elsewhere, most DJs assumed that this mixture of funk rhythms and electronic sequences was black. But it was not. Many of the ideas behind the sound had been borrowed from Europe. According to Simon Reynolds,

> it's difficult to imagine a genre more place-less or hostile to an infusion of ethnicity. Although it comes from a place (Chicago) it does not draw anything from its environment. House departs from the old organic language of music – roots, cross-pollination, hybridization.
>
> (Reynolds 1990: 174)

At the same time, however, it creates a new mix of ethnicities, erupting at a multitude of places in a large number of hybrid forms. The question of origins and proper boundaries in house music and its various sub-genres – acid house, hip house, techno house, Euro house, Chicago house, etc. – blurs into a complex synthesis of musics. To some, this represents the ultimate destruction of locality and cultural particularity, the unfortunate victory of global capital over authentic cultural expressions. To others, the phenomenon of house music is a hyperbolic refraction of what is happening elsewhere in culture: the collapse of boundaries, the end of sequential narrative processes, the repeatability of sounds and genres, the pleasure of synthetic as opposed to organic processes, the elevation of technique over presence, and the construction of an eternal cultural present. According to such a logic, house is the intoxicating music of the endless dance remix, 'the sound of machines talking among themselves' (ibid.: 175). The mediation of music through the electronic elements that form today's recording studios has transformed the way we participate in these kinds of dance music.

Despite its overnight appearance and virus-like spread, house would never have emerged without the rise of the DJ as technical innovator and (later on) as fully fledged producer. The techniques and styles developed at house parties and clubs (in Chicago and New York at first) provided the basic model upon which all house music is based – a hypnotic R & B derived rhythm track mixed in with sequenced keyboard sounds and drum patterns, together with cuts and slices from an assortment of other recordings. The DJ would play an old soul, disco or R & B record, remixing it and adjusting the tone on a graphic equalizer along the way, taking the drums out, getting the bass line to sit higher in the mix, and then perhaps adding a little 'energy' from another track. Initially it was a way to give the audience

a different sound, based on whatever the DJ could improvise on the spot, with whatever pieces of equipment were cheaply available. New musical forms were being invented out of a collective imagination in a lively dialogue with a cultural history and a growing battery of electronic machines.

Here, as in the early days of hip hop, the DJ was intent on keeping a groove going for as long as possible by linking track after track without losing the interest of an audience well versed in various genres of music and cross-referencing. Technique and musical referencing were inextricably linked. Neither one preceded the other. Rather, the determinate possibilities of the various items of technology intersect with the formal dimensions of genre and style in a manner that exceeds the intrinsic properties of both. Hence knowledge of how different kinds of music could be merged together was just as important as possessing new equipment and traditional musical/technical skills to play/operate music. Here lies the 'fecund dynamism' of mechanical invention.

Eventually this method of mixing machines in with records made it into the record studios and on to vinyl release, providing an ideal structure for other producers who were beginning to work with an ever more accessible range of digital recording equipment. It would provide the formula for a cast of thousands, (initially) anonymous producers pumping out placeless house anthems on crude electronic devices.

Broader questions related to the legal and ethical effects of sampling are central to any debate about these new recording methods, but it is also true to say that such controversies surrounding copyright, originality, authorship, live musicianship and so on are giving way to other questions to do with the nature, effect and history of these newly recontextualized sounds. How was it possible, culturally speaking, for producers to employ sampling technologies in their music in the first place? What conditions allowed for digital machines slowly to be incorporated into the everyday practices of music producers? As we have seen, sampling has had such a massive effect on house and hip hop not because it gave birth to those genres, but because the technology could be adapted to already existing musical methods and approaches that could use, abuse and distort digital sampling for their own iconoclastic ends.

Under such a rubric, changes in technology form a source of resistance to corporate control of music. Hip hop and house producers never used samplers exactly as they were intended by the manufacturers. But the same also holds for their use of every other piece of equipment they plugged in 'to create their sounds' – from the most humble of turntables to the most sophisticated MIDI machines. Rather than having their music influenced by the introduction of new technologies, these producers came up with new and unforeseen uses for these machines. For instance, a Fairlight CMI or an Akai S900 sampler may well have been designed to play back crisp clean

223

copies of orchestral sounds, but novelty was ultimately located in its ability to cut, loop and reassemble gritty funk or heavy metal into a pounding crush-groove – the rhythmic backbone of hip hop. Frith is correct when he notes that if

> there's one thing to be learned from twentieth century pop history it is that technological inventions have unexpected consequences. The 'industrialization of music' has changed what we do when we play or listen to music, and it has changed our sense of what 'music' is, both in itself and as an aspect of our lives and leisure, but these changes aren't just the result of producer decisions and control. They also reflect musicians' and consumers' responses.
>
> (Frith 1987: 72)

Although it is impossible to predict the outcome of corporate gambles against potential consumer advantages made possible by particular new technologies, it is precisely this space of potentiality that allows many enthusiastic users of new products to make liberatory claims about hi-tech developments. Echoing the punks of the 1960s and 1970s, today's renegade producers and consumers are more likely to refer to DIY 'garage multi-media' and 'street tech' than the lustre of hi-tech, arguing that the only position worth occupying is that of low-end technological improvisation and electronic monkey-wrenching. 'The street has its own use for things,' as cyberpunk luminary William Gibson once wrote.

GEO-CULTURAL HYBRIDS

Writing at the end of the 1960s, Ben Sidran noted that each 'period in the evolution of black music has a locality that seems to spawn for years to come the new style or *approach*, of black musicians' (Sidran 1971: 83). Since the mid-1980s the specificity of location has been increasingly eroded. Particular styles and innovations continue to emerge from certain places (such as Chicago, New Jersey, Brooklyn and the myriad of other places synonymous with a particular sound) that tend to foster the exchange of ideas and sounds in a defined locale. Yet these 'origins' are quickly erased by the technological pace with which these sounds are made and distributed. Production of records, licensing deals and other factors that facilitate the movement of music today operate at such a speed that the timescales and geographic conditions that once governed the circulation of music no longer hold. A Chicago producer may get a release on a European label, packaged as an American import, and sell thousands before anything is released locally. Regional scenes such as those thriving in Chicago have not disappeared – they have simply been extended, translated and responded to in a virtual instantaneity.

As has been suggested, it is no longer possible to judge with any

certainty the origin of any music, whether from sonic content or external packaging. National boundaries matter little in the contemporary music world, where a Detroit producer may have more in common with a London-based DJ or a Belgian remixer than anybody in his or her immediate geographic environs. House music stretches this phenomenon to its limits, accelerating across spatial and temporal bounds. Even from its early pop days, house included the music not only of Chicago DJs and producers like Frankie Knuckles, Rocky Jones, Marshall Jefferson, Farley Jackmaster Funk, DJ Pierre or Lil Louis, but also 'Jack to the Sound of the Underground' by Hithouse, 'Check This Out' by Hardhouse, Full House's 'Communicate', Brandon Cooke and Roxanne Shante's 'Sharp as a Knife', Todd Terry's 'Weekend' and the Jungle Brothers' 'I'll House You'. Each artist hailed from a completely different musical and geographic locale, and yet house jumbled them all into the same electronic melting pot.

Other examples of geo-cultural hybridization can be found further afield in the rise of another contemporary dance genre – Detroit techno. Aptly described as the kind of music that would arise if Kraftwerk and George Clinton were stranded in an elevator with only a sequencer and a drum machine to amuse themselves, techno emerged as a minimalist blend of Euro synthesizer aesthetics and a black Detroit rhythm. The elevator spilled out on to the dancefloor soon enough, somehow managing to marry the cold automation of pared-back drum machines (whose sounds were favoured because of their unique 'mechanized' quality, and not for their emulation of real drum sounds) with the soulful pop melodies for which the Motor City is famous.

Frankie Bones's 'Call it Techno' and Arnold Jarvis's 'Take Some Time Out' feature the standard hallmarks of techno – each piece is crammed with mechanical rhythm tracks, ultra synthesized keyboard sounds, distinctive piano sequences, near-subsonic kick drums, and a rhythmic, pulsing bass. Derrick May of Rhythim Is Rhythim – probably the most influential, though least commercial of the Detroit techno artists – considers Depeche Mode to be an integral part of techno's intercontinental heart. 'They have dance in their blood', he told John McReady in a 1989 *Face* interview (McCready 1989: 76). In a strange feedback loop, Rhythim Is Rhythim has consequently provided the inspiration for a whole generation of younger techno producers across Europe. The group's 'It Is What It Is', 'Strings of Life' and 'Beyond the Dance' are classic instrumental anthems which have injected technological energy into the thriving dance-bleep scene in the north of England. Bands such as LFO, Tricky Disco and The Forgemasters owe much to the almost avant-garde innovations of this and other Detroit groups. The Detroit producers might be thousands of miles from the Euro sounds they base their music on, but they have seamlessly adopted them as their own, in turn relaying their mutations to others across the globe.

Kevin Saunderson's Inner City has been the most successful of these

outfits internationally, with the sleek modern sound of its chart successes like 'Good Life' and 'Big Fun'. Ironically, neither Saunderson nor the other half of the duo, Paris Grey, hails from the Motor City. Their own geographic roots are in New York and Chicago, confounding efforts to reduce house music to a singular place. To compound this situation further, the commercial scene in Detroit is in fact unsupportive of their techno music. Ironically many radio stations don't accept their style as being black enough, and refuse to give their music commercial airplay. Although Detroit has a legendary underground club scene, world techno revolutionaries like Inner City are lucky to sell 3,000 records in their home-base city with a population of one million. The absurdity implied by such inflexible and anachronistic conceptions of what black music should and should not be is only heightened when Inner City cover songs like the Stephanie Mills club classic 'Whatcha Gonna Do With My Lovin'?' in their unmistakably futuristic fashion. To much of the traditional black music industry and audience, techno house represents the transgression of too many boundaries, the combination of too many styles.

NEW JACKS

During the 1980s, hip hop made a move from marginal to mainstream culture with the emergence of a number of rap superstars, such as MC Hammer, Big Daddy Kane, Kool Moe Dee, LL Cool J, Run DMC, Public Enemy and Ice T among others. But the sonic texture of hip hop has changed dramatically over the past few years. The full-on attack launched by producers such as the Bomb Squad, Mantronix and BDP Productions added a further dimension to the hardcore elements of hip hop. Cutting up heavy break-beats beyond their usual limits, and slicing sounds into an aggressive musical assault, these producers politicized the very form of hip hop music. No longer the sole province of boasters, hip hop turned sexism, racism and political futility into a hyperbolic reflection of 'the system' itself.

It is at this nexus that the question of crossover and technological change curiously intersect. The dilemma of whether black artists will beat 'the system' or be defeated and assimilated by it is an old problem that is interestingly recast in technological terms. Sampling, as we have seen, did not inaugurate a new age of theft, of whites pillaging black music and of blacks recording watered down versions of their own. In *The Death of Rhythm and Blues*, Nelson George presents a challenging account of the relationship that black music developed with the recording institutions, radio stations, management networks and the white music industry from the turn of the century to the present. Although at pains to maintain his argument that R & B and its derivatives have been all but destroyed by their surrender to white values, genres and desires, he none the less

indicates the mechanisms by which black music has been transformed. Although for George the changes are anything but healthy, he effectively details the two-way process that institutionalized the evolution of R & B to pop – including the incorporation of small black record companies by the corporate majors, the function of black and white payola, the formation of new FM radio formats, the emergence of successful disco and Philly production styles, and so on. However, as Steve Perry has shown, the history of this miscegenation goes much deeper. It

> didn't commence with Stax, or Sun, or for that matter with the invention of the phonograph. Rather it dated back to the early nineteenth century, and before. While the precise history of the various black and white folk musics is impossible to trace . . . some of its outlines are apparent. . . . In the most general sense, we know that the first recorded blues, country, gospel, and jazz (circa 1920–40) reflected both Afro-American and Anglo-European fundaments.
>
> (Perry 1988: 74)

Disco was the first genre that fused black music to recent electronic devices (such as sequencers and drum machines) in order to create a mass reproducible form. But rather than signalling the beginning of the end, the fusion ushered in an entirely new form of dance music, as had previously happened in the relation between black and other musics. Italo house merely picked up where Italo disco left off. The subsequent 'mistranslation' of Philly soul functioned to create another genre rather than destroying something essential.

In contrast, hip hop has attempted to present itself as a street-based antithesis of disco and house, battening down the hatches and protecting the last bastion of authentic black music. Ironically, hip hop's very existence owes much to a style that foregrounds its techniques based upon the availability of new cheap cassette players (ghetto blasters), discarded drum machines and the repetitive playing of rhythm tracks on record players (later also performed by samplers) – hardly the authentic feel of a guitar, piano, drums or sax that writers like Nelson George might ordinarily point to as the index of authenticity.

To steel itself against what is often perceived as wholesale unsanctioned borrowings, hip hop has developed a particular language that has unsuccessfully attempted to distinguish black from white counterparts. In hip hop as opposed to house, there is a constantly changing set of references and experiences which are culturally specific and difficult to emulate. They are certainly reproducible, but only after these references – hip talk, opaque lingo, and uncompromising style – have passed out of an underground or street usage, and into the popular domain. Here we find a striking parallel to the way black jazz musicians kept their music to themselves during the be-bop era.[3] In the house music no such tendency

exists, while in hip hop the ownership of sounds, rhyme styles, and hip phrases remains a fertile field of linguistic invention and cultural definition.

Although the story of the origins of rap and the rise of hip hop in New York is often invoked in the popular music press and has been well documented and commented upon in a number of specialist publications,[4] we should remind ourselves of some key points. Hip hop (unlike house) is a rough-and-ready technological melding of popular oral traditions of 'toasting' and 'signifying' with a raw scratching and mixing of vinyl records by party DJs. It has a long history of connections to other musical traditions, and not all of them are black. Techniques of collage, sampling and breaking down sound were being tried and tested by DJs and rappers during the late 1980s:

> The hip hoppers 'stole' music from off air and cut it up. Then they broke it down into its component parts and remixed it on tape. By doing this they were breaking the law of copyright. But the cut 'n' mix attitude was that no one owns a rhythm or a sound. You just borrow it, use it and give it back to the people in a slightly different form.
>
> (Hebdige 1987: 141)

Little did we know just how different this form would eventually be, how absolutely malleable and concretized these slices of rhythms and grabs of vocals were soon to become. They provide a direct line that can be traced from the early sound systems of Jamaican DJs like Kool Herc to the techniques of today's remixers, from New York based DJ Mark the 45 King to Chicago's David Morales, from London's Jazzy B to Manchester's Paul Oakenfold.

Robert Farris Thompson has suggested that the reason James Brown is 'The Most Sampled Man in Showbusiness' is because he 'does what the hip hop producer does with a high-tech, sophisticated, space-age machine. He samples with his throat and body' (Rose 1990: 139). In this sense, digital technology has allowed for the easy reproduction of a particular pre-existing style, making it more widespread, more accessible. Somewhere in the process of emulation and reproduction, however, mutations are bound to occur – as indeed they do. These mutations form the basis of contemporary dance music whose 'use and meaning . . . remain[s] wedded to earlier aesthetics' (Goodwin 1990: 261).

BEYOND THE MIX

In surveying some of the recent trends in the technologization of dance music, I have tried to show how we need to move beyond polarized accounts of contemporary music as either a postmodern dreamland or a machine-driven dystopia. The legacy of music that forms the collaged musical backdrop to so many contemporary songs carries with it 'the whole

panoply of a diaspora and its peoples – connected by an underground of musical reference points' (ibid.: 141). These references provide the basis for many musical innovations in dance music that have occurred over the past two decades. No longer tied to a geographic site that has in the past given rise to particular new and vital sounds (in a unifying and concretizing fashion), older structures of recording and listening have given way to new forms of music and identity that are inscribed in the sounds, words, structures, technologies and rhythms of the music itself.

The impact of new digital technologies is not dissimilar to that of earlier electro-mechanical inventions which also profoundly changed the ways that music could be made, heard and circulated. We don't have to agree with a postmodern view that privileges pastiche, parody and the end of history to acknowledge that contemporary dance music has invented a new language that has evolved out of a symbiotic relationship between new technologies and older musical styles and practices. Rather than randomly collaging various styles of music together into new monsters, I have argued that the technological ability to quote and recontextualize fragments of music has followed the logic of the previous genres and histories that they sample or emulate. If digital sampling in dance music seems to assert some kind of radical unauthenticity, it is important we remember that this is not unconditional or particularly threatening to the pop music 'system'. Rather than dancing around the broken pieces of an outmoded system of signs, contemporary dance music sits side by side with familiar (and at times radically modified) discourses of originality, ownership, historical reference and social meaning.

NOTES

1 Even Stock Aitken & Waterman, British pop-out dance producers extraordinaire, have been pushed out of the charts by Italian production teams like Groove Groove Melody, who masquerade variously as black Box, Starlight Sensation, The Mixmaster, Magic Atta Segundo, Wood Allen, and at least a dozen other names.

2 The hip hop group Stetsasonic was among the first to remunerate a sampled artist – Lonnie Liston Smith, who received $3,000 for the use of his 'Expansions'.

3 Sidran observes that the constantly changing linguistic codes of the underground led to a situation wherein whites 'brought a different set of experiences . . . to the language. Moreover, when a facet or phrase of black, or "hip" jargon gained too much currency within the white world, it was summarily dropped. . . . At its most elementary, ingroup language is simply a means of easy communication to integrate shared experience into its semantics and thereby exclude those who do not share a background' (Sidran 1971: 111).

4 See Steven Hager (1984) *Hip Hop; The Illustrated History of Break Dancing, Rap Music, and Graffiti*, New York: St Martin's Press; Dick Hebdige (1987); Cynthia Rose (1990); and David Toop (1984) *The Rap Attack; African Jive to New York Hip Hop*, London: Pluto Press, for particularly well-framed presentations of the rise and significance of hip hop. For an especially poor version of a

similar story, see Mark Costello and David Foster Wallace (1990) *Signifying Rappers: Rap and Race in the Urban Present*, New York: The Ecco Press.

BIBLIOGRAPHY

Attali, Jacques (1985) *Noise: The Political Economy of Music*, trans. Brian Massumi, Manchester: Manchester University Press.

Corbett, John (1990) 'Free, single, and disengaged: listening pleasure and the popular music object', *October* 54, Fall.

Cosgrove, Stuart (1987) 'On the wheels of steal', *New Musical Express* 11 July.

Durant, Alan (1989) 'Improvisation in the political economy of music', in Christopher Norris (ed.), *Music and the Politics of Culture*, New York: St Martin's Press.

—— (1991) 'A new day for music? Digital technologies in contemporary music-making', in Philip Hayward (ed.), *Culture, Technology and Creativity in the Late Twentieth Century*, London: John Libbey.

Foucault, Michel (1977) 'What is an author?', in *Language Counter-Memory, Practice: Selected Essays and Interviews*, trans. Donald Bouchard and Sherry Simon, New York: Cornell University Press.

Frith, Simon (1987) 'The industrialization of popular music', in J. Lull (ed.), *Popular Music and Communication*, Newbury Park: Sage.

—— (1988) 'Video pop: picking up the pieces', in Simon Frith (ed.), *Facing The Music; Essays on Pop, Rock and Culture*, New York: Mandarin.

George, Nelson (1988) *The Death of Rhythm and Blues*, New York: Plume.

Goodwin, Andrew (1990) 'Sample and hold: pop music in the age of digital reproduction', in Simon Frith and Andrew Goodwin (eds), *On Record: Rock, Pop, and the Written Word*, London: Routledge.

Hebdige, Dick (1987) *Cut'N'Mix; Culture, Identity and Caribbean Music*, London: Comedia.

McCready, John (1989) 'Modus operandum: Depeche Mode in Detroit', *The Face* 2(5), February.

Mowitt, John (1987) 'The sound of music in the era of its electronic reproducibility', in Richard Leppert and Susan McClary (eds), *Music and Society: The Politics of Composition*, Cambridge: Cambridge University Press.

Perry, Steve (1988) 'Ain't no mountain high enough: the politics of crossover', in Simon Frith (ed.), *Facing The Music; Essays on Pop, Rock and Culture*, New York: Mandarin.

Reynolds, Simon (1990) *Blissed Out; The Rapture of Rock*, London: Serpent's Tail.

Rose, Cynthia (1990) *Living in America; The Soul Saga of James Brown*, London: Serpent's Tail.

Sidran, Ben (1971) *black Talk*, New York: Da Capo Press.

Tate, Greg (1990) 'black to the Futurism', *Artforum* April.

14

BLACK POPULAR MUSIC: CROSSING OVER OR GOING UNDER?

Reebee Garofalo

Recently, I was invited to give a talk on black popular music in conjunction with a touring visual arts exhibition entitled 'Next Generation: Southern black Aesthetic'. A number of observers of the exhibition had already noted that the sub-title of 'Next Generation' raised provocative questions as to whether or not there is an aesthetic which is distinctly Southern and distinctly black. The issue was raised in curator Lowery Simms's essay describing the show, Michael Brenson's *New York Times* review, and Judith Wilson's panel presentation on the occasion of the show's debut at the Southeastern Centre for Contemporary Art (SECCA) in Winston-Salem, North Carolina. The difficulties these commentators addressed were fundamentally those of wrestling with definitions and processes which are elusive and slippery. In that same SECCA forum, panelist Richard Powell made an explicit connection to black popular music in drawing on critic Nelson George's *The Death of Rhythm and Blues* to accentuate the struggle of all African-American artists to maintain an Afro-centric focus in their work in the pull toward mainstream success. In highlighting this tension, Powell touched on what has long been a hot topic in the music industry: namely, the merits of 'crossing over'.

THE CROSSOVER DEBATE

In popular music history, the term 'crossover' refers to that process whereby an artist or a recording from a 'secondary' marketing category like country and western, Latin, or rhythm and blues achieves hit status in the mainstream or 'pop' market. While the term can and has been used simply to indicate multiple chart listings in any direction, its most common usage in popular music history clearly connotes movement from margin to mainstream. The late Arnold Shaw informs us that

> crossovers were to be found all through the '30s, '40s and '50s. . . .
> The crossover concept was inherent in R & B from the start. In fact,

acceptance by the pop market of an R & B disk (Cecil Gant's 'I Wonder') generated the first mushrooming of R & B record companies. While these labels produced disks basically for ghetto consumption, they always hoped that the larger white market might be receptive.

(Shaw 1978: 524)

It is in this sense that I use the term in this essay. The 'crossover debate' concerns what is gained and lost in this process. Given the particular history of the United States, the discussion is often highly charged racially.

Of late, the poles of the debate have been occupied most forcefully by the aforementioned Nelson George, a former black music editor for *Billboard* and more recently a writer for the *Village Voice*, and Steve Perry, a journalist/rock critic from Minneapolis and a contributing editor to *Rock'n'Roll Confidential*. Perry takes an essentially liberal or 'integrationist' position on the issue, arguing that, because the category 'black music' is structured as an inferior marketing category, it is actually harmful to black musicians and should therefore be eliminated. George, on the other hand, comes from a black nationalist perspective and maintains that without the admittedly limited access afforded by the black music market, African-American artists might well be in an even more difficult position. He maintains further that something is lost culturally in the process of crossing over.

Perry's essay, 'Ain't no mountain high enough: the politics of crossover', celebrates the degree of 'integration' in the pop market in the 1980s as making clear 'to anyone with eyes and ears just how profoundly black experience has shaped the cultural mainstream' (Perry 1988: 52). To those critics who are concerned about 'a sellout of the tougher strains of black musical tradition – or of blackness itself', he charges that 'right thinking opponents of crossover dutifully ignore changes in social relations, technology, and prevailing musical styles' (ibid.: 52). More importantly, he is critical of a 'second anticrossover position . . . rooted in the politics of black nationalism and black capitalism. Simply put, the erosion of racial barriers in the production, distribution, and consumption of black music poses an economic threat to the class of entrepreneurs and professionals who make their living from black music markets' (ibid.: 52). His biggest villain in this regard is none other than Nelson George, whom he accuses of being 'disingenuous' for concealing 'this agenda in a series of harrangues about musical standards' (ibid.: 58).

As if to challenge Perry's accusation, George begins his opening chapter with the query: 'Assimilation or self-sufficiency? Within the realities of the American system both are necessary for advancement but only assimilation, the strategy that dilutes the racial power bloc in exchange for an American identity of dubious rewards, has dominated the thinking of most

black Americans' (George 1988: 3–4). Thus, what Perry celebrates as liberating integration, George decries as mere assimilation without self-sufficiency.

Already the seemingly narrow issue of cultural crossover raises larger questions of economic self-determination, strategies for change, and the definition of black culture – indeed, the definition of culture itself. In the case of popular music, the problem is further complicated by the historical tension between a popular art and the dynamics of the mass market. Because the popular arts depend for their very existence on success in the market-place, questions of quality, lineage and even authorship are often confounded by economic imperatives. In order to deal with the phenomenon of crossover, therefore, it is necessary to distinguish between popular music as a collection of musical genres and popular music as a succession of marketing categories.

Nelson George underscores this distinction in proposing 'two meanings' for rhythm and blues, 'one musical and one socioeconomic'.

> The term originated in the 1940s as a description of a synthesis of black musical genres – gospel, big-band swing, blues – that, along with new technology, specifically the popularization of the electric bass, produced a propulsive, spirited brand of popular music. . . . But the 'rhythm and blues world' means something extramusical as well. R & B – and music in general – have been an integral part of . . . a black community forged by common political, economic, and geographic conditions.
>
> (ibid.: xii)

For Perry, George's formulation of the problem obscures the issues because 'his implicit point – which can hardly be made explicit since it isn't true – is that black artists would stand a better chance of succeeding with small labels, or with record divisions that appeal to principally black markets' (Perry 1988: 59). While I will return to a critical analysis of these positions later, at this point I would simply note that whatever one's position on the issue, the distinction between music markets and musical styles is real enough and must be understood if we are to grapple with the politics of culture in a market economy.

Despite occasional rhetoric to the contrary, the music industry clearly deals with music in terms of markets. In this context, black popular music becomes operationally defined either as what African-American artists play or as what African-American consumers buy. Needless to say, such definitions can make for some peculiar musical choices. Defining black popular music as what African-American artists play often becomes in practice a device for slotting African-American artists into an inferior marketing structure no matter what they play. 'No matter how deep they get into Beethoven or the symphony', lamented Curtis Mayfield in 1970,

'that's an R & B product. And pop, that's the white artist.'[1] If we define black popular music as what the African-American audience buys, then any number of hits by, say, Madonna or George Michael would have to be considered black popular music. Such are the vagaries of music-as-marketing category. If, on the other hand, we look at black popular music as a genre which grows from a particular history and tradition, then in its social dimension we might view it as the music that emerges from partici-pation in the African-American experience. Such a definition presents us with a basis for making aesthetic judgements that goes beyond a simple consideration of market demographics, but we are still forced to deal with a key element in the definition of culture.

RACE AND CULTURE

Culture is perhaps one of the most misused and misunderstood terms in the English language. There are literally hundreds of definitions of the term in the literature. The one aspect of culture that all observers seem to agree on is that it is learned through social interaction; it is not passed on geneti-cally. This being the case, it would follow that anyone who takes the time to learn and practise the rules and styles of a given culture can, in some sense, become a member of that culture. Rhythm and blues artist Johnny Otis, for example, was so immersed in black culture that he was (and is) thought to be African-American by many fans and critics alike. In fact, he was of Greek descent.

A contemporary and far more controversial example of this process involves the case of British-born George Michael who won the 1989 American Music Award for Best black Male Vocal. Paradoxically, the award was defended by Nelson George, a self-described black nationalist. According to George,

> Michael has cultivated a black audience via television appearances (singing with Smokey Robinson and Stevie Wonder on 'Motown at the Apollo'), duets (with Aretha Franklin), and special promotional items (his 'Hard Day' remix serviced to black radio). . . . When one looks objectively at Michael's play on black radio and his sales to black consumers, one can see that this shrewd British singer has as much right to his American Music Award as either Jackson – Michael or Freddie.
>
> (George 1989: 26)

Here, George is appealing to the learned aspects of culture, but he frames his arguments more in terms of market forces than cultural contributions. In the final analysis, it has to be noted that cultivating markets is not quite the same as learning culture. Not surprisingly, many African-Americans were offended by what George described as George Michael's 'victory'.

In the field of popular music studies, there is nothing particularly new about this controversy. It surfaced when a Southern white named Elvis Presley captured the rock'n'roll crown from its black innovators. It was evident in the 1960s when so-called 'blue-eyed soul' groups like the Young Rascals began appearing on the playlists of black radio outlets. It has become particularly lively since whites like Vanilla Ice have achieved superstar status in rap. At issue are questions of authenticity in the case of whites, questions of self-determination for blacks, and questions of cultural identity for all concerned.

Part of the confusion in the debate arises from a long-standing and well-intentioned separation of the terms 'race' and 'culture' in the field of anthropology. Race, it is argued, is a biological category, and a rather imprecise one at that. Culture, as we have noted, is socially constructed. According to the anthropologists, the two should be neither confused nor linked. This perspective was applied to the study of popular music in Charles Keil's classic *Urban Blues*. 'A basic axiom that underlies anthropological thought is that culture is always learned and never inherited,' wrote Keil in 1966. 'Anthropologists have long recognized this clear distinction between race and culture. But, judging by the current vocabulary of "race relations", the distinction is still not generally understood. . . . I, for one, would like to see the term race abandoned altogether' (Keil 1966: 2–3). Recently, this position has been articulated more vehemently by ethnomusicologist Steven Feld. 'There are no "racial" cultures or musics,' states Feld. 'The only people who use such terminology are racists who thinly wrap their ideology in an appeal to dubious sociobiology. . . . Invocation of "racial" bases of culture serves racism and little else.'[2] Accordingly, except for the questionable contributions of the occasional upstart geneticist, most biological notions of race have been scientifically discredited as a basis for measuring human capacities. 'Racial equality is an established fact. . . . The struggle is for cultural pluralism' (ibid.: 3).

But if genetic explanations for social behaviour have been discarded by the scientific community, how do we explain the persistence of the category 'race' as a major determinant of the life chances of whole groups of people in the United States? A partial answer lies in distinguishing between biological notions of race and what social scientists call 'social race'. While the term race has clearly eluded precise biological definition, it persists as an ever-changing social construct. Thus, the importance of race lies in the social meaning we attach to it. To the extent that perceived physical differences are believed to correspond to particular behavioural traits, they will tend to shape the character of social interaction and intergroup relations. 'Racial classification is a matter of identity,' state Michael Omi and Howard Winant. 'One of the first things we notice about people (along with their sex) is their race. We utilize race to provide clues about who a person is and to suggest how we should relate to him or her' (Omi and

Winant 1983: 49). As to the consequences of these interactions at the systemic level, Stuart Hall argues that 'Racial and ethnic categories continue today to be the forms in which the structures of domination and exploitation are "lived"' (Hall 1985: 110).

At the same time, these writers note that, as a human invention, the social meaning of race is neither objective nor static. Rather, it exists as an unstable and constantly shifting classification at the level of ideology.

> Often, ideological struggle actually consists of attempting to win some new set of meanings for an existing term or category, of disarticulating it from its place in a signifying structure. For example, it is precisely because 'black' is the term which connotes the most despised, the dispossessed, the unenlightened, the uncivilized, the uncultivated, the scheming, the incompetent, that it can be contested, transformed and invested with a positive ideological value. The concept 'black' is not the exclusive property of any particular social group, or any single discourse.
>
> (ibid.: 112)

It was precisely this aspect of ideological struggle which characterized the Black pride movement of the late 1960s. In articulating the slogan 'Black is Beautiful', the attempt was made to turn the negative connotations of the term 'black' on their head – to transform what was perceived as a social deficiency into a source of racial pride. A similar motivation is apparent in Nelson George's re-reading of the term 'race music', which was the official industry designation for black popular music until the late 1940s.

> While the term 'jazz' gave Whiteman equal weight with Ellington, and Bix Beiderbecke comparable standing with Louis Armstrong, the term 'race' was applied to forms of black music – primarily blues – that whites and, again, the black elite distained. Some writers in recent years have attacked the use of the phrase 'race music', as record labels of the period called blues, but as Albert Murray wrote in *Stomping the Blues* (1976), 'race' was commonly used by blacks themselves in the early part of this century to define themselves. 'The fact remains – oblivious as certain critics may be to it – that in the black press of the 1920s the most prominent Negro leaders and spokesmen referred to themselves as race spokesmen and race leaders . . . the indignation over the race terminology as applied to records has been misguided at best.'
>
> In fact, I think the appeal of this working class, rural black music is very well described as race music.
>
> (George 1988: 9)

But in viewing rhythm and blues as the music of 'the race', isn't George reuniting the terms race and culture in a way that would be anathema –

236

indeed, racist – to the social scientists? Perhaps not. Perhaps George is implying that what we call 'black culture' is so intimately connected to the experience of slavery and subsequent oppression that it is necessarily linked to the struggles of a particular racial group, not on the basis of their genetic characteristics, but because of their shared social experience. Perhaps, because of these particular socio-historical circumstances, there is simply an unusual degree of fit between race and culture in the case of black popular music. In any case, the point to be made is that it is not always so easy to separate race from culture. Moreover, in the case of African-American artists, eliminating the category race may not even be desirable. 'Without a racial identity', Omi and Winant remind us, 'one is in danger of having no identity' (Omi and Winant 1983: 49).

If we are to credit George with a certain creativity in his re-reading of the term 'race music', he must then be challenged for his paradoxical acceptance of George Michael. It can perhaps be argued that Michael learned the cultural rules of black music well enough to deliver a performance that was appealing to an African-American audience. But if the 'rhythm and blues world', as George puts it, is defined on the basis of shared experience and a common history, then George Michael simply can't be a part of it. George cannot have it both ways. Such considerations, of course, have profound implications for how one views the phenomenon of crossover. In order to evaluate particular instances of the phenomenon, it would first be useful to understand the structure and operations of the music industry and the historical place of black popular music within it.

BLACK MUSIC AND THE MUSIC INDUSTRY

Every major record company in the United States maintains separate divisions or subsidiaries for different categories of music such as rock, country, rhythm and blues, Latin, and classical, which are, in turn, marketed to different publics with separate and unequal production and promotion budgets. Accordingly *Billboard*, the leading music trade magazine, maintains separate chart listings for pop, country, rhythm and blues, and a number of other categories. In economic terms, pop is the most important category; it defines mainstream culture. The pop charts are constructed on the basis of reports from mainstream radio and retail outlets; the rhythm and blues charts from outlets based in the black community. For a rhythm and blues release to become a pop hit, it must 'cross over' from the rhythm and blues charts to the pop charts, which is to say, it must first sell well in the black community. A recording is listed on the pop charts only after it is distributed and sold in mainstream outlets. This is the essence of the concept of crossover; by and large, African-American artists must first demonstrate success in the black market before gaining access to the mainstream. Even black superstars like Tina Turner, Prince, and Anita

Baker, who eventually achieved top positions in popular music, were originally listed on the rhythm and blues charts and then 'crossed over'. A Bruce Springsteen, on the other hand, does not cross over from somewhere else. As a white artist, he is marketed to the mainstream audience right from the beginning and either he has a pop hit or he doesn't. This curious method of determining popularity, which holds black artists to a higher standard of performance than white, reflects not only the character of record company marketing and promotion, but also radio and television programming, the packaging of live performances, and reportage in the music press. There is a disjuncture in career development for African-American artists which dates back to formative developments in the operations of the recording industry.

Historically, the systematic exploitation of recorded black popular music began in the 1920s with the accidental discovery that there was a substantial market for classic blues recordings which were termed, at the time, 'race records'. The race market developed as an undercapitalized sub-industry, during a period when the society-at-large was still legally segregated. With some notable exceptions, African-American artists were systematically barred from radio performances and live appearances in established white venues. At first, the race market appeared to be sufficiently profitable that it encouraged the formation of a handful of black-owned independent labels such as Black Swan, Sunshine, Meritt and Black Patti. Without sufficient resources for national promotion or distribution outside their home territories, however, they were soon forced out of the industry. The race market was eventually taken over by Okeh, Columbia and Paramount. Not a single black-owned label survived the 1920s intact.

Social, economic and technological changes associated primarily with World War II rendered this inequitable state of affairs more and more untenable. The rumblings of more lasting structural and aesthetic changes in the music industry began with the rise of independent rhythm and blues record companies and radio programmes in the late 1940s. Having abandoned the production of race records during the war due to a shellac shortage which forced a cutback in production, the major labels decided to ignore the small, but growing market for rhythm and blues which developed after the war. Literally hundreds of black-oriented, but mostly white-owned labels came into existence to fill the void. The most successful of these – Atlantic, Modern, Imperial, and Chess, among others – gained a substantial foothold in the industry. Their product found a ready home on the new rhythm and blues radio shows which were being launched to serve the new audiences created by the population migrations associated with World War II.

While it was still possible to segregate juke boxes, record stores, dance halls and night clubs, it was no longer possible to segregate the airwaves. In growing numbers, white as well as black listeners chose to tune their radio

dials to the archetypically fast-talking 'personality jocks', as the R & B DJs were called. These were the men who popularized the music that would later be called rock'n'roll. At first, the deep South was the centre for rhythm and blues radio. As record sales indicated the growing popularity of the music among white Northern teenagers, pioneer black DJs like 'Jockey' Jack Gibson in Atlanta, 'Professor Bop' in Shreveport and 'Sugar Daddy' in Birmingham were soon followed by white R & B DJs such as Alan Freed, the self-appointed 'father of rock'n'roll'. Particularly in racial terms, this music was widely regarded as transforming the character of popular music as well as the operations of the music industry. While there is considerable truth to this perception, the situation is more complicated than most observers acknowledge.

ROCK'N'ROLL

Steve Perry correctly rejects the version of rock'n'roll history which describes 'the story of "original" black music and "derivative" white imitations' as too simplistic. For Perry, the social importance of the music was in its 'remarkable biracial composition'. 'From 1955–58', argues Perry, 'the roster of popular rock'n'rollers was more racially equal than at any time before or since. Chuck Berry, Little Richard, the Coasters, The Platters, Fats Domino, Lloyd Price – major stars all, and on a rough par with the likes of Bill Haley, Jerry Lee Lewis, and Buddy Holly' (Perry 1988: 67–8). What Perry overlooks is that prior to 1955, the overwhelming majority of artists who could be considered rock'n'rollers were black, at a time when the pop market was almost exclusively white. From the pioneering electric guitar figures of T-Bone Walker and B.B. King to the boogie piano riffs of Professor Longhair, from the jazz/gospel fusions of Ray Charles to the elegant doo wop harmonies of the Crows, the Chords, and the Penguins, most of the formative influences of rock'n'roll as well as virtually all of its early innovators were African-American. The picture that emerges in the face of more complete information, therefore, is not one of black and white performers sharing the market-place as equals, but rather one in which African-American artists had to struggle for a less than proportionate market share of a musical form in which they predominated. The issue is not whether Haley, Lewis or Holly brought originality and freshness to the music. They did. The issue is one of historical and cultural accuracy and concomitant reward. To conflate integration and equality runs the risk of undervaluing the African-American contribution.

Perry's focus on integration is not so much wrong as it is distorted. To see what Perry calls 'the Pat Boone syndrome' – the practice of white artists 'covering' or rerecording black releases in a more 'acceptable' style – simply as 'a reaction to the unprecedented integration being lived out in this new music, and by its fans', is to miss the point in a subtle but

important way (ibid.: 71). The racists and conservatives who reacted to the integration that rock'n'roll represented did not object to black and white 'infractions' equally. They wanted to eliminate rock'n'roll because they were threatened by the prospect of African-American encroachment in the social and cultural mainstream, not the other way around. Though quite conservative politically, Pat Boone, under the guidance of his record company, took a more enlightened path; he simply tried to transform rock'n'roll into a cultural form that would be perceived and remembered as white. According to rock'n'roll legend, this strategy didn't work. Discriminating fans, we are told, soon learned to tell the difference. Still, Pat Boone had bigger hits than most of the African-American artists he covered, and the racial politics of his contribution to rock'n'roll is at the heart of the controversy over whether to induct him into the Rock'n'Roll Hall of Fame.

Not surprisingly, the differences between Perry and George show up clearly in the way they perceive the performer who is remembered as the king of rock'n'roll. Both writers acknowledge Elvis Presley as a performer of considerable stature. But for Perry, Elvis represented 'a revolutionary fusion of black and white music whose time had come' (ibid.: 71). For George, 'Elvis's immersion in black culture was as deep as his white Mississippi background would allow' (George 1988: 62). George credits Presley with having learned his cultural lessons well, but he identifies the African-American roots of the music as its most important aspect. Perry emphasizes the contributions of black and white in a way that implies equality. Paradoxically, Perry then goes on to acknowledge that Presley's label 'Sun Records in its glory days was almost entirely white. . . . The Sun mythology doesn't capture the leading role of blacks in the evolution of the new popular music, or their continuing role in its development' (Perry 1988: 72).

SOUL

The enterprise which truly embodies the mutuality of black and white for Perry was 'Southern soul' – the music that issued primarily from Stax Records in Memphis and Fame Studios in Muscle Shoals, Alabama, in the mid-1960s, and featured artists like Aretha Franklin, Wilson Pickett, Otis Redding, and Sam and Dave, among others. By the mid-1960s, Stax, having joined forces with Atlantic, became Motown's chief competitor in the production of black popular music. A number of ironies in the politics of crossover can be gleaned from a comparison of what Nelson George calls 'the twin towers of sixties soul' (George 1988: 86) Both founded around 1960, Motown was as secretive and tightly controlled as Stax was open and disorganized. Stax was originally a white-owned company; even its creative functions were as likely to be handled by whites as by blacks.

The label's formidable output of 1960s soul classics was almost invariably the product of cross-racial collaborations. Initially the credits on all Stax recordings read simply: 'produced by the Stax staff'. black-owned and very private, Motown opened a new chapter in the treatment of African-American artists in the music industry. Virtually all of its creative personnel – artists, writers, producers and session musicians – were African-American and all were groomed for the long haul. It was clearly a haven for African-American talent.

Motown became the largest black-owned corporation in the United States. With its recent sale to MCA, which was itself bought by Matsushita, there is no longer a single black-owned label in the United States that can rival the output of the majors. From its inception, the label logo for Motown boasted the slogan: 'The Sound of Young America'. Described by George as being 'totally committed to reaching the white audience' (ibid.: 86), Motown's founder, Berry Gordy, Jr, came up with a pop formula that was the perfect metaphor for the integrationist phase of the early civil rights movement: upbeat, gospel-tinged, black pop, produced with a white audience in mind, that was threatening to no one in tone or content, and was irresistibly danceable.

As the comparatively moderate early civil rights movement evolved into the more militant demand for 'black power', Motown's hegemony over black pop was successfully challenged by a resurgence of the closer-to-the-roots, hard-driving sound of Southern soul. This music captured the spirit of the emerging black militancy not so much in content as in tone. Southern soul was raw, basic – almost angry – and much less 'produced' than the cleaner, brighter Motown sound. In the context of black pride, Motown's lavish use of multi-track studio production to achieve a more 'pop' sound seemed somehow out of sync with the search for African roots. Ironically, it was the very simplicity and straightforwardness of Southern soul production that gave this integrated music a claim on 'black authenticity'. Stax recordings were, even in the words of Nelson George, 'consistently aimed at R & B fans first, the pop market second' (ibid.: 86). Perhaps the supreme irony for both writers is that it was this largely integrated effort which came to signify black power at its most militant.

DISCO

The trend which came to dominate – indeed, define – popular music in the 1970s was disco. Like rock'n'roll, most of the early disco releases in the United States were by African-American artists, and like rock'n'roll, disco was initially ignored by the established powers of the music industry. Early on it seemed as though self-contained funk bands such as Kool and the Gang, the Ohio Players, and Earth, Wind, and Fire would make a major contribution. But as disco developed into a more 'upscale' trend, the

'cruder' sensuality of post-Sly, James Brown-inspired funk was eventually eclipsed by the smoother, sleeker sounds associated with Philadelphia soft soul and the more controlled energy of what came to be known as Eurodisco. Typically, it wasn't until a white supergroup – in this case the Bee Gees – came to dominate the scene that disco finally took on the mantle of respectability. Commenting from the vantage point of 1979, culture analyst Andrew Kopkind observed:

> This past year has seen several disco stars achieve the necessary 'crossover' effect, bringing the music out of the subcultural ghettoes into mainstream life. The Bee Gees were crucial to that passage; they made disco safe for white, straight, male, young, and middle-class America. What Elvis Presley did for black rhythm and blues, . . . the Brothers Gibb have done for disco.
>
> (Kopkind 1979: 16)

The industry may have been slow to catch on to disco but, always hungry for a new trend, it soon milked the successful 120 beats-per-minute formula for all it was worth, and more. The full commercial potential of disco was realized when WKTU, an obscure, 'soft rock' station in New York, converted to an all-disco format in late 1978. Within months, WKTU scored a double-digit market share and became the most listened to station in the country. Soon after, there were some two hundred all-disco stations broadcasting in almost every major market from coast to coast. By this time, white artists of all persuasions, from Cher and Dolly Parton to Rod Stewart and the Rolling Stones, had jumped on the bandwagon, as everything from Glenn Miller's 'Chattanooga Choo-Choo' to Beethoven's 'Fifth Symphony' fell prey to disco's hypnotic pounding. Many African-American artists complained that they had no alternative but to capitulate to the demand for disco.

With the market saturated to this degree, there was bound to be a backlash. Given disco's particular history, it was bound to have racial overtones. The most visceral anti-disco reactions came from the hard rock/heavy metal axis of popular music. FM rock radio followed its audience almost instinctively by initiating anti-disco campaigns. Slogans like 'death to disco' and 'disco sucks' were as much racial (and sexual) epithets as they were statements of musical preference. Black radio was also in a quandary. To the extent that disco was perceived as a black popular music, but one which was being performed more and more by whites, black radio stations were in the position of having to add more white artists to their playlists in order to hold on to their listenership. Just as Alan Baake and Brian Webber turned the logic of affirmative action on its head, disco instituted a process of 'reverse crossover' which operated like the cultural analogue of 'reverse discrimination'. Disco, at its overblown height, thus engendered racist outbursts among

242

antagonistic whites even as it limited opportunity for African-American artists.

Following the death of disco, rock radio reasserted its primacy with such a vengeance that black-oriented radio was forced to move in a new direction to maintain its listenership. Urban Contemporary (UC), as the new format was called, was seemingly progressive in that it was a multi-racial format. In its original conception, a broad range of African-American artists, including Stevie Wonder, Donna Summer, Rick James, Funkadelic, Quincy Jones, and George Benson, remained the staples of a station's playlist as white acts who fitted the format, like David Bowie or Hall and Oates, were added. While the UC stations appeared to be a refreshing change of pace, and one which was commercially successful, Urban Contemporary may have simply institutionalized the process of 'reverse crossover' which had begun during the height of the disco craze. UC outlets provided greater access for white musicians on what had been black-oriented stations, but African-American performers did not gain any reciprocal access to rock radio. From this perspective, Urban Contemporary may well have proven to be a net loss for African-American artists.

BLACK POP IN THE 1980s

This restriction of access to African-American artists occurred during the first recession in the music business since the late 1940s. Recovery, beginning in 1983, was based primarily on the multi-platinum, world-wide sales of a limited number of recordings, rather than a general increase in unit sales. The number of new releases in the United States actually declined by almost 50 per cent in the early 1980s. Paradoxically, it was the runaway success of Michael Jackson's *Thriller* LP, with international sales of some 40 million units, which pointed the way to the immediate future for the industry. *Thriller* thus signalled an era of blockbuster LPs featuring a limited number of superstar artists as the solution to the industry's economic woes. Interestingly, many of these superstars – Michael Jackson, Prince, Lionel Richie, Tina Turner, etc. – were African-American. They were immediately catapulted into an upper-level industry infrastructure fully owned and operated by whites. In this rarified atmosphere, they were confronted with considerable pressure to sever their ties with the attorneys, managers, booking agents and promoters who may have been responsible for building their careers in the first place. 'Aside from Sammy Davis, Jr, Nancy Wilson, and Stephanie Mills', says Nelson George, citing a 1984 *Ebony* story, there were 'no other black household names with black management. . . . Michael Jackson, Lionel Richie, Prince, Luther Vandross, the Pointer Sisters, Earth, Wind and Fire, Ray Parker, Jr and Donna Summer all relied on white figures for guidance' (George 1988: 174).

Following their pop successes, these artists were further distinguished from their less successful African-American colleagues in that they were now marketed directly to the mainstream audience, a practice which has since proven to be successful even with the début releases of artists like Whitney Houston, and more recently Mariah Carey. Typically, their recordings appear on the pop charts about a week or two before they appear on the rhythm and blues charts. It is important to note that this practice runs contrary to what had been the conventional wisdom in the recording industry until this time. Motown certainly had the intention of reaching a mainstream audience, but most of its artists followed a cross-over pattern. The industry-wide marketing of black artists as pop stars is a relatively new one and represents a significant policy change for the major labels. The positive reading of this turnabout is that the industry has finally come to realize that artists who do pop-oriented material are appealing to a broad-based audience regardless of race, a prospect which reinforces Steve Perry's vision of an integrated industry. At the same time, it is important to recognize the potential for divisiveness in what could be a two-tiered system of promotion for African-American artists, wherein the upper tier encourages the compromise of certain African-American cultural values. This is the fear which feeds Nelson George's analysis of the forces killing rhythm and blues.

Steve Perry praises the creative eclecticism of his native Minneapolis, a music scene dominated by Prince, as 'a triumph of integrationist impulses' (Perry 1988: 81). Reviewing Prince's admittedly flawed film, *Cherry Moon*, Perry writes that

> the movie offers a fantasy not unlike that suggested by Michael Jackson's long-form 'Bad' video, in which the aspiration is neither to be black in any traditional sense nor to pass for white; it is to become a new class of being altogether: free, mobile, empowered, colorblind – the 'new breed' Prince used to exalt in the days when he intentionally obscured his own racial origins . . . and heterosexuality.
>
> (ibid.: 84)

For Nelson George, 'The two greatest black stars of the decade, Michael Jackson and Prince, ran fast and far both from blackness and from conventional images of male sexuality' (George 1988: 174). Many critics, George included, pointed to things like cosmetic surgery and blue and green contact lenses as acts of racial treason.

In 1986, George coined the term 'retronuevo' to distinguish between assimilationist crossover and 'black music that appreciates its heritage' (ibid.: 196). The category includes artists as diverse as Maze, Anita Baker, Living Color and Tracy Chapman. Most surprisingly, George argues that 'the two most important retronuevo artists have been Michael Jackson and Prince' (ibid.: 194). When George defends this choice partially on the

grounds of their economic self-sufficiency, he is vulnerable to Perry's charge that 'nationalists almost always elevate economics over the music itself' (Perry 1988: 78). But it must also be said that George's primary justification is musical. 'Despite the unfortunate impact of their imagery', he argues, 'this dynamic duo proved to be the decade's finest music historians, consistently using techniques that echoed the past as the base for their superstardom' (George 1988: 194).

RAP

If the emergence of black superstars complicates the crossover debate, even more bewildering is the phenomenon of rap. Rap must be understood as one cultural element within a larger social movement known as hip hop, which also included breakdancing and graffiti art. With its roots in the gang cultures and ghetto communities of the South Bronx and Harlem, the movement started about the same time as disco but, given the isolation of its place of origin, hip hop flourished as a self-contained street movement for more than five years before coming to the attention of a wider audience. By the time early pioneers like Afrika Bambaataa and Grandmaster Flash passed the baton to a second generation of rappers – most notably Run-DMC – rap had begun to cross over into the mainstream, more or less on its own terms. Since it seemed to be a limited form musically, the death of rap was predicted time and again by the critics in the mid-1980s. Since that time, the music has, if anything, grown stronger, its artists have become more socially engaged, its message has become more explicitly political, and at the same time, its audience has expanded significantly.

Rap's popularity has been equalled only by the level of controversy surrounding it. Since its widespread mainstream acceptance, rap has been associated with sexism, violence and anti-Semitism, and has become – along with heavy metal – the music which currently defines youth culture and the main target of a movement to suppress certain forms of popular music. The shortcomings of rap should not be excused, but it should be noted that there are alternative voices within the rap community. From the Stop the Violence Movement, aimed specifically at black-on-black crime, to Queen Latifah offering a female – if not feminist – corrective to abusive sexual rantings, the progressive voices in rap seem, almost invariably, to be nourished by an Afro-centric impulse. In fact, one of the things that makes rap such an interesting phenomenon is that it is perhaps the only form of black popular music which has become more Afro-centric – indeed, nationalist – as it has gained in mainstream acceptance. As such, rap has avoided the usual pattern in which crossover success is linked to an increase of white performers in the genre. In the early 1980s, the Beastie Boys – the first white rappers of note – failed to ascend to the rap throne.

245

There have been no other significant white pretenders until the emergence of Vanilla Ice in 1990.

After touring as the opening act for M.C. Hammer, the reigning king of rap, Ice skyrocketed to Number One on the pop charts and multi-platinum certification with his LP *To the Extreme*. Ice ran into credibility problems when it was discovered that part of his bio had been falsified to make him look more 'street'. He added fuel to the fire on the occasion of receiving an American Music Award when he told his detractors on network television to 'Kiss my white ass'. He was then taken to task publicly on the Arsenio Hall Show when he brought Public Enemy frontman Flavor Flav out from backstage for an unscheduled appearance. Queried Arsenio: 'Did you bring him out to prove to black folks that you had some support among black rappers?'

Other white rap groups like Third Base have been received more sympathetically by the rap community. To some extent their acceptance seems to be based on a certain repudiation of white skin privilege in their own life styles. One group of white rappers took the name Young Black Teenagers, pushing the identification with black culture to the limit. Their début release included a song called 'Proud to be Black', even though there is not a drop of African-American blood among them. Explained Lindsay Williams, head of promotions and marketing for their record label, 'the name Young Black Teenagers is . . . a reflection of where the group's head is. These guys weren't created, they really live with the uncertainty and prejudice they sing about' (Smith 1991: A41). One observer who did not buy this explanation was Harvard professor and 'Cosby Show' consultant Alvin Poussaint. 'What they're doing is saying there's a black cultural concept that's separate from the black racial concept' (ibid.). With such a statement, Poussaint appeared to be dangerously close to reopening the question of whether culture is learned or inherited.

Members of the rap community seemed more inclined to take the group at face value and judge them on their merits. 'Hey, the bottom line is the music', comments Public Enemy's Chuck D., 'and musically I think they're pretty good' (ibid.). If it seems odd that the leader of the most politically credible rap group should be defending a group of white rappers, the issue becomes even more complicated when one learns that Young Black Teenager's producers are also Public Enemy's producers. One is forced to wonder, as Steve Perry often does, what role economics might be playing in these musical judgements.

In fact, economics plays a major role in almost all decisions related to popular music. Beginning as a street movement, rap was initially produced by independent labels, some of which (e.g., the notorious Sugar Hill, which has since faded from the scene, and Def Jam) were black-owned, and all of which were independently distributed. In signing Curtis

Blow, Mercury was the only major to take a chance on rap before it was a proven commodity. Mainstream success, however, almost demands the kind of national distribution provided by the major labels. Beginning in the mid-1980s,

> buy-ins and distribution deals with successful rap indies soon became commonplace. Columbia Records was the first to bank on rap's potential when they concluded a custom label deal with Def Jam (LL Cool J, Oran 'Juice' Jones, the Beastie Boys, Public Enemy) in 1985. Jive Records (Whodini, Kool Moe Dee, Steady B, DJ Jazzy Jeff and the Fresh Prince, Boogie Down Productions) entered into distribution arrangements with both RCA and Arista. Cold Chillin' Records (Marly Marl, Roxanne Shante, Biz Markie, MC Shan) signed a distribution deal with Warner Bros. in 1987. Warner Bros. also bought a piece of the action at Tommy Boy (Stetsasonic, Force MDs, De La Soul, Queen Latifah, Black By Demand). Delicious Vinyl (Ton Loc, Def Jef) has a national distribution deal with Island. National distribution for Priority (NWA, Eazy E) is handled by Capitol.
>
> (Garofalo 1990: 116–17)

In a market economy, there is, of course, a certain logic to such developments. It is bewildering, however, that increased record sales did not correspond to greater radio play, two aspects of record promotion that usually go hand in hand.

In general, the major record companies have been intelligent enough to leave the creative functions of rap production at street level. Even MTV, once heavily criticized for its racism, initiated Yo! MTV Raps, which has become the station's most popular show. But radio – and most bewilderingly, black radio – has shown a real reluctance to broadcast rap. Reminiscent of the anti-disco crusades, there are some rock stations which have incorporated the slogan 'no rap or heavy metal' into their station IDs. The timidity of black radio speaks to other issues. An avoidance of the randier cuts on, say, NWA's *Efil4zaggin* is understandable, even though the album shipped gold without a video and with no radio play. But in most instances, black radio is passing on completely uncontroversial material which is clearly outselling other selections on their playlists. These stations seem to be making aesthetic and, in some cases, moral judgements which may well run counter to their economic self-interest. Such decisions indicate that rap has become the most visible manifestation of age, and to a great extent, class differences within the African-American community, even as it bridges the gap among the races. The complexity of these issues will undoubtedly produce some interesting realignments as the next chapter in the crossover debate unfolds.

CONCLUSION

It is clear that writers like Nelson George and Steve Perry address issues that live on and are, as yet, unresolved. George believes that crossover entails abandoning one's racial identity and that it leads to cultural suicide or, at best, serious compromise. His judgement, however, is tempered, if not revised, when economic clout is factored into the equation. Perry assumes that integration is equivalent to equality. Ultimately, he fails to understand or acknowledge the necessity for black self-determination in the process. Both authors write sensitively and supportively about African-American culture. If it is too facile to say that each could learn something from the other, I will close with another comment.

I have seen some interesting messages on T-shirts recently. One of them said: 'It's a black thing. You wouldn't understand.' Another boasted: 'It's a black thing. You can't understand.' There was a third message, however, which read: 'It's a black thing. You must understand.' Given the projected demographics of the United States over the next few decades, this is the T-shirt, it seems to me, that points the way to the future.

NOTES

1 *Billboard* 22 August 1970: 18.
2 Organizational communication with the author, 14 March 1988.

BIBLIOGRAPHY

Garofalo, Reebee (1990) 'Crossing Over, 1939–1989', in Jannette L. Dates and William Barlow (eds), *Split Image: African Americans in the Mass Media*, Washington, DC: Howard University Press.

George, Nelson (1988) *The Death of Rhythm and Blues*, New York: Pantheon.

—— (1989) 'The Rhythm and the Blues', *Billboard* 18 February: 26.

Hall, Stuart (1985) 'Signification, representation, ideology: Althusser and the post-structuralist debates', *Critical Studies in Mass Communication* June.

Keil, Charles (1966) *Urban Blues*, Chicago: University of Chicago Press.

Kopkind, Andrew (1979) 'The dialectic of disco', *Village Voice* 12 February: 16.

Omi, Michael and Winant, Howard (1983) 'By the Rivers of Babylon: race in the United States', *Socialist Review* Sept./Oct.: 49.

Perry, Steve (1988) 'Ain't no mountain high enough: the politics of crossover', in Simon Frith (ed.), *Facing the Music; Essays on Pop, Rock and Culture*, New York: Mandarin.

Shaw, Arnold (1978) *Honkers and Shouters*, New York: Collier Books.

Smith, Patricia (1991) 'Proud to be black', *Boston Globe* 10 February.

15

ABORIGINAL ROCK MUSIC: SPACE AND PLACE

Chris Lawe Davies

The black Australian band Yothu Yindi flew into New York in July 1991 for the New Music Seminar. They did three showcase gigs, with major record industry heads bidding for American distribution. Then the band flew out again, back to their home in far north central Australia – Yirrkala – where the Gumatj community lives on sacred land. While Yothu Yindi played the seminar, New Yorkers moved to the band's dance hit 'Treaty' in the clubs. In Australia and Britain the single achieved chart status. Their album *Tribal Voice* did too. Back in Yirrkala, the same month they played in their own country – in community halls, on sports fields.

Urban whites need permission to get to Yirrkala. You get there only by light aircraft, or boat, or four-wheel drive. It's 2,000 miles from Sydney but nowhere from paradise. There are no sealed roads – just car tracks, wild game tracks and the imaginary dreaming tracks of 40,000 years history. Part of the recent history is rock'n'roll along with the political struggle for land rights, penal justice and equality. Finally, it's difficult to separate the politics and the music.

In the song 'Treaty', the rock'n'roll condemns the English invasion of its country in 1788. But at the same time it calls for a treaty. There's never been a treaty, yet peaceful coexistence has always been assumed by white governments, but on grossly unequal terms. Until the mid-1960s, Aboriginal people were used as slave labour on farms and pastoral leases. They were jailed when they ran away. Yet there is never talk of a slave trade. Aboriginal people constitute about 1 per cent of the population. Yet in some states jail populations contain more than 40 per cent Aboriginal people.[1]

While the political and social marginality of Australian Aboriginal people is quite distinctive and recognizable, it doesn't always find its way into the music. Definitions of what makes Aboriginal music seem wide and various. Musicologists take a range of criteria. The contributors to Breen (1989), for instance, produced six, dealing with instrumental style, form and rhythm, characteristics of voice, vocal dominance over instruments, preferred genres and the communal/collective nature of the music (ibid.:

91–3). But while these characteristics appear to describe some aspects of most Aboriginal music, there is no clear sense in which the listener might easily recognize any of them, in the way that reggae or calypso, say, is instantly recognizable as Caribbean. Popular Aboriginal musicians play a range of genres – country, ballad, rockabilly, rock, soul, blues, reggae, calypso. Sometimes the lyrics are heavy; often they sing about love and pain, not always embodied within questions of Aboriginality. Breen et al. admit there is no simple descriptor, except to say that Aboriginal music is varied. It shows variety of style, subject, region and individual performer. Traditional music is different. It has been navigated and contained within anthropological and ethnomusicological discourses around questions of cultural authenticity (see Ellis 1985: 149), and of course, it is experienced first-hand through the traditional knowledges which produce it.

For popular music there is no authenticity, at least not stylistically. Certainly there are recurrent themes which parallel the social/political conditions – land rights, historical ballads, translations of Dreaming,[2] songs about jail and authority, living black in a white world, and so on. But there are also the universals – love songs, nostalgia for regions/youth/home – that seem to preoccupy song writers of any culture.

In terms of style, the dance mix of Yothu Yindi's 'Treaty' stands like a movie set in relation to the real world of the culture it draws from. The album version foregrounds the song's politics, simply through a 'straighter', less produced approach. Other tracks on the album deal with the land and Yolngu (local generic for Aboriginal) way of life. But much of the appeal of the (Filthy Lucre) dance mix is its exotic Aboriginality. Reviews in the US dubbed it 'world music' coming from a contemporary blend with '40 centuries [of] traditional music and dance' (*Chicago Bulletin*). *Time Magazine* spoke of the music's 'millenniums-old chants'.[3] To many people outside Australia, the 'blackness' of the music lies in its haunting didgeridoo beat, along with the clap sticks and chanting Aboriginal song. You don't understand all the words ('Treaty' has some English language), but you take them as cultural icons along with the other Aboriginal sounds. Mix it as dance music and you extend the genre.[4]

While the appeal of Yothu Yindi is undoubtedly the 'exotic' and strange sounds revitalizing a familiar genre, seeing the music only in this way tends to 'orientalize' it and thus render the music remote from its social/political context (Said 1985).[5] The music becomes mere decoration for the genre, a new sound, harkening nostalgically to some kind of ethnic elsewhere. Additionally, there is a danger of fetishism. The Yothu Yindi sound becomes 'the Aboriginal sound', setting up ethnic categories through which other Aboriginal bands can gain recognition. Yothu Yindi are, after all, only a band. It's only *their sound*. Their signatures of Aboriginality should not be mistaken for some kind of ethnic revival.

There are many other Aboriginal bands which are just as well known as

Yothu Yindi in Australia, but they mainly come from the cities or regional urban centres. Yothu Yindi's Australian distribution executive, Michael Gudinski of Mushroom Records, claims that other black bands, with the right management, could be as popular as Yothu Yindi outside Australia (Australian Broadcasting Corporation 1991). Certainly Yothu Yindi use more Aboriginal language than some, but in terms of the iconic markers of Aboriginal rock, some or all are present in most of the music – the language and vocal inflection, didgeridoo, clap sticks, lyrics, and so on. The first Aboriginal band to use traditional language in popular music was Warumpi in 1983 with their *Out from Jail* album. It came about through the band's involvement in an education programme enabling Aboriginal kids to use their own language in schools. The same year, the (white) Goanna Band brought out the album *Solid Rock*, with the 'rock' reference harkening not only to the style of music and to a central icon of Aboriginal culture, Uluru, a huge sacred rock in the centre of Australia, (Ayers Rock) which featured on the album cover, but also to the permanency of the culture they were singing about. Didgeridoo was used extensively on the album. The fact that Goanna Band members were white was never really an issue. Neither was the fact that Warumpi are not all Aboriginal people; nor are Yothu Yindi.

AUTHENTICITY

Already, questions of 'authenticity' appear highly problematic. There is no authenticity in terms of sound, instrumentation, or lyrics. Neither is there authenticity in terms of the people who make up the band. Like its progenitors, the music is largely urban and miscegenous, and simply there, as part of the constellation of experiences called everyday life.

But this miscegenous history remains a central political issue in Australia. Most people claiming Aboriginal heritage live in urban areas. Most are descended from Aboriginal plus other heritages: that is, like any person, their 'blood line' is miscegenous. Yet while nothing is made of the miscegenous origins of most Australians, in the case of the Aboriginal people it has a certain negative political capital value. A 1985 opinion poll, used by the Federal Government to go soft on its support for land rights legislation, seemed to confirm a distinction between 'authentic' tribal and 'unauthentic' urban Aboriginal people (Rowse 1988: 73). As a result of this attitude, there is often support for 'Aboriginality' in the outback, remote from people's immediate vested interests, especially when it involves tourism, but when Aboriginal people make a claim for their culture in cities and urban areas there is almost always open hostility. Notions of cultural 'unauthenticity' are invoked to smother political demands.[6]

An example of this was when the Aboriginal lawyer Michael Mansel visited Libya's Gaddafi in late 1986 to discuss support for revolutionary

action. The obvious middle-class disapproval for the Gaddafi connection was often deflected on to Mansel's 'unauthentic' Aboriginality, that is, his lack of tribal characteristics. Being from the southern island state of Tasmania, where most Aboriginal people were killed off either by guns, poison or disease before the twentieth century, the only survivors come from several generations of 'union' with the colonizers. In short, Mansel has blond hair and fair skin. He lacks the external markings of an authentic cultural representative. Thus, he doesn't fit the 'authentic' mould – holding a spear in tribal costume. This form of orientalism not only reduces the culture to an ethnic elsewhere, but also places the weight of approval on the smallest, remotest portion of the culture.

When it comes to the music, traditional sounds like the language and didgeridoo evoke nostalgia for an authenticism which bears little relation to the political context in which Aboriginal people find themselves. Again, Yothu Yindi are not typical. Their first video clip, 'Mainstream' from the album *Homeland Movement*, talks of confluences of cultures, drawing parallels with inland freshwater streams meeting saltwater in a kind of estuarine harmony. It's a nice idea, and it probably reflects the state of some black/white relations in Australia, but the genesis of black Australian rock was not half so romantic. Its roots lie unquestionably in the politics and style of reggae.

The first Aboriginal rock bands to penetrate the popular Australian consciousness were No Fixed Address and Us Mob in 1980 when they appeared in/made the film *Wrong Side of the Road*. The bands formed at Adelaide city's Centre for Aboriginal Studies in Music just after a 1979 Bob Marley tour. The music was uncompromising and reggae and like their autobiographical film dealt with life on the wrong side, especially the difficulty black bands have getting venues, on top of the usual violence with police, publicans and other figures of colonial domination. The film showcased the song 'We Have Survived', penned by NFA drummer and founder, Bart Willoughby. While initially a celebration of Bart's own ability to survive the streets, the song has outlived the band and gone on to become a virtual anthem of cultural persistence.[7]

Survival, however, was urban, not tribal. The film plot works towards a band simply getting a gig in a community hall, on their own terms with their own people. Black people dance to black musicians, without white authority figures moving them on – well, not for ten minutes or so, at least. There have always been Aboriginal musicians working the country circuits, towns and reserves in ballads, country, blues, rockabilly, but the value of the film *Wrong Side* was that it enunciated a new urban politics, a new swagger, in the style and patois of an internationalist black roots movement. Certainly parallels can be made between Afro-American blues and Aboriginal music. Both speak of the relation between white dominance and black oppression; use patois as a secret cultural code of resistance;

have distinctive forms of 'English' pronunciation which in themselves are transgressive; and find their current social location/formations were the result of being transported from their cultural homelands through slavery. Reggae does this too. But what links contemporary Aboriginal rock to reggae fundamentally is the attempt to recover the cultural homeland, if only spiritually in the case of Rastafarianism.[8] Cultural survival for Aboriginal Australians is tied to land rights, to origins, to a cultural integrity beyond contemporary industrial arrangements. In the words of Yothu Yindi's Mandawuy Yunupingu:

> 'What we're trying to say to the white man is, if you recognize my ownership, where I come from, then you're recognizing the future for us. . . . We'd like to leave a very solid basis for the next gener- ation. . . . That's been . . . my role as a musician . . . as a song writer . . . as a dancer . . . as a good member of my tribe . . . to bring about social reform, social justice for our people'.
>
> (Australian Broadcasting Corporation 1991)

Australia's black music has a homeland. But it was undoubtedly *Wrong Side* which began to move the idea of 'blackness' into the urban discursive field. Where once it might have been incontestably fixed within denigratory 'colonialist' connotations, there is perhaps now a sense in which the 'power to signify' is becoming more evenly distributed. Black Australian musicians are attempting not only to shift the terms of debate, but also to alter the logic of their oppression.[9]

Like reggae, looks matter as well as sounds. Besides the long untidy hair, dreadlocks, binis and ragged dress which have been part of the youth-look since the 1960s, NFA and Us Mob had the swagger of people who had finished with apologizing. Aboriginal people have always lived on the fringes – whether it's the reserves, the tin shanties outside country towns or the slum areas of cities. Discursively that had always been their place as well. But the style has changed.

Hebdige's arguments for the 'integrity' of reggae are centrally linked to questions of style. There is a sense in which the 'style' of reggae is beyond the grasp of middle-class record producers. Reggae simply isn't music alone. It's dress, rudeness, blackness, identity, hair, excitement, resistance – all of those things encapsulated in something called 'style'. The question of 'recognition' re-emerges as a central problematic for the resistance by Aboriginal musicians to penetration by Euro-Australian structures. In Hebdige's terms the negative sign for Aboriginality is rearticulated 'liter-ally on the "skin" of the social formation' (Hebdige 1979: 37). Much of reggae and Aboriginal rock is about colour, skin colour; and much of the rhetoric which surrounds the music operates at the level of style – the surfaces of culture: the clothes, colours, flags, swagger and 'groupness'. The reggae surfaces are familiar enough. In Australia, Aboriginal activists

are recognizable occasionally by their adapted Rasta styles, which are also signs of an internationalist black consciousness – a common sense of resistance. But there are distinctive signs of Aboriginality in this resistance as well. Primarily there is the presence of the Aboriginal flag. You see it on land rights claims in cities or tribal areas. The flag's reappearance on T-shirts, bumper stickers and the colours of the clothes people wear is important and distinctive. Ex-NFA member now soloist, Joe Geia, celebrates the flag in his song 'Yil Lull'. Written in 1988, the white bicentenary, and frequently performed by Geia, the song places the flag's three colours – black, red and gold – into a broader social narrative. The black and red halves of the flag are the blood spilled by Aboriginal people under colonial repression. The gold disc in the centre is the new year coming on.

Much of the ideological work done by bands like NFA in the early 1980s provided discursive space for new bands to emerge. The late 1980s and early 1990s have seen a rapid expansion in the kind of recognition both record companies and the public are giving Aboriginal bands. Styles move on. While in the early 1980s getting mainstream distribution was possible – the soundtrack for the film *Wrong Side* was an EMI/Polygram distribution – the grittiness of the music and politics came first. But that was the 1980s. Now it's the vehicle itself which is getting more attention. They're working on the mix.

THE MIX

Mushroom's Michael Gudinski says of Yothu Yindi's 'Treaty':

> 'Sometimes you've got to back the message off a little, otherwise the message doesn't get through to the majority. The way the song works now, so many more people would have been exposed to it . . . than had they not approached it . . . that way'.
>
> (Australian Broadcasting Corporation 1991)

Gudinski seems to be reiterating the well-worn principle of 'political rock' – the mix delivers the message. In a slightly different guise, Bob Marley's producer, Chris blackwell, had a similar idea. Assuming reggae's rhetoric – to spread the word to as wide an audience as possible – you lay down music which is uncompromising in its social and political content and package it just like any other slick, highly produced pop music (Hebdige 1987: 79). That way you achieve the 'crossover' – the market shift to include black and white audiences. But while blackwell sees some kind of 'authenticity' as central to the crossover, Gudinski prefers the mix to dominate. These two ideas appear contradictory, but closer inspection suggests a more sympathetic alignment.

With reggae's style being so predominant, authenticity seems an easy concept to invoke. The style, the politics, the dress and swagger all seem to

add nicely to a music which is varied, to be sure, but around a 'waxy beat and rebel base' (ibid.: 75). The music is a form of social organization, a means whereby a slave culture fights back (ibid.: 26). While arguments for an Aboriginal style are impossible to sustain, there is some accounting for the music at an affective level, which seems to diminish the importance of lyrics and genre, and instead to raise the possibility of affective alliances forming around the music. The case must be made for the music operating not necessarily at the semantic level, but predominantly at the level of desire. Grossberg argues that rock'n'roll is a set of

> practices of strategic empowerment rather than of signification [organized around the idea of power as desire]. . . . There seems to be little correlation between semantic readings and uses/pleasures. I do not mean to suggest a disjunction of lyrics and sounds (which may operate in a variety of relations to each other) but rather that rock and roll cannot be approached by some textual analysis of its message. Rock and roll, whether live or recorded, is a performance whose 'significance' cannot be read off the 'text'. It is not that rock and roll does not produce and manipulate meaning but rather that meaning itself functions in rock and roll affectively, that is, to produce and organize desires and pleasures.
>
> (Grossberg 1984a: 227, 233)

Later he suggests the privacy of these desires and pleasures also acts publicly, by creating 'common experiences out of them . . . affective alliances as modes of survival' (ibid.: 235).

This account of the music's 'affectivity' leads analysis away from concerns with textual 'signs' of Aboriginality, and even the heritage of the musicians themselves. Instead it centres on questions of the nature of the pleasure derived from the music – what Grossberg (1984b) after Hebdige (1981) calls 'cartographies of taste'.[10] That is, affective alliances are not so much fan clubs of particular bands, but form around some of the work which some bands do some of the time. They are provisional and mobile, and shift and re-form themselves around particular affective moments. While many Aboriginal musicians (by heritage) don't sing obsessively about Aboriginal issues, equally, some 'white' music is 'Aboriginal'. Goanna Band has already been mentioned. The white soloist Paul Kelly has produced a trenchant rewriting of colonial history in his song 'Special Treatment', released in 1988.[11] Kelly also performs with and produces the award-winning black musician Archie Roach. Midnight Oil have often foregrounded Aboriginal politics in their music. Several of their national and international tours have showcased black bands. Clearly, therefore, white bands who include black issues, lyrics, instrumentation and even language in their music are not Aboriginal bands; but at the same time, Aboriginality isn't absent. Its articulation

comes through a complex range of sites – what Grossberg calls the apparatus:

> The rock and roll apparatus includes not only musical texts and practices but also economic determinations, technological possibilities, images (of performers and fans), social relations, aesthetic conventions, styles of language, movement, appearance and dance, media practices, ideological commitments and media representations of the apparatus itself. The apparatus describes 'cartographies of taste' which are both synchronic and diachronic and which encompass both musical and non-musical registers of everyday life.
>
> (Grossberg 1984a: 236)

THE APPARATUS

The apparatus acts specifically. Each form of rock and roll works to achieve its specific affectivity through its specific apparatuses. The apparatus demands we read rock music (whether it's rockabilly, folk rock, metal or whatever) within the industrial and aesthetic conditions and relations of its production and distribution. Part of that, of course, is acknowledgement of rock's audience: its affective alliances. However, while Grossberg suggests those alliances are resistive, finally he grants them only provisional status, suggesting that rock's resistive tendencies are only revolutionary simulacra as they remain within the political and economic space of the dominant culture (ibid.: 232). In a later essay (1991: 361), he claims that rock's challenge to the *status quo* is more likely to come from outside it than from within, probably even from conservatives themselves.

While no attempt will be made here to account for the reception of black Australian rock, its occupation of the apparatuses of a dominant colonial culture will be seen for its revolutionary possibilities rather than as a provisional and ephemeral presence. Black Australian rock, because of its attachment in varying degrees to the revolutionary politics of land rights, must be seen in terms of at least two different sets of empowering practices.

First, the Aboriginality of black Australian rock is a form of empowerment accomplished through a reversal and decentring of colonialist social relations, especially in performance (as against recorded) contexts; and second, beyond Grossberg's 'apparatus', the political economy of the music's distribution through mainstream rock labels places Aboriginality within a set of commercial and economic practices, thus forcing the marginalizing tendencies of the homoglossia – which has always excluded Aboriginal people from 'legitimate commerce' – into a heteroglossic relation. In other words, the instrumentalities which act unproblematically on the Aboriginal body within a colonial common sense (welfare, employ-

ment practices, law enforcement, imprisonment and punishment, housing practices, journalism, etc.) are contested by a marginalized community taking up a strategic (and more central) position. While the second point seems fairly self-evident, if we accept the view that mainstream publishing does not necessarily 'corrupt' the music's oppositional power, the first needs further development: that is, the question of empowerment through the pleasuring and affective relations acted on the body by the music and its social context. Quite simply, listening or dancing to an Aboriginal band enacts a whole different set of pleasures within colonial relations from those elicited by bands with 'white' faces. They play, you dance. But it's more than a reversal of the polarities of social power. You're there on their terms – the band's and the crowd's.

DANCING THE ROEBUCK

In the remote north-west Australian town of Broome, there's a music venue called the Branding Iron bar in the Roebuck Hotel. It's a black bar in a middle-class hotel, but it operates oxymoronically both as a cultural oasis and corral. On the surface it's an exclusive black venue – there are still few enough of them. A closer look, though, suggests it's a microcosm of white colonial repression. The black bar is 'encircled' by a series of white venues. The name of the bar evokes a cultural capture, both in terms of the constraints imposed by English colonialism (property ownership), and the cattle industry which for so long employed Aboriginal people under slave conditions. The purchase of alcohol, pleasurable though it is, is a form of commodified repression with its history of addiction, violence, arrest and death in custody; but it buys them a right of assembly. Police prowl outside in Ford pick-ups. White dude bouncers work the insides. Yet while white colonial authority is present, finally the band is there because the crowd is there. Most of Broome's prodigious number of musicians have come through the Branding Iron – most prominent among them Jimmy Chi and the Kuckles Band, Scrap Metal and the Pigram brothers. Broome is tropical – an old pearling port. Nights at the Branding Iron are sweaty, sexual, sensual and political. But they work because there's something entirely separate going on. Land rights, black solidarity, special and sacred knowledges, broken hearts and true love move transgressively beneath the authoritarian gaze of the dominant white culture.

This claim for a connection between rock music and politics is made in the face of convincing arguments which suggest there is little connection in general, and that rightists are attempting to reconstruct a new conservatism in and through the appropriation of popular culture (Grossberg 1989). Obviously there is a huge difference between 'feeling the politics' at an isolated cultural moment like a rock gig, and seeing that moment translate

257

into fundamental shifts in broader social relations. Yet the temptation to make this broader claim seems legitimate, largely because of how the apparatus for Aboriginal rock is constituted, and the history of its formation.

THE POLICY APPARATUS

Until the 1980s, Aboriginal music received little public support. Like other musics, Aboriginal affectivity operated in a 'free market' dominated by American and British Top 40. In the 1950s, close alignments between record labels and radio formatting meant Australian rock was relegated to live venues until in the 1960s television – with shows such as Brian Henderson's *Bandstand* and later Molly (Ian) Meldrum's *Countdown* – gradually made room for some local talent. For bands operating within the Aboriginal affectivity there was this problem of 'international' hegemony, but within their own national boundary exclusion from the airwaves and studios was almost axiomatic of their heritage. Those who achieved mainstream airplay tended to reinforce rather than challenge exploitative colonial relations. Prominent among these was the country singer Jimmy Little, whose biggest hits were covers of 'Danny Boy' and 'Royal Telephone'. Also, former world champion boxer, Lionel Rose, fared badly in the culturally weighted contest of the music industry. Despite support from music television's Johnny Young,[12] who penned his hit 'I Thank You', Rose had a brief career. Clearly, boxing rather than music had given him national status, in an arena properly occupied by heroes of the side show and other cultural marginalities.[13]

One of the few black Australian musicians in the 1960s popularly to enunciate the terms of his cultural capture was Bob Randall, originally of the politically active Pitjantjatjara people in central Australia.[14] Many of Randall's better-known songs focus on the central moment of colonial domination, namely the sexual exploitation which led to genocidal government policies, separating parents and children, people and culture (see Lawe Davies 1989). But few Aboriginal musicians made vinyl during the 1960s and 1970s. The apparatus for the rhetoric of black oppression was sporadically occupied by whites, most notably Ted Egan. Egan's 'Gurindji Blues' (1967) virtually stood alone as a piece of recorded protest music, gaining wide airplay, even occasionally on commercial radio. With Bob Randall, Egan often played live with the black activists Paul Coe and Garry Foley, who became key figures in the establishment of the Aboriginal Embassy in Canberra as a way of asserting claims to the status of 'a nation within a nation'.[15] Egan's 'Gurindji Blues' was virtually a song of mobilization among activists, both black and white, charting the beginning of the modern land rights movement – the walk off Vestey's cattle stations (ranches) by Aboriginal workers in 1966.[16] The next year

Aboriginal people 'won' the right to vote for the first time since white occupation in 1788. Then there was the Embassy five years after that.

Even though black politics moved rapidly after the Embasssy, it took a further ten years to set up the public infrastructure to enable the musical shifts to occur. The appearance of new bands like No Fixed Address, Us Mob, Coloured Stone, Warumpi, Scrap Metal, black Lace, and others in the 1980s was marked by a new relation to a mass market. Characterized by recording rather than live performance, the apparatus of a 'second wave' for black Australian music operated within the crossover. But there would never have been a second wave without the publicly funded Aboriginal music agencies, which in turn only came about through the political groundwork laid by land rights agitation (cultural identity) and the Embassy. The founding agency was the Centre for Aboriginal Studies in Music (CASM) which started in Adelaide from the musicological base provided by Dr Catherine Ellis in the 1960s. Its aim was to bridge the gap between tribal and urban people (Breen 1989: 113). But by 1980 reggae and rock had come to CASM, the same year as the Central Australian Aboriginal Music Association (CAAMA) was established at Alice Springs. From then on, a great number of agencies spread through the country, recording, teaching, funding, promoting and distributing black musicians. Many artists are listed in Breen's (1989) discography, which reveals a wealth of country, traditional, rock and gospel artists. The extensive copyright list held by CAAMA, CASM and the other agencies is testimony to the vital role they have played since the early 1980s as first contacts in the recording industry. CAAMA has gone on to become a major centre of not only music, but also Aboriginal radio and television.

CAAMA's best-known music production was the 1988 crossover album *Building Bridges*. Some of the musicians featured were Paul Kelly, Yothu Yindi, Goanna, Hunters and Collectors, Joe Geia, Midnight Oil, Areyonga Desert Tigers, Spy Vs Spy, Do Re Mi, Weddings Parties Anything, Scrap Metal, Coloured Stone, James Reyne, Ilkari Maru, Crowded House, Gondwanaland, The Saints, and No Fixed Address. That album was distributed by CBS. A more recent production has been *From the Bush* (1990), featuring a greater number of Aboriginal musicians. ABC television has also been crucial. It broadcasts the Aboriginal Music Festival, the first of which – *Sing Loud Play Strong* (1988) – was a landmark of original sound and vision.

The third wave has been marked by a common sense of the role which Aboriginal music and politics plays in Australian life. Rather than the 'menacing' visage of No Fixed Address adorning record covers, Aboriginal rock seems to have found a niche within a more complex apparatus. Productions are smoother, distribution is more mainstream but the politics don't seem to have changed. It's the same with the political organization. The old Department of Aboriginal Affairs with its few Aboriginal

employees glossing over entrenched colonial dynamics was replaced in 1989 by a black proto-parliament/executive – the Aboriginal and Torres Straits Islanders Commission (ATSIC) – which handles all Aboriginal matters, from legal aid and land rights to arts funding. The music and the politics are growing together – they must, in order for a common sense of acceptance to have become evident in the wider commercial market. In the 'crossover', the apparatus has been pierced by a new history. The insertion is political, it has been publicly funded, and it insists on an admission of colonial repression. In the words of the sub-title to the *Building Bridges* album (1988), 'white Australia has a black history'.

Some evidence of this new 'third wave' common sense is the sound of black music on commercial radio (not much of it still) and the accolades which black musicians are beginning to attract in the commercial market-place. At the 1991 Australian Record Industry Awards (ARIA), Archie Roach won the Best New Talent award as well as the Best Indigenous Musician award. His *Charcoal Lane* album featured widely on commercial radio during 1991. Many of the tracks gained airplay. In particular his single 'They Took the Children Away' gained significant resonance. The song picks up the central problematic in the music of Bob Randall, where racialist claims to a miscegenous unauthenticity are used to disarm practices of black cultural empowerment. Broome musician Jimmy Chi (Kuckles Band) won the prestigious 1991 Sidney Myer Award for his musical *Bran Nue Dae* and has had two approaches from major English theatre companies for European tours.[17] There has also been a road movie and book, a human rights award, and so on. Yothu Yindi came away with five awards from the 1992 ARIA

CONCLUSION

The foregoing discussion of the Australian black rock apparatus was set up to contest Grossberg's notion of a weak, if any, link between the transgressive possibilities of rock music and its political affectivity in the audience. Grossberg (1989: 31) supplies anecdotal evidence which suggests that some fans at U2 or Midnight Oil concerts in the mid-west United States get disappointed by the politics in the music! The same reaction is imaginable with those two bands in Australia as well. However, anecdotally, the case can also be made for fans at a Yothu Yindi gig or any other black band being there because there is a musical and a political accord. When fans attend concerts/gigs, it is most likely that they do so with some kind of political accord as part of their expectation of pleasure, largely because black music in Australia is more than just the music. A publicly funded infrastructure has driven music and political knowledge, almost inseparably.

But Grossberg's point is conceded when the dimension of scale is

considered. Quite clearly, it is one thing to have a bunch of political groupies come to your gig – maybe a couple of thousand at best – and quite another to expect the same political sympathy in the market-place where albums are sold. At some point the argument clearly needs to address this difference of scale. Many fans of Yothu Yindi's dance hit may find the band's other music boring; they may never attend a Yothu Yindi concert, just groove to it in the disco – another variation in sound and style.

Clearly, the apparatus is not a politically uniform space, but is only ever the site of competing and contradictory vectors (ibid.: 36). As was suggested earlier, Aboriginality is an affectivity which is constituted by a mobile set of articulations – different bands at different moments. But always it speaks of the 'other', and it is always its otherness or difference which gives it transgressive potency.

Aboriginal popular music, therefore, is more than white stuff with the colour changed. It is the music, and it is the other. Chambers (1987) argues that Afro-American and Afro-Hispanic music has become somewhat routine and museum: 'the already seen, the already worn, the already played, the already heard' (Chambers 1987: 9). Clearly Chambers' view of the fixity of Afro-music is limited by his refusal to acknowledge its context and the political economy of its circulation – he treats the 'otherness' of the social formation from which it speaks as either non-existent, unimportant or disconnected. This suggests a postmodern tendency of privileging textual style over social formation. Certainly the same fixity does not describe Aboriginality in Australia. Cultural self-determination is very much an issue, whether it is argued within the political economy of land rights for urban or remote sites, or the debates around the circulation of music, writing, film, art, and so on. 'Otherness' and a sense of 'becoming', not the fixity of 'being', are central to the Australian context.

Like Chambers, Harvey supplies metaphors of 'real politic' pessimism when he suggests any cultural production exists in the maelstrom which constitutes the 'postmodern ontological landscape . . . [where] spaces of very different worlds seem to collapse upon each other . . . and all manner of sub-cultures get juxtaposed' (Harvey 1989: 301–2). Harvey argues that in the face of this disruptive spatiality, the arsenal of any subcultural voice (racial minorities, colonized people, women) is limited to an occupation of 'place'. Powerless to occupy the discursive space of the dominant culture, identity becomes locality, whether it's a working-class suburb struggling to retain its original residents and life styles in the face of escalating rents and gentrification, or similar localisms tied to ethnicity. Inevitably the flux and ephemerality of capital renders any such historical continuity nostalgic, museum.[18] The architecture and life style of inner-city working-class suburbs, for example, become gentrified simulacra. Space, the overarching

261

metaphor of the dominant culture, appropriates place, and neuters its significance.

Clearly, Aboriginal culture too, powerless in the colonizing space of the past two hundred years, has had its places appropriated and a fraction of it now museumized, touristicated and rendered simulacra. However, a lot of mainstream label black music works towards disarming the colonizing body. That is, the musical apparatus is tied to land rights and other forms of political self-determination, and asserts an occupation of both place and space (Aboriginality within a postcolonial discourse). This conflation of both 'space' and 'place' into a political alliance suggests something more potent within the intertextual narrative than Harvey's general view of the 'real politic' of subcultural geographies, as tactical, localized aesthetic responses asserting themselves against a collage of homogenizing and imploding spacialities (ibid.: 303–4).

As a middle-class white, therefore, I speak from the dance floor, the auditorium, the pub, party and stereo system. I speak from the position technology has provided, that is, from the 'crossover', within a massively heterogeneous audience addressed by mass-produced and distributed rock 'n' roll. Whether or not the music speaks overtly of Aboriginality, it is likely to be part of a broader social narrative of Aboriginality constructed intertextually through personal contacts, journalism of crime waves, urban violence, drinking and land rights, fetishized traditional art, postcards, music, video, film . . .

NOTES

1 According to Steve Mickler, one of the authors of the report of the Royal Commission into Aboriginal Deaths in Custody, the gaoling rate in Western Australia, a year after the release of the report, climbed from about 35 per cent to 41 per cent. Interview conducted 4 May 1992.

2 The Dreaming is an ongoing process of knowledge-making central to Aboriginal culture. Through ceremonies and other cultural expressions it enunciates relationships between 'kin' and 'landscape' with the force of law. See Michaels (1989: 28–34).

3 *Time Magazine* and *Chicago Bulletin*, cited in Mushroom Records' press kit, late 1991.

4 But even that most 'authentic' of sounds, the didgeridoo, had to be synthetically repitched and remetered to satisfy the demands of the disco beat. (See Neuenfeldt (1992).

5 See also Hodge (1990) who has translocated 'orientalism' to Australian 'aboriginalism'.

6 See Mickler (1991).

7 'We Have Survived' featured particularly in Australia's bicentennial celebrations (in 1988). Ever since Australia Day (26 January) was established, it has had two foci: one which celebrates the first landing of the English colonizers in 1788 (Captain Arthur Phillip), and the other which sees it as an invasion from which the indigenous culture is still attempting to recover and rebuild.

8 See particularly Hebdige (1979: 35–9).
9 Adopting Gramsci, Stuart Hall has argued:

> Changing the terms of an argument is exceedingly difficult, since the dominant definition of the problem acquires, by repetition, and by the weight and credibility of those who propose or subscribe it, the warrant of 'common sense'. Arguments which hold to this definition of the problem are accounted as following 'logically'. Arguments which seek to change the terms of reference are read as 'straying from the point'. So part of the struggle is over the way the problem is formulated: the terms of the debate, and the 'logic' it entails.

(Hall 1982: 81)

10 See also Hebdige (1988: 45–76).
11 The song deals with an issue which white racists have found impossible to fathom, namely, the special treatment given to many Aboriginal people in terms of subsidized housing, health, and so on. Kelly's rhetoric moves on a continuum from the familiar and 'acceptable' treatment – slavery, forced prostitution, indiscriminate gaoling and no citizenship – to that which rednecks find unacceptable – such as health care, housing assistance, and other forms of compensation.
12 Young was himself a struggling white musician of the 1960s. He started in Perth, Western Australia, with his band Johnny and the Strangers, and gained some prominence in a move to Melbourne later that decade. Finally, national recognition came when, in the 1970s, he began hosting his television show *Young Talent Time*, and promoted 'internationalist' (production value) song and dance acts from local kids.
13 Aboriginal boxers have always dominated the side-show troupes at touring agricultural fairs. The attraction is to see who in the crowd will pay money to knock one of the troupe senseless. As the challenger is invariably white, the colonial common sense of this 'match' is difficult to leave unremarked.
14 Interview with Bob Randall, 13 February 1992. See also n. 16.
15 Aboriginal people first gained Australian citizenship in 1967, after a Federal referendum to include them in the census. Since 1788, when the Englishman Arthur Phillip landed near what is now Sydney, they've been captives in their own land. War was never declared, though the casualties have been genocidal. No treaty has been signed, yet peaceful coexistence has always been assumed by governments and empowered citizens. In 1972 Aboriginal people camped on the manicured lawns outside Federal Parliament and established an Embassy to begin the long haul of regaining occupancy and control over some of their land. There had been earlier struggles for land rights (see n. 16), but the Embassy brought the issue to a head. It was a national act, not only because it was in Canberra, but also because the media's prurient fascination with their contempt for white law and protocol on the front steps of the legislature gave land rights a singular and unified presence, forcing a heteroglossic agenda almost daily on television news, where previously from the fragmented, remote fringes, Aboriginality had scarcely existed. The Embassy stayed in the news and in front of Parliament for six months. A second national act occurred on 26 January 1988 (Australia Day), when empowered citizens celebrated the English arrival and 200 years' empowerment. In the streets of Sydney and over the world's television networks, Aboriginal people celebrated 40,000 years' occupation and spurned the 200-year interjection. For many the significance of 26 January was black, not white. It was not the foundation of a nation, but another imperialist moment in First World history.

16 The Gurindji people walked off Wave Hill station owned by the English Vestey company in protest at the deplorable pay (virtually none) and conditions. They subsequently claimed tribal land. Though only partly successful, they had started something. In 1968 the Yirrkala people in the Gove Peninsula in the Northern Territory challenged the right of the Swiss mining company Nabalco to mine on sacred land. They too were unsuccessful, though they also got partial and conditional land grants. The first strike by Aboriginal people came earlier in 1945 by what came to be known as the Pindan movement of Western Australia's Pilbara. They walked off a station over pay and conditions and took up independent mining leases. With a Federal Labor government in power in late 1972, moves were made to proclaim a land rights bill, giving Aboriginal people right of occupation and control over land. After a change back to conservatives in 1975, an Act giving occupation but no control in the Northern Territory was proclaimed in 1977. By 1980 there were forty claims before the government. Probably the most famous land rights claim was that by the Pitjantjatjara people in 1976 (Lippmann 1981). Then there was Noonkanbah in 1978 (see Hawke and Gallagher 1989).

17 Philip Hedley from the Theatre Royal, Stratford East, and Rose Fenton from the London International Festival Theatre came to Australia to solicit possible tours. However, the company controlling the play, Bran Nue Dae Productions, chaired by Mr Peter Yu, will consider overseas tours later rather than sooner. Their main concern is to retain the play's artistic and cultural integrity.

18 Harvey's flux and ephemerality characterizing the late-capitalist compression of space and time.

BIBLIOGRAPHY

Aboriginal Deaths in Custody (1991), *Report of the Royal Commission*, Canberra: Australian Government Publishing Service.
Australian Broadcasting Corporation (1991) 'In the Mix', *Radio National*, 6 September, Sydney.
Breen, M. (ed.) (1989) *Our Place Our Music*, Canberra: Aboriginal Studies Press.
Caama (1989) *The Caama Group*, Alice Springs: The Caama Group of Companies.
Chambers, I. (1987) 'Maps for the metropolis: a possible guide to the present', *Cultural Studies* 1: 1–22.
Chi, J. (1991) *Bran Nue Dae*, Sydney: Currency/Magabala.
Clifford, J. (1988) *The Predicament of Culture: Twentieth-Century Ethnography, Literature and Art*, Cambridge, Massachusetts: Harvard University Press.
Ellis, C. (1985) *Aboriginal Music: Education for Living*, Brisbane: University of Queensland Press.
Grossberg, L. (1984a) 'Another boring day in paradise: rock and roll and the empowerment of everyday life', *Popular Music* 4: 225–58.
—— (1984b) '"I'd rather feel bad than not feel anything at all": rock and roll, pleasure and power', *Enclitic* 8: 94–110.
—— (1989) 'Rock resistance and the resistance to rock', in Tony Bennett (ed.) *Rock Music: Politics and Policy*, Brisbane: Institute for Cultural Policy Studies.
—— (1991) 'Rock, territorialization and power', *Cultural Studies* 5 (3): 358–67.
Hall, S. (1982) 'The rediscovery of "Ideology": return of the repressed in media studies', in T. Bennett, J. Curran, M. Gurevitch and G. Martin (eds), *Culture, Society and the Media*, London: Methuen.
Harvey, D. (1989) *The Condition of Postmodernity: An Enquiry into the Origins of Cultural Change*, Oxford: blackwell.

Hawke, S. and Gallagher, M. (1989) *Noonkanbah: Whose Land, Whose Law*, Fremantle: Fremantle Arts Centre Press.

Hebdige, D. (1979) *Subculture: The Meaning of Style*, London: Methuen.

—— (1981) 'Towards a cartography of taste', in B. Waites et al. (eds), *Popular Culture Past and Present*, London: Croom-Helm.

—— (1987) *Cut 'N' Mix: Culture, Identity and Caribbean Music*, London: Comedia.

—— (1988) *Hiding in the Light*, London: Routledge.

Hodge, R. (1990) 'Aboriginal truth and the white media: Eric Michaels meets the spirit of Aboriginalism', *Continuum* 3 (2): 201–25.

Lawe Davies, C. (1989) 'Looking for signs of style in contemporary popular Aboriginal music', *Australian Journal of Communication* 16: 74–86.

Lippmann, L. (1981) *Generations of Resistance: the Aboriginal Struggle for Justice*, Melbourne: Longman Cheshire.

Michaels, E. (1989) *For a Cultural Future: Francis Jupurrurla makes TV at Yuendumu*, Malvern: Art and Text Publications.

Mickler, S (1991) 'The battle for Goonininup', *Arena* 96, Spring: 69–88.

Neuenfeldt, K. (1992) 'Aural Images of Aboriginality', unpublished Ph.D. thesis, Curtin University of Technology, Western Australia.

Rowse, T. (1988) 'Middle Australia and the noble savage: a political romance', in J. Beckett (ed.), *Past and Present: The Construction of Aboriginality*, Canberra: Aboriginal Studies Press.

Said, E. (1985) *Orientalism*, Harmondsworth: Penguin.

Waites, B., T. Bennett and G. Martin (eds) (1981) *Popular Culture Past and Present*, London: Croom-Helm.

AFTERWORD: MUSIC POLICY, AESTHETIC AND SOCIAL DIFFERENCE[1]

Georgina Born

CULTURE, POLICY, AND THE POLITICAL

> While her son Sacha, a pallid 10-year-old, gapes at Tom and Jerry on cable, [Galina] Kuznetsova, carefully made up for an evening in front of the television, explains that long before January's price rises, she had nothing left over after buying food. . . . 'I just feel deep sadness about my future, especially when I see western movies on cable TV, and I see lots of people in fashionable clothes, and little well-dressed, red-cheeked children, and I get more and more emotional'.
>
> (The *Guardian* 22 January 1992: 21)

This description of the tower-block existence of a Moscovite divorcee and her child, and of the teasing centrality of cable TV and its western diet in their imaginative lives, brings issues of 'the local and the global' into sharp post-1989 (or post-1991) focus. There is a terrible pathos in this consumption of the 'global' (the American-based multinational) by those locked into the immobility of the local and regional; trapped also by a newly dominant ideology in which the previous totalitarian state and command economy are seen as giving way to the heroic new 'freedom' of market capitalism. What emerges from this woman's situation is a frank despair – despair at the failure of the promise of change piled on the despair of history – and it seems that it is constantly stoked by the envy, the idealizing and narcissistic fantasies generated by western movies as they invade and confront the actual conditions of her life.

Despite its myriad critiques, then, I begin here by resurrecting the problematic of cultural imperialism: a problematic which current international economic crises and recent global geopolitical shifts – not least the revival of various nationalisms and fundamentalisms – must surely reinvigorate rather than efface. I raise this as a complement to the way that issues of the local and the global have been discussed in this book in terms of the possibility of resilient local musical identities withstanding the depredations of cultural centralization, mainly through the support of local

266

networks of popular music production, and/or through quota arrangements and subsidies for the distribution (by radio, performance venues, record and tape production and distribution) of local popular music products. My first intention is to clarify the basic conditions for such a cultural policy: a degree of economic well-being and of political strength and autonomy which have ensured that the main examples have been drawn from the developed world – western Europe, Canada, Australia. In this sense, and ironically, the 'local' as produced in cultural policy risks becoming an effect of already existing power.

Of all the media industries, popular music has often been depicted as exceptional in terms of its periodic capacity to nurture and sustain active and innovative local spheres of production, thereby resisting the general tendency towards concentration of production, if not of manufacture or distribution.[2] Yet despite this, one of the most striking messages of this book, even in relation to the developed countries let alone economically and politically weaker ones, is of the overwhelming forces for centralization and standardization in the production and dissemination of popular music. Adorno shakes his head from beyond the grave. Thus the papers by Wallis and Malm, Berland and Turner in different ways point to increasing centralization and concentration of record and radio industries, and at the same time to a standardization of radio formats and of aesthetic: a parallel at the centre of Adorno's critique of the culture industries. This evidence reinstates processes of cultural centralization and concentration as important dimensions of the debate around cultural imperialism, and reminds us that they continue apace. It is in this context that the policy initiatives mentioned come to play a crucial role in the fostering of local production sites and in helping to generate the possibility of aesthetic diversity.[3]

The stress in this book on cultural policy echoes the main conclusion of a suggestive review of theories of international communications by Sreberny-Mohammadi (1991), in which she calls for a move beyond the naively polarized terms of the 'global/local' paradigm, and for the insertion of a third level of analysis: that of the nation-state and its potential policies for the regulation of media and culture.

At least Sreberny-Mohammadi raises the role of state policies in regulating international and national media flows. This is an advance on some of the more abstract recent collections purporting to theorize culture and globalization (Featherstone 1990; King 1991), which not only fail to define coherently what they mean by 'culture', but also seem to be stuck in a ping-pong antinomy between an economistic world-systems perspective and a purely relational and constructivist 'politics' of identity.[4] These positions are equally problematic, and their theoretical overdetermination threatens to occlude any careful consideration of historical processes: of the relation, in any concrete instance, between the economic, political and legal conditions specific to the cultural industries and to subsidized cultural insti-

tutions, and processes of cultural production and consumption as they, in turn, relate not only to identity formation but also to aesthetic strategies; and as all of these are crossed by wider social and political movements – whether ethnic, regional, anti-racist, anti-sexist or class-based.

This is where this collection, albeit addressing music, makes a far more general and much-needed theoretical contribution to debates about culture, politics, aesthetics, identity and the world order. For as many essays in the book indicate, the nation-state is itself an inadequate unit of analysis since what is at stake are all the potential political agencies – international, national, regional, local governmental and city-based, and indeed informal and self-constituted political collectivities – which may play a role in both formal cultural policy and in cultural politics writ large. To exemplify this range from contributions in this book: while Rutten, Breen, Wallis and Malm concentrate on national popular music policies, and Frith and Grenier focus on local governmental and regional music initiatives and their effectivity in cultural and industrial terms, Bayton analyses the practices and dilemmas of feminist rock musicians who developed both alternative subcultures and industrial forms.

More importantly, without this multiple and 'constellatory' conception of the political, it is impossible to grasp *conflicts and contestations* between different forms and arenas of the political in relation to culture. Only in this way does it become possible to analyse conflicts between the normative policies of the nation-state (whether in relation to commercial media or institutions of official culture) or the operational politics and ideologies of the media industries, and other formal and informal political agencies, some of them specific to culture. I will give five varied examples from the book.

Frith's account of the new musicians' institutions operating under the aegis of the Greater London Council (GLC), London's erstwhile local government, and other local (city) governments in Britain during the early 1980s, shows how these formed a powerful, politicized and working alternative to national government policies, and one which eventually provoked not-so-subtle retaliation from Thatcher (as shown by the abolition of the GLC).[5]

At the same time, because of the character of GLC policy, Frith's paper also instances a phenomenon which is often, and significantly, neglected in the rush to read culture as the site of only certain kinds of politics: that is, the potential for conflict between extant state policies or industrial operations, and the 'professional' cultural politics of producers working within specific cultural areas and wanting, simply, to gain a space of subsidy to develop different forms of aesthetic and practice – that is, a cultural politics specific to particular cultural spheres. This is a form of constant informal and sometimes formal political negotiation which at certain points may erupt into clearer oppositional strategies.

GLC music policies were the result of formal and informal lobbying by various groups of young, radical musicians and producers who envisaged new forms of musical practice and resultant aesthetics. They eventually gained local government support for setting up small new institutions – studios and practice halls, venues, labels – by clothing their intentions in educational, employment-training and small-business terms: the 'hard-speak' of leftist 'cultural industries' policy. This therefore represented a proto-professional politics of negotiation and engagement with the median level of local government, the result of which was clearly in tension with both national music policies and dominant industrial forms.

It is, therefore, only by ignoring, and by implication delegitimizing, professional and proto-professional cultural production itself as a site of politicization and as a mediation of wider social and political currents that 'cultural politics' has been collapsed, in the neo-Gramscian perspective of much British cultural studies, into the attempt to read off from audiences and their consumption of cultural forms alone the current play of cultural politics. This is a strange state of affairs, to which I shall return later.

A second example of the uses of a multiple conception of the political from this book is Bayton's paper, which analyses the opposition between the cultural politics of feminism and the masculinist and mysogynist workings not only of the music industries but also, microsocially, of the everyday practices and schedules of most rock bands. Bayton shows how the feminist politics of popular music have involved both the 'effects' of feminism 'on' production – perhaps most significantly, the entry of many new women into music-making as an attempt to accrue for themselves the power of musical production and expression; and their exploration of the potential for sounds, lyrics, performances, working practices and relationships different from the extant norms; and the gradual politicization of women who were already professionally involved in popular music – an instance of a diffuse, wider politics finding mediated expression within professional cultural production.

A third example is Lawe Davies' discussion of the disparate playing out in Australian popular music of a more implicit and evanescent, if socially and historically grounded, Aboriginal politics of identity. This is a political strategy in which, he argues, the winning of the 'low ground' of mainstream record industry success by certain bands has provided them with precisely whatever power and credibility they have *vis-à-vis* the state and its historical tactics of exclusion and domination. Here it is suggested that capital itself, in its separation from the state and its different logics, provides a platform for inchoate critique – a critique made effective only by the bands' aesthetic successes.

A fourth example is Shepherd and Wicke's sketch of the popular music policies and institutions of the former East German state, which epitomized state control of music and which suppressed market forces and

commercialism; and how these were riven with contradiction because of the politicizing character of popular music and because of popular music's inherent capacity for becoming a medium of the political. Thus popular music became the fulcrum for anti-state alliances which co-opted the state's leading rock musicians, through which were spoken some of the forces which eventually led to the downfall of the state.

A fifth example is Grenier's account of the conflicting ideologies and strategies at stake in recent debates between the state, recording and radio industries over popular music policies to promote Québécois linguistic and cultural identity in Canada. In this, she hints at a Foucauldian analysis by focusing on the variant discourses employed, and at their different constructions of the object. Grenier manages to capture the complexity of the war of positions, and the essential ambiguity of the industrial politics of music: that nationalist, statist and commercial formations were engaged not so much (or not only) in simplistic interest-driven politics, but in speculation over the best way to stimulate diversity in Québécois popular music and, at the same time, to please and hold on to an audience showing signs of deserting the cause. On this last point, it is worth noting that Grenier's is just one of a number of essays in the book (see also Berland and Turner) which face us with uncomfortably Adornian evidence on consumption. These essays convey a changing radio audience which is composed (or which composes itself) more and more as a receptor for restricted and backward-looking playlists and standardized formats.

This book is valuable, then, in contributing an increasingly complex understanding of the centrality of the political in historical processes of cultural production and distribution; but also, in suggesting music's particular potentiality as a medium for politicization (cf. Attali 1985). This is a salutary point which must immediately be qualified to prevent it becoming the vehicle for excessive utopianism: music, with its pedagogic, ritual and emotive functions, has also been the medium *par excellence* for ideological conditioning and depoliticization (cf. Meier 1992).

It is a question, then, of inscribing policy and the political, broadly conceived, into the analysis of both global and local cultural processes. In fact just as free-market ideology, in attempting to absent the political role of the state in the regulation of the economy and of the public sphere, at the same time implicitly confirms its omnipresence, so we should conceive of the political in relation to culture – as 'always already there'. Thus, especially for those states strong enough in the international hierarchy, regulation is always an option which, if relatively absent, must itself be theorized as an ideological and political position. It is therefore unfortunate that current debates around culture and globalization have paid so little attention to the political – especially state policies, let alone attempting to theorize the complex and interrelated dynamics of different forms of the political in the way that I have begun to sketch above.

PRODUCTION, AND THE AUTHOR HERSELF

Implicit in much of the foregoing section is a basic principle which under-
lies many contributions to this book. That is, in order to combat the global
hegemony of multinational entertainment industries at the level of con-
sumption (as evidenced by my opening quotation), the main option is to
theorize the possibility of changes in production and distribution. To do
this is to work against the grain of orthodoxy of neo-Gramscian cultural
studies in which consumption itself has been overburdened with bearing
the full weight of resistance to both ideological incursion in general, and
cultural imperialism – the former standing as a sort of metonym of the
latter.[6]

The influence of this perspective has been due to the meeting point, in
consumption, of several strands of theory and politics. As they are often
invoked,[7] I will only sketch them here: a rejection of the mass culture
critique; the wish to redress the absence of analysis of consumption in
Marxist theory; the critique of linguistic structuralism via Volosinov, and
the embrace of elements of poststructuralism, in particular the later
Barthes on the 'birth of the reader'; complementary aspects of hermeneu-
tics; the desire of feminist cultural studies to examine and revalue women's
everyday consumption practices; the championing of aspects of Gramsci's
cultural theory, refracted through the highly diffused 'anthropological'
conception of culture (as a 'way of life') outlined in certain works by
Raymond Williams; and all of this culminating in celebrated work such as
Hebdige's (1979) on subcultures, Radway's (1987) on women reading
romance fiction, and Hall's (1973) and Morley's (1980) theory of the social
motivation of variant decodings.

At its worst, the consumption orthodoxy has condensed a dual 'strategy'.
Implicitly it has evaded the theorization of forms and degrees of cultural
power (and has thus been remarkably unreflexive) whether in terms of the
specifics of cultural institutions – market and statist – or in the broader
terms of cultural and intellectual production as they intersect (locally and
globally) with relations of class, gender and ethnicity. Explicitly, and as
others have also commented (e.g. Turner 1990: ch. 6), it has risked
becoming in certain hands a banal defence of any and all consumption as
potentially an expression of resistance and autonomy.[8]

Popular music research has always been one of the areas of cultural
studies least affected by the moratorium on consideration of production.
Major analyses have been produced of the practices and institutional forms
of the production and reproduction of popular musics, and research has
been continually updated on the political economy of the music industries,
although this book represents an acknowledgement of the need for inte-
gration and for greater attention to policies. But there are also signs of a
change in cultural studies at large with increasing calls for theoretical and

empirical consideration of the practices and institutions of cultural production, some of the most promising of which draw upon Foucault.[9]

In both cultural and popular music studies, one of the overriding tasks is for greater clarity in conceptualizing the different levels, moments and forms in any potential process of cultural production, so as to account for both the commonality and the differentiation of cultural production.[10] Such a conceptualization would have to take account of cultural production as a complex labour process and division of labour; as informal and amateur, or formal and professional; and these as conditioned by economic forces, legal and political regulation, and also by the history of institutional and intellectual forms specific to each cultural sector. But cultural production also needs to be understood as involving imaginative and aesthetic constructions – projected connections both to imagined social communities, and to aesthetic genres which themselves have histories. Cultural production, then, as a composite of discursive, technological and social mediations, its labour process enjoining both social and imaginative processes moving between more and less individuated or socialized phases. In other words, cultural production needs to be thought of at once in its imaginary social and aesthetic dimensions. Only in this way is it possible to grasp for any specific cultural production how these different moments and forms may come, in various ways, to be politicized. Music shows this particularly well in that its extraordinary potential as a political medium can be related directly to the prolixity of its many social, technological and discursive mediations, which derive in turn from its sonic, abstract and performative phenomenal character (Born 1991 and 1992; Hennion 1991). I want now to discuss four varying tendencies in recent work which does *not* conceptualize cultural production in this way, and the problems to which this gives rise.

The first is exemplified at its most persuasive by Straw (1991), a comparative analysis of two popular music cultures: alternative rock and dance music. In this paper Straw draws out the implicit generic codes, the aesthetic, social and discursive forms of these cultures; in particular, their different constructions of sociality, aesthetic temporality and geographical space. Straw uses an analytical category – the musical 'scene' – to avoid outmoded notions of authentic musical community rooted in local tradition. 'Scenes' emerge from a landscape of cultural fracture, and coalesce at the point of the 'building of musical alliances and the drawing of musical boundaries' (ibid.: 373).

This is an extremely suggestive analysis, not least for its insights into the two cultures' different forms of musical practice and production; but this emerges as part of a broader analysis which focuses equally on reproduction and consumption – the role of campus radio stations or of the dance floor, the cultivation of varied connoisseurships by rock and dance music audiences. The concept of 'scene' serves finally, then, to obscure the

theorization of differences between moments of (primarily) production and of (primarily) consumption, of the different experiences of producers and fans. It makes it impossible to ask the basic question, 'what pushes people into wanting to be performers or wanting to create' (Frith 1992: 184), as opposed to being fans? It also evades the issue of to what extent producers do create musics which meet the desires of fans, by assuming a teleology of communal and successful purpose between producer and consumer. This in turn evades the analysis of the difference between successful and unsuccessful cultural production, and the scrutiny of producers' ideologies – precisely, whether they intend or not to have 'success' or to meet audiences' immediate desires. In this way, Straw reproduces a problem which has dogged cultural studies for years: the elision of production with consumption through the notion of consumption as 'self-production', which neglects the differences which exist between (proto-) professional production and consumption.

A different case is Caughie's (1991) exploration of the potential for an aesthetic politics of television production in which he considers how the characteristics of the medium, including its scheduling structure, delimit what form such an aesthetics might take; and in which, citing Hutcheon (1985), he sees parody as the key reflexive and progressive form for contemporary televisual texts. Again this is a welcome development, which Caughie rightly frames against a lack of theorization of the aesthetic politics of production in recent television studies.[11] At the same time, however, Caughie risks reducing the politics of television production to aesthetic strategies alone, thereby neglecting to consider the politics of the institutions and social relations within which aesthetic decisions are made.

A third case, almost the opposite to Caughie's, is Bennett's (1990) rejection of all formalist and avant-garde theories of cultural politics through his critique of Marxist models predicated on the dualism of internal object (aesthetic) and external conditions (history analysed in the terms of historical materialism). On the one hand, Bennett argues, aesthetic discourse has served historically to constitute a cultural object which is conceived not only as separate from, but also transcendant of, its own institutional and social forms – a mystification which has in itself served cultural domination. This is close to Bourdieu (1986). On the other hand, aesthetics has been seen as a functionary of broader political forces (raising class consciousness, critiquing ideology), so that Marxist critics have seen their aim as speculation on the correct aesthetic strategies that would most advance these (external) functions. Bennett calls instead for a cultural politics which would site itself 'inside' the institutions of literature and which – by attending to the particular kinds of sociality and practice, classification and legitimation which these enjoin – would be able strategically to inform cultural policy.

While I agree with the overall direction of the critique, Bennett may go

too far in displacing the aesthetic as a site of the political in culture. That is, even if insufficient in itself, and despite the dangers of fetishization, the aesthetic must also be rejoined as part of a politics of cultural production. Bennett (1990: 166) himself proposes a Brechtian solution: a provisional, conjunctural conception of the aesthetic concerned with 'political use-value' which avoids the universalizing, ethical and idealized character of historical aesthetic systems. Again, while I applaud much of this, I will argue later that whatever political aims one may have for the aesthetic, the need to evaluate how cultural producers and their works deal with issues of form, meaning, pleasure and displeasure which are specific to a particular medium – that is, problems which cannot ultimately be reduced to the social and institutional – will inevitably remain one central concern of cultural policy.

My fourth 'case' is really a wider, diffuse absence in the theorization of cultural production which also characterizes the work I have mentioned: that is, the absence of consideration of the author as creator. Cut to a recent British television programme, in which Salman Rushdie emerged from hiding momentarily to materialize on screen in discussion with Stuart Hall on the *Fin de Siècle*. At a certain point (and poignantly for a man who might be tempted to erase his authorship of a text which has led to his own incarceration), Rushdie made a plea for the author to be reinstated – for a re-birth of the 'dead' author (*pace* Barthes 1977); for recognition of the agency, the responsibility and the creativity of the author. Perhaps Rushdie can epitomize the contemporary author who takes responsibility for his clashes with power; and in writing this, I may be in danger of evoking romantic images of the heroic author-subject pitted alone against the Law (whether of Islam, or of extant aesthetic or theoretical norms). Yet despite the resilience of an unreconstructed romantic discourse of authorship, it seems to me time to move beyond the rigid inhibitions instituted by the various structuralist and poststructuralist deconstructions of authorship and to begin tentatively again to talk of the author, his/her role, and his/her potential political engagement.

This project would be important not only, as I have implied, as part of a (re)turn to analysing production in reaction to the consumption orthodoxy, but also as a response to the latter's particular take on poststructuralism. The need to rethink is brought home by several notorious recent contro-versies – those around Rushdie, and artists Serra and Mapplethorpe[12] – which make it clear that authorship should not only be conceived as a characteristic motif of cultural mystification and domination, but also that the author may inhabit other positions within broader structures of power – that he/she may indeed place herself, or be placed, in confrontation with different forms of power: state, corporate capitalist, religious/ideological. From this book, Bayton's essay again illustrates one of the commoner forms this can take. She shows how many feminist rock musicians, in trying

to maintain control over the production and dissemination of their music, have found it necessary to work outside the dominant structures of the music industry, and are therefore able to connect with only a limited audience. Here a politicized context of production, whatever the character of the resultant texts, leads unavoidably to confrontation with, and disengagement from, corporate capitalist power.

Thus, against the (ironically) almost totalizing flavour of poststructuralist and structuralist critiques of the author – as a nostalgic trope standing for an illusory point of origination, as a means of legitimation, or as an authoritarian fixer of meaning – I would assert two principles. First, that the political position of the author is not foreclosed. Second, that cultural works are produced not through some kind of monadic 'auto-reproduction' or intertextual 'auto-transformation' of existing generic and discursive forms,[13] nor through some illusorily transparent, circular market movement by which producers simply read off and implement the 'needs' and 'desires' of consumers, but through the conditioned interaction of originating subjects with extant forms and, in some cases, extant audiences. I am calling, then, for a return of agency in theorizing cultural production, and for acknowledgement of the place of originating creativity or, simply, work.[14] At the same time, in speaking again of the author it will be crucial to employ the productive research – both empirical and theoretical – which has been done in the name of these critiques to complexify our conception of authorship, and in particular its embeddedness in extensive divisions of labour,[15] and its varying functions within specific discursive, aesthetic and institutional regimes.[16]

While I do not mean to elide authorship with production, then, I would strongly resist the tendency to dissolve the category of the author into that of the cultural division of labour as a whole. To do this blocks perception of the differential creative inputs and responsibilities of those engaged, and makes it impossible to analyse different degrees and kinds of agency. The author may perhaps be conceived as an individual or collective subject – a Proppian 'function' – and as one who initiates or supervises a process of production, thereby marking the process aesthetically and socially in a pronounced way. But this does not obviate specifying the discursive and historical conditions, the generic and aesthetic forms, within which such an author-agent operates.

I want finally in this section to speculate on the links between this 'puzzle' of the absenting of authorship by poststructuralism (and, relatedly, the absenting of cultural production by the consumption orthodoxy in cultural studies) and the interrelated crises of modernism, cultural authority and non-market spheres of cultural policy and production. In my view, the delegitimation of issues of authorship, and of the politics of author-as-agent, derive from their implication in the wider and historically deeper crises of legitimation of philosophical and aesthetic modernism,

and of the notion of an avant-garde (artistic and/or political); these in turn resonate with a questioning of the authority of high culture and of its extra-market discursive, institutional and policy apparatuses.[17] Simply put, the author (as intellectual, as point of origin, as '*responsable*') becomes tainted with guilt for the failures of modernity, for the impasses of the several grand narratives of progress (art, science, Marxism . . .)

However intuitively compelling, this perspective rests on questionable reasoning. First, it involves a categorical slippage whereby those 'guilty' of *aesthetic* 'misdemeanours' come to be seen as somehow responsible for other failures and forms of domination – of a social, political, ideological, or scientific kind – perpetrated by enlightenment rationality. Second, it neglects the uneven historical fates of aesthetic modernisms. While musical modernism remains resolutely unpopular with the general public and with fractions of the art music elite, modernism in the visual arts has found both a cultivated and a mass audience, and has successfully entered the vocabulary of popular design. Therefore, just as some avant-gardes have got it wrong, others seem to have got right their teleological 'prediction' of changes in the tastes and markets for art.

What is extraordinary in cultural terms, then, is that both authorship, and the whole possibility of non-market cultural forms and apparatuses, are seen as contaminated by the crises of aesthetic modernism and modernity. Instead of picking through the rubble to trace the specific role of the various elements in these historical 'disasters' or disappointments, it is as though the whole *mélange* – including cultural policy and its *necessary* basis in legitimizing judgements – has become unthinkable.

CAN THERE BE A POSTMODERN MUSIC-CULTURAL POLICY?

Although they do examine production, the kind of perspective I have just criticized is consonant with the contribution by Shepherd and Wicke in this volume. From an analysis of the contradictions of popular music production in former East Germany, the paper takes as its base-line that non-market, statist cultural apparatuses tend to work against political and cultural freedom, and foster 'undemocratic and hierarchical control of cultural life'. Counterposed to this is their view that market forces are endemic to healthy cultural production since without the feedback afforded by the market in cultural goods as a sign of the 'reality' of audiences' aesthetic desires, production becomes inherently repressive, self-referring and aesthetically inert. Thus cultural production in the West is freer, they argue, than under the totalitarian conditions of East Germany.

What is interesting about Shepherd and Wicke's contribution is that the material it gives can generate almost the opposite reading. For instance,

they cite the fact that the East German system involved musicians in the onerous task of becoming adept at dealing with state bureaucracies and ideologies for the administration of rock. But one can reply that in the West, rock musicians have to become adept at working the no less recalcitrant, and equally – if implicitly – ideological and politicized, institutional apparatuses of the major entertainment corporations.

But more importantly, Shepherd and Wicke describe a situation where East German rock musicians wielded an enormous amount of ideological and political power; where they were also under a great deal of pressure from their audiences to represent their interests, often against the state; and where the highest state functionaries – even Honecker himself – were anxious about the degree of popular politicization of rock music and its subversive ideological effects. Moreover several features of the working conditions of East German rock musicians which are condemned by the authors strike me as quite progressive: for example, the fixed price of tickets for concerts; the eradication of the usual hierarchy between urban and rural venues because musicians' fees were the same for either, and therefore the fact that the only way for musicians to make more money was to play more often. One could read the East German case study, then, not so much as a lesson in the evils of the state administration of culture, but as one detailing insightfully the serious problems and also extraordinary potentials of attempting to create representative, non-market institutions for the administration of cultural production. If anything, it seems that the East German state's experiment in the controlled politicization of rock music worked too well, and became a beacon of political responsiveness amidst the bleak totalitarian landscape.

The perspectives which I have now outlined – stemming respectively from radical doubts about modernism and about statist cultural institutions, and involving an accommodation to commercial market forces – together map out some of the key co-ordinates of postmodern cultural theory. At the level of the aesthetic, this is also characterized by an absence of historical certainty, by exploration and parody of earlier cultural forms, by the embrace of 'other' (ethnic, non-western and popular) cultures, and so greater pluralism and populism. The established view, then, from proponents and critics alike, is that postmodernism is the 'cultural dominant' of our times and marks the *rapprochement* of high and popular culture, and of high culture with commerce – in contrast to the alienated history of modernism.

Postmodernism thus sits uneasily with the question of developing progressive cultural policy, and the problems of the legitimation and judgement of different cultural or musical forms for subsidy which that subsumes. Indeed the whole historical apparatus of cultural subsidy has depended on an aesthetic discourse which purports to separate out culture

of transcendent historical value from the ephemera of the present – a separation which, as some have begun to explore,[18] depends in turn upon an often unconscious desire to assert high culture's absolute difference from popular culture. Throughout this century this anxious (and defensive) assertion of difference has become embodied in the 'autonomous' abstractions of modernism, at the same time that the institutions of cultural subsidy, legitimation and canonization have become mature and entrenched.

Are cultural subsidy and policy therefore irrelevant or even obstructive to the postmodern present? Certainly, throughout the 1980s in Britain, Thatcher's government cut away at the roots of state cultural subsidy, enjoining the arts to get tough and face the naked truth of the judgement of the market-place; and so 'cultural policy' appeared to wither away. Of course, as I have suggested, this anti-statist approach was just as much a form of policy and masked deep attacks on various spheres of cultural political opposition to the government – from the GLC to the BBC. Despite a common awareness of these motives, it is remarkable how the free-market ideology of culture has taken hold in both everyday and intellectual consciousness in Britain. In France, by contrast, since the Socialists' advent to power in 1981, state cultural policy and subsidy have grown stronger than ever. However, what appears there as a 'directed cultural pluralism' shows the cracks of trying to bridge the contradictions of a statist postmodernism. Thus while populist in intent, this policy is didactic while pretending not to be and has produced results which are still primarily consumed by the cultured middle classes.[19] The proliferation of museums for every aspect of cultural life, and their unrelenting scientism, are sure signs of this.[20] The discourse of cultural pluralism in France therefore conceals a still centralized, didactic and elitist cultural policy.

The cumulative weight of my argument thus seems to militate against the very possibility of cultural policy in the postmodern present. This has been intentional: to give a sense of the tremendous forces – perhaps more than at any time in history – stacked *against* continuing to think of the *institutional existence* of culture in plural terms; stacked also against trying to think at the same time of the potential politicization of both the institutions and the aesthetics of cultural production.

I want now to turn to work, written under the auspices of the postmodern but from a consciously avant-garde or radical position within that discourse, which tries to articulate the forms that such a policy might take, and in particular the new kinds of legitimation which might be involved. This work, of which the best example is the collection edited by Foster (1985a), differentiates between two aspects of the legacy of the historical avant-gardes: the aesthetic and the sociological. In doing so, it recalls Bürger's (1984) distinction between the purely aesthetic 'radicalism' of most modernist movements, and those few avant-gardes who engaged in

278

guerilla actions against the institutional and social forms of art (Russian constructivism, Italian futurism, dada, surrealism). Bürger reserves the term 'avant-garde' for these politically engaged movements, opposing them to formalist modernism, and so retains a political reading of the notion of an avant-garde. He proposes this as the basis for a politicized contemporary art. In line with this, Foster (1985b) criticizes the predominantly formalist and elitist cultural politics of modernism, and advocates instead an 'anti-aesthetic' – by which he means a rejection of the modernist belief in the autonomy of the aesthetic and an embrace of the social character of cultural practice. With his co-authors, Foster calls for a renewed postmodern avant-garde, now allied to or rooted in the 'new social movements' around race and ethnicity, gender and sexuality.

We can now discern the main themes which compose proposals for postmodern cultural policy – most simply, support for aesthetic pluralism, to encourage aesthetic experiment and diversity within different extant genres. In relation to music, for example, this would aim to support the evolution of musics which have hitherto lacked the legitimate authority to claim subsidy – jazz, rock, pop, ethnic and improvised musics. This was exactly the kind of policy implemented by the GLC during its brief period of cultural radicalism. In France, the regime of Socialist music minister Maurice Fleuret also gestured at such a policy in the early 1980s, although on close scrutiny the funds given to popular musics were minimal compared with those being fed to the institutions of contemporary art music.

Crucially, however, this limited kind of aesthetic politics to encourage a 'regulated aesthetic diversity' is itself linked to two further policy proposals: first, support for new social sources and forms of culture, for instance to encourage the production of music by women, blacks, ethnic and sexual minorities, and for this to be organized socially in new ways; second, support to enable musics which have not been effectively mass-produced and distributed, to be industrialized on a small scale – to find some kind of market niche. This is where the commitment to fostering aesthetic diversity, and diverse social roots and forms for cultural production, meets the critique of statism and the advocacy of (regulated) markets. These strategies represent, then, two forms of social-institutional politics of music: one to do with equalizing access to the power of musical expression, and transforming the social relations of cultural practice; the other to do with subsidizing a 'localized', mixed economy in music, in order to weigh against the concentration and conglomeration of the music industries by buoying up local producers and alternative networks of distribution. Again, as Frith's paper shows, these were precisely the policies of the GLC and other British local governments in the early 1980s, which involved the setting up of popular music centres and alternative circuits of production and distribution in order to break down the monopolistic hold of the leisure multinationals.

I suggested just now that these forms of postmodern cultural policy were linked. Clearly, new social bases and new organizational and industrial forms of cultural production may well encourage aesthetic innovation and greater aesthetic diversity. They will also, according to Foster and others, favour the development of newly politicized postmodern avant-gardes informed by the politics of feminism, anti-racism, or gay rights. These are complex issues, and such policy initiatives reflect cultural activity which is currently developing, and will continue to, subsidized or not. However, I want to air a couple of critical issues in relation to these 'solutions' which are sometimes overlooked.

Although new social bases and institutional experiments in cultural production may generate musical-aesthetic innovation, this is by no means assured. What are we to make of this? On the one hand, if we follow the critique of formalism, we might take the view that this is no reason not to engage in such experiments, which have their own legitimacy. This is why it is essential for a politics of cultural production to separate out the social/ institutional from the aesthetic, and to interrogate and politicize both. From this perspective new forms of local cultural production – small-scale, drawing on local sounds as new aesthetic ingredients in the musical mix, growing out of new forms of social identification and new political collectivities, but still based in a shared sense of locality, place – *may* foster aesthetic diversity; but if they do not, they are still valid.

Although I find this persuasive, I want to signal my reservations about this approach which elevates the social to such an extent that it risks obliterating the specificity of the aesthetic – and therefore risks the whole experiment. This is because, in the end, both producers and their potential consumers are not sufficiently satisfied by innovations and political advances in the social and institutional forms of cultural production if they are not matched by '*good enough music*' – by music itself which seduces the aesthetic as well as the social imaginary. Neither the commitment to support previously 'illegitimate' popular musics, nor musics from hitherto 'unheard' social and cultural sources, can obviate the need (also) for specifically *musical-aesthetic* judgements of the musics so produced. Thus whatever the genre, whoever the producers and whatever their politics, whatever the contexts of production and distribution, there remain (different) aesthetic criteria which need consciously to evolve through open critical debate and musical interplay. Ironically, when cultural work is being produced under the pluralist and politicized conditions fostered by postmodern policies, there can arise a sense of repression of the potential for, and reality of, aesthetic dissent and conflict. One example of an important and productive conflict which did surface was that within British feminism around the artist Mary Kelly with regard to the psychoanalytic theory informing her work and its artistic results. The debate concerned whether this was successful or resulted in a mystifying and elitist art which

would alienate the majority feminist audience, despite common political aims (Parker and Pollock 1987: 203–5). But the problem is that such open and strenuous debate within feminist art practice is, at least in Britain, quite rare.

Thus in the end, musical-aesthetic judgements must be made, and not evaded by recourse to a self-righteous sociologism or a new discourse of sociological-political legitimation which inverts the error of formalism by reducing cultural politics exclusively to the social or to a politics external to the musical object itself. At the same time, musical-aesthetic judgement is not easy. The problem has been that we seek either to hive it off to those (modernist) experts propounding a legitimizing metanarrative of historical progress, or to avoid the problem of judgement by recourse to the apparently irreproachable immediacy of the market and its supposed 'reflection' of taste. Both strategies of elitism and populism, then, bring illusory relief from the stress of aesthetic responsibility.

To produce new kinds of judgement – which escape the extremes of universalism and total relativism – requires, in my view, imagining new, non-market *social* forms of aesthetic judgement. For a postmodern music policy, we might speculate on producing a social organization for aesthetic judgement which models as closely as possible the contemporary aesthetic process itself: a diverse, plural and volatile set of genre-specific panels, made up of elected *musical* 'experts' (organic intellectuals) from those genres; but changing, evolving, and above all *interrelating*, shifting the boundaries – so emulating the promiscuous and productive, syncretic history of much musical-aesthetic innovation. Such a 'vision' is intended only as a provocation to nudge cultural and popular music studies beyond the populism – the suspension of judgement, of the interrogation of production and of aesthetics – to which they have been susceptible. It may also make it possible to reconfigure the deeper historical antinomy whereby the modernist avant-garde has allowed the 'autonomous' art object to tyrannize the subject, while the populist position mirrors this by favouring the (consuming) subject's tyranny over the musical object.

'WHAT IS IT THAT POP MUSICIANS REALLY WANT?': AGAINST NEGATION

I want to offer here some further speculations on strategies of cultural production, the subjectivities which they enjoin, and how these might intersect with future forms of music policy. In doing so I will to some extent be working against my plea for consideration of authorship in context, and my caution about an overemphasis on structuralist approaches to authorship. My defence is simply that we require both a developed concept of agency, and an understanding of the structures within which such agents operate. I offer these ideas because they address, structurally, a level often

ignored: the psychic and imaginary dynamics of creativity. To begin, I counterpose three dominant after-images left in mind by the contributions to this book:

1 Of the ever-increasing economic concentration, aesthetic standardiz-ation, and technological and administrative rationalization of the music industry and of its distributive extensions – radio, satellite and cable TV (Berland, Turner, Wallis and Malm . . .);

2 Of the space of innovative aesthetic and technological entrepreneurs and composers of new pop forms, especially from black music (Garo-falo, Harley . . .);

3 Of the politics of 'new-social-movements-in-music': feminist, black, Aboriginal, regionalist/nationalist – or anti-multinational (Bayton, Garofalo, Lawe Davies, Grenier, Frith . . .).

I want to read behind these to take a view on what pop producers want, to transmute issues of the local and global into a set of questions about the psychic, imaginative and aesthetic strategies followed by pop musicians. Simply, I want to think speculatively about how they place themselves and why, and about how aesthetic self-placing relates to the courting or con-struction of socio-cultural identities. I want to think about 'imagined communities' in relation to the politics of cultural production: the projec-tion of socio-cultural positioning through strategies of production. Although I cannot finally answer these questions here, I want to ask: what kind of 'community' do aesthetic strategies articulate/imagine? And if this is aesthetically produced, what political effectivity or social meaning does it have?

As I have tried to indicate, strategies of cultural production imagine (or construct) at once both aesthetic and social/institutional positions. In short, one can discern two fundamental, potential forms of imagining at play in each of these levels of cultural production, including that of pop musicians. These are, on the one hand, a strategy which constructs alterity, difference, marginality, the small-scale, the 'local', the 'independent', the 'avant-garde', and on the other, a strategy which seeks fusion and merging, submersion into the dominant collectivity, which constructs the main-stream, the 'global', the communal and consensual. They therefore form two ends of a spectrum ranging from the courting of (various kinds of) difference to the desire for merging, massification, internationalization.

The point is that both strategies involve basic structures of identification and of the constitution of (individual or collective) self *through cultural production*. Both produce different kinds of psychic states, of pleasure and prestige, of *'culturally imagined community'* – for producers, but also for their consumers who are invited to enter into complicit imaginary identifi-cation with the producers. The global strategy invokes the pleasure of overcoming boundaries, of an idealized ultimate reconciliation, of the

reflected narcissism of seeing self and other as 'becoming one'; and at the same time the darker phantasized pleasures of omnipotence, of banishing difference, of bringing everyone else tyrannically under one's own regime. The strategy of alterity enjoys the sense of constituting difference, of defining the (collective) self against others, the small and hard-to-find as opposed to the widely available, the exotic or complex as opposed to the banal – and this without any necessary antagonism. Yet this too carries its darker side: defensive phantasies of fragmentation, of the destruction of the 'unity', and the splitting involved in denigrating the ordinary and dominant while self-idealizing the different. What I am trying to get at are the kinds of imaginary and psychic investments which are immanent in cultural producers' aesthetic and institutional self-placing; which form part of the conscious agency of authors, but which are also psychically imbued; and which are irreducible to – and may be in tension with – cruder instrumental calculations such as the economic rewards of mainstream commercial success, or the cultural capital attending avant-garde status.

I will extend these ideas by reference to the essays by Straw (1991) and Caughie (1991) mentioned above. In many ways, Straw takes the kind of approach I am suggesting much further than I can here: by his close and knowledgeable comparison of two popular music cultures, but above all by adding into the equation his interesting analysis of the different temporalities of the two genres. Thus he summarizes the two musics, and the composition of their respective 'scenes' (his term for what I would call musically imagined communities), in terms of their contrasting 'values': dance music as a rapidly evolving internationalism, at once highly localized and globally dispersed, against alternative rock as a static, canonical and cosmopolitan localism. Straw implies that the two genres' contrasting constructions of time are inherent not only in the aesthetic pleasures afforded by each, but also in constituting their different socialities. In doing so he suggests a temporal dimension to the psychic forces which I have outlined, but one which confounds the expectation that 'alterity' allies itself with constant innovation while the mainstream implies stasis. Rather, and ironically, the values of 'avant-garde' alternative rock have sedimented while Adorno's 'motionless' dance music – a music 'on the road to nowhere' – has become, at least in its own terms, a site of incessant generic unrest.

Caughie's essay develops a theory of difference in aesthetic strategies, and also proposes this theory as the basis of an aesthetic politics (of television). While valuing the paper, I want to question both of these moves. In terms of the analysis of aesthetic difference in popular culture, Caughie's basic point is that we should look again at the Adornian distinction between difference as negation – 'a difference . . . in which something is at stake' (1991: 132) – and which, he suggests, is the key to both aesthetic and political value, and the kind of difference to which it stands opposed –

an 'in-different' repetition or variation which, he implies, characterizes much television (and genre production) just as Adorno saw it as characteristic of the culture industries. Caughie derives from this a theory in which parody becomes the latest form taken by negation in recent high-quality American television.

A first observation is that, as Caughie himself admits (ibid.: 152), negation always rapidly itself becomes a form of repetition and variation – of previously codified aesthetic negations as they exist in relation to particular genres. This logic is always a problem for attempts to produce 'structural' readings of avant-garde negation, as though these strategies could somehow themselves evade the identification of genre, their own historicity (see also Born 1987: 66–70). Thus parody itself becomes standard (and invites the parody of parody?). In this important sense, Caughie's (and Adorno's) distinction is problematic.

My second comment is that negation – even as reworked into parody – does not help to analyse the key aesthetic processes of popular cultural production. The subtle transformations involved in successful genre production are dismissed in the Adornian perspective as regressive or illusory. Similarly, Caughie's dismissal of the 'in-difference' of repetition or variation jettisons, at one stroke, probably the hardest questions posed by the powerful psychic attractions of televisual and popular musical genre production – that is, how desire is constantly stoked by those products (not all) which *are* primarily variations, and yet which somehow, imperceptibly, recreate or *prolong the life of* the 'original' seductions of the genre. (The closest I can come to describing this is the feeling some of the best mainstream pop evokes that one is absolutely sure one has heard this song before, because the sound is 'exactly right', has anticipated perfectly, as it were, the 'only possible solution' to the projected temporal unfolding of the genre.)

The mystery of repetitive genre productions, then, is not so much how they may be radically transformed (by irony, parody, satire), but how they miraculously continue to be seductive, and to innovate while remaining firmly within existing rules, for so long. In my view the concept of negation comes nowhere near helping to theorize the far more complex, subtle and differentiated forms of difference inherent in popular cultural production. Hence despite insights, Caughie fails in his initial task – elucidating the role of difference in these aesthetic processes. He also risks underestimating both the reflexivity and the creativity inherent in innovative genre production.

But if this is so, then another of Caughie's central aims is undermined, since if negation is the point of conversion between aesthetic and political value, and if negation cannot help to theorize the aesthetic, then its political role must also be in doubt. In fact by defining the politics of the aesthetic in terms of negation as opposed to variation, Caughie announces

his intention of elevating political over aesthetic value. I would go in exactly the opposite direction. It seems to me that before we can even begin to develop an aesthetic politics of cultural production, we require first a subtler and wider account of the aesthetic in terms of the production of meaning by different cultural forms and also by their social, discursive and institutional mediations. In other words, a better understanding of the cultural object – as a complex constellation of mediations – must precede, provide the basis for, political analysis. This returns, of course, to the start of my essay where I suggested that the contributions in this book show precisely how, in analysing the politics of pop music production, it is necessary to examine how this may inhere in its various mediations – which, I am suggesting, constitute the cultural-political object as much as the 'music itself'.

Caughie's scheme of difference thus shows the strains of following the Adornian legacy in several ways: first, by giving insufficient weight to the potential politicization of the social and institutional mediations of cultural production, and so requiring of the aesthetic that it must necessarily be *the* site of the political in culture; second, by searching for signs of the political in the aesthetic, and by reducing this to the political-read-as-negation irrespective of the more complex aesthetic actualities (and real aesthetic successes) of popular culture. But negation is also unhelpful in examining the social and institutional dimensions of cultural production, since these are constituted as much through positive as through negational imaginings of difference. My use of 'alterity' to describe strategies of difference implies a *positivity*, difference without any necessary antagonism, another form of positively constitutive imaginary identity to that of merging with the mainstream. The social and institutional 'genres' of cultural production, then, may sometimes, or may partly, be structured by opposition (in the way Bourdieu (1981) suggests in analysing the field of cultural production). But this does not in itself guarantee political value; and these social forms of cultural production are also imagined, elected and transformed (through variation).

On this question, most politicized rock has been produced out of petty capitalist enterprises – some of them intentionally negating aspects of the major industrial institutions, some not at all – or out of hybrid part-subsidized operations, while many small-scale, experimental art music groups operate in the margins of the subsidized high arts. Both, then, derive from positions of institutional alterity which appear to allow for a degree of reflexive disengagement from the aesthetic and/or political priorities of the mainstream. However, this is not a causal relation: institutional alterity does not produce aesthetic difference or political dissent, just as inhabiting the institutional mainstream does not completely preclude them, even if it overwhelmingly favours the reproduction of aesthetic and ideological dominants. Overall, aesthetic choice will tend to imply a certain

institutional placing, just as the desire to construct a certain social imaginary through music – to produce a music, say, which would cohere a particular alliance of subcultures – will imply a set of aesthetic (and institutional) choices. Yet the effectivity (or 'success') of these aesthetic choices, and the crystallization of this musically imagined community, is not assured.

To return to the global imaginary: this has, for cultural producers, seductive psychic aspects both aesthetically and socially. Aesthetically, because of the pleasures and the immense skills of the kind indicated which are involved in 'hitting upon' the next transformation of extant mainstream genres. Socially, because of the pleasures – derived from the phantasy in play – of aligning around a musical product a vast, diverse and unknowable international community of connoisseur-fans; a phantasy of social and cultural power which is at once both utopian and omnipotent. The point is that any of these may be at work in motivating the desire for global cultural reach. In bringing these ideas together with the problem with which this essay began I want only to note, without closing this crucial issue, that in analysing cultural imperialism the psychic dimensions of production require to be theorized in their full complexity as much as those of consumption, and to take their place as part of the broader scheme of forces and conditions. In short, neglecting these internal yet very real components of the psychic investment of producers risks reducing cultural production in general, and cultural imperialism in particular, to a set of banal economistic and institutional forces. What these are *animated by* psychically and imaginatively – the self-positioning of authors within basic contours such as those I have provisionally sketched – are left unaccounted for. Thus a global social imaginary which is at once *both* utopian and tyrannically omnipotent comes to be read as either/or, and is yoked unproblematically to a far more straightforward institutional technology of market maximization as though it was simply mimetic. Thus, in addition, the possibility of authors becoming more aware of the way their own psychic investments drive their own agency, and of how these might therefore connect with such a technology, is obscured.

Finally, and most interestingly, the imaginary strategies informing the different mediations of cultural production – the aesthetic, social and institutional – may or may not be set up *in tension*. Moreover these tensions may or may not be designed, or sought, by their authors. I will give some contrasting examples to explain what I mean. I have myself been involved in two experiments in 'alterity' in rock and popular music (both partly subsidized, inhabiting a mixed economy). The first, a politicized rock group called Henry Cow from the 1970s, attempted a unified, cumulative strategy of aesthetic, socio-political and institutional difference – a Brechtian politics of popular music. Aesthetically it brought modernist negational techniques from the musical avant-garde into rock; in its own

286

social relations it aimed to operate according to the politicized principles of a non-hierarchical collective; institutionally it set up its own record labels, used small-scale recording and manufacturing facilities, and developed a highly successful 'alternative' network of both performance and distribution (which reached far into eastern Europe at a time when unofficial rock and jazz were liable to repression).

This contrasts with a second experiment in which I took a marginal part: one of the most ambitious GLC-funded popular music centres, called Firehouse, in the early to mid-1980s. Firehouse existed socially as a collective, which tried scrupulously to compose itself according to rules of positive discrimination for women and black people (rules which were by and large 'imagined' by the 'collective's' leading male intellectuals). The facilities consisted of recording and rehearsal studios, which served as resources for production and education. But aesthetically, Firehouse was enchanted by the wish to enter the pop musical mainstream – specifically, to produce high-class electro funk of the kind that was then a pop musical dominant. Firehouse therefore operated in a mode of alterity and of politicization at the level of its internal social relations and institutional form, while its aesthetic imaginary was focused firmly on the global and commercial – a very postmodern mix. The fascination of the experiment lay, if anything, in this very conscious, discordant, piquant twist of the imaginaries – in the desire to produce music for massive psychic merging out of the most astute (and sternly theorized and implemented) institutional politics of music production.

If we compare these with material from the contributions by Garofalo, Lawe Davies or Bayton in the book we can see examples of a different kind of 'twist' or misfit – evidence of the desire by those producing from the social and political margins (black, Aboriginal and feminist musicians), producing what they consider to be aesthetically global music (albeit inflected with their own innovative variant sounds), to have this matched by mainstream commercial success, which they may or may not achieve. In fact, the working out of this tension, in the move from the imaginary to the real, differs in each case, and in significant ways. Bayton shows that feminist rock musicians compromise this desire for major industrial success, and reluctantly embrace marginality, because the social and ideological price for inhabiting the mainstream is too high. Lawe Davies conveys Aboriginal musicians' near incredulity that the aesthetic niche which they occupy has come to be one which the Australian majors want currently to exploit, so that their dominant commercial position can also, by symbiosis, be exploited politically by musicians to raise mass consciousness of the situation of Aboriginals.

Perhaps most interesting of all, Garofalo outlines the sustained debates within black American popular music cultures concerning the relative aesthetic and socio-political gains and losses involved in crossing over from

the position of alterity – the 'black music market' – into the commercial mainstream. The conflicts which he examines are driven by a reflexive, historically honed awareness: of the tensions between black musics' cyclical successes at imagining the next 'global' sound – at predicting the key shifts in the dominant pop aesthetic – and the processes of depoliticization and of white takeover which have invariably followed mainstream commercial exploitation. But there is more at stake in these debates since one central issue is whether the very innovative creativity of new black pop musics derives from the experience of social alterity – from the tension between the global aesthetic imaginary and social marginality/ independence. In this perspective the imagining of an aesthetic dominant is generated out of black subcultural experiences, and/or out of a positively self-defined and separatist black nationalism with its own cultural and institutional forms. So in crossing over, the vitality of this culture is threatened. In the opposite view, black music which makes the move from the industrial margins to the (white-dominated) centre achieves the logical institutional corollary of its global aesthetic reach, and in this way serves even better to augment black music's cultural power.

This essay is not the place to 'resolve' these debates, which will continue to be played out in practice. But as a coda I shall reiterate a well-known position: if the market takes care of the yearning for aesthetic/social merging, dominant consensuality, globalization, massiveness, then policy should look after the other basic structure of yearning – that for experiments in alterity, the small-scale, the local, the 'independent', the sub-cultural – whether aesthetic, or socio-institutional, or both. Social/institutional innovation in cultural production is itself valuable, especially in a post-Marxist world, yet it cannot ultimately stand in for specifically musical success, just as the generation and support of musical diversity is both urgent and valuable, but may be compromised by deriving from unpoliticized and unreconstructed social and institutional forms.[21]

NOTES

1 My thanks to Andrew Barry and Simon Frith for feedback and support; to Vincent Woropay for the Serra history; to Irma Brenman Pick for psycho-analytic insights; and to Henry Cow, the Feminist Improvising Group and Firehouse for the raw material of experiments in politicized musical work.
2 An important study on this theme is Wallis and Malm (1984), which is discussed in relation to the cultural imperialism thesis by Laing (1986). Recent work suggests a new form of interdependence between the multinational music industry – no longer primarily Anglo-American – and local sites of professional production (Frith 1991).
3 By mentioning local sites of production and diverse aesthetics in the same sentence I am not implying that the two are synonymous; nor that only local production can guarantee diversity, and that it does so by reference to some 'authentic', traditional aesthetic forms. But while I do not buy into this equation

I do hold the view, as I will make clear later, that cultural policy can support both of these things autonomously, and that they may well be correlated.

4 I am being intentionally provocative in writing of 'politics' in relation to identity since I remain to be convinced that it is productive to consider such an ungraspable and inchoate 'politics' in the same terms as the conscious and developed politics of, say, anti-racism, feminism, or indeed most nationalisms. See McRobbie (1992) on the problems of theorizing identity politics.

5 For further discussion of the cultural policies of the GLC, see Bianchini (1987).

6 Morley (1989: 31–4) can exemplify attempts to refute the cultural imperialism thesis by reference to theorizing consumption, here primarily in relation to television. Morley cites Katz and Liebes (1986) on cross-cultural variation in decodings of *Dallas*, and Hebdige (1987) on the mid-century reception of American popular culture in Britain and it becoming a vehicle for class antagonism. These cases are seen by Morley to undermine notions of cultural imperialism since, he implies, there is no cultural domination at work when imported cultural forms are pleasurable to culturally varied audiences, and when their (global) meanings may become reworked as subversive of local power structures. A similar argument is made for music by Laing (1986: 336–8). Despite important insights, there are a number of problems in this position which cannot be taken up fully here. Suffice it to mention two. First, it ignores the asymmetrical economic, industrial and institutional structures at work in these cultural flows. Second, it reduces reception to a series of untheorized notions of 'pleasure', 'attraction', 'appeal'. There seems no possibility of more negative psychological factors also being in play – whether hopeless desire, excessive idealization, envy or ambivalence – as suggested, for example, by my opening quotation.

7 For a recent summary of the development of the consumption orthodoxy, see Nava (1991: 163–6).

8 See also Born (1987: 60–2) and Frith (1992: 180), both of whom point to the special status given to popular music consumption in the cultural studies orthodoxy as exemplary of processes of 'active' consumption.

9 Frith (1992: 178) also criticizes the neglect of cultural production in cultural studies. The potential uses of Foucauldian analysis for the sociology of culture and art was raised a decade ago by Wolff (1983: 91–5); and is now being developed in various ways by Bennett (1988; 1990), Hunter (1988a; 1988b), and Born (forthcoming a and b).

10 For an innovative empirical study which gives a 'synchronous' account of a range of coexistent forms of cultural production in one locale, so allowing comparison between them, see Finnegan (1989).

11 Caughie (1991: 133–4) makes a point, here in relation to television studies, very similar to one I argue shortly in this paper: that the shift from a (discredited) Adornian modernist cultural criticism to a postmodern criticism, the former associated with film theory and the latter with television studies, has also been a shift from theorizing the aesthetics of production to examining consumption.

12 On the Serra case, see Weyergraf-Serra and Buskirk (1991). On the political ramifications of the Mapplethorpe controversy, see Hughes (1992).

13 Caughie's (1991) essay illustrates the continuing possibilities of structuralist approaches to the aesthetic. Coming as it does from the editor of a classic text on (post)structuralist debates around authorship (1981), the essay is also a good example of the continued avoidance of more humanistic conceptions of strategies of authorship.

14 This may be the moment to confess the personal motivation of my argument in

as much as, having worked for years as a musician in various politicized groups and networks, and having engaged in debate over the precise aesthetic and institutional positions that we should take, it amounts to a call for recognition of the reality and (limited) effectivity of this form of cultural work.

15 The writings of Becker (1974; 1982) and his students (e.g., Bennett 1980; Faulkner 1971; Kealy 1974) remain exemplary of empirically based analyses of cultural production, in particular the divisions of labour and labour processes of different spheres.

16 For my own examination of one discursive site of authorship, and the role of authorship in individual and institutional legitimation, see Born (forthcoming a).

17 For discussion of the legitimation crisis of one form of high cultural institution – the science museum – see MacDonald and Silverstone (1990). This is interesting in showing how the crisis of the museum is 'met' by a relativist turn to privileging consumption as the site of production of meaning – as though that in itself would solve the problem of the production of knowledge by the museum. See also Born (forthcoming b) for an account of a different kind of high cultural institution – one dedicated to avant-garde music – and its solutions to the problems of internal and external legitimation.

18 See, for example, Huyssen (1986) and Crow (1985).

19 On the audience for one key postmodern French cultural institution – the Centre Georges Pompidou – see Heinich (1988).

20 For example, the new museum of science and technology at La Villette is surrounded by a new Parisian park which holds not only gardens and restaurants, but also areas devoted to the scientific study of gardening and of cuisine. Apparently pleasure and leisure activities alone are insufficient!

21 For an impassioned discussion of the problems of sustaining musical diversity in the face of commercial and industrial globalization, see Feld (1991).

BIBLIOGRAPHY

Attali, J. (1985) *Noise: the Political Economy of Music*, Manchester: Manchester University Press.

Barthes, R. (1977) 'The death of the author', in *Image Music Text*, London: Fontana.

Becker, H. (1974) 'Art as collective action', *American Sociological Review* 39 (6).

—— (1982) *Art Worlds*, Berkeley: University of California Press.

Bennett, H.S. (1980) *On Becoming a Rock Musician*, Amherst: University of Massachusetts Press.

Bennett, T. (1988) 'The exhibitionary complex', *New Formations* 4.

—— (1990) *Outside Literature*, London: Routledge.

—— (1992) 'Putting policy into cultural studies', in L. Grossberg, C. Nelson and P. Treichler (eds), *Cultural Studies*, London: Routledge.

Bianchini, F. (1987) 'GLC RIP: cultural policies in London 1981–1986', *New Formations* 1.

Born, G. (1987) 'On modern music culture: shock, pop and synthesis', *New Formations* 2.

—— (1991) 'Music, modernism and signification', in A. Benjamin and P. Osborne (eds), *Thinking Art: Beyond Traditional Aesthetics*, London: Institute of Contemporary Arts.

—— (1992) 'Understanding music as culture: contributions from popular music studies to a social semiotics of music', in R. Pozzi (ed.), *Current Trends and*

Methods in Musicological Research, Florence: Olschki.

—— (forthcoming a) 'Authorship, technology, and legitimation: the institutionaliza-
tion of contemporary art music', *Cultural Anthropology*.

—— (forthcoming b) *Rational Music: the Anthropology of the Musical Avant-Garde*,
Berkeley, CA: University of California Press.

Bourdieu, P. (1981) 'The production of belief', *Media, Culture & Society* 3(3).

—— (1986) *Distinction: a Social Critique of the Judgement of Taste*, London:
Routledge Kegan Paul.

Bürger, P. (1984) *Theory of the Avant-Garde*, Manchester: Manchester University
Press.

Caughie, J. (1981) *Theories of Authorship*, London: Routledge Kegan Paul.

—— (1991) 'Adorno's reproach: repetition, difference and television genre', *Screen*
32(2).

Crow, T. (1985) 'Modernism and mass culture in the visual arts', in F. Frascina
(ed.), *Pollock and After: the Critical Debate*, London: Harper & Row.

Faulkner, R. (1971) *Hollywood Studio Musicians*, Chicago: University of Chicago
Press.

Featherstone, M. (1990) *Global Culture: Nationalism, Globalization and
Modernity*, London: Sage.

Feld, S. (1991) 'Voices of the rainforest', *Public Culture* 4(1).

Finnegan, R. (1989) *The Hidden Musicians: Music-Making in an English Town*,
Cambridge: Cambridge University Press.

Foster, H. (ed.) (1985a) *Postmodern Culture*, London: Pluto.

—— (1985b) 'Postmodernism: a preface', in H. Foster (ed.), *Postmodern Culture*,
London: Pluto.

Frith, S. (1991) 'Anglo-America and its discontents', *Cultural Studies* 5(3).

—— (1992) 'The cultural study of popular music', in L. Grossberg, C. Nelson and P.
Treichler (eds), *Cultural Studies*, London: Routledge.

Grossberg, L., Nelson, C. and Treichler, P. (eds) (1992) *Cultural Studies*, London:
Routledge.

Hall, S. (1973) 'Encoding and decoding in the television message', in S. Hall, D.
Hobson, A. Lowe and P. Willis (eds) (1980), *Culture, Media, Language*,
London: Hutchinson.

Hebdige, D. (1979) *Subculture: the Meaning of Style*, London: Methuen.

—— (1987) 'Towards a cartography of taste 1935–1962', in *Hiding in the Light*,
London: Comedia.

Heinich, N. (1988) 'The Pompidou Centre and its public: the limits of a utopian
site', in R. Lumley (ed.), *The Museum Time-Machine*, New York: Comedia/
Routledge.

Hennion, A. (1991) *La Médiation musicale*, unpublished thesis, Ecole des Hautes
Etudes en Sciences Sociales, Paris.

Hughes, R. (1992) 'Art, morals, and politics', *New York Review of Books* 23 April.

Hunter, I. (1988a) 'Setting limits to culture', *New Formations* 4.

—— (1988b) *Culture and Government: the Emergence of Modern Literary
Education*, London: Macmillan.

Hutcheon, L. (1985) *A Theory of Parody*, London: Methuen.

Huyssen, A. (1986) *Across the Great Divide: Modernism, Mass Culture,
Postmodernism*, Bloomington: Indiana University Press.

Katz, E. and Liebes, T. (1986) 'Mutual aid in the decoding of *Dallas*: preliminary
notes from a cross-cultural study', in P. Drummond and R. Paterson (eds),
Television in Transition, London: British Film Institute.

Kealy, E. (1974) *The Real Rock Revolution: Sound Mixers, Social Inequality and*

the Aesthetics of Popular Music Production, unpublished Ph. D. thesis, Northwestern University.

King, A. (1991) *Culture, Globalization and the World-System*, London: Macmillan.

Laing, D. (1986) 'The music industry and the "cultural imperialism" thesis', *Media, Culture & Society* 8(3).

Lyotard, J.-F. (1984) *The Postmodern Condition: a Report on Knowledge*, Manchester: Manchester University Press.

MacDonald, S. and Silverstone, R. (1990) 'Rewriting the museums' fictions: taxonomies, stories and readers', *Cultural Studies* 4(2).

McRobbie, A. (1992) 'Post-Marxism and cultural studies: a post-script', in L. Grossberg, C. Nelson and P. Treichler (eds), *Cultural Studies*, London: Routledge.

Meier, S. (1992) *A Generation Led Astray: Community Singing as a Means of National Socialist Indoctrination of the Youth*, unpublished Ph.D. thesis, Goldsmiths' College, University of London.

Morley, D. (1980) *The Nationwide Audience*, London: British Film Institute.

—— (1989) 'Changing paradigms in audience studies', in E. Seiter, H. Borchers, G. Kreutzner and E.-M. Warth (eds), *Remote Control: Television, Audiences, and Cultural Power*, London: Routledge.

Nava, M. (1991) 'Consumerism reconsidered', *Cultural Studies* 5(2).

Parker, R. and Pollock, G. (1987) *Framing Feminism: Art and the Women's Movement 1970–1985*, New York: Routledge Kegan Paul.

Radway, J. (1987) *Reading the Romance: Women, Patriarchy, and Popular Literature*, London: Verso.

Sreberny-Mohammadi, A. (1991) 'The global and the local in international communications', in J. Curran and M. Gurevitch (eds), *Mass Media and Society*, London: Edward Arnold.

Straw, W. (1991) 'Systems of articulation, logics of change: communities and scenes in popular music', *Cultural Studies* 5(3).

Turner, G. (1990) *British Cultural Studies*, London: Unwin Hyman.

Wallis, R. and Malm, K. (1984) *Big Sounds from Small Peoples*, London: Constable.

Weyergraf-Serra, C. and Buskirk, M. (1991) *The Destruction of Tilted Arc: Documents*, London: MIT Press.

Williams, R. (1981) *Culture*, London: Fontana.

Wolff, J. (1983) *Aesthetics and the Sociology of Art*, London: Allen & Unwin.

NAME INDEX

SUBJECT INDEX